The Art
of
Responsive Drawing

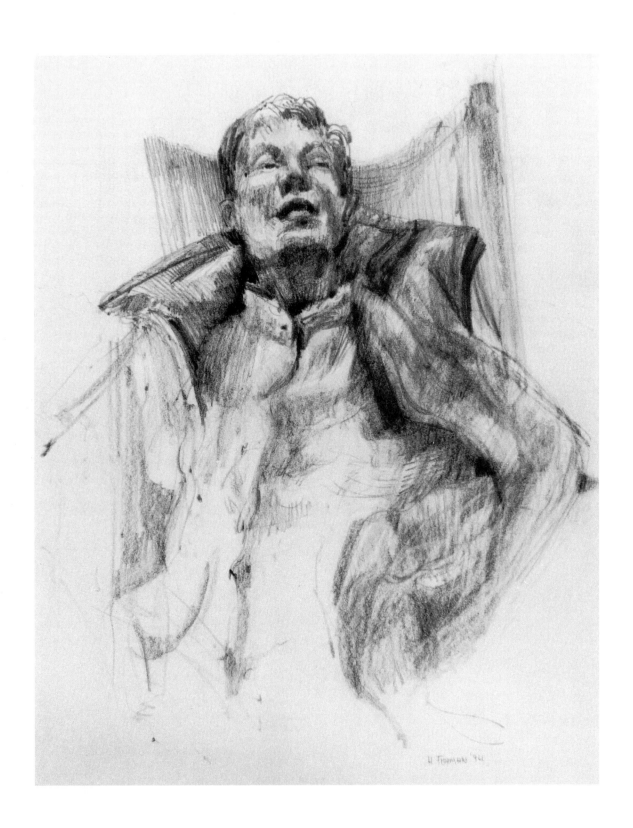

The Art of Responsive Drawing

fifth edition

Nathan Goldstein

Prentice Hall
Upper Saddle River, New Jersey 07458

Library of Congress Cataloging-in-Publication Data

GOLDSTEIN, NATHAN.
 The art of responsive drawing/Nathan Goldstein.—5th ed.
 p. cm.
 Includes bibliographical references and index.
 ISBN 0–13–597931–5
 1. Drawing—Technique. I. Title.
NC740.G6 1999
741—dc21 97-1975
 CIP

Editor in Chief: *Charlyce Jones Owen*
Acquisition Editor: *Bud Therien*
Assistant Editor: *Marion Gottlieb*
Managing Editor: *Jan Stephan*
Production Liaison: *Fran Russello*
Editorial/Production Supervision: *Kim Gueterman*
Prepress and Manufacturing Buyer: *Bob Anderson*
Cover Director: *Jayne Conte*
Cover Designer: *Bruce Kenselaar*
Permissions Specialist: *Meg Jacobs*
Marketing Manager: *Sheryl Adams*

This book was set in 10/12 Palatino by Electra Graphics
and was printed and bound by Banta Company.
The cover was printed by Webcrafters, Inc.

 © 1999, 1993, 1984, 1977, 1973 by Prentice-Hall, Inc.
Simon & Schuster/A Viacom Company
Upper Saddle River, New Jersey 07458

Printed in the United States of America
10 9 8 7 6 5 4 3 2 1

ISBN 0-13-597931-5

Prentice-Hall International (UK) Limited, *London*
Prentice-Hall of Australia Pty. Limited, *Sydney*
Prentice-Hall Canada Inc., *Toronto*
Prentice-Hall Hispanoamericana, S.A., *Mexico*
Prentice-Hall of India Private Limited, *New Delhi*
Prentice-Hall of Japan, Inc., *Tokyo*
Simon & Schuster Asia Pte. Ltd., *Singapore*
Editora Prentice-Hall do Brasil, Ltda., *Rio de Janeiro*

contents

foreword

I have always wanted to go to art school and I still do. Instead, in my youth I looked at lots of art books while working in sign shops, print shops, art departments, and advertising agencies. In these shops, offices, and studios, many kind people took time to show me how things like drawings, rendering, and designing are suppose to be done. Most of these professionals attended art and design schools and their instruction and examples were and are of importance to me. But the books on drawing became even more central to what I eventually wanted to do—that is, to try to be a part of that extraordinary community of artists that produces such beautiful masterpieces of drawing and painting.

For the past 45 years I have been teaching drawing and painting and introducing students to the deep pleasure of learning how to draw. One interesting result of all my years in art education is that I have become convinced that each of us is primarily self-taught. Genuine, meaningful learning seems to evolve only after a student is intimately and personally inner-directed. Further, I have found that a good drawing textbook aids each individual in this process in a unique way, providing a wide variety of information students can use as their development as artists unfolds. Therefore, in the drawing classes I teach a good drawing textbook is a fundamental requirement.

Drawing is something we do naturally: we doodle, draw diagrams, sketch. But in order for drawing to be extraordinary it must contain elements that are complex and challenging—for example, volumetric rendering, planometric recession, and figure gesticulation. Indeed, drawing ranges from the silly to the sublime. But to fully appreciate all types of drawing, we need to employ critical analysis, a skill we can learn from using instructive diagrams and first-rate drawings that exemplify standards of excellence. Certainly constant viewing of inspirational masterworks helps us improve our own works. These illustrations are to be found in an excellent drawing textbook such as this.

This book is meant to be used as a tool for critical analysis. Filled with prime examples of many of the most beautiful and expressive drawings ever made in our world, it should be a constant companion for any art student. Here is an invitation to the wonders and joys of self-education.

WAYNE THIEBAUD
Professor Emeritus
University of California
Davis, CA

preface

The public's generous acceptance of each new edition of *The Art of Responsive Drawing* has been both gratifying and informing. Gratifying, because my views on how we may effectively come to understand and function in the great realm of drawing continue to meet with the approval of so many art teachers, students, and professional artists; and informing, because their comments have helped me to reshape each edition in ways that more effectively meet their needs. This fifth edition too was, at least in part, stimulated by the insights gained in discussions and correspondence with artist-readers about how to strengthen further the book's theme and spirit. Also, my continuing experiences as an artist and teacher have had their inevitable influence on how I present the case for drawings that come alive to communicate in terms that can be understood universally.

Responsive artists are those who want to make permanent their impressions of, and experiences with, something they see or envision. They do so by harnessing the visual forces that will abstractly support and energize a drawing's depictive manner. The responsive artist's understanding of a subject's "look" *and* of the dynamic forces used to express it create the give-and-take between a drawing's "what" and "how"; it is this give-and-take that shapes the drawing's *content*—the total impact of its configuration. It is the responsive artist's resulting insights and innovations that make the work an invention rather than a report. And it is the quality of the negotiations between these simultaneous and mutually stimulating considerations that creates the union we call art, in which the whole is not only greater than the sum of its parts.

Like the photographer who finds yet another means for sharpening the focus, and get even closer to the subject, in this edition I have made a number of additions, deletions, and other adjustments throughout the text, which I feel have added to its clarity and effect.

In the visual sphere, there are some 26 new drawings, while 13 were deleted. A substantial percentage of these are by contemporary artists.

As before, this book is intended for the art student, the art teacher, the interested amateur, and the practicing artist who want to refresh or broaden an understanding of the main factors and processes of drawing.

All drawings motivated by a wish to inquire and to experience—whether they are interpretations of observed or of envisioned subjects—are *responsive*. Such drawings are neither arbitrary nor willful in execution, but are founded on our intellectual and intuitive judgments about a subject and its organized expression on the page. However, the primary concern of beginning students (and of most amateur and professional artists) is to expand their ability to experience and state their world in visual terms that communicate, and to understand better the options and obstacles that confront them when they are drawing the world around them. For this important reason, and because there is no way to test fully the aptness of responses to imaginary stimuli, this book emphasizes drawing as a responsive encounter with our physical world. However, Chapter 11 explores avenues of approach to envisioned images that benefit strongly from the skills and insights gained in drawing from nature.

Here, *responsive* refers to our perceptual, esthetic, and emphatic interpretations of a subject's properties that hold potential for creative drawing. In responsive drawing, comprehending a subject's actualities precedes and affects the nature of our responses. Such drawings do more than recall what our outer or inner world *looks* like. They tell us what our intuitive knowledge informs us it *is*.

This, then, is not really a how-to-do-it book; rather, it is a kind of how-to-see-it book. The exercises in the first eleven chapters are designed to help the reader experience the concepts and processes dealt with in each, not to suggest techniques or ready-made solutions. The book explores the disguises and characteristics of shapes and forms in nature; it examines the visual elements and the relational, moving, and emotive forces that constitute (and animate) the language of drawing.

The book begins by examining the factors that enable us to respond to a subject's measurable, structural actualities, its relational possibilities, and its emotive character. It then proceeds to explore the tools and materials of drawing, and the concepts, forces, and "pathologies," or common (but seldom discussed) failings of perception, organization, and expression in drawing. The examination of these pathologies in Chapter 12 is, I believe, the first attempt to catalog the various misconceptions, inconsistencies, and errors that lie in wait for those of us who draw. The pathologies discussed should enable the reader to apply a much wider range of criteria in evaluating his or her drawings—for becoming good "diagnosticians" of the problems in our work is part of learning to draw.

I have not attempted the impossible task of defining all the characteristics of great drawings. I have, however, pointed out those factors which, if left unregarded, make the creating of such drawings impossible.

I wish to express my deep appreciation to the many students, artists, and friends whose experiences, advice, and interest have helped to test, shape, and sustain the forming of this fourth edition. Thanks also to the artist-teachers at the many art schools and departments who contributed outstanding student works. I wish also to thank the many museums and individuals who granted permission to reproduce drawings from their collections.

I especially wish to thank Jonothan Goell, David Yawnick, and Gabrielle Keller, whose excellent photographs make an important contribution to the book's clarity; Bud Therien, of Prentice Hall, for the many considerate and generous ways in which he helped bring this fifth revision into being; assistant editor, Marion Gottlieb; production editor, and Kim Gueterman, for their skill, patience, and care in helping to give this fifth edition its present, attractive form. A special thanks to Harriet and Jessica, whose spirit, patience, and practical assistance figured importantly in the forming of this revision.

Finally, my heartfelt gratitude to my daughter, Sarah, for her enduring affection and understanding that have meant so much to me over the years.

NATHAN GOLDSTEIN

1

gestural expression
deduction through feeling

A DEFINITION

Responsive drawing is the ability to choose from among the parts and impressions of an observed or envisioned subject those characteristics that hold meaning for us and to be able to set them down in concise and (to us) attractive visual terms. It is the ability to join percept to concept, that is, to merge what we see in the subject with what we want to see in the drawing, and to show this integration of inquiry and intent in the completed work.

To do this we must recognize that one of the most compelling features of any subject is its overall expressive character—its fundamental visual and emotive nature. The French painter Paul Cezanne gave sound advice when he urged artists to "get to the heart of what is before you and continue to express yourself as logically as possible."[1] An important aspect of "what is at the heart" of any subject is the arrangement—the pattern or formation of its parts. Seeing this general arrangement of the parts is a

necessary first step in creating a drawing that would reflect a subject's fundamental visual and emotive character.

Too often, however, beginners start at the other end of what there is to see. Instead of establishing a subject's overall configuration and character, they start by recording a host of small facts. Usually, they are soon bogged down among these details and, like the person who could not see the forest for the trees, fail to see just those facts and forces in the subject that would enable them to draw it in a personal and telling way.

No wonder, then, that when confronted by any subject, whether a figure, landscape, or still life, most beginners ask, "How shall I start?" The complexity of a subject's volumes, values, and textures, and the difficulty of judging the relative scale and the position of its parts, seem overwhelming. There appears to be no logical point of entry, no clues on how to proceed. If the subject is a figure, many students—knowing no other way—begin by drawing the head, *followed* by the neck, *followed* by the torso, and so on. Such a sequential approach inevitably results in

[1] From a letter to Emile Bernard, Aix, May 26, 1904.

1

a stilted assembly of parts having little affinity for each other as segments of the whole figure. Regardless of the subject, the process of collecting parts in sequence which should add up to a figure, a tree, a bridge, or whatever is always *bound to fail*.

It will fail in the same way that the construction of a house will fail if we begin with the roof or the doorknobs, or, realizing this is impossible, if we finish and furnish one room at a time. Such a structure must collapse because no supportive framework holds the independently built rooms together. Without an overall structural design in place, none of the systems common to various rooms, such as wiring or heating, can be installed without tearing apart each room. Without such a design or pattern, none of the final relationships of size or location can be fully anticipated.

Every building process must begin with a *general* design framework, its development advanced by progressive stages until the *specifics* of various nonstructural details are added to complete the project. So it is with drawing.

Before the construction of a building can start, there is always the design—the blueprint. Even before the measurements and layout of the building hardened into the blueprint, there was the architect's idea: a *felt* attitude about certain forms and spaces, and about their scale, location, texture, and material as capable of conveying *an expressive order*. An architectural structure, like any work of art, really begins as a state of excitation about certain form relationships.

Similarly, all drawings should begin with a sense of excitation about certain energies and patterns beneath the surface of the subject's forms. Seeing these possibilities in the raw material of a subject, the responsive artist establishes a basis

> ***All drawings should begin with a sense of excitation about certain energies and patterns beneath the surface of the subject's forms.***

for interpretation. The "answer" to the question, "How shall I start?" is provided by the general arrangement of the subject's forms. Seeing the harmonies and contrasts of large masses, the patterns of movement suggested by their various directions in space, and their differing shapes, values, and sizes, gives the artist vital facts about the subject's essential visual and emotive nature—what we call its *gesture*.[2]

Gesture drawing is more about the rhythmic movements and energies coursing through a subject's parts than about the parts themselves. That is why such drawings show a concentra-

[2] See Kimon Nicolaides, *The Natural Way to Draw* (Boston: Houghton Mifflin Company, 1941), pp. 14–28.

Figure 1.1

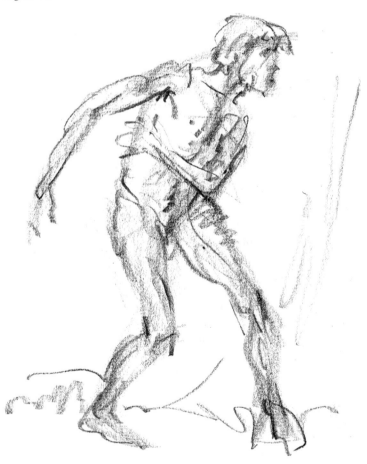

tion more on the essential pattern and the general form of the parts than on their edges, or *contours*. In gesture drawing, contour is secondary to urgings of motion among broadly stated forms. Such drawings tell about the actions, tensions, and pulsations that issue from the general condition of a subject's masses and their alignments in space—they are about spirit rather than specifics (Figure 1.1).

To draw a subject's gestural expression is to draw *the major moving actions and general form character* of its parts rather than their specific physical characteristics. Like our example of the building put up without an overall supportive framework, a drawing begun without the search for a cohesive gestural pattern "collapses." Likewise, to introduce gestural considerations *after* a drawing is underway would require undoing and reworking nearly all of it.

Experienced artists, even before they ask themselves, "What does the subject look like?" ask, "What is the subject *doing?*" That is, how does the arrangement of the major parts of the figure, the flower, the lamp, or the landscape allude to movement? What suggestions are there in the subject of directed energies coursing through its forms? For virtually everything we see implies some kind and degree of moving action. Such actions are *inherent* in the subject's formation and structure.[3] The gentle curve of a tree limb or a human one, the forceful thrust of a church spire or a schooner, the graceful spiral of a staircase or a seashell, all these suggest moving actions—types of animated behavior; in other words, they all disclose some kind of gestural expression (Figure 1.2).

For experienced artists this is the case even when the subject is an envisioned one. Picasso's *Guernica* (Figure 1.3) is a visual protest against one of the first instances of saturation bombing of a civilian population, carried out in Spain by German forces in support of the Spanish fascists. Yet this arresting masterpiece had its origins in a hasty gestural sketch that captured the essentials of the artist's intended image (Figure 1.4).

Gestural expression must not be understood as simply the rhythmic nature of a subject's components, although such action is always part of a subject's gestural expression. It is

not to be found in any one of the subject's visual properties of shape, value, or direction, nor in its type or class, arrangement of parts, or even in its "mood," but rather in the sum of all these qualities. The moving, emotive energy of gesture cannot be seen until it is experienced—it must be felt. Empathy—the ability to *feel with* a person, place, or thing—is needed to give expressive meaning to our drawings.

In part, such empathic responses result from our *kinetic* sensibilities—our ability to identify through our senses with the many tensions, movements, and weights among the things we observe. It is such sensory experience that helps us feel the tension in the bending action of the woman in Figure 1.2 and the energy of the great arc that runs from the figure's hands through to the feet. In part, too, we identify with the behavior of our subjects in a psychological way. We at-

Figure 1.2 *(student drawing)*
LYNN TRUNELLE
Black chalk. 18 × 24 in.
Art Institute of Boston

[3] Throughout this book the term *structure* refers to the constructional, volumetric nature of a subject. See Chapter 6, "Volume."

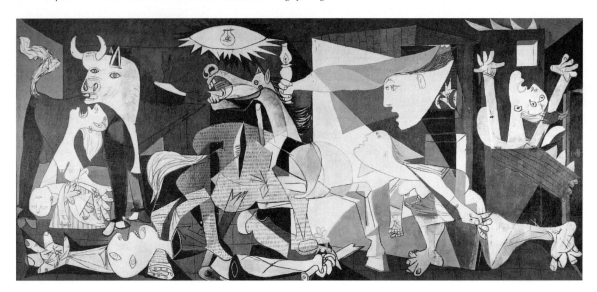

Figure 1.3

PABLO PICASSO (1881–1974)
Guernica (1937)
Oil on canvas. 11 ft. 5½ in. × 25 ft. 5¼ in.
Courtesy of the Prado Museum
Copyright 1991 ARS, N.Y./SPADEM

Figure 1.4

PABLO PICASSO (1881–1974)
First Composition Study for "Guernica" (1937)
Pencil on blue paper. 8¼ × 10⅝ in.
Courtesy of the Prado Museum
Copyright 1991 ARS, N.Y./SPADEM

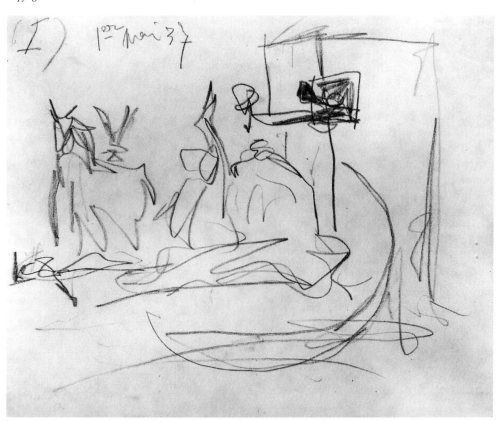

tribute human attitudes and feelings to a subject's condition in verbal expressions such as "an angry sea" or "a cheerful fire." In the same way, an artist responding to a subject's gestural expression feels a drape as "limp," a cave opening as "yawning," and a tree as "stately" or "sheltering." The response to a subject's gestural expression, then, is the understanding of the essential nature of its *total* behavior.

Not until we experience a subject's gestural expression do we really understand why (and how) each part serves to convey whatever visual and emotive meanings attract us to it in the first place. For, no matter what else about the subject excites our interest, some formation of

moving energies is always one of the attracting features.

The beginner who starts a drawing convinced that if only enough effort is put into the careful rendering of each part's *surface effects*, the subject's form and spirit will somehow emerge, is sure to be disappointed. Good drawings do not result from the accumulation of details; they arise from an underlying "armature" that suggests the subject's basic design and structure. The essential form and spirit of any subject must be first considerations in a work if they are to be found more fully realized in its completed state. Good drawing, then, is deductive, not inductive.

In Figure 1.5, Rembrandt uses gestural

Figure 1.5
REMBRANDT VAN RIJN (1606–1669)
Saskia Asleep
Pen, brush and ink. 13 × 17.1 cm.
The Pierpont Morgan Library, New York. I, 180.

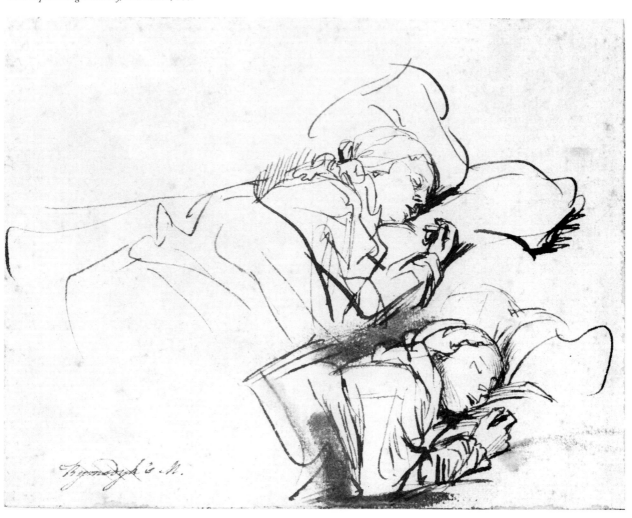

means to convey the tired, resting figure of his wife, Saskia. Rembrandt *feels* (and consequently we do too) the essence of her pose as an expression of limp weight. What Saskia is doing and feeling is as important to Rembrandt as the delineation of specific forms and textures. His felt perception of her relaxed body pressing into the pliant bedding is intensified by the forceful speed of the lines in the pillow. Those lines *enact* as well as describe the action. And directed movements are the chief means for expressing the action in any drawing, even where, as here, the subject is one of repose.

When the subject itself is in action, a gestural approach can intensify that action further, as is demonstrated in Figure 1.6, where the artist's attention moves past the subject's surface state to extract the figure's essential action and form character. That the enlivening energy of gesture drawing can animate drawings of subjects other than the figure is evident in Figure 1.7. Note that the gesture drawings we have been looking at show little concentration on contour—the beginner's trusted device for drawing. Although it is necessary when drawing to see a subject's contours objectively, it is just as important to recognize that those contours are shaped by the subject's structure and arrangement, as we shall see in Chapter 6.

GESTURE AND DIRECTION

Closely related to the search for a subject's gesture, and usually running parallel with it in a drawing's development, is the inquiry into each part's axial *direction*—the tilt of its long axis—relative to a true vertical or horizontal direction. Learning to see a part's *exact* orientation as it would appear *on a two-dimensional surface* is one of the most important early skills the beginner must acquire. Just as we cannot endow our drawings with enlivening gestural qualities unless

we respond to them at the outset of a drawing, so we cannot draw any form in relation to any other without consciously discovering its exact position in space.

Virtually every form, whether a leaf or a leg, a head or a house, has a length and width of differing dimensions. Every form then, can be imagined as having a straight or curved centerline or *long axis* running in the direction of its longer dimension. Additionally, the edges of all forms are made up of segments oriented at various angles, as we can see in Figure 1.5 in the short, often straight pen lines by which Rembrandt "tracks" the changing directions of his subject's contours. Seeing a part's directions means seeing both its long axis and the various

Figure 1.6
ARTIST UNKNOWN, 16TH CENTURY
Dancing Figures
Red chalk
The Metropolitan Museum of Art Gift of Cornelius Vanderbilt, 1880.

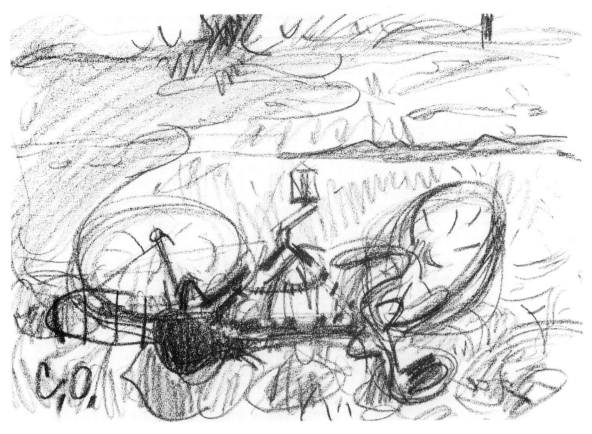

Figure 1.7
CLAES OLDENBURG (1929–)
Bicycle on Ground (1959)
Crayon on paper. 12 × 17⅝ in.
*Collection of Whitney Museum of American Art. Gift of the Lauder
Foundation-Drawing Fund*

turnings of its edges. We will more fully explore these considerations in Chapter 6, but here it should be noted that the search for a subject's inner and outer directions generally accompanies or is a natural outgrowth of the search for its gestural expression, and that the need for seeing these two related conditions in our subjects is necessary to any responsive drawing's further development.

Exercise 1a suggests a means by which we can extract a subject's gestural expression and note the axial directions of its forms and at least some of the turnings of its contours.

exercise 1a

MATERIALS: Black or sanguine conté crayon or compressed charcoal. An 18 × 24-inch pad of newsprint or bond paper.

SUBJECT: The human figure, draped or nude. If no model is available, use plants, house pets, simple still-life arrangements, toys, clothing, or some visually interesting or fanciful furniture forms. Even your own hand can be placed in a variety of active poses and used as a subject.

PROCEDURE: If possible, draw in a standing position at an easel or any comparable support. Be sure that your subject and your paper are both well illuminated, preferably by a single light source.

You will make a total of twenty drawings. The first five will be two-minute poses, the next ten will be one-minute poses, and the last five will again be two-minute poses.

During the first half-minute of every drawing, *do not draw*. Instead, search for the most inclusive response to the subject by relying as much on your feelings about the nature of the subject's action and form character as on your analysis of its

proportions, directions, and other measurable matters. You may not be able to describe it verbally, but you should get an impression of the subject's overall pattern of movement and of the arrangement of its major segments.

> ***Try to experience the forms moving back and forth in a field of space, because whatever the subject, it exists in space.***

Only when you sense you are responding to both the subject's action and the arrangement—that is, when the subject is seen as "doing," as well as "being"—should you begin to draw.

Use a small fragment of your conté crayon or chalk (about three-quarters of an inch long), holding it loosely by your fingertips. Do not hold it in the manner used for writing. The hard line such a pinched grasp produces is too restricting for gestural drawing. Let your hand and arm swing freely as you draw. Be daring to the point of recklessness in stating the essence of what you see; but don't make *arbitrary* lines, lines not triggered by perception. If you see a movement running through the entire subject, draw it as one continuous action. Avoid lifting your drawing instrument often. When you stop to make new observations or associations of parts, simply leave your chalk touching the page where your previous mark ended. In this way, you reduce the amount of short, broken segments of line or tone, which imply a faltering in the search for gesture. Here, it is the simplest and most direct summary of the expressive action you want, so avoid the enticements of interesting, smaller considerations.

A gesture drawing is not a fast contour drawing. As you draw, you will almost certainly find that you cannot stay away from the edges of forms. It will require a concentrated effort to leave the "safety" of the contours and make your drawing describe the path of an arm, branch, or chair leg in space. Occasionally using the side of the small fragment of chalk will help to check the tendency to draw the contour, because the broad, foggy tone thus produced is suited more to describing the core or direction of a form rather than its edges. Using your chalk this way also helps to keep you from being distracted by details—such a tone line is too broad for small particulars. Try to experience the forms moving back and forth in a field of space, because whatever the subject, it exists in space. Imagine your hand actually reaching in and out of the "container" of space that holds your subject as you describe the action of the forms.

In the one-minute poses only half of your time will be spent drawing. This will make it necessary to see, summarize, and state the gesture more aggressively. Now there will be only enough time to perceive the strongest actions and form characteristics. These drawings should be more general in purpose, more direct in handling, as in Figures 1.8, and 1.9. Often, such brief sketches capture gestural characteristics more successfully than gesture drawings of two or more minutes. You become more aware of the limited drawing time and more intensely see parts massed into generalities of

Figure 1.8 *(student drawing)*
SUSAN CAIN
Red conté crayon. 18 × 24 in.
Art Institute of Boston

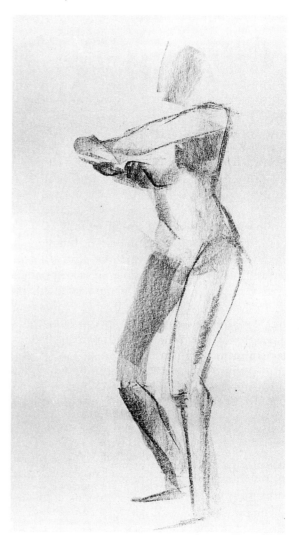

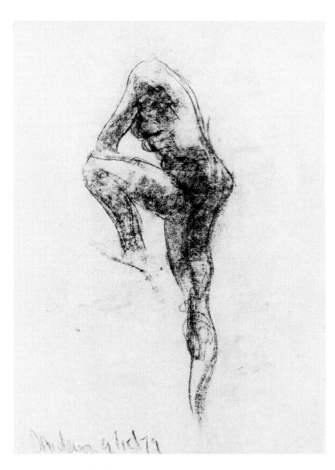

Figure 1.9 *(student drawing)*
DOUG ANDERSON
Charcoal. 18 × 24 in. (1980)
University of North Dakota

action and form. For example, a side view of a man, legs straight, leaning over and touching his toes, might be stated as an inverted tear-drop form.

Your experience in speeding up the pace and broadening the scope of your summaries during the one-minute drawings will help you use the expanded time better in your last five drawings. Now, a two-minute drawing time feels more comfortable and allows you to see some of the smaller affinities, contrasts, and characteristics that evoke gesture.

Although a gesture drawing is neither a contour nor a stick-figure drawing, it is mainly through the general look and feel of mass and direction that a subject's gesture reveals itself. Therefore, in all these quick drawings, remember to concentrate on the subject's essentials, not its embellishments (Figure 1.10).

THE DIVIDENDS OF GESTURAL EXPRESSION

Drawing from the general to the specific leads us from the gestural to the precise. Once a subject's general state has been established, further analysis leads us to smaller, more specific facts about it. If you continue with a gesture drawing for five minutes or more, your responses will begin to shift from the analytical depths of generalities about character and movement up toward the surfaces of the forms. Like the swimmer who dives to the bottom, we *do* come up to the surface. But the perception of factual details *develops from* our search for a subject's gesture and cannot, as we have seen, precede it.

The search for gesture at the outset of a drawing is visually logical for two reasons: it is the necessary basis for all that follows, and it cannot enter a drawing already underway. But this search for a subject's essential masses and movements does more than infuse a drawing with a sense of forms related by movement. Having done Exercise 1a, you may have recognized that seeing the general character of the forms in action provides other kinds of information about the subject.

There are at least ten important ways in which extracting gesture serves to inform and assist us in drawing. It helps us establish: (1) the proportions or *scale relationships* between parts of a subject; (2) the placement or *location* of parts; (3) the particular "tilt" or *position in space* of parts (direction); (4) the general tonal or *value* differences between the parts; (5) the boundaries or *shape-states* of the parts; (6) the abstract or *formal visual order* of the parts; (7) the *economical* and *authoritative* graphic statement; (8) the first general analysis of the volumetric or *structural* state of the parts; (9) the first general considerations of mass, space, shape, line, value, and texture as dynamic elements of the organizational design or *composition* of the drawing; and (10) the drawing's emotive spirit—its *essential expressive nature*.

Many of these insights are natural by-products of seeing *all* the subject within a minute or two. We visually grasp the spirit of the entire figure almost at once. The likelihood of seeing the relative scale, location, position, and so on is

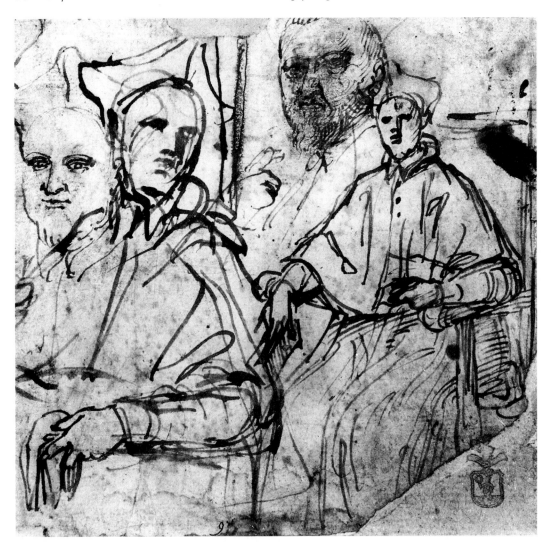

Figure 1.10
ANNIBALE CARRACCI (1560–1609)
Studies for a Portrait
Pen and ink. 13.1 × 13.9 cm.
Albertina Museum, Vienna

much improved over a piecemeal approach, since we are everywhere in seconds and draw by hovering over the entire image, advancing it on a broad front.

The severe restriction in drawing time serves to increase our awareness of the relativeness of parts. No one intentionally misjudges the scale, location, or value differences of a subject's components. These errors in judgment result from failure to see relationships—associations. And these failures are most commonly the result of a sequential system of drawing wherein each part is dealt with independently and "finished"

with little or no reference to other parts. In such an isolated, piecemeal approach it is mere luck when segments form a unified image.

No one intentionally makes errors in perception, but many artists do alter their drawings, to varying extents. But these changes are based (or should be) on a knowledge of what the subject's actual conditions are. In responsive drawing, seeing the state of things as they are is a necessary precondition to change.

Since a gestural drawing proceeds from the general to the specific, any line, value, or texture that "works," that is, that helps to establish the

artist's intent early in the drawing's development, can be allowed to remain. Because of the fluid and generalized nature of gestural drawing, not many such lines and tones are likely to survive. Some do, and their simple, direct quality serves to influence the artist in establishing other, equally direct graphic inventions. The spontaneous quality of gestural drawing and the subsequent drawing influenced by it tend to convey a sense of resolute directness. These qualities of authority and economy, and the spontaneity they promote, are essential to good drawing, of whatever stylistic or esthetic persuasion.

In Figure 1.11 the gestural expression of the scene tells us much more than "horses-carriage-people"; it evokes the clatter of the carriage, the nervous energy of the animals and their speed. In this sketchbook drawing by

Toulouse-Lautrec the economy of means, the authoritative handling, and the quality of spontaneity they create—the energetic *presence* of the subject—were born in the artist's initial grasp of the subject's gesture.

Because we wish to see the expressive action of forms *in space*, gestural drawing requires us to move back and forth in a spatial field denoting not only the tilt, shape, scale, and (where necessary to structure or expression) value of the forms, but also some general suggestions of their volumetric nature. In Rembrandt's rugged drawing *Portrait of a Man* (Figure 1.12), the gestural drawing of the figure also conveys some broad suggestions about the volume of his cloak—we even sense the mass of his right arm beneath it, as well as the volume of the hat, head, torso, and right hand. Although several areas of the figure are not fully clarified as

Figure 1.11
HENRI DE TOULOUSE-LAUTREC (1864–1901)
Study for Painting "La Comtesse Noire"
Black grease crayon. 16 × 25.6 cm.
Collection of The Art Institute of Chicago. The Robert A. Waller Fund. Photograph © 1996, The Art Institute of Chicago. All Rights Reserved.

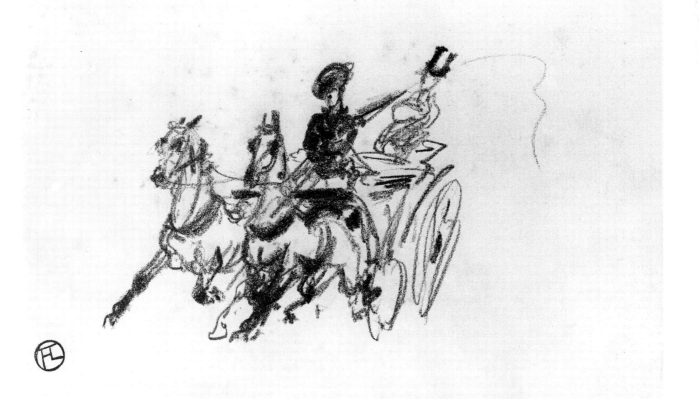

masses, there is an overall sense of his substance and weight.

Note the bold gestural lines in evidence throughout the drawing, and those that establish the direction of parts and of edges. Here, Rembrandt uses a long-standing means for better seeing the changing directions of a part's edge by restating all such turnings, however cursive they may be, by short, straight lines. Many poor judgments about the actual nature of a curved edge can be quickly improved by breaking up such curves into straight line segments (see Figure 6.6). Once such lightly drawn notations have been made, the part's more curved boundaries can better be objectively stated.

The compositional order of a subject in a bounded, flat area (dealt with in Chapter 9) is likewise easier to evaluate by gesture's requirement to be "everywhere at once." We can thus see, within the first minutes of a drawing, the placement of the subject on the page, the general divisions of the page resulting from its placement, and the general state of any other matters relating to the drawing's composition. The earlier we establish the general state of the *formal* relationships—the system of abstract harmonies and contrasts that constitute a drawing's particular organizational system—the more integrated the completed drawing will be. And, for the responsive artist, a drawing's abstract life—that is, its *dynamics*—is as important as its representational state.

In *Two Barristers* by Daumier (Figure 1.13), the general state of a compositional idea is seen in the lines near each figure, which begin to search out the essential action of two more figures. Here, Daumier lets us see his very first gestural and compositional probes. Similar gestural lines underlie the more developed figures of the barristers. Note the character of the action of the two barristers. It is expressed not only by their gestures but by the animated nature of the lines that define them.

In Exercise 1a the search for the subject's gestural expression and the direction of major parts and edges were your main goals. In the

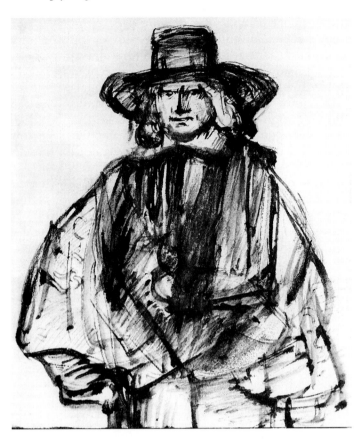

Figure 1.12
REMBRANDT VAN RIJN (1606–1669)
Portrait of a Man
Pen, brush, brown ink, and white body color.
$7^5/_{16} \times 6^1/_8$ in.
*Courtesy of The Fogg Art Museum, Harvard University Art Museums,
Annie S. Coburn and Alpheus Hyatt Funds*

following exercise you will consciously look for the other kinds of information and influence—the "dividends" that the gestural approach provides.

exercise 1b

Use the same materials and subjects as suggested in Exercise 1a. Again, draw in a standing position. Try to *feel* the subject's action and emotive state as you begin to search freely for the expressive behavior of the forms.

One purpose of this exercise is to build upon the ten "assists" provided by the gestural approach, to allow its direct and assertive nature to help you state strong and simple masses and moving actions, and an ordered pattern of visual forces on the page. Another purpose is to experience the

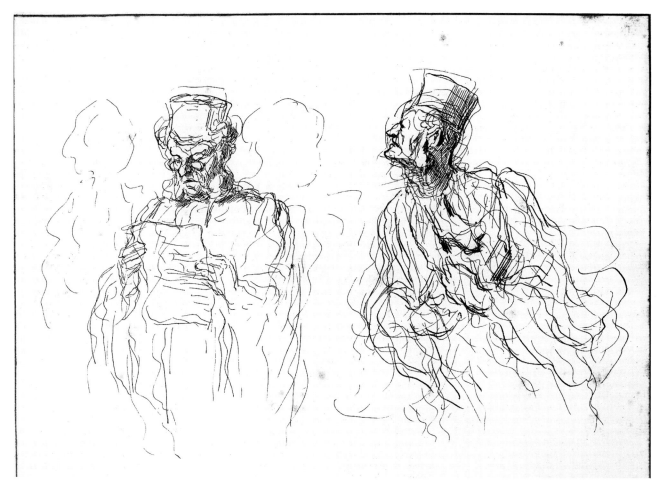

Figure 1.13
HONORÉ DAUMIER (1808–1879)
Two Barristers
Pen and ink. 20.5 × 29.5 cm.
Courtesy of the Board of Trustees of the Victoria and Albert Museum, London

shift from drawing the expressive action to drawing the factual state of your subject *and* its immediate environment.

Because compositional design requires an enclosed area, draw a border just inside the limits of your page. The page itself *is* a bounded, flat field, but drawing this inner border will make you far more aware of the limits of the drawing area. The use of such drawn borders is a temporary but helpful device.

You will make three ten-minute drawings and one half-hour drawing. Again, do not draw for the first half-minute or so, but use the time to familiarize yourself with the subject's essential form character, its moving actions, and its general design. This time, also observe the subject's overall shape, or, if it is comprised of a number of separate units, its several large shapes. Decide where you

will place the configuration within the page and what its scale will be. Avoid drawing the subject so small that it appears as a "tiny actor" on a large "stage." Instead, use a scale that will make the subject fill a large portion of the page.

Now look around your subject to see what foreground or background material you wish to include. If the background is a blank wall, plan to place your subject on the page so that the surrounding blank areas are divided up into interesting shapes. Should there be some other objects, values, or textures around the subject you wish to include in your drawing, consider how their scale, shape, and gestural character may relate to the subject's gestural expression. Plan to omit anything that you feel will conflict with, crowd, or confuse the drawing of your subject.

Those things you choose to include in the

drawing are now regarded as an extension of your original subject. For example, if your original subject is a figure and you plan to include a chair, rug, and darkened corner of a room, your subject is now the figure and *all* these.

Begin all four drawings as if they were two-minute gesture drawings. In all four, after the half-minute of study, use the first two or three minutes to state the subject's gestural character (which now includes its immediate surroundings). Next, keep searching for further, smaller gestural actions until the basic gestural nature of all the major and secondary forms have been realized. In the last three or four minutes of the ten-minute drawings, revisit every part of the drawing, this time estimating the scale relationships of the forms, their location in relation to each other, and the direction of each form as well as of its changing edges, as in Figure 1.14. In this drawing the location of the head has been lowered, the right leg moved to one side, the arm adjusted toward the right. In every part, especially in the torso, we can see judgments about the direction of the segments that make up the figure's contours. The student has even extended straight lines that measure the relative loca-

tion of parts. The drawing shows a disciplined concentration on these first considerations, although some of the earlier gestural lines have been erased or softened. But for this very reason we are better able to see this second stage of development.

In Dufy's *The Artist's Studio* (Figure 1.15) there is an engaging impartiality in how he treats the components of his subject. Note the animated character of the chairs and the drawings on the wall, the economical and authoritative handling, the suggestions of volume and space, and the drawing's balanced and unified character. Note, too, that even though this is a brush and ink drawing of a linear type, in which an extensive gestural underdrawing is not suitable, some lighter, gestural lines are still utilized.

As Figure 1.15 shows, in making these additions and changes to your earlier gestural perceptions, you are beginning to draw the contours of forms—you are establishing the shapes of forms (dealt with fully in Chapter 2). We saw in Exercise 1a that continuing a gesture drawing eventually brings us to the edges of forms. There it marked the end of the exercise, now it is the beginning of a

Figure 1.14 *(student drawing)*
Black conté crayon. 18 × 24 in.
Art Institute of Boston

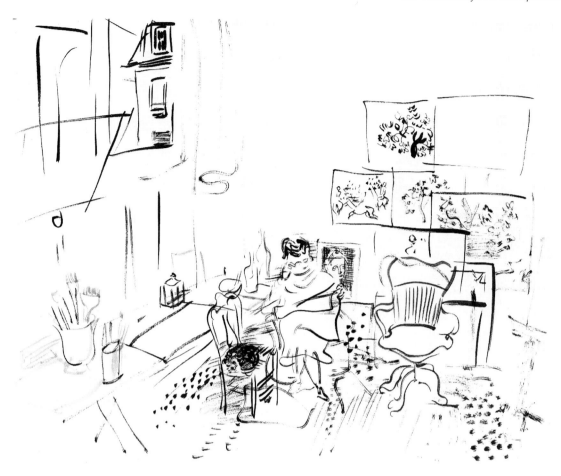

Figure 1.15
RAOUL DUFY (1887–1953)
The Artist's Studio (c. 1942)
Brush and ink. 19⅝ × 26 in.
The Museum of Modern Art, New York
Gift of Mr. and Mrs. Peter A. Rübel
Photograph © 1997 The Museum of Modern Art, New York

shift from the concern for what the subject is doing to a search for what it looks like.

Continue to draw the contours of the forms, slowing down somewhat to follow the major changes in the directions of the forms' edges and of inner edges created by abutments between the larger facets, or *planes*, of a form's surface (the important role of planes is explored in Chapter 6). Erase any earlier gestural marks that seem to confuse or obscure the forms. Most of the gestural lines and tones *do* become integrated into the values and textures of the later stages of a drawing. It is surprising how little of the original gesture drawing is visible at the completion of even a ten-minute drawing. Avoid overemphasizing the edges. Contours that are heavy or hard tend to stiffen the drawing and weaken the gestural quality.

Use those values you feel are necessary to convey the general sense of the subject's masses. Avoid the "coloring-book syndrome" of adding values after the drawing is developed through line. If you mean to use values, do this early in the drawing, as in Figures 1.2, 1.9, and 1.18.

As you draw, be mindful of the ten ways in which gestural drawing assists perceptions and broadens the range of your responses. It may be helpful to list them in a corner of your drawing board or sketchbook for easy reference. With so much to be aware of—and *do*—ten minutes is not much time. This restriction is intended to keep your attention focused on the subject's major dynamic and structural cues. Kokoschka's drawing, *Portrait of Mrs. Lanyi* (Figure 1.16) provides an example of a drawing emerging from a search for gestural expression to form more substantial ab-

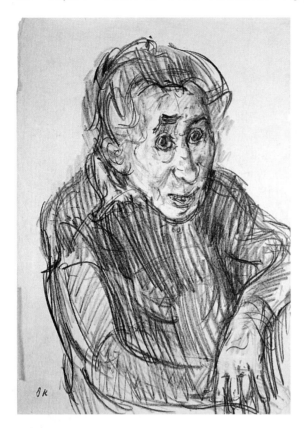

Figure 1.16
OSKAR KOKOSCHKA (1886–1980)
Portrait of Mrs. Lanyi
Crayon. 26 × 17¹³/₁₆ in.
The Dial Collection

to look like) depends on the guidance and influence of the drawing's initial gestural qualities.

In the ten-minute drawings there was about as much time for stating the gestural character of your subject as for its overall structural and surface character. In a thirty-minute drawing, however, the gestural expression often becomes somewhat muted. While personal attitudes will determine whether gestural considerations continue to play a major or minor role, here we use gesture mainly to guide the development of the subject's masses, for which there is now more time (as for example, Katzman does in Figure 1.18).

There is a danger here. If you lose too much

Figure 1.17
LLOYD LILLIE (1932–)
Standing Figure
Pencil. 14 × 17 in.
Courtesy of the artist

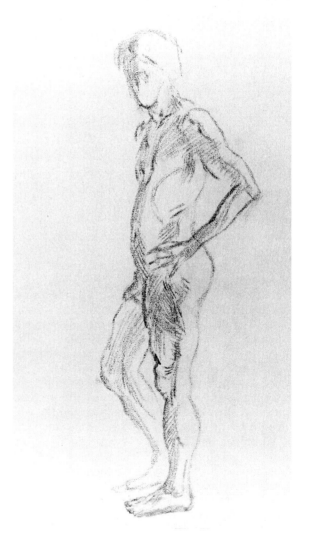

stract and representational conditions. Again, in Lillie's drawing *Standing Figure* (Figure 1.17), subtler relational and structural observations overlay the gestural drawing.

Regard the ten-minute drawings as warm-ups for the thirty-minute one. At the end of ten minutes you should have developed this drawing as far as the earlier three. At this point, stop drawing for a minute or so. Look at your drawing from a few feet away. You will more easily see errors in scale, location, and direction. Additionally, you will see the drawing's gestural and compositional state. Continue drawing for the remaining time, stressing the structural character of the forms. This search for volume should be a natural development of the perceptions you made during the first ten minutes of the drawing, when you felt and evoked the subject's gestural character. Many of these perceptions carried strong clues about the structure of the subject's forms. Now you are building upon the gestural expression rather than strengthening it further. The shift from comprehending what the subject *does* to what it *looks like* (or what you want it

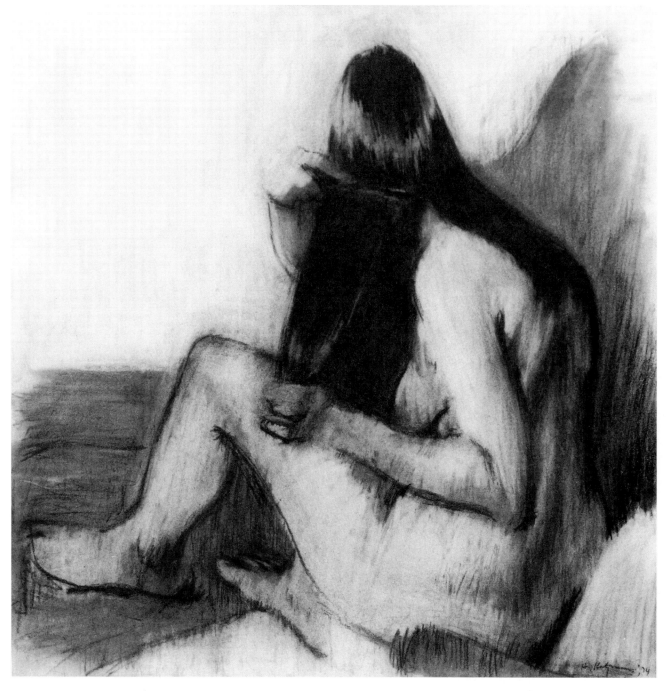

Figure 1.18
HERBERT KATZMAN (1923–)
Nude Brushing Her Hair, I (1974)
Sepia. 28 × 28 in.
Courtesy of Terry Dintenfass, Inc.

of the gestural expression, if you sacrifice too much economy of means, if both the felt and analytical quality of the drawing are too muffled by a meticulous rendering of surfaces, too much of the life and excitement of the drawing may be lost.

The shift from the expressive action to the measurable actualities does not mean that you stop gestural responses. You may see some moving actions late in the drawing. Nor does it mean that some facts about the subject's measurements are

Figure 1.19 *(student drawing)*
BECKY WRONSKI
Brush and ink. 18 × 24 in.
Michigan State University

not stated early in the drawing's progress. There is no such clean break in responding to a subject. Rather, there is a gradual change in emphasis.

Do some two-minute and ten-minute drawings daily and at least one thirty-minute drawing. Do some of these in your sketchbook. Two-minute drawings can fill a sketchbook page, as in Figure 1.19, where brush and ink are used to extract the gestural essentials of the torso. While our two-minute gesture drawings usually show powerful rhythmic actions, be careful not to modify too many of these enlivening energies in the longer drawings. In Figure 1.20, a drawing of about thirty minutes, there is an engaging gestural strength that reinforces the subject's form and action. Do not regard such drawings as only exercises. The gestural theme has motivated countless drawings of the finest kind (Figures 1.21, 1.22, and 1.23).

This chapter has not attempted to suggest a way to draw, but only a way of seeing, feeling, and thinking about the things around us. This way leads us to an early involvement with the factors of empathy, order, and structure that challenge all serious exponents of responsive drawing. And while the search for gestural expression is no more the key to sound drawing than any other of the several basic concepts necessary to an understanding of drawing, its mastery is essential and must come early in our development as artists. Whatever visual goals and ideals we wish to pursue, the process will develop through advancing our works from the general to the specific and not through a system of piecemeal assembly. Responsive drawings do not accumulate—they grow.

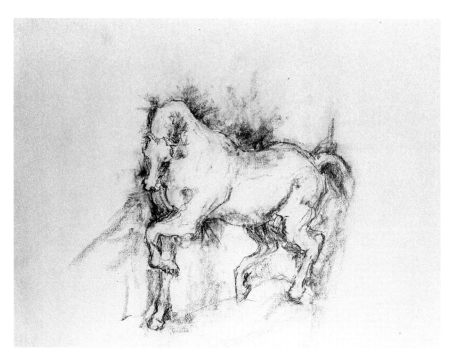

Figure 1.20 *(student drawing)*
CLAUDIA ROBERTS
Black chalk. 14 × 17 in.
Private Study, Newton, Mass.

Figure 1.21
PAUL CÉZANNE (1839–1906)
Seated Nude
Pencil. 13.1 × 20.9 cm.
Kupferstichkabinett der Offentliche Kunstsammlung Basel

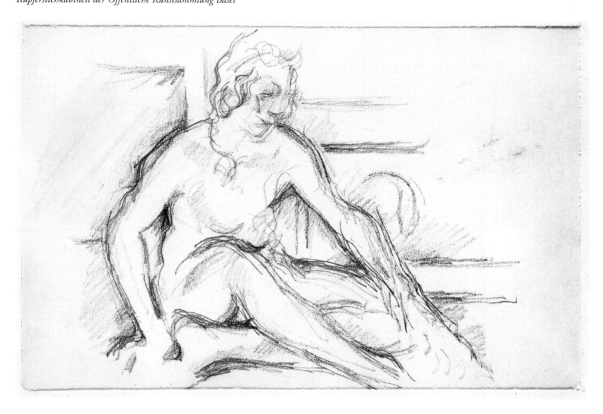

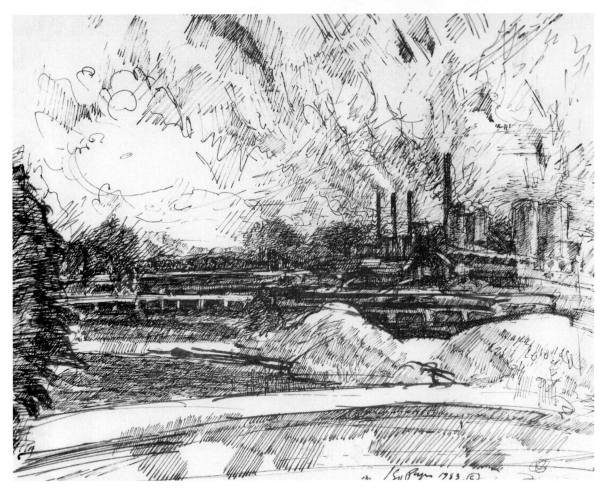

Figure 1.22
ISO PAPO (1925–)
On the Outskirts of Boston
Pen and ink. 8 × 10 in.
Courtesy of the artist

Figure 1.23
JUDITH ROODE (1942–)
Guardian Spirit (1988)
Oil paint, oil stick, oil pastel. 29 × 44 in.
Courtesy of the artist

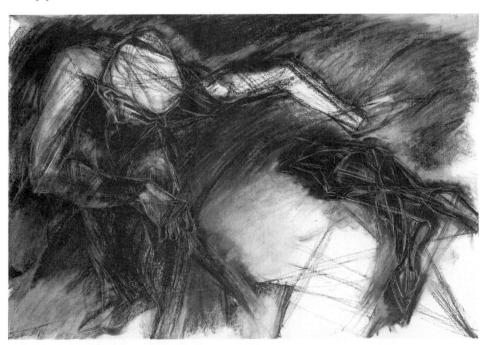

2

s h a p e
an irony

A DEFINITION

Just as every subject possesses gestural energies, so does it possess a system of shapes. Seeing a subject's gesture tells us what the subject does; seeing its shapes tells us important things about what it looks like.

Put simply, a shape is the two-dimensional configuration of a volume or of the interspaces between volumes. It can usefully be thought of as a silhouette (Figure 2.1).

The drawing surface itself, that is, the sheet of paper, board, or canvas, is also a shape. The first shape drawn on the blank shape of the drawing surface, or *picture-plane,* by its presence creates a second shape—the remainder of the picture-plane. This first drawn shape, understood as an area of active "thingness," is called a *figure,* or *positive shape;* the remaining, passive, "empty" area is called a *ground,* or *negative shape.* In this relationship positive shapes are not seen as hovering in a spatial field of depth, nor do negative shapes represent a spatial field of depth. They all should be understood to exist on the same level: the picture-plane. Together, they

are the picture-plane. Having no volume and intending no recession into a spatial field, shapes have width and height but no depth (Figure 2.2).

All volumes when viewed from a fixed point offer an absolute shape delineation. Perceiving this "flat" state of a form is essential to understanding its placement, scale, and structure. What its shape *is* will largely determine what its volume and position in space *will be.*

Most beginners are functionally blind to shape. This is so because we are "programmed" to understand the world around us in terms of volume and space; being able to do so is a matter of survival. Students of drawing must learn to see the two-dimensional facts about their

Figure 2.1

21

A **B**

Figure 2.2

Figure 2.3

three-dimensional surroundings. For artists, both of these are interchangeable considerations, and both ways of seeing a subject are necessary in order to understand it objectively.

Seeing through the camouflage of a subject's volume, color, and surface details to get at its shape actualities is basic to responsive drawing.

A shape, then, is any puzzle-piece-like area bounded by line or value or both. Shapes can be classified in two general families: *geometric* and *organic* (sometimes called biomorphic or amoebic). A geometric shape, as the term implies, may be, for example, a circle, triangle, or the like, or any combination of the angular or curved boundaries associated with pure geometric shapes. An organic shape is any irregular, "undulating" shape in which extensive use of straight or evenly curved edges is minor or absent. Organic shapes tend to echo the contours in nature.

As was previously discussed, shapes may have a positive or negative function. They may be hard-edged or vague. They may be active and gestural, or passive and stable. Shapes may be large or small, totally or only partially enclosed. They may have simple or complex boundaries, and may be consistent or varied in their inner properties.

Because we are conditioned to see *things* rather than the spaces that separate them, learning to see negative interspaces as providing important visual information requires concentration. For example, seeing Figure 2.3 as a black door slid back far enough to show daylight outside makes us "see" the black area as a positive shape—as a thing of substance—and the white shape as negative—as an absence of substance. Our concentration favors the door, and we pay less attention to the area of daylight. If we now

reverse things and regard the white area to be a white door slid back to reveal a night sky, our attention shifts to the white door, and the black shape receives less consideration. Similarly, the black vase in Figure 2.4 keeps us from seeing the two white profiles that shape it. Once we find these profiles, it becomes difficult to see the vase as more than an interspace; we concentrate on *things* at the cost of disregarding the areas sepa-

Figure 2.4

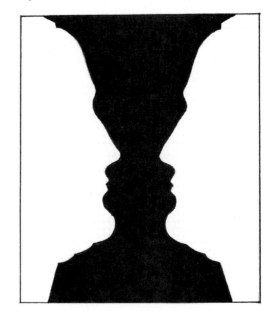

Figure 2.5
CONLEY HARRIS
Doubles/Triples, Italy
Charcoal. 23 × 30 in.
Print Division, Boston Public Library

rating them. While it is almost impossible to hold both readings in mind at the same time, we need to develop the skill to make such reversals with ease, to see the silhouettes of both positive and negative shapes objectively if we are to draw our subjects with any degree of accuracy.

Look around you and notice that the shape of any object you concentrate on, in covering part of its background, creates shapes in the background. Purposely squinting at our object and its surroundings obscures details and reduces the sense of depth perception. This loss of clarity tends to flatten both volume and space, helping us better to see our object's shape and the background shapes that its presence created. Squinting helps us perceive a sphere as a disk, a foreshortened disk as an ellipse, and a road running back to the horizon as a wedge. Artists, by training themselves to see the shapes of volumes and interspaces objectively, are able to know their subject's shape actualities in a way that greatly enhances their understanding of what they are seeing. In fact, we cannot accurately draw any subject whose shapes we have not ob-

jectively examined. Figures 2.5 and 2.6 emphasize just this kind of sensitivity to both positive and negative shape.

A form's inner divisions can be seen in the same way. If, for example, we set out to draw the cone in Figure 2.7, we can regard, say, the upper shape to be positive and temporarily regard the lower shape as a negative one. Once the upper shape is drawn, we can consider *it* as a negative one when drawing the shape of the ellipse. This switching of positive-negative identities helps us see all of a form's shapes more accurately. And, after all, it is difficult to think of a subject that doesn't show some kind of inner divisions (shapes) either by overlap, value, interspace, or clearly abutting planes (Figure 2.7).

A useful dividend of seeing adjacent shapes as alternating between positive and negative states has to do with the common tendency to see convexities more accurately than concavities. For some reason, perhaps because we are conditioned to think of convexities as containing something and concavities as containing nothing, a line drawn to represent a convexity in a

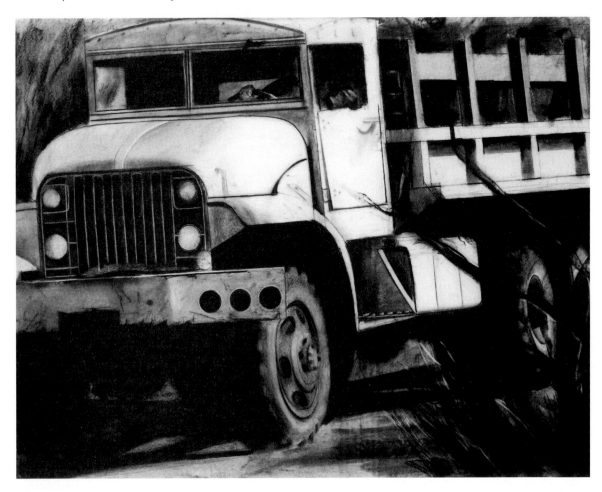

Figure 2.6
MATT TASLEY
Truck, (1985)
Charcoal on paper, 5' × 7' 1"
The Arkansas Art Center, Foundation Collection

contour is more likely to reflect accurately the scale and degree of the observed convex passage than a line that notes a concave one. By switching positive and negative shape orientations, we can always get on the other side of a concavity, transforming it into a convexity.

Exercise 2a presents a drawing challenge that makes it necessary to consciously examine both positive and negative shapes. As you do this exercise, you should begin to experience the interchangeability of positive and negative shapes and recognize that the one cannot be fully comprehended without the other. Disregarding so basic a concept as discovering the shape-state of a subject's parts blinds us to much of their structural and dynamic condition.

Figure 2.7

exercise 2a

In doing the two drawings in this exercise, you may erase whenever necessary. In general, too much erasing gives an unpleasant fussiness, but here you can make as many changes and adjustments as you need to complete your drawings.

MATERIALS: A moderately soft pencil (2B or 3B) and a sheet of tracing paper (or any paper thin enough to see through). A ruler, if necessary.

SUBJECT: Invented shapes.

PROCEDURE:

drawing 1 Draw a square approximately five by five inches. Use a ruler if you wish. Inside the square draw a simple organic shape as in Figure 2.8A. Draw it large enough to allow some of its

Figure 2.8

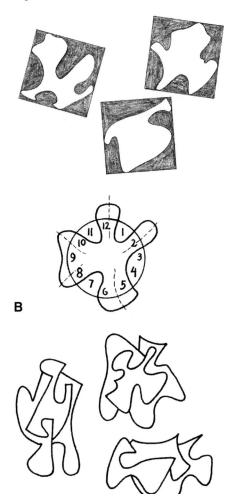

B

projections to touch the borders of the square, causing the remainder of the square to be seen as four or five isolated shape-segments. Leave the organic shape the white of the paper and apply a gray tone to all of the remaining shapes. The completed drawing should look somewhat like a jigsaw puzzle-piece touching each of the square's borders at least once. Avoid making the shape complex and contorted—the simpler, the better.

The resulting ground shapes seem to suggest a spatial field. But to *see* the shapes that comprise this spatial "cavity," disregard its impression of spatial depth and treat *all* the shapes within the square as two-dimensional divisions of the picture-plane.

Now take a second sheet of paper and draw another five-inch square. Inside this second square, draw the organic shape again as accurately as you can, using your first drawing as your model. This time you will find that letting your hand flow across the paper will not reproduce the original shape. Your second drawing may be fairly close to the original, but it should reproduce it *exactly*. To do this, you will have to study the original with great care. You will want to see the tilt, or long axis, of each projection and indent of the original, as well as their relative scale. As you draw, ask yourself, "What is the axis and shape of this projection? . . . of this indent? Which is the narrowest projection? . . . which the largest?" Examining the several negative shapes bordering on the organic one, you will see differences from your original drawing. In adjusting these in your second drawing, you will be adjusting the organic shape as well. Soon you may find that you no longer regard the organic shape as more important than the shapes around it. You may sense that until *each* shape matches its original, the organic shape will not have been accurately drawn. As you draw, try reversing the figure-ground relationship. That is, imagine the white "puzzle-piece" to be missing from a gray puzzle. Now the white shape is a negative one. Seeing your drawing this way, continue to adjust the remaining "puzzle-pieces." To estimate the angle of a particular projection or indent more accurately, imagine a clock face surrounding the part, as in Figure 2.8B. Try to locate the long axis of a segment by finding its position on the clock. For example, a segment that is vertical would be twelve o'clock (or six o'clock); if tilted slightly to the right, it might appear at one o'clock; and so on.

When you cannot find any further differences between the two drawings, place one over the other and hold them up to the light. You may be surprised at the several differences still remaining. Continue to make further adjustments based on these differences until the two drawings match.

drawing 2 When you drew the several shapes that formed the square, the camouflage of the "squareness" that each participated in may have kept you from considering them as much as you did the organic shape. In this drawing, combine any three shapes that form an irregular outline. Do not enclose them in a square. These shapes can have some geometric properties, as in Figure 2.8C. Again, make as accurate a duplication of this group as you can. Now the shape-state of each will be very evident. They do not contribute to a common shape strong enough to obscure an awareness of each. Instead, these shapes more evenly interact. It is important to be able to study objectively any of a subject's shapes, no matter how actively engaged they are with others. The three shapes you have selected do, of course, collectively produce a fourth. As you draw this group, divide your attention between seeing each of the three shapes separately and seeing the greater shape they make. Recalling the advantages of working from the general to the specific, begin this drawing by roughly searching out the overall gesture and shape of the configuration first. When completed, again match the two drawings and make any necessary changes.

> **Only when two or more shapes join or interact do they communicate the idea of structure and mass.**

THE SHAPE OF VOLUME

Being two-dimensional, a single shape generally cannot convey the impression of volume convincingly. Only when two or more shapes join or interact do they communicate the idea of structure and mass.

When shapes unite to form a volume, they are seen as flat or curved facets of the volume's surface and are called *planes*. The various ways these planes abut and blend into each other determine the volume's particular "topographical" state.

To interpret a subject's shape and structure we must begin by avoiding *exclusive* attention to its existence as mass in space. Instead, "read" its planes as positive shapes on the same level as the negative shapes around it. A simultaneous perception of the subject as both two- and three-dimensional then occurs. Figure 2.9 visualizes the dual role of a plane: as a discernible facet of a volume's surface, and as a shape upon the picture-plane. Figure 2.9A tells us nothing about mass or structure. In Figure 2.9B the outline of the shape remains identical: only the interior lines have been added, subdividing the original shape into three smaller ones. Seeing these shapes as planes creates an impression of volume. This volume appears solid because we cannot see any of the boundary lines that would be visible if the structure were made of glass or wire. We now understand the form to be turned to an oblique angle to the right. Further, the three visible planes strongly imply the three unseen planes necessary to our understanding of the volume as a box form. In Figure 2.9C, separating the planes creates three shapes that suggest no more about mass and structure than Figure 2.9A does. Taken as a group, they form a Y-shaped negative area. While not wholly enclosed by boundaries, this is still "readable" as a shape. These "open" shapes occur when encompassing positive shapes provide segments of enclosure greater than segments of separation. The partially enclosed area is seen as a shape since we tend to "complete" shapes that provide strong clues to their simplest totality.[1]

Sometimes artists will favor open shapes for their animating effects. Such shapes cause our eyes to scan an image in a faster and more sweeping manner because we are not stopped at the borders of each shape. In more readily seeing the whole image at once we can better experience a drawing that intends to convey a strong emotional meaning. In Figure 2.10, the bond between the two figures is more effectively stated

[1] Rudolf Arnheim, *Art and Visual Perception* (Berkeley and Los Angeles: University of California Press, 1954), pp. 54–55.

Figure 2.9

A B C

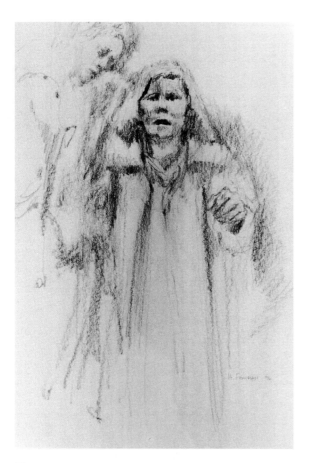

Figure 2.10
HARRIET FISHMAN
Woman with Apparition (1996)
Black chalk, $9^5/8 \times 14$ in.
Collection of Charles Goldstone, Brookline, Mass.

by open shapes, as are the two contradictory expressions of fury and amusement in Figure 2.11

Considering the single-shape limitations of the silhouette, some artists of the eighteenth and nineteenth centuries did quite well in suggesting, to a degree, a sense of volume (Figure 2.12). But their efforts tend to support rather than contest the view that a single shape is understood primarily as a flat configuration and only secondarily suggests some clues about volume. Shapes, then, tend to offer their edges. The simpler their interiors, the more emphasis on boundaries, as Figure 2.13 shows.

When a subject (or any of its parts) is complex in tonal or textural properties, the unwary beginner is more likely to be diverted from a recognition of its shape character. Likewise, when many shapes and planes combine to form

a volume, their individual (and collective) shape actualities might be missed. Goodman, in his drawing *Eileen* (Figure 2.14), avoids both of these pitfalls. The strong overall shape of the hair is not visually "overruled" by the imposing dark values and rich texture, nor are the planes that "carve" the head and blouse weakened by the demands of modeling the form. In fact, by showing how these planes interjoin, Goodman not only enhances the figure's structural clarity, he also provides a vigorous design of wedgelike shapes that activate the picture-plane.

This is not to suggest that edge, contour, or outline must necessarily be a dominant graphic factor. Many artists avoid emphasizing edges (see Seurat, *Sleeping Man*, Figure 4.6). But learning to search for a volume's shape-state helps us to locate those edges of planes forming the volume's boundaries, and thus to better comprehend its inner structure. We can see that in Figure 2.14, where the contours of the woman's face are the inevitable outcome of the head's surface structure. The head's planes demand just those contours, and the contours demand just those planar turnings.

Nowhere else does the beginner's need to see a form's actual shape configuration show itself more plainly than in the drawing of foreshortened forms. Many beginners find themselves at a loss when confronted by a volume such as an arm or leg that is turned to show itself to be receding sharply into the spatial field. But seeing the shapes provided by such telescoped views of forms is among the most important discoveries in drawing them successfully. Seeing that a form *is* foreshortened, they turn their exclusive attention to the problem of explaining its volume, *before* they have observed its shape actuality. Like the search for gesture, the analysis of a volume's shape actualities must be an early perception in the act of drawing. To proceed without considering either of these acts of inquiry is to draw preconceived notions of a subject's general appearance and is not responsive to a particular subject as seen from a particular view. Seasoned artists recognize that a subject's shape-state will change as they change their position in relation to it. They know that objectively seeing the outline of a particular form gives them the information that shape provides about structure as well as the form's position in space, for its position creates its shape—its "field of play" (Figure 2.15).

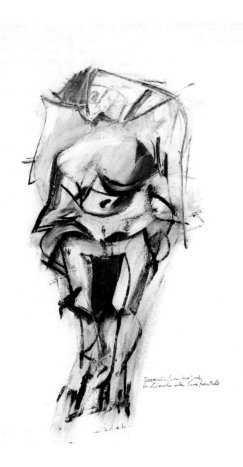

Figure 2.11
WILLEM DE KOONING (1904–1997)
Woman (1951/52)
Oil and pencil on paperboard, 25¼" × 19¾"
Hirshhorn Museum and Sculpture Garden, Smithsonian Institution
Gift of Joseph H. Hirshhorn, 1966

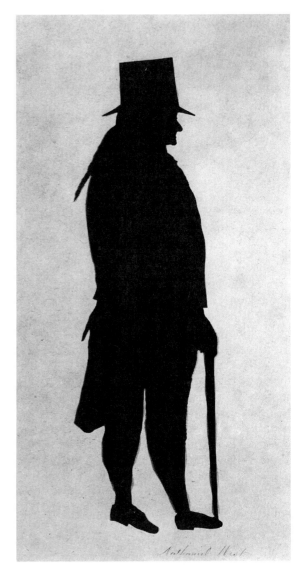

Figure 2.12
AMERICAN, EARLY 19TH CENTURY
Silhouette of Nathaniel West
Cut and pasted on background of tan paper.
11⅞ × 7¾ in.
Gift of Mrs. William C. West
Courtesy, Museum of Fine Arts, Boston

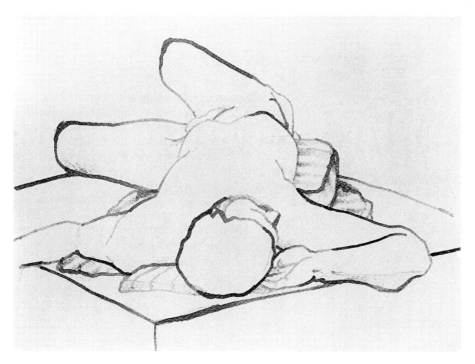

Figure 2.13 *(student drawing)*
SUE BURRUS
Reed pen and brown ink. 14 × 17 in.
Art Institute of Boston

Figure 2.14
SIDNEY GOODMAN (1936–)
Eileen (1969)
Charcoal. 30^1/$_2$ × 42 in.
Courtesy, Terry Dintenfass Gallery, New York

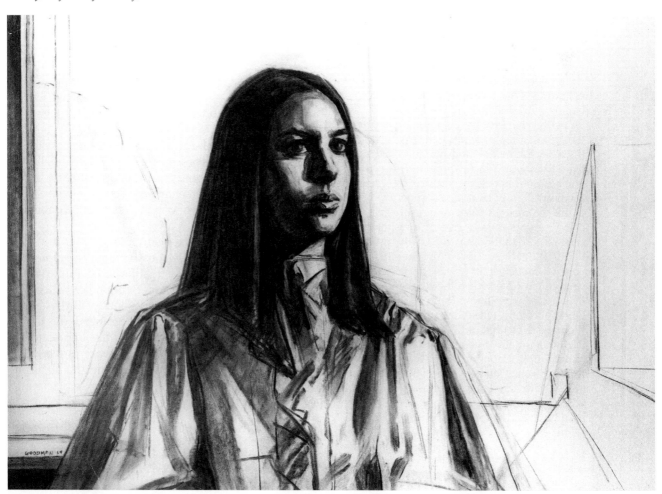

A **B**

Figure 2.15

Further discussion of the means available to understand foreshortening volumes will be found in Chapters 5 and 6. The following exercise should help you see a volume's shape-state.

exercise 2b

MATERIALS: Pencil and paper.

SUBJECT: Cylinder.

PROCEDURE: Place any cylindrical form (such as a rolled sheet of paper, mailing tube, juice can, etc.) on a flat surface about 12 to 15 inches away, but only 2 or 3 inches below the level of your eyes, so you can see a side view only. If it is correctly placed and centered, neither end plane of the cylindrical object should be visible. Using a pencil, begin your drawing in the middle of the page. Draw the shape you see approximately actual size, trying to estimate carefully the proportion between the shape's height and width. Next, rotate the cylinder about 2 inches in either direction so that you see two shapes: the shape of the end plane and the now slightly tapering shape of the curved side plane. To make a third drawing, again rotate the cylinder so that its degree of foreshortening is increased. By continuing to turn the cylinder a few inches for each successive drawing, you should be able to make eight or ten drawings showing a changing ratio between the sizes and shapes of the cylinder's two planes. These can be arranged like the spokes of a wheel or can appear randomly on the page. Note that until you have placed the cylinder in a totally foreshortened position, the end plane will not approach the shape of a true circle. Note, too, that because the cylinder is placed just below your eye level, even a quite long cylinder, when severely foreshortened, will show a smaller body than end shape.

Foreshortening exercises warrant frequent practice. Use other forms such as vases, bottles, pipes, carrots, or bananas, and draw them in foreshortened positions. Point a finger in the general direction of your eye and draw it. Place objects before a mirror and draw both the object and its reflection.

Though they are composed of joined planes, simple subjects such as the cylinder, cube, or banana can be seen as a single shape. Even complicated subjects can be seen in this way. Other objects appear as a group of volumes, some of which partially block our view of others—as in a view of a still-life arrangement or a human figure. When studying such complex forms it is generally necessary to divide the subject into several shape groupings in a more or less arbitrary way—more or less because the subject itself will suggest groupings according to size, value, placement, direction, or texture. Included in these considerations should be any negative shapes present. Whether the subject is reduced to a single shape or several shape subdivisions, this simplification process increases our understanding of the general shape-state of the subject, thus helping us locate the smaller shapes within.

VALUE SHAPES

If a volume requires two or more shapes, what about the sphere? It would seem to have only one: the circle. But recall that shapes may be hard-edged or *vague*. The sphere, cone, cup, or any other mass formed exclusively or mainly of curved planes offer a preponderance of subtly graduated value changes. Here, the ordering of values into some volume-revealing system becomes necessary.

As we have seen, planes are the basic building unit in the construction of volume, and seeing their shape actualities is as important as seeing those of the parent volume of which they are a part. When, additionally, these planes show a variety of values arranged to suggest light falling upon a volume, the impression of three-dimensional form and space is increased. These differences in value among the planes result from the direction of the light source in relation to the subject's variously turned surface facets, and they change as the planes turn to-

ward and away from the light, as Figure 2.16 shows. The more abrupt the change between the direction of planes, the more abrupt the changes in value will be.

To simplify the organizing of the subject's many values, it is useful to establish a few general value divisions. Considering white as zero degrees and black as 100 degrees, and calibrating a scale in degrees of ten, we have a value scale that is helpful in establishing some order out of a subject's (usually) many and seemingly elusive value changes. Using this scale, we can more easily sort values into several general divisions. A four-division grouping might be: white (or the tone of the paper), a light gray (30 percent), a dark gray (70 percent), and black. We will, of course, see many more than these four values in most subjects. Each of the "in-

Figure 2.16
IRA KORMAN
Sweet Virginia
Charcoal, 47^1/4" × 28^3/4"
Arkansas Art Center, Foundation Collection

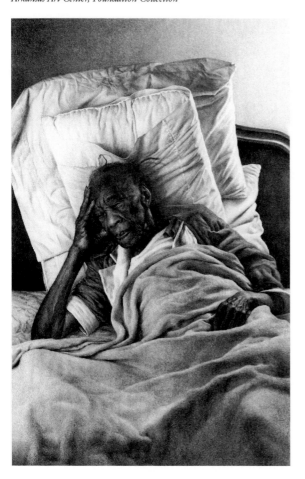

between" values should be drawn as belonging to the value division closest to it in degree.

Some artists find it useful at the outset to apply such a value-grouping system in tonal drawings, since it quickly provides a pattern of values on the picture-plane that helps in composing a work's order, and as quickly provides a sense of mass and space. Then, after establishing this stage of a drawing, they make whatever adjustments in value they feel are necessary to complete the work. Other artists will do this sorting in the mind's eye. The mental sorting will have influenced their use of value and the completed work will reflect the tonal order of the value-grouping system. Whether or not such divisions of tone appear at some stage in the drawing is less important than their having been consciously searched for. As the observed values are assigned to their appropriate group, larger value-shapes spring up. These shapes may be composed of parts of several independent volumes—as would occur if we were to shine a flashlight into a darkened room. A "shape" of light could then include all or parts of several pieces of furniture, part of the floor, wall, and so on. In Figure 2.17 the value shapes in B frequently exist independently of the shapes of the volumes seen in A. Note that B shows a four-value grouping of the still life A. The early perception of these value shapes also serves to establish scale and directional relationships among them, and helps the artist to sense their abstract behavior. Value shapes within a form, like the overall shape that describes the boundaries of a volume, should be seen first as flat areas and not only as existing in space upon advancing and receding terrain. Ipousteguy, in his drawing *Anatomy Study: Breasts* (Figure 2.18), utilizes the value shapes resulting from a harsh light source to create an image in which the pattern of values not only defines the forms, but establishes an engaging two-dimensional design. The artist, by intentionally providing as many clues to shape as to volume, creates in the image a provoking visual pulsation between its fiat and structural properties.

In Cretara's *Spanish Landscape* (Figure 2.19), values are active in both two- and three-dimensional ways: in the former mode they produce a pattern of balanced, harmonious tones, and in the latter, a system of volume- and space-revealing planes. Despite the blurred edges of the variously toned shapes in Cretara's

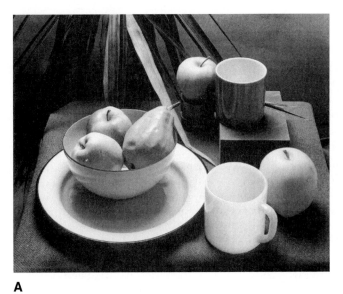

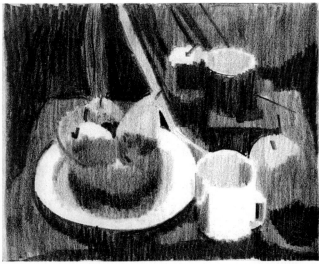

A

B

Figure 2.17

Figure 2.18
JEAN IPOUSTEGUY (1920–)
Anatomy Study: Breasts (1969)
Conté crayon. 18 × 24 in.
Courtesy, George Adams Gallery

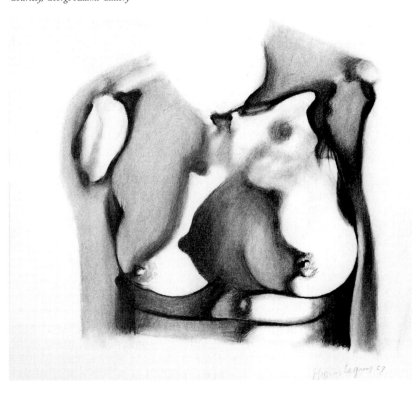

Figure 2.19
DOMENIC CRETARA (1946–)
Spanish Landscape
Graphite pencil, 8¹/₂ × 12 in.
Courtesy of the artist

drawing, we can still tell that the artist thought in terms of value shapes and patterns.

The following exercise concentrates on searching out a subject's values. It should help you to see that value shapes are an intrinsic part of a subject's visual condition and can play an important role in clarifying and organizing what you see.

exercise 2c

This exercise requires three drawings. Each will cause you to make a different value grouping, resulting in different value shapes. They will provide progressively greater freedom and control in the use of value. You will also find the modeling of the general masses achieved through the organization of tones progressively more convincing.

MATERIALS: Compressed charcoal, black conté crayon, or India ink, 18 × 24-inch sheets of charcoal paper, or, if you choose to work with India ink, any large-sized heavyweight paper that will not buckle (see The Suitable Support in Chapter 8), and a number 6 or 7 pointed sable brush (see Brushes in Chapter 8).

SUBJECT: Upon a simply draped cloth of one value (towel, pillow case, or the like), arrange a simple still life consisting of nonreflecting surfaces

such as unglazed pottery, wood and paper products, or foodstuffs in any combination of three or four you find interesting.

PROCEDURE:

drawing 1 Group the observed values into two divisions—white and black. Select any point near the middle of the value scale and leave any observed value lighter than that point (nearer to the white end of the scale) as the white of the paper; any value darker than that point (nearer to the black end of the scale) should be drawn as black. Use a strong light source and arrange the forms in a way that permits the light to "explain" the basic volumetric nature of the objects.

Selecting a point nearer to the white end of the scale will produce a drawing with fewer white shapes and much larger black ones. Conversely, placing the point of value separation nearer to the black end of the scale will result in fewer black shapes and larger areas of white. By changing the point at which the values will be separated you can create different value shapes which will convey new structural clues about a subject's volume, as well as different light intensity and expressive mood. Figure 2.20 is a good example of the structural strength that this limited value system can yield.

Continue to draw until your drawing suggests at least a general impression of volume. Many students are surprised to find that the sense

Figure 2.20
KÄTHE KOLLWITZ (1867–1945)
The Mothers
Brush drawing, India ink and Chinese white.
18 × 23¹/8 in.
Frederick Brown Fund
Courtesy, Museum of Fine Arts, Boston

of volume persists despite the severe tonal restriction. Though many values disappear into the black or white groupings, and many smaller planes are absorbed into them, still the big planes that these value shapes create convey a sense of structure.

Now study the drawing to see how the shapes relate on the picture-plane. Notice that they have certain scale, shape, and directional similarities and contrasts that produce a pattern. But does this pattern seem balanced on the page? Rework the shapes to provide a more unified and balanced state among them. But in doing so, try to strengthen the sense of solid mass further, not weaken it.

drawing 2 Draw the same subject from the same view, but use *three* values: the white of the paper to represent the lightest third of the values in the still-life arrangement; a middle tone of approximately a 50 percent gray to represent the middle, darker tones; and black for the very dark values (70 percent or darker). This may still seem to be a severe restriction, but notice how effectively Degas uses it (Figure 2.21) to create a handsome format for his visual and expressive interests. Here, the three values are used to show value shapes both as pattern on the page and as clearly defined planes that carve the forms with great authority. Notice how, in the figure's back, the artist changes values to indicate changes in the direction of the surface

Figure 2.21
EDGAR DEGAS (1834–1917)
After the Bath (1890–92)
Charcoal and brush on pink paper. 19³/₄ × 25⁵/₈ in.
Courtesy of The Fogg Art Museum, Harvard University
Art Museums. Bequest of Meta and Paul J. Sachs

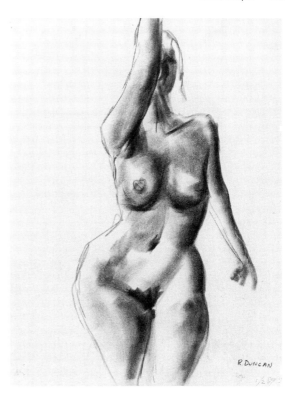

Figure 2.22 *(student drawing)*
ROGER DUNCAN
Compressed charcoal. 18 × 24 in.
Michigan State University

terrain. Note too that Degas takes care to balance the three areas of dark tone. As Figure 2.22 further shows, drawing with three values is hardly the restriction it may at first appear to be. In fact, many tonal drawings, in whatever medium, will be found to be comprised mainly of three values, with perhaps some intermediate tones resulting from the "drag" of the chalk or brush, or the occasional overlaying of these three tones.

These are things to try for in your drawing. As it develops, look for ways in which you can get the greatest yield of volume and dynamic spirit through these three values. As Figures 2.21 and 2.22 demonstrate, this three-value restriction can produce a great sense of volume.

drawing 3 This will again be the same view of the still life but now use the four-value divisions mentioned on page 31. Depending on the nature of your subject's values, the lighting, and your own inclination toward lighter or darker drawings, you may wish to adjust the values. The following variation would result in a darker image (1) white or the tone of the paper; (2) a 25 percent gray; (3) a 60 percent gray; and (4) black. Whichever four-division grouping you choose, you may be surprised by how many of the observed values can now be stated as they actually appear in the subject. Not nearly so many will have to be altered in tone (and most of these only slightly) to join one of the four divisions.

Many artists change the tonal scheme when their subject and medium change. Another drawing by Kollwitz (Figure 2.23) shows a four-value division. Notice that the artist subtly interworks these values to subdue their shape impact but is careful not to lessen their structural function.

Your third drawing can be carried further, since a four-value grouping can distinguish more differences between value shapes and can suggest subtler shape interactions. Try to use this expanded tonal range to establish some of the smaller planes. After the drawing has been carried to a firmer, more volumetric stage, you might wish to abandon the restrictions on values to get at some useful nuances and transitions of tone that will develop the forms further. However, avoid going so far as to lose the sense of shape and planar structure.

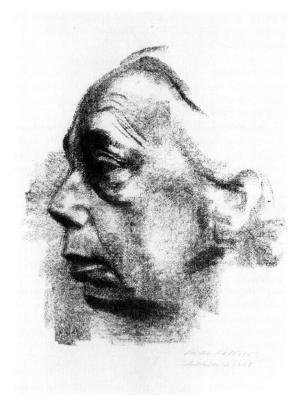

Figure 2.23
KÄTHE KOLLWITZ (1867–1945)
Self-Portrait in Profile (1927)
Lithograph. 12¹/₈ × 11³/₈ in.
Courtesy of the Fogg Art Museum, Harvard University Art Museums.
Gray Collection of Engravings Fund

These three exercises are in no way intended as "how-to-draw" systems (though, as we have seen, a number of notable artists have used the several formats discussed here). They are offered as one more means of organizing your observations. Their primary purpose here is to sensitize you to the value shape as a unit of volume-building *and* pattern-making. Also, these exercises may help you feel more comfortable with the powerful but less familiar (and thus more feared) element of value. Finally, they will enable you to see the shapes that planes and values offer the discerning artist.

THE INTERDEPENDENCE OF SHAPE AND VOLUME

When volumes emerge from shapes, their third-dimensional quality can affect our degree of awareness to the two-dimensional life of the shapes in a drawing. It is important to recognize the power we have to increase or diminish the viewer's attention to "edgeness." To subdue and thus deny shape most of its dynamic potential deprives the viewer of picture-plane events of much esthetic worth. For without shapes' surface tensions, their directional play, their value or texture contrasts, and their gestural and structural behavior, an important source of dynamic energy is lost. The absence of a sense of shape activity, then, diminishes the means by which expressive and organizational meanings can be established.

This seeming modification of shape considerations by those of volume is seen by some as creating a dilemma. If emphasis on the third dimension reduces attention to the second dimension, and vice versa, how can one maintain a satisfying activity of both? Some artists make wide swings in emphasis, working in a pronounced two-dimensional or three-dimensional manner according to their expressive purposes. That a rich union of both dimensions can occur is attested to by the drawings of Rembrandt, Degas, Cézanne, Matisse, and many others. Such works show that it isn't the amount of emphasis on one or the other dimension that matters, but the quality of the interplay between them.

This issue is largely absent in the works of those artists who intentionally eliminate structured, volumetric content, thereby clearing the way for the expression of concepts not otherwise possible. Paul Klee, in his drawing *The Angler* (Figure 2.24), could not have probed the playful and dreamlike issues necessary to him if the sense of volume continued to be a major factor in the pictorial organization of this drawing. And Rubens, in his *Study of a Male Figure, Seen from Behind* (Figure 2.25), could not have created his powerfully sculpted images if he had insisted on strong shape confrontations as the *primary* visual strategy. But unlike artists who exclude the impression of volumes in space as a goal (although two-dimensionally oriented drawings often impart some degree of spatial depth), no artist who intends a convincing impression of solid masses as part of his or her language of graphic expression is free of the responsibilities of a drawing's two-dimensional activities. For example, note how effectively the shapes in the Rubens drawing reinforce its expressive power. All sound drawings that empha-

size the third dimension must be sound drawings in their two-dimensional properties (see also Figure 2.16).

Actually, the dilemma dissolves in the presence of a need to experience fully an encounter with a subject. The need to express this experience (within the framework of a personal esthetic persuasion), not the exploration of both dimensions (or either) *as an end in itself,* is at the heart of responsive drawing. The richest visual and expressive responses result from the richest complemental activity between the dimensions—between the dynamic and depictive forces. In art, one person's dilemma can be another's motive.

Figure 2.24
PAUL KLEE (1879–1940)
The Angler (1921)
Watercolor, transfer drawing, and pen and ink on paper, mounted on cardboard. 20 × 12⅝ in.
The Museum of Modern Art, New York. John S. Newberry Collection

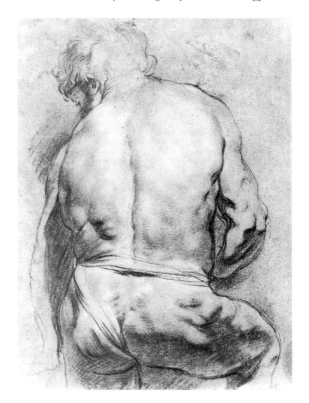

Figure 2.25
PETER PAUL RUBENS (1577–1640)
Study of a Male Figure, Seen from Behind
Charcoal heightened with white. 35.7 × 28.5 cm.
Fitzwilliam Museum, Cambridge

SHAPE AS AN AGENT OF DIRECTION AND ENERGY

So far shape has been considered mainly for its role in the structural organization of volume and for its two-dimensional configurations. As we shall see in later chapters, shape has other functions. In this section we want to recognize that shape is an important agent of direction. The familiar arrow on signs directing us to exits, shelters, and the like aims the viewer toward a particular goal, and the shape itself *inherently* suggests movement. Not only do we understand it as symbolizing an arrow in flight, but its shape character urges us on in the direction it points to with considerable energy. In the first chapter we saw the compelling force of shapes when they were activated to convey a subject's gestural behavior. Our sense of the arrow's "movement" is a response to that energy. But the role of shape as an agent of direction goes beyond gesture. If

A **B**

Figure 2.26

gestural expression is understood as the emotive character of movement, then directions provide the "itinerary," the formal pattern of movement.

Shapes, whether as flat configurations or as planes on volumes, do much to guide us in or out of the spatial field or in any direction on the picture-plane. All shapes, except those whose radii are roughly equal, such as circular or square ones, suggest movement in the direction of their long axis (Figure 2.26A).

Generally, the more geometrically simple a shape, the faster and more forcefully it appears to move (Figure 2.26B). Compared with others in

Figure 2.27
EL LISSITZKY
Gravedigger (1923)
Color lithograph. $14^5/_8 \times 10^5/_8$ in.
(Totengräber) from the portfolio "Victory Over the Sun"
Collection of Lois B. Torf

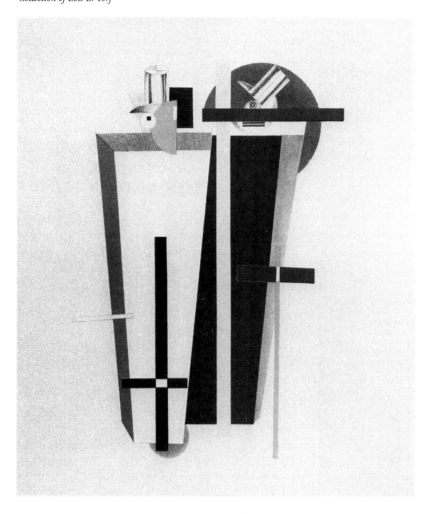

a drawing, longer shapes and those with simpler, more sharply defined boundaries appear to have swifter directed movement. When several shapes are arranged in a similar direction they intensify each other's moving energy (Figure 2.27). Conversely, the more complex the shape, the more convoluted and/or diffuse the boundary; the more its directional force is impeded by shapes moving in contrasting directions, the slower and even more tranquil it will appear to be (Figure 2.28).

> ***Generally, the more geometrically simple a shape, the faster and more forcefully it appears to move***

Exercise 2d will enable you to explore the possibilities for control over the speed of shapes and forms in drawing. Preliminary sketches, roughly in the manner of the last part of the exercise, are useful in planning the pattern of directed energies in more extended works.

exercise 2d

MATERIALS: Sketchbook and graphite pencil or pen and ink.

SUBJECT: Geometric and organic shapes.

PROCEDURE: Draw three pairs of squares of the same size, making six squares in all. We will call the first pair A1 and A2, the second pair B1 and B2, etc.

In A1, place, at any angle, a straight or simply curved *geometric* shape that appears to move fast. Do not let its boundaries touch any edge of the picture-plane. Fill the rest of the picture-plane with shapes that seem to add to its speed, as in Figure 2.29A.

In A2, redraw the original shape in A1 and try to slow down its inherent speed by filling the rest of the picture-plane with shapes that counteract its movement. These can appear to move faster or slower than the original shape and can cut across or under a small part of it to cancel its speed by moving in an opposing direction, as in Figure 2.29B. You may use both organic and geometric shapes for this purpose.

In B1 and B2, repeat the exercise, using an *organic* shape for your original. First, try to speed it up by adding other shapes; then slow it down. Again, both geometric and organic shapes can be used to influence the speed of the original.

In C1 and C2, repeat the exercise, using sim-

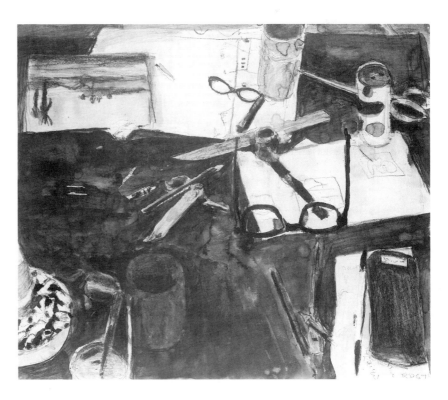

Figure 2.28
RICHARD DIEBENKORN
(1922–1993)
Still Life/Cigarette Butts, 1967
Pencil and Ink, 14" × 17"
National Gallery of Art, Washington, D.C.
Gift of Mr. and Mrs. Richard Diebenkorn

A

B

Figure 2.29

ple geometric and organic volumes, as in Figure 2.30. In C1, arrange forms to create an impression of vigorous movement as in Figure 2.30A; in C2, try to slow down each form by contrasting movements in neighboring forms, as in Figure 2.30B.

There are other factors that affect the speed of a shape's direction: the differences of value between shapes, their scale and textural differences, even the haste or patience with which a shape is drawn affects its directional energy. Reexamine some of your earlier drawings to see how changing the directional energy of the forms can improve their relational order and life. Responding to the directional cues of shapes in nature and governing their movement character are important perceptual skills.

THE CHARACTER OF SHAPE

Shape can be a picture-plane component, a facet on a volume, a spatial cavity, and an agent of directed energy all at the same time. Additionally, shape has a quality that does not directly participate in these activities but declares the shapes in a drawing as having certain common "inter-

ests." One of these is a familial resemblance. That is, the various shape configurations in a work may show some common characteristics that help to make it seem "more of a piece." Another is an interest in support of expressive as well as formal, organizational matters. That is, the various shape configurations in a work may show traits that serve to amplify the artist's expressive purposes. These characteristics among shapes, their "personality" as being clearly defined or unfocused, curvilinear or angular, boldly or delicately stated, and so forth, and their behavior as agents of expression, must be recognized as another given factor of drawing. Since drawing without shapes is impossible, the need to establish their collective unity—their "oneness"—*and* their suitability to the artist's expressive intent is great.

In the drawing by Degas (Figure 2.21), the feeling of weighty mass, the avoidance of intricate edges, and the forceful energy of these monumental shapes establish their unity of character and expressive mood. How these differ from the character of the shapes in a similar subject is shown in a drawing by Renoir (Figure 2.31). Here the shapes flow in an agile, rhythmic man-

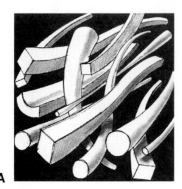

A

B

Figure 2.30

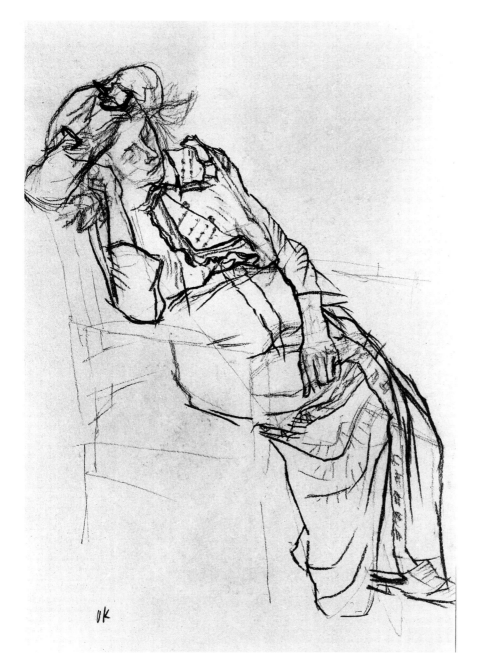

Figure 3.9
OSKAR KOKOSCHKA (1886–1980)
Study of the Artist's Mother
Black chalk. 40.2 × 28 cm.
Albertina Museum, Vienna

Figure 3.9, where a rich variety of line assists the location of planes and edges and establishes solid forms, Matisse's more uniform line tends to flatten the forms somewhat by stressing the cut-out character of the edges. This occurs because contours represent the most distant sur- faces of a rounded form. Emphasizing contours brings forward the receding, foreshortened planes they are meant to represent. Matisse fur- ther accents the second dimension by creating strong, attention-getting shapes.

The animated lines in Cano's drawing (Fig-

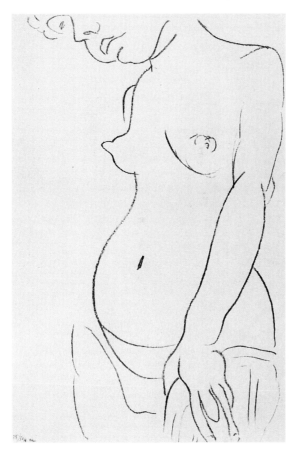

Figure 3.10
HENRI MATISSE (1869–1954)
Three-Quarter Nude, Head Partly Showing (1913)
Transfer lithograph, printed in black, composition.
19³/₄ × 12 in.
Collection, The Museum of Modern Art, New York
Frank Crowninshield Fund

ure 3.11) contrast sharply with the graceful un-dulations of the lines in Utamaro's (Figure 3.12), and both these uses of line differ from the rhyth-mic vigor of the lines in Figure 3.13, yet all are strong calligraphic expressions. In each of the five preceding works the artist utilizes line's capacity for visual and expressive excitation and not its ability for description alone.

THE EXPRESSIVE LINE

As was observed earlier, all lines exhibit *some* expressive characteristics. After all, they represent an artist's intellectual *and* emotional encounter with a subject, resolved by both esthetic and temperamental attitudes to line, and these qualities influence every mark. But we can regard

lines as chiefly expressive when we sense in a drawing that the artist's need to experience and share feelings pervades all other motives for line's use.

Figure 3.11
ALFONSO CANO (1601–1667)
Study for the Figure of a Franciscan Monk
Pen and ink. 17.6 × 7.5 cm.
Prado Museum, Madrid

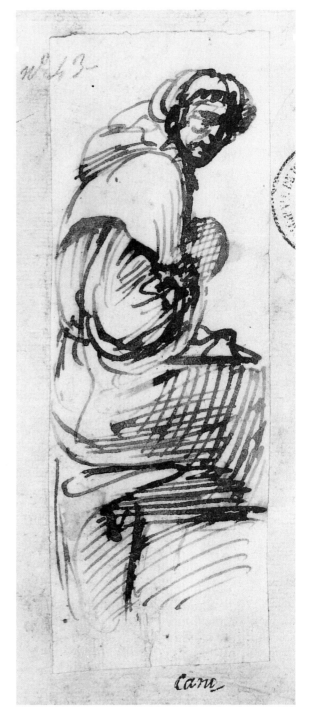

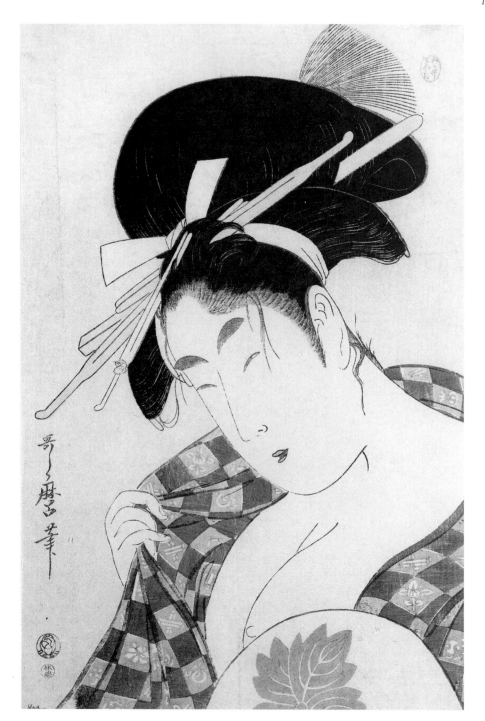

Figure 3.12
KITAGAWA UTAMARO
An Oiran, 18th century
$14^{11}/_{16} \times 9^{3}/_{4}$ in.
The Metropolitan Museum of Art, Bequest of Mrs. H. O. Havemeyer

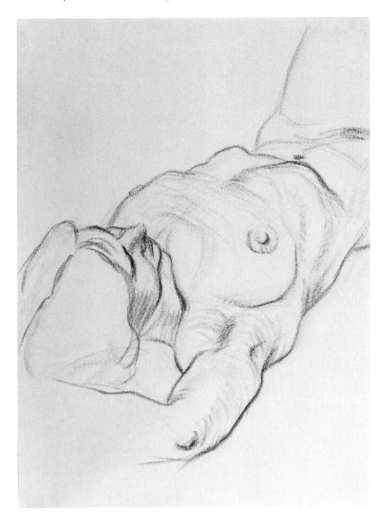

Figure 3.13 *(student drawing)*
MIGUEL COLLAZO
Conté crayon. 24 × 18 in.

Unlike the artist for whom line's expressive power is triggered mainly by visual stimuli, some artists, such as Goya (Figure 3.14), come to the blank page with an established expressive intent of another kind. For these artists the expressive character of line, though it may result in part from visual challenges and insights that occur while they are drawing, receives its initial impetus from a need to experience and share feelings *through* and not merely *about* the content of the drawing. In Goya's etching, the first in a series called *The Disasters of War,* it is not the representational matter alone that expresses his ominous warning of oncoming doom. The character of the lines reveals this through their slashing, cross-hatched clash and the brooding tones they form. That these lines carry the grim message intrinsically can be seen if you cover any portion of the etching. Even small segments cannot be seen as cheerful, gentle, or serene.

Goya's interest in visual phenomena—in structure, design or dynamic activities—exists only insofar as they strengthen his expressive message. This is not to suggest that these matters were of little importance to him, but rather that they were not important as ends in themselves. They were a necessary means to the clarity of his expressive ends. His lines, then, do not stem from some "policy" concerning the act of drawing, but from a deeply felt emotional force that led him to these graphic strategies.

Pascin's *Girl in an Armchair* (Figure 3.15) shows a use of line that conveys a sensual, even erotic, interest in the female figure. There is honest fascination evident in the slow search of the forms. These lines, *by their nature,* express the pliancy and weight of the body. Pascin delights in experiencing every fold and swell of the figure and of the yielding, receiving character of the sofa. Everything in this drawing is felt as

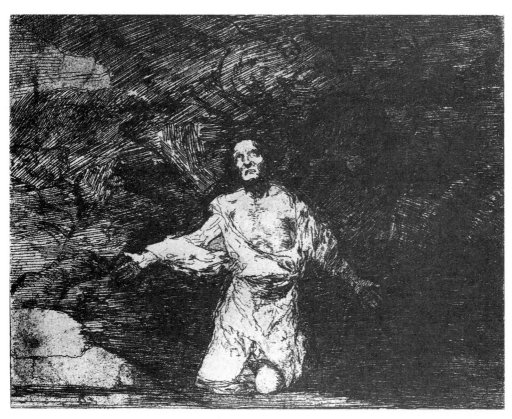

Figure 3.14
FRANCISCO DE GOYA (1746–1828)
Sad Presentiments of What Must Come to Pass from "The Disasters of War"
Etching, 4th state. 10.5 × 18.7 cm.
Print Department, Boston Public Library

supple and pliant—terms that describe the character of the lines themselves. Again, covering a section of the drawing would show remaining portions capable of communicating Pascin's sensual message.

A very different kind of expression is conveyed by the rugged and resolute chalk lines in Schiele's drawing (Figure 3.16). These lines fully agree with the figure's assertive stance; they evoke as well as depict the subject's assurance.

Artists may support the emotive meanings of representational content through line's expressive powers for many reasons. Historical, religious, political, and social issues have been catalysts for such drawings.[2] But many other motives can and have stimulated artists to use line for expressive purposes beyond those triggered by formal visual issues. The aggressive and tension-filled strokes that shape the forms in Figure 3.17 suggest the mood of the figure's menacing attitude. And the lines that reveal Picasso's understanding of a mother's love for her child (Figure 3.18) are themselves gentle caresses.

ON USING LINE

This discussion of the several basic attitudes to line may leave the impression that artists make a conscious choice among them. This is virtually never the case, although the more experience artists have in exploring various line characteristics, the greater their control of line's "vocabu-

[2] For an interesting exploration of such motives, see Ralph E. Shikes, *The Indignant Eye* (Boston: Beacon Press, 1969).

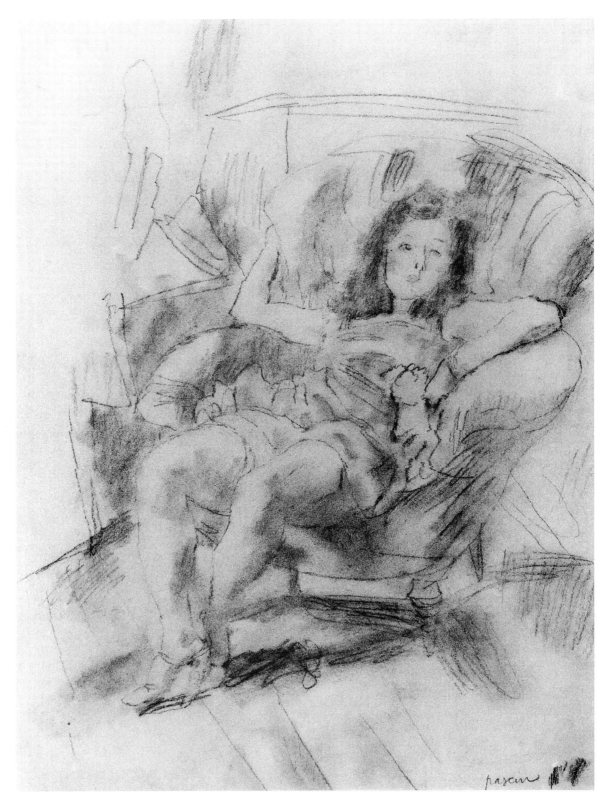

Figure 3.15
JULES PASCIN (1885–1930)
Girl in an Armchair
Charcoal, some yellow chalk. 55.9 × 43.1 cm.
Collection of The Newark Museum
Gift of Mr. and Mrs. Bernard M. Douglas, 1957

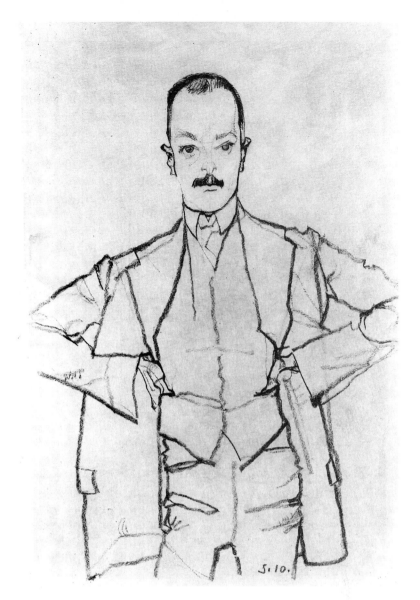

Figure 3.16
EGON SCHIELE
(1890–1918)
Arthur Roessler Standing with
Arms Akimbo
Black chalk.
Albertina Museum, Vienna

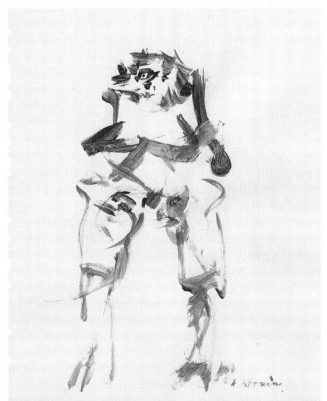

Figure 3.17
WILLEM DE KOONING (1904–1997)
Untitled. Woman (1961)
Pastel and pencil on tracing paper.
$23^{11}/_{16} \times 18^{11}/_{16}$ in.
Hirschhorn Museum and Sculpture Garden, Smithsonian
Institution
Gift of Joseph H. Hirschhorn, 1966

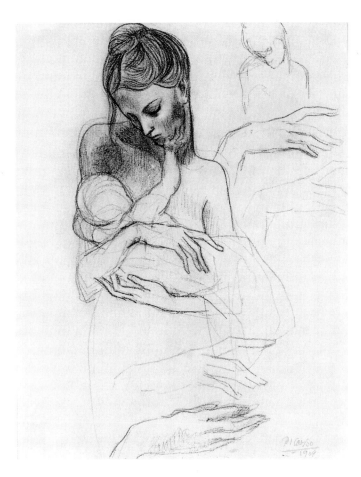

Figure 3.18
PABLO PICASSO (1881–1973)
Mother and Child and Four Studies of Her Right Hand (1904)
Black crayon. $13\frac{1}{2} \times 10\frac{1}{2}$ in.
Courtesy of The Fogg Art Museum, Harvard University Art Museums, Cambridge, Mass.
Bequest of Meta and Paul J. Sachs

lary." Still, because of certain factors, no one has complete freedom in the selection of line.

First, our choice is influenced physiologically, in the same way that we are not altogether free to choose our individual handwriting. Neuromuscular coordination and control imprints certain pathways of line-making and blocks others. These personal idiosyncrasies are not easily overcome. Nor should we struggle to overcome them, for these traits form part of our unique way of drawing (or writing). And our way of using line is just as capable of creating fine drawings as any other. Second, we are influenced psychologically. Our intuitive and intellectual interests—how we like to use and see line—insist on a particular "recipe" based on the options available. This creative imperative may vary with the choice of subject or medium, and as our moods and interests fluctuate within a certain esthetic point of view. For example, compare Toulouse-Lautrec's use of line in Figure 3.3 with that in his sketch of a music hall figure (Figure 3.19). Although these drawings differ from each other as much as they do from other Toulouse-Lautrec drawings in this book, all of them exhibit variations of line usage that fall within a range determined by his idiosyncratic and creative instincts. All bear the stamp of the artist's temperament and handling.

In responsive drawing, line always functions at three levels: it *describes,* it *acts,* and it *interacts* with other lines, producing various dynamic phenomena. If description is the only motive for using line, we lose all of line's dynamic potential—its ability to add meanings and activities that support the depiction. Description alone skirts all the responsive possibilities of line and is always expressively dull. As we have seen in the previous two chapters, an exclusive concern with a subject's surface appearance blinds us to a subject's gestures and shapes. Here, it blinds us to the many possibilities for creative activity and meaning of the very tool being used to make the drawing—line.

The following exercise explores the several line qualities discussed.

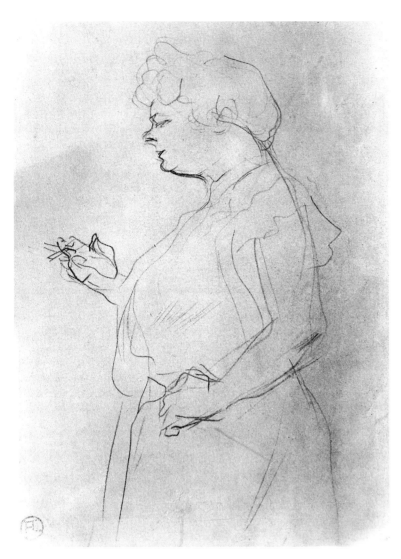

Figure 3.19
HENRI DE TOULOUSE-LAUTREC (1864–1901)
Sketch for "Aux Ambassadeurs"
Pencil. 26.2 × 20 cm.
Albertina Museum, Vienna

exercise 3a

This exercise consists of five drawings. Each should start as a two-minute gestural drawing.

MATERIALS: Use pen and ink on any suitable drawing paper. These drawings should all be about the same size, approximately 10 × 14 inches.

SUBJECT: In each of these five drawings your model will be the same: your own hand, holding a tool, letter, utensil, flower, or anything else that is not much larger than the hand, is com-

fortable to hold, and has some interest for you as a visual and/or expressive object.

PROCEDURE: Allow about fifteen to twenty minutes for each drawing. The five drawings are:

1. calligraphic emphasis
2. diagrammatic emphasis
3. structural emphasis
4. expressive emphasis
5. unrestricted line drawing

In each, try to draw actual size, but don't hesitate to work a little larger or smaller if your drawing requires it.

Beginning a pen-and-ink drawing may create some anxious moments for you. The earlier gestural drawings in pencil or chalk seemed "safer." It was like walking a tightrope with a net below. Here, there is no net. The ability to erase and the foggy tone lines, so useful in grasping a subject's broad actions and masses, are not possible in this medium. Obviously we must alter our tactics.

Many artists will first make a practice gestural drawing in pencil *on another sheet of paper.* Such a preliminary pencil drawing helps them become familiar with a subject's essential action and structure, and allows for a more informing and economical use of line in the pen-and-ink gesture drawing. And using the fewest lines possible is now necessary, for every mark will be visible in the completed drawing.

This being the case, more effort and time must be given to an analysis of the forms *before* you begin to draw. Where chalks could make broad sweeps in tone, a few short lines, or even dots, must suffice to show the basic action and form character. However, do not hesitate to use continuous lines if you wish. That such a pen-and-ink gesture drawing can convey as much about the action as chalk can is evident in a spirited student drawing (Figure 3.20). Although intended as a final statement, it is an impressive example of how much gestural action can be grasped with a few felt lines, resolutely stated.

Think of these lines and dots as clues—a kind of gestural shorthand—about the expressive action, as well as clues to major directions, shapes, and masses.

drawing 1 Calligraphic. After the two-minute gestural phase, try to complete the drawing by lifting the pen from the paper as little as possible. Holding your pen upon the paper at the completion of a line, while you look up to make further observations, often leads to discoveries of nearby edges or tangential forms that allow the line to continue. This continuity gives to lines a sense of animation and promotes an economical handling, as in Figure 3.20. Although a shorter, vigorous line like Dufy's (see Figure 1.15) also suggests an energetic calligraphy, as does the rich variety of Kokoschka's lines (Figure 3.9), continuous lines more clearly reveal line's capacity for dynamic activity and demand that you make more conclusive,

simpler line judgments. However, do not hesitate to use line ideas such as those in the Dufy and Kokoschka drawings where you feel they are necessary to your drawing.

There is no one way to draw calligraphically. Your continuing study of the drawings by artists who emphasize calligraphy will reveal the endless possibilities for such linear actions. Calligraphic lines are not "free-born"—to wander where they will—but they can, simultaneously with their representational role, offer animated configurations that are esthetically satisfying.

In Oldenburg's energetic drawing (Figure 3.21), gestural and calligraphic line qualities occur throughout. The artist enjoys the sheer act of drawing, as the knowledgeable flourishes of his "handwriting" strongly show. These lines depict forms with an easy confidence while simultaneously asserting their own vitality.

Your goal in this first drawing is to interpret the subject as a system of forms which offer inter-

> ## *The calligraphic line is, to some extent, a tactile, sensual line.*

Figure 3.20 *(student drawing)*
ANNE-MARIE HODGES
Pen and ink. 14 × 17 in.
Art Institute of Boston

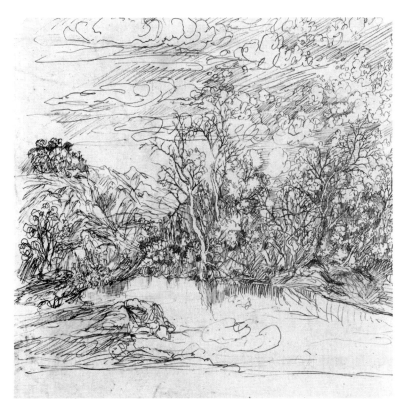

Figure 3.35
RODOLPHE BRESDIN (1822–1885)
Bank of a Pond (Bord d'Etang)
Pen and black ink on buff tracing paper. 16.3 × 16.9 cm.
*Collection of The Art Institute of Chicago. Gift of the Print and
Drawing Club. Photograph © 1996, The Art Institute of Chicago.
All Rights Reserved.*

as a gentle inquiry may end as a furious declaration.

In this drawing your are on your own. Do not dwell on line attitudes; instead concentrate on your visual and expressive responses that are now under none of the influences and restrictions of the previous four drawings. Having worked with each attitude has helped you understand their various qualities better. You made some judgments about their capabilities and their "feel." Much more drawing experience is needed to fully grasp their worth. But let your experiences of the previous four drawings influence your use of line in this drawing, as in Figure 3.37. Compare this drawing with Figure 3.32, by the same student. Your attention should shift from line's uses to what it is you want to explore and convey. But your expanded repertoire of line uses should help you communicate your intent in more effective and satisfying ways.

This drawing may lack the control and clarity of meanings you had hoped for. Even though your primary attention is upon comprehension and response, it will take patience, commitment, and the experience of many encounters with subjects drawn in line before these concepts and procedures, adapted to your interests, become necessary, natural, and satisfying. As William Hazlitt observed, "We never do anything well till we cease to think about the manner of doing it."

DELINEATING CONTOUR

"Delineating" should be understood here as establishing the physical boundaries of a form or plane with any of the four line concepts already discussed. That any kind of line can be used to convey the "edgeness"—the *contours* of forms—is clearly seen in the drawings that illustrate this chapter. The character of their delineating lines is largely consistent with the type of

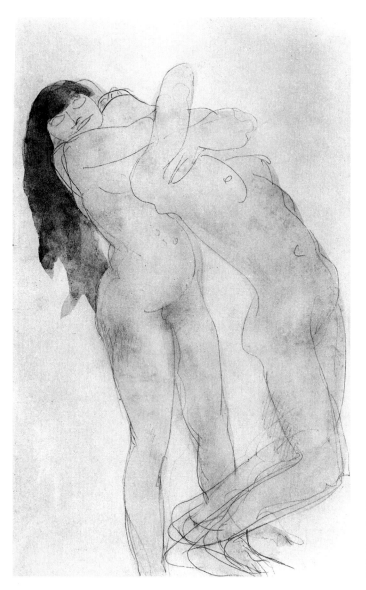

Figure 3.36
AUGUSTE RODIN (1840–1917)
Two Female Nudes
Graphite pencil and brown watercolor washes on
gray paper. 30.5 × 19.5 cm.
Albertina Museum, Vienna

Figure 3.37 *(student drawing)*
DAVID BROWER
Pen and ink. 14 × 17 in.
Art Institute of Boston

line quality used throughout the drawing. Delineation, then, is a task that *any* type of line can perform. But, unlike the untrained, for whom delineation is only outlining, responsive artists regard delineation as a volume-producing process. For them, the line that creates an edge, regardless of its calligraphic or other properties, is understood as denoting planes seen in full foreshortening, as when a playing card is held in such a way as to reduce it to a line.

This is true whether the drawing consists mainly of contour, as in Figures 3.10 and 3.19, or is densely filled with lines, as are Figures 3.5 and 3.6. Only in drawings that avoid or subdue a sense of edge, as does Figure 3.25, is the issue of form-revealing delineation absent. And even there, despite the negation of a continuous contour, edge as *turning form* is implied.

The tradition of drawings that rely mainly on form-revealing contour dates back to the prehistoric cave artists of France and Spain. In Eastern art the contour line has always prevailed (see Figure 3.12). In Europe the emphasis on contour through use of sharply "focused" line of a continuous nature was a dominant graphic device until the late Renaissance. Contour drawing remains a universally popular means of graphic expression because of its ability to economically state volumetric impressions of a form at its edges and even to suggest conditions of the form's terrain well within its edges.

Still, contour drawing is not another attitudinal category of line but, as was mentioned earlier, is an "adopted" function of any of the line qualities already discussed. As such, its function tends to set it apart. For example, in da Vinci's drawing (Figure 3.5) the contours are essentially structural in character, but by their running at a right angle to many of the hatched lines that model the form, and by their continuity, we recognize their somewhat independent nature. That such an independence of contour can be modified is evident in the structural lines of Cézanne's *Card Player* (Figure 3.7).

For beginners, drawings restricted to volume-revealing contours help them see the often complex state of a subject's edges with heightened objectivity. Such drawings encourage conscientiousness in the efforts required to "track" the condition of edges, similar to the kind of searching explored in Exercise 2A in Chapter 2. However, here the lines are understood to repre-

sent planes in space as seen in total foreshortening and not just the limits of a shape.

Whether or not delineation becomes an unselective tracing of edges—a kind of fussy scrutiny—depends on the artist's ability to recognize what is essential to the impression of volume and what is irrelevant or detrimental to it. Rubens' drawing (Figure 3.38) is a quite faithful denoting of his subject, but not slavish imitation. His choices and changes make each delineating line reveal volume. Also, Rubens is sensitive to the rhythmic flow that organic forms possess, and his line includes that graceful rhythm among the parts.

Exercise 3b provides some suggestions for delineating contours that will help you experience line as edge *and* volume-maker.

Figure 3.38
PETER PAUL RUBENS (1577–1640)
Study of the Figure of Christ
Black chalk, later outlining in charcoal, heightened with white, reinforced at left edge of torso with brush and thin wash on buff paper.
The Fogg Art Museum, Harvard University Art Museums, Cambridge, Mass.
Gift of Meta and Paul S. Sachs
© *President and Fellows of Harvard College*

exercise 3b

MATERIALS: Any kind of pen or soft grade of pencil and a sheet of good quality bond or vellum paper, approximately 18 × 24 inches.

SUBJECT: One or more mechanical or manufactured objects that offer an interesting collection of shapes and forms—gears, wheels, cylinders, pipes, or anything else that you would find interesting and challenging to draw. A lawn mower, an eggbeater, or a bicycle will work well, as will parts of discarded engines or carved furniture.

PROCEDURE: This drawing requires your sharpest perceptual commitment—not for purposes of imitation, but to analyze and understand the volumes you will be delineating. This being the case, try to favor a structural attitude to line. As such drawing becomes more familiar to you, it will reveal your own calligraphic idiosyncrasies about contour. Rubens' drawing shows his "recipe" of structural-calligraphic qualities. Diagrammatic themes being often too schematic, and expressive themes too little concerned with objective analysis, most contour drawings show a blend of structural and calligraphic interests.

Arrange your subject so that parts overlap. This time do not make a gesture drawing, but be-

gin by sighting on some edge of your subject and, drawing in a large scale (where possible, close to actual size), *slowly* follow the edge with a single, continuous line. Lift your drawing tool as seldom as possible, and take all the time you need to complete this exercise. Regard your line to be recording the edges of planes. Because your line helps to explain a form's direction in the spatial field, try to feel the line moving in and out of space as it follows an edge, as in Figure 3.39, which is somewhat related to the nature of this exercise. By increasing and decreasing pressure on your drawing instrument, you can vary the value and weight of lines to help suggest a form's near and far parts. Additionally, such variations help suggest whether an edge is rounded or not. Thinner, lighter, and/or less sharply incisive lines suggest the edges of rounded forms; heavier, darker, and/or more sharply "focused" lines indicate the edges of flat planes. Do not use lines to suggest values.

Ideally, you should not lift your drawing tool more than seven or eight times during the entire exercise. However, do not hesitate to do so more often if you find this restriction too limiting; or less often, if you can. While most artists do not restrict their contour line in this way, here it will help to increase your awareness of delineation as a distinct graphic activity with its own dynamic potential. A line can be kept going by continuing to find

Figure 3.39 *(student drawing)*
DENNIS SOPCZYNSKI
Graphite pencil. 18 × 24 in.
University of Indiana at South Bend

"routes" for it to take. Often, a line, having reached a dead end, can be made to continue by backtracking. Just draw your line (as slowly and as well observed) along the same edge it came up, until you find some way out (Figure 3.40).

As you draw, you will notice that some lines begun at a form's edge have moved into its interior, as may happen with an object such as a spiral-shaped chair leg. Follow such edges with an awareness of their coming toward and moving away from you. Each time a spiraling edge turns away and out of view, continue your line on the new edge that blocked your view—but recognize that doing this means leaving a form at one level in space to "hop" to another one located nearer to you. Sometimes an edge turns inward—"dies out." When this occurs you can either reverse your line to get back to the outer edge of the form or "legitimately" begin a new line as in Figure 3.40.

In contour drawing you will find that the angle of interception of one line by another—the impression of space and volume resulting from perspective principles (see Chapter 5)—is as important as are particular changes along a form's edge. Perspective is a factor in all volumetric drawing, but drawings that rely on contour lines to communicate several kinds of information require the artist to be especially sensitive to the direction of edges in space. Part of the impact of such lines is in being "right" the first time.

The slower the line, the more you will see. Avoid the natural tendency to speed up the line. Doing so usually results in drawing uncertain generalities to represent intricate or subtle passages in the subject. Here your attitude should be "the more difficult or subtle the passage, the more committed my perceptual skills will be to changes and overlappings of edges." An extreme example of this attitude would be to draw every strand of spaghetti in a dish, just as you see them, avoiding none of their coiled, interlaced complexities. One of the frequent pitfalls for the beginner is to relax his or her perceptual powers when confronting a complex or unusual subject. Just at that critical moment, where continued or even intensified efforts to analyze would cause the breakthrough to the understanding necessary for the control of a demanding passage, there is a retreat to vague generality. Known as "lazy vision," this turning away from visual challenges must always be guarded against.

In this drawing, do not worry about proportions which may be awry or about poor organization. You are extracting one idea only: "Here is what I found about the volumetric properties of my subject that were capable of being stated in a few, more or less continuous lines."

Other concepts and uses of line are dealt with in Chapters 9 and 10. While our interest has been focused here on the responsive possibilities of line, we should remember that its unseen presence abounds in everything we see. In Chapter 1 we sensed, in the search for gestural expression, some of the linear forces that forms generate by their direction and rhythms. This sense of directional energy—of "pathways"—moving through a subject, should be permitted to influence all uses of line. We are always aware of directional force, a kind of "invisible" line, even when it runs through several forms, as when we speak of furniture "lined up" or an arm "aligned" with a leg, or when several linear directions form a discernible pattern such as the lifting upward and outward of tree branches from their origin in the trunk. Adding such "felt" lines to the line considerations already discussed, we recognize line's powerful role in the acts of perceiving *and* drawing. We must also recognize that it is inquiry, empathy, economy, and invention, not the desire to imitate nature, that is at the heart of a knowing use of line.

Figure 3.40

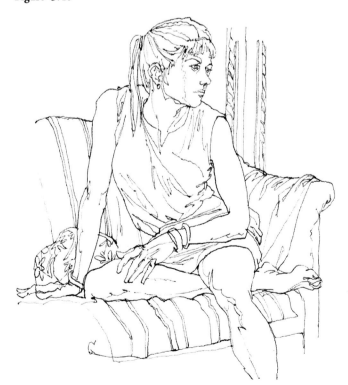

4

value

light, local tone, and mood

A DEFINITION

A children's riddle asks what the subject of a black sheet of paper is. The answer: a coal miner with no headlamp, in a mine at midnight. Why not? A black surface *can* be imagined to be anything–in itself, it *is* nothing. A coal miner *with* a headlamp–and there is no riddle. Forms in nature, as even the children who ask the riddle know, are revealed by light. In drawing, the impression of volume and light is conveyed by values.

If line is the basic visual element in drawing, value is next in importance. Indeed, it is through the use of these two basic elements that the elements of shape, texture, mass, and space are created. And if one of line's chief functions is to set boundaries, then value's domain is often within such boundaries. We might think of line as the tool often used to chart a subject's geographical limits (although as we saw in the previous chapter, it does far more than that), and of value as the tool more often used to explain a subject's terrain in a particular atmosphere.

Values, the many differing tones between white and black, can be produced in just two ways: (1) by variously hatched lines creating optical grays, that is, impressions of value resulting from the collective tone of massed lines, their value resulting from the density of the hatching; and (2) by deposits of actual gray tone by chalk, pencil, or diluted washes of ink or paint.

The use of massed lines to model forms provides important information about their planes and therefore helps us to see the structural aspects of volumes (see Chapter 6). But the application of actual gray tones has its own versatile uses, as we shall see.

Value, whether of massed (usually structural) lines, broad strokes, or washes, is the necessary and (except for color) the only tool for modeling form with light. It enables artists to show subtle changes in a form's surface and it helps clarify the relative distance between forms. Value also conveys the inherent lightness or darkness of a form—its *local tone*. This is a given quality of all forms. It is affected by, but separate from, the light and dark areas that result from light falling on forms. The local tone is the intrinsic value of a thing—excluding any effects of

light. The local tone of a common pearl is very nearly white; that of a lump of coal, nearly black. If we use the value scale described in Chapter 2, the pearl's local tone is about a 10 percent value, the lump of coal's, about 90 percent. Light falling on both would make them lighter and darker in places, but under most lighting conditions the darkest value on the pearl will not be as dark as the lightest value on the coal. Light is incidental to local tone. Values, then, enable us to state a subject's intrinsic *and* incidental tonalities (Figure 4.1).

> *How we contrast, shape, and distribute values, and the amount and manner of tonal changes among them, are potent factors in a drawing's psychological mood.*

Values can also suggest expressive meanings. How we contrast, shape, and distribute values, and the amount and manner of tonal changes among them, are potent factors in a drawing's psychological mood. In the powerful seventeenth-century drawing of a triumphant general (Figure 4.2), the amount and manner of application and the bold contrast of values between the configuration and the page suggest strength and grandeur. The forward part of the horse and rider "burst" through the splashy field of tone, asserting aggressive en-

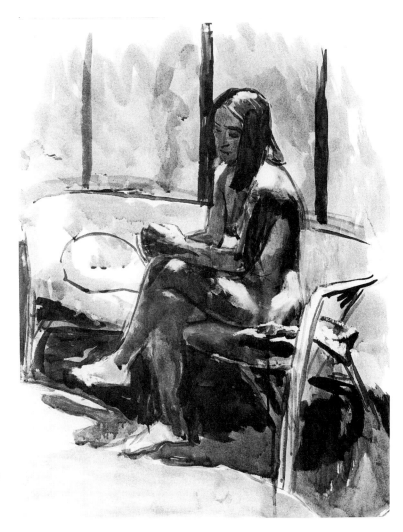

Figure 4.1
DOMENIC CRETARA (1946–)
Seated Nude Figure (1981)
Oil on paper. 20 × 16 in.
Courtesy of the artist

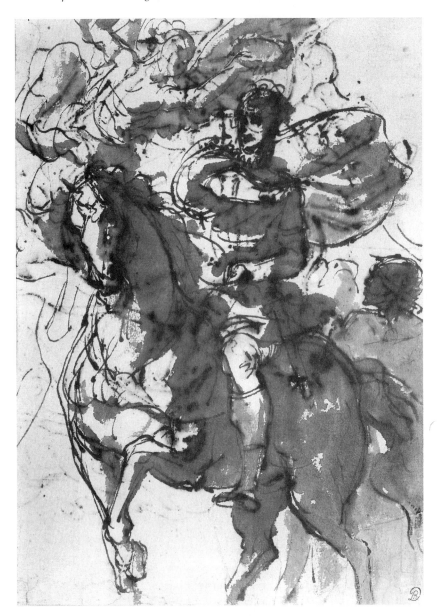

Figure 4.2
ITALIAN, 17TH CENTURY, VENETIAN SCHOOL
Triumphant General Crowned by a Flying Figure
Pen and brown wash on white paper. $10^3/4 \times 7^3/4$ in.
Courtesy of Fogg Art Museum, Harvard University Art Museums,
Cambridge, Mass.
Bequests of Meta and Paul J. Sachs

ergy. The shapes of the tones, their spontaneous application, only loosely confined by the lines, further signify powerful force.

Like line and shape, value is a versatile compositional tool. Value can increase attention to a form's direction, weight, or importance; it creates visual diversity but also serves as a strong unifying agent.

Unfortunately, most beginners seldom use values. Partly because of a universal tendency to regard drawing as a process limited to line, and partly because of its seeming complexity, they restrict their responsive options by the avoidance of value. When introduced to value, many beginners are uneasy about drawing large or dark tones. They are afraid that such areas will

be hard to manage—or to remove—that they will surely "mess up" the drawing. These are understandable concerns. But once value's functions are understood, it is often quickly adopted and soon controlled. How soon and how well depends on how soon and how well they understand the several functions of and approaches to value. Drawing with line alone—freely selected as a mode of graphic expression—is excellent, but when drawings are restricted to line because of innocence or fear, it is a regrettable limitation. Value provides the only means to convey a broad range of responses which must otherwise remain unstated.

> *The basic skill of tonal drawing is the transposing of colored forms and the light upon them into values.*

THE DISGUISES OF VALUE

Our world is a collection of colored forms in space. A lake is seen as blue, not as a value of 50 or 60 degrees; grass is green—its value not usually a conscious consideration. Beginners, if they are painting a lemon and a plum, are generally more aware of their color than of their inherent local tone. They may paint the lemon yellow and the plum purple, but their color choices may be lighter or darker *in value* than those of the fruits. If they are making a tonal drawing with, say, charcoal or pencil, they will of course disregard the subject's colors. But often they will also disregard the values inherent in the colors, neglecting to extract their local tone. If they do try to show their local tone, it will often be at the cost of the *value variations*. Establishing a subject's value variations in the context of its local tones is not likely before students see the difference between these two aspects of the subject's value-state. For them, color disguises local tone. Or, seeing it, color adds to their confusion in attempting to sort out a form's inherent values and those produced by light.

The basic skill of tonal drawing is the transposing of colored forms and the light upon them into values. However, unlike the black and white photograph, which unselectively records the values of illuminated, colored forms, the student can and must make selections from, and changes in, the observed values, for light can *distort* as well as explain both local tone and value variations.

Texture can also disguise both given and light-induced values. What we mean here by texture is the surface character of depicted forms and of the media used to draw them. When a surface has a pronounced, all-over tactile quality, such as a tree trunk or silk, when it has qualities inherent in its physical composition, such as a calm or stormy sea, or when a surface results from the proximity of many small forms, such as leaves or the threads of a lace collar—the visual activity thus generated can be regarded as texture.

Texture also defines value and color changes of either a patterned or random nature in a form's surface. A plaid shirt, a tiger's stripes, and the markings of a marble slab are examples of nontactile textures. The term also includes groups of forms when they activate a large area such as a table top or a field. A display of dishes, a herd of cattle, a crowd at a rally as in Goya's drawing *Crowd in a Park* (Figure 4.3)—all these can be seen as textures.

Additionally, all drawings show the texture inherent in the medium used and in the way it is used. For example, the given texture of charcoal markings is grainy and rough; but the stippling, hatching, or smudging uses of charcoal, while never losing their grainy character, can suggest many other textures. In Figure 4.4 the rough grain of charcoal does not intrude on the delicate texture of the water's surface or the various textures of the surrounding foliage. Even the grain or *tooth* of the surface drawn on reveals its texture by the way a medium acts upon it. As an example, compare the texture of the charcoal's behavior on the grainy paper used for Figure 3.15 with the texture of the charcoal in Figure 4.4.

The texture of some subjects, like a tree with a deeply rutted trunk, or a shrub with its countless leaves catching the light from many angles, produces such an array of values that it is difficult to judge either the subject's local tone or the behavior of the light striking it. Other subjects are so boldly textured that they cannot be reduced to a single local tone. A chessboard, a

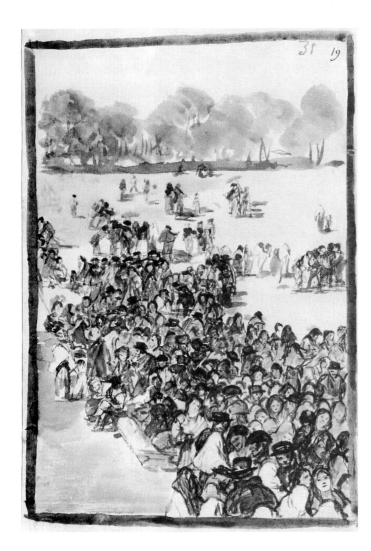

zebra, a boldly patterned wallpaper or flag—or anything else that has striking and frequent contrasts in color or texture—inherently possesses two or more local tones.

But if an intense light illuminates part of such a surface, leaving the remainder in a pronounced shadow, the surface's tonal differences are made subordinate to the strong contrast of light and shadow upon it. In Figure 4.5A a strong light strikes half a chessboard, unifying the alternating light and dark squares of the illuminated part into a pair of values lighter in contrast to the light and dark values of the unlit part. Here the intense light unifies the two local tones of the board by showing their differences to be less great than the contrast between the lit and unlit halves of the board. But this is achieved at the cost of seeing the chessboard as split into two halves. In Figure 4.5B, the contrast occurs less abruptly than in 4.5A, resulting in a

Figure 4.3
FRANCISCO DE GOYA (1746–1828)
Crowd in a Park
Brush and brown wash. $8^1/_8 \times 5^5/_8$ in.
The Metropolitan Museum of Art
Harris Brisbane Dick Fund, 1935

Figure 4.4 *(student drawing)*
JANET KAHN
Charcoal. 18×24 in.
Private Study

Figure 4.5

more unified image, without losing the impression of a strongly lighted board. Seurat uses just this solution in his drawing, *Sleeping Man* (Figure 4.6), where a gradual change in illumination leaves the head connected to the body.

The textures that result from a covering of smaller forms or effects upon an unchanging background tone, such as cattle in a field, markings on a marble slab, or polka dots on a scarf, often make it difficult to judge the tone of the

Figure 4.6
GEORGES SEURAT (1859–1891)
Sleeping Man
Black chalk. 24 × 30.8 cm.
The Louvre Museum

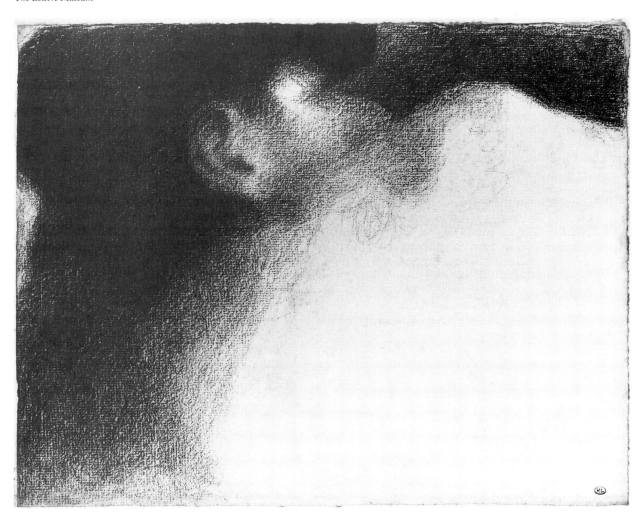

background. This is easier to do if we temporarily disregard the smaller "interruptions" to concentrate on estimating the subject's ground tone. Once the ground tone is established, the values of the smaller, figure units can be better judged in relation to it.

Before such demanding differentiations can be made, we must experience the controlling of values as they relate to each other in some ordered scale. Being able to see and to govern such value relationships as discussed above is fundamental to responsive drawing. Exercise 4a suggests how this skill may be practiced and developed.

exercise 4a

MATERIALS: A good grade of bond drawing paper, a ruler, and three pencils: a 2H, which makes a rather light gray tone; a 2B, which makes a moderately soft, deeper tone; and a 6B, which makes a deep, velvety gray-black tone.

SUBJECT: Value charts.

PROCEDURE: Using the 2H pencil, rule a horizontal rectangle one inch high and eight inches wide. Divide the rectangle into eight squares by drawing lines at one-inch intervals.

Make eight values progress in even "jumps" from white to black (or as near to black as the 6B pencil permits). The first square on the left will be the white of the paper. Fill the second square with an *even*, light tone. Use the 2H pencil for the first few squares, darkening them as needed with the 2B pencil. For the next few squares, the 2B pencil, used with increasing pressure, will be needed. Where necessary, combine it with the 6B pencil to establish darker tones. The last squares may require the softest pencil only, but use all three in any way that helps you achieve evenly darkening tones.

In choosing the first light tone to put beside the white square on the far left, remember that you need to make five more value jumps before you reach the nearly black square on the right. All eight squares must show *the same degree of difference between values*. If you make the first tone too light, the small difference in tone between it and the white

square to its left sets the degree of value difference between all the values to come. Because the goal here is to have the eight values progress evenly on the value scale—with white zero and black 100—starting at the left, each square must be just over 12 degrees darker than the one on its left. In Figure 4.7 there are intentional errors in the eight values shown. These cause some squares to be too greatly separated in value from neighboring squares, while others are too close in value. Avoid such blending as occurs between squares 3 and 4, and such splits as occur between squares 4 and 5. Draw each tone evenly, permitting no value changes *within* a square. By placing lines close together in one direction, or by cross-hatching and varying the pressure on your pencil, you can produce a uniform value of any degree.

When completed, this chart should be studied from a distance of nine or ten feet. Are there any sudden breaks in the value changes? Are any values so similar that they seem to blend at this distance? Do the values on the left side seem grouped together and split off from the values on the right? Are the values from left to right so light that they seem to drop off to black too suddenly? Check to see if any of the tones, *including white and black*, break the even progression of the values. In making any adjustments in these tones, you may find that changing one often requires changing one or more of the others.

In deciding whether or not your exercise is successful, you will be making judgments about its *tonal order*. Evaluating the tonal order here—weighing the differences between degrees of value—is similar to the way values in an observed subject are assessed. Then, too, we want to see the range and relationships of the values. If our goal is to reproduce the tonal order of a subject, we must study our drawing to search for false notes—for faulty tonal judgments.

Try some variations of this chart. Here are a few suggestions:

1. Draw a ten-square value chart. Here the value changes will be subtler, their differences more critical.

2. Draw a ten-square chart using pen and ink. The true black now possible makes it somewhat easier to show ten different values, but the inability to lighten any tone makes establishing an even

Figure 4.7

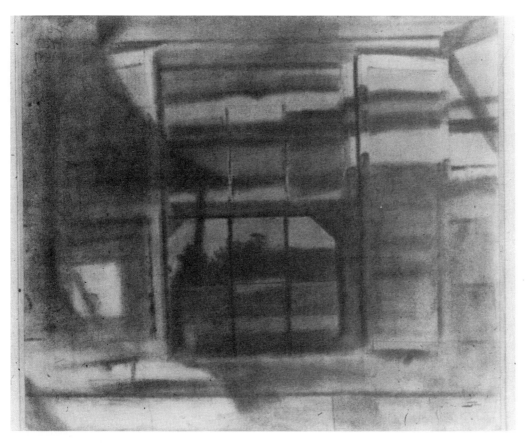

Figure 4.13
EDWIN DICKINSON (1891–1978)
Cottage Window
Charcoal. $10^7/_8 \times 12^7/_8$ in.
Courtesy of Clark Atlanta University Collection of Contemporary Art

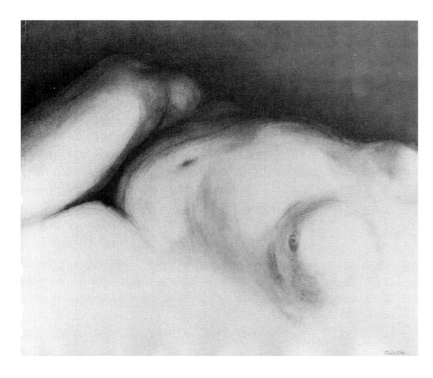

Figure 4.14 *(student drawing)*
ROCHELLE ALLEN
Charcoal and conté crayon.
26×40 in.
Utah State University

Figure 4.15
REMBRANDT VAN RIJN (1606–1679)
Cottage before a Storm
Pen, brush and ink.
Albertina Museum, Vienna

As the preceding several drawings imply, works in which light is the dominant graphic idea imply a view of our world as existing in darkness—darkness is the norm and light the transitory, revealing exception.

Light, then, not only can be made to explain and unify forms, it can provide important visual and expressive meanings. Rembrandt's *Cottage before a Storm* (Figure 4.15) is a striking example of the power that the impression of light can bestow. What might otherwise have been a pleasant, if ordinary, rural scene is transformed by an extraordinary control of light into a dramatic, even spiritual event. And note how space- and volume-informing are the tones that create this transcendental light.

THE ELEMENTS OF LIGHT

In drawings where values represent light, the value contrasts can denote the forms, the spaces surrounding them, and the shadows they cast. These contrasts conform to six discernible divisions, regarded here as the *elements of light*. As seen in Figure 4.16, they are:

1. The lightest value on a form, or *highlight*.
2. The next lightest value, or the *light-tone*.
3. The third lightest value, often found on surfaces that parallel the direction of the light rays, or *half-tone*.
4. The darkest value, or *base-tone*.

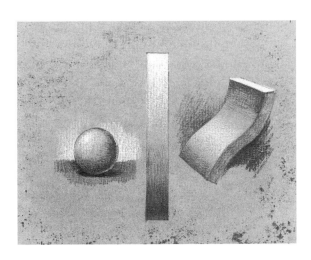

Figure 4.34

tones, both local and light induced, develop the drawing further by using structural lines.

VALUE AS AN EXPRESSIVE FORCE

Values can do more than establish local tones, build forms, and suggest light. They can help artists convey their emotional reactions to their subject. The nature of their conscious and intuitive feelings about the subject are revealed by what artists select, omit, and emphasize, and by how they organize and draw—give expression to—the image. Value plays a potent role in drawings that excite, calm, amuse, sadden, or otherwise affect the viewer.

Returning to Matisse's *Standing Nude* (Figure 4.27), we find the values of the background and figure express powerful moving vibrations. Although we see most of these values as composed of thick lines, and even react to their furi-

and white ink. The black and white inks may interweave in various hatchings to produce the required grays and textures.

variation 4 Using ink washes and/or chalk, charcoal, or graphite tones to establish general

Figure 4.35
Attributed to KUO HSI SUNG (11th Century)
Clearing Autumn Skies over Mountains and Valley (detail)
Ink and tint on silk. $81^{1}/_{8} \times 10^{1}/_{4}$ in.
Freer Gallery of Art, Courtesy of the Smithsonian Institution, Washington, D.C.

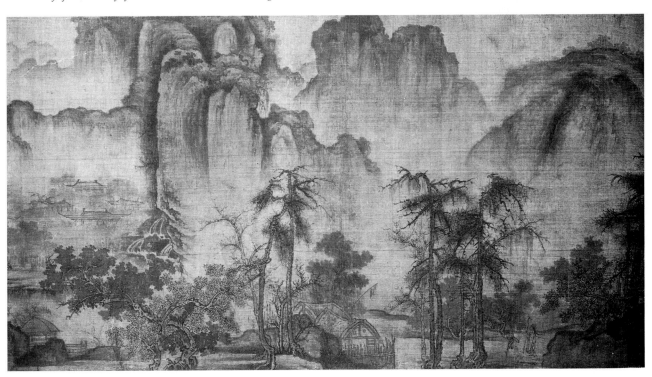

ous action, the *dominant* impression of their collective behavior is more one of value than of line. These values not only convey form and, to some extent, light, they pulsate with vigorous rhythms, reinforcing the figure's action. The fury with which Matisse attacks the page is necessary to his expressive idea—the figure's strong forms and bold stance, and the background's envelopment of its forms. Matisse invents value shapes that animate and clash with great force. In the lower part of the drawing the values seem to "invade" the figure; above, the stark white of the torso and arms "break free" of the background

to give the upper body dramatic strength. In this drawing, Matisse's values are expressively descriptive and abstract—they inform *and* they evoke.

Whether Matisse's disposition to such energetic drawing had found a "cause" in the subject's potentialities or was triggered by them, energy and idea are fused here in an image of explosive force.

In contrast with the Matisse drawing, Kuo Hsi, an eleventh-century Chinese artist (Figure 4.35), uses values to express a majestic serenity in this section of a handscroll. Tonalities range

Figure 4.36
HYMAN BLOOM (1913–)
Fish Skeletons
White ink on maroon paper. $16^3/4 \times 22^3/4$ in.
Collection, Mr. and Mrs. Ralph Werman

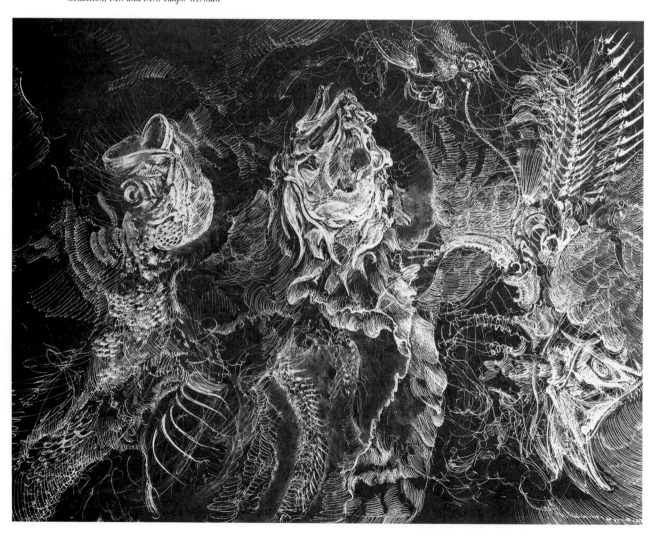

from nearly invisible nuances that describe distant peaks to emphatic contrasts in the mountainside. The values suggest space, atmosphere, texture, and volume and do so with a delicacy that expresses a quiet stillness. Kuo Hsi's rhythmic design, the undulations of shapes, tones, and directions, and the gentle character of his handling—the sensitive care in making the lines and tones themselves—is as delicate as the mood they convey.

Fish Skeletons by Hyman Bloom (Figure 4.36) offers an approach to value that reverses the usual role of white or light paper and black or dark drawing materials. Here Bloom draws in white ink on a maroon surface. Depending on the subject and the expressive intent, this can be both figuratively and dynamically logical. In this instance, the reversal of light tones upon a dark surface helps convey the feeling of underwater depths—its mystery and darkness. The spikey fish skeletons are drawn light in value—which they are. Note the flowing quality of the forms, and how the artist causes them to "flash" into bright light and then fade into the deeper background.

In his drawing *Reclining Figure* (Figure 4.37), Lebrun draws the figure's head obscured by the shadow of the hoodlike drape, as contrasting with the lines and light tones of the rest of the drawing. The shaded head becomes the

Figure 4.37
RICO LEBRUN (1900–1954)
Reclining Figure
Graphite, ink, and chalk on cream paper. 19 × 25 in.
Courtesy of Fogg Art Museum, Harvard University Art Museums, Cambridge, Mass. Gift of Arthur Sachs, Esq.

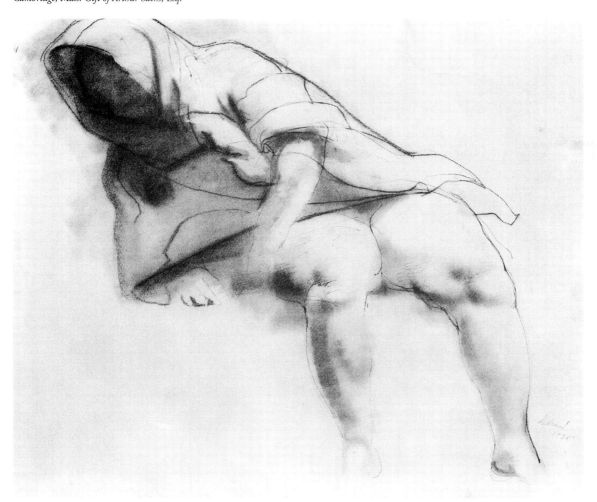

visual and expressive center of emphasis—the focal point of the drawing's representational *and* abstract theme. Note that Lebrun "loses" other parts of the figure, making the tonal "crescendo" at the head even more expressively powerful.

Like Lebrun, many artists prefer to integrate line and value, because doing so provides an image richly varied in visual tactics and expressive effects. But sometimes the use of value shapes alone can be very effective, even though these shapes may be comprised of hatched lines, as in Picasso's *Visage* (Figure 4.38). On occasion, however, values are applied in such a way that no evidence of line remains, as in Perella's drawing of a seated figure (Figure 4.39). Notice that despite Picasso's use of only a few tones and Perella's use of many, the forms in each work owe their clarity as mass in space to an accurate judging of just the right shape and tone in just the right place. Note too that both drawings suggest a light source and that in Figure 4.40, we can easily understand that the pronounced

bands of light and dark tones are the result of light shining through a Venetian blind.

For many artists, such as Lebrun and Katzman, the expressive intent of a particular drawing is triggered largely by their subject. Although such artists *do* bring attitudes, feelings, and ideas—their unique psychological and temperamental tone—to a confrontation with a subject, their expressive responses are strongly influencd by their perceptions. Thus, their use of value (and all other visual elements) is heavily dependent on what expressive cues they find in the subject.

Other artists, such as Dickinson and Bloom, experience a deeply felt "presence"; more than an idea, less than a vision, they seek forms that will make their meanings clear. They can be said to intend *before* they see. Neither kind of artist functions as he or she does exclusive of the other's means of approach. The perceptually stimulated artist brings certain concepts and emotions to the encounter with a

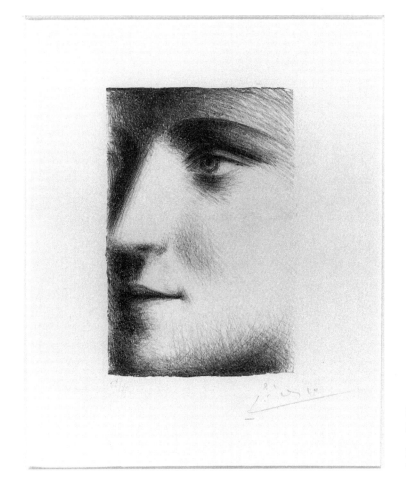

Figure 4.38
PABLO PICASSO (1881–1973)
Visage (1928)
Lithograph. 8 × 8⁵⁄₈ in.
Collection of Lois B. Torf

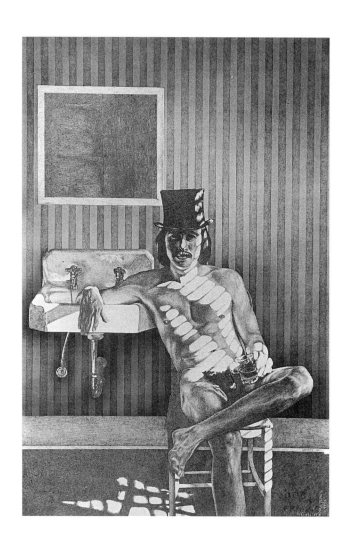

Figure 4.39 *(student drawing)*
RANI PERELLA
Graphite and ink. 22 × 15 in.
School of Art, Arizona State University

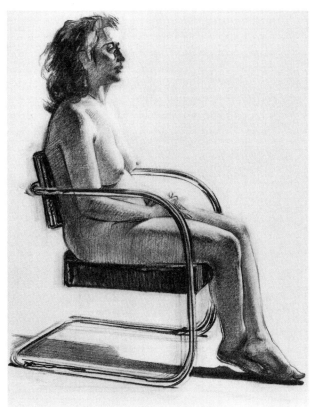

Figure 4.40
WAYNE THIEBAUD
Nude in a Chrome Chair (1976)
Charcoal, 30⅛ × 22⅜ in.
Courtesy of Campbell-Thiebaud Gallery

subject; the conceptually stimulated artist responds to the measurable and dynamic provocations of the subject. Both require value to do more than describe.

VALUE AS AN AGENT OF COMPOSITION

Value's uses in pictorial issues such as direction, balance, emphasis, diversity, and unity will be examined in Chapter 9. Here, it is necessary to mention, in general terms, the various ways in which value can participate in these design considerations.

Like line, value enjoys an abstract existence that can animate and relate as well as define. For example, in Figure 4.40, the dark value of the chair seat and of the shadow cast by the woman's feet take our eye downward, adding weight and substance to the seated figure, just as the middle tone of the woman's shaded side hints at the artist's interpretation of the sitter as a gentle and graceful person.

Value can relate dissimilar shapes, forms, textures, and spatial areas. In drawings where these visual phenomena appear isolated, confused, or in conflict, value can enforce visual affinities that cause groupings, emphasis, and directions to emerge, as in Figure 4.41, where three differently relating arrangements occur through change in the values of the same design of shapes. Note that while 4.41A seems balanced and unified, 4.41B appears to be too heavy on the right side. Additionally, the vertical alignment of the black shapes is somewhat overpowering. In 4.41C, the division of the light and dark values "breaks" the design into isolated halves and weights the image too much on the left.

Charles Sheeler's *Interior with Stove* (Figure 4.42) directs our attention to the play of vertical and horizontal movements in a room's interior. Throughout the drawing, values merge and contrast in a tonal pattern that activates, balances, and unites the scene into units which emphasize the strong directional force of the shapes and forms. Note how the dark tone of the stove, seen against the surrounding light tones, fixes our attention upon the stove's powerful verticality as well as its "mystery." Through value, Sheeler makes us aware of both shape and volume, guiding us to both the two- and three-dimensional design of the image. Here, values simultaneously serve descriptive, expressive, and organizational matters.

As was observed in Chapter 2, shape is a basic, given quality. It is important to recall that value always has shape. Whether it is as clearly defined as the shapes in Sheeler's drawing or as diffuse as a puff of smoke, the termination of a value within the boundaries of a drawing establishes its shape. Although the value shapes in Seurat's drawings (Figure 4.6 and 4.28) are vaguely defined, he balances them with all the care that Sheeler gives to his more focused ones. Thus, in tonal drawings of whatever style or degree of subjective interpretation, the artist must visually weigh the effects of value on shape, and vice versa.

Value can help locate the position in space of similar volumes when other graphic clues, such as linear perspective, fail to do so. Because

Figure 4.41

A

B

C

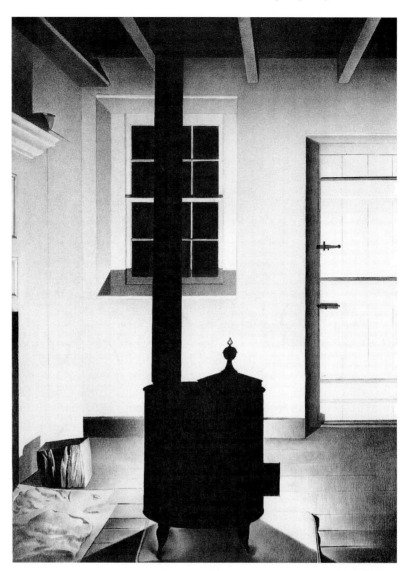

Figure 4.42
CHARLES SHEELER (1883–1965)
Interior with Stove (1932)
Conté crayon. 28⁵/₈ × 20³/₄ in.
Collection of Joanna T. Steichen, New York
Photo courtesy of The Museum of Modern Art, New York

of the weak value contrast, we read the hill on the right in Figure 4.43 as farther off than the similar one on the left. Likewise, the spheres and cubes occupy different positions in space because of their value differences, despite their sameness in shape and scale. In this illustration the impression of distance given through value is assisted by our recognition of the phenomenon of aerial perspective (see Chapter 5), which causes distant objects to appear lighter in value. The position of forms in a shallow spatial field such as a still life can also be clarified by value. Then, the value of the forms relative to the value of the background determines their position in space. An object possessing a light overall tone, seen against a similarly toned background, will

appear farther back than a similar but dark-toned object located alongside it.

Value can also exist free of mass. As was mentioned earlier, light can envelop several forms or segment them. In Figure 4.44, a shape of light envelops a wall, dancer, and floor. When objects stand in the path of a light source, cast shadow can, as here, take on important compositional meaning. Sometimes, as in Figure 4.13, although the objects in the path of the light are "off stage," their participation in the design can be considerable.

We have seen that value is a potent graphic force. Sometimes value's powers of illumination, design, and expression are so subtly interlaced as to defy analysis. Its uses in drawing are lim-

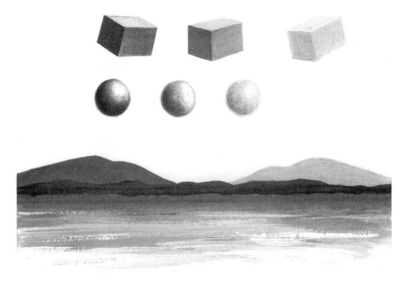

Figure 4.43

ited only by our perceptual understanding and inventive wit. Its relevance to responsive painting, which, like responsive drawing, attempts to shape a subject's actual and potential qualities into some system of expressive order, is clear, though sometimes overlooked by the student. Many responsive painting problems are really drawing problems, and those involving a subject's tonalities are among the most vexing to the beginning artist. These are more easily recognized and solved in tonal drawing than in paint-

ing, where value, like hue and intensity, is a property of color and harder to isolate for consideration.

It is no coincidence that Rembrandt was not only a great painter but also a prolific and brilliant draftsman from his earliest days as a young aspiring artist until the end of his life. Rembrandt's mastery of value (Figure 4.45) enabled him to convey more inventively profound visual and expressive meanings through light and volume with an economy, power, and elo-

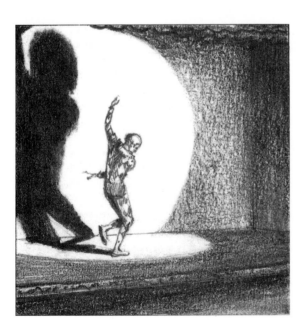

Figure 4.44

quence rarely equalled. His penetrating grasp of the dynamic potentials of value is amply evident in his paintings (Figure 4.46).

The development of graphic freedom—the ability to pursue your drawing interests in *any* direction for *any* purpose—depends on the comprehension and control of value's several roles in drawing. Whatever uses value will hold for you later on, its study now is essential to your development as a responsive artist.

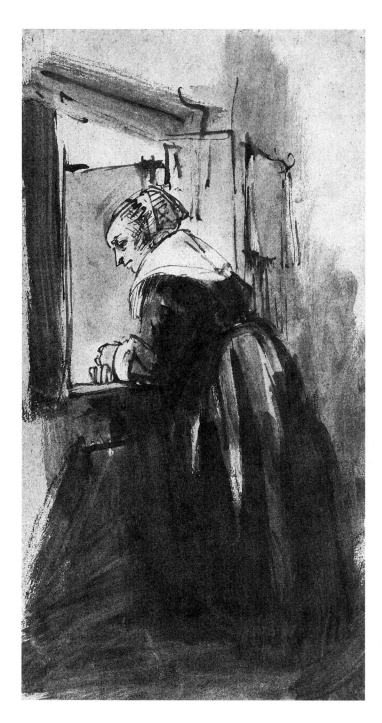

Figure 4.45
REMBRANDT VAN RIJN (1606–1669)
Woman Looking through Window
Pen, brush and ink. 29.3 × 16.4 cm.
The Louvre Museum

Figure 4.46
REMBRANDT VAN RIJN (1606–1669)
Lady with a Pink
Oil on canvas. $36^{1}/_{4} \times 29^{3}/_{8}$ in.
The Metropolitan Museum of Art
Bequest of Benjamin Altman, 1913
All rights reserved. The Metropolitan Museum of Art

5

perspective

the foreshortened view

A DEFINITION

For responsive artists, the term *perspective* applies to a number of important visual facts concerning the position of volumes in space. It is an implicit condition of any volume's scale, location, and direction in a spatial field. Using this broader meaning of perspective, we discover its presence in all drawings that convey an impression of masses arranged in some logical spatial order. Even some primitive works show a rudimentary employment of perspective, as in Figure 5.1, where the figures on the left, because of their smaller scale and higher position in the format, appear located farther back in the spatial field.

The broader interpretation of the term *perspective*, namely as clues to the appearances of volumes in space, may reassure the student who feels confronted with a complex and rather dry system. Actually, for most artists the exact (and exacting) complexities that stem from the basics of perspective hold little interest. Moreover, a preoccupation with perspective often restricts inventive freedom. Because perspective deals

with appearances, students know more about the subject than they realize. In fact, they have been using many of its basic principles, and probably sensing others. What they need to do is clarify and expand their understanding of these principles to benefit from the specific information and control they provide.

A knowledge of perspective is helpful in three ways. First, it serves as a "checklist" for uncovering unintended distortions of the subject's actualities. Second, it encourages the drawing of more complex and/or interesting subjects, which the student might otherwise avoid. Third, it enables us to regard space and volume clues that we might otherwise not consider.

A number of perspective methods have been devised in the past. Ancient Egyptian, Persian, and Asian artists developed visually clear-cut and esthetically pleasing systems. There have been others. The system normally used in the Western world is called *linear perspective*. Like all other systems, it is not completely successful in projecting real volumes in real space onto a flat surface, without some distortion. It differs from all other methods in being based

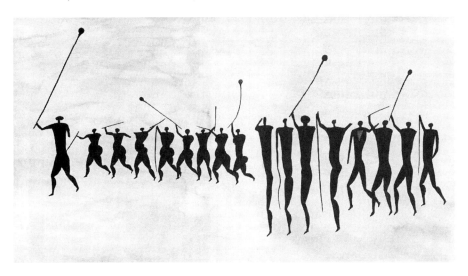

Figure 5.1
Bushman Rock Painting of a Dance
South African Museum, Capetown

upon what forms in space really look like when observed from a fixed position with one eye closed.

Along with linear perspective are some observable phenomena (the results of atmospheric conditions and particles of matter suspended in the air) called *aerial perspective*. These affect the clarity, texture, and values of subjects seen at a distance.

Together, these concepts have helped Western artists convey much observed visual fact with little intrusive distortion (Figure 5.2). But most artists have wisely regarded perspective as a tool, and one with definite limits.

It must be remembered that in responsive drawing, results emerge from the interactions—the negotiations—between perception, intuition, and intent. The information provided by linear and aerial perspective, like all other visual information, is subject to this interpretive process. Perspective, then, is useful as a means but can have restraining tendencies as an end. It is especially useful in the matter of foreshortening.

The foreshortening of forms in space is inherent in three-dimensional drawing. In fact, much of linear perspective concerns the visual nature of things moving toward or away from us at various angles. Look around you and notice how seldom you see an object centered vertically and horizontally on your line of sight. Most of what you see is positioned at various

angles, "aiming" in different directions. Even if you confront a row of books or trees, except for the ones directly in front of you, all are seen in some degree of foreshortening. This being so, we seldom see a form from a view that offers only one plane. Indeed, it's rare to see only one plane of even so geometrically severe a form as a cube. The seasoned artist usually avoids such totally foreshortened views of objects because they hide too much of the object's mass. A line drawing of a circle, representing an end plane of a cylinder, tells us nothing of the cylinder's length. Unless we are told the circle represents one end of a cylinder, we would have no way of deducing this from the circle itself. It could represent the base of a cone, or half a sphere, or any other form that resolves itself to a circular plane at its base.

An understanding of linear perspective helps us to clarify the impression of foreshortening in unobtrusive ways, as in Vermeer's drawing *View of Town with Tower and Windmill* (Figure 5.3). This complex arrangement of forms in space is not overbearingly aligned and rigid, but presented with the subtlety and ease that a sound grasp of perspective makes possible. In fact, Vermeer has not unselectively followed the dictates of perspective. We will return later to note how he has "broken" a rule of perspective in order to strengthen a dynamic theme.

Readers interested in examining some of the more complex applications of linear perspec-

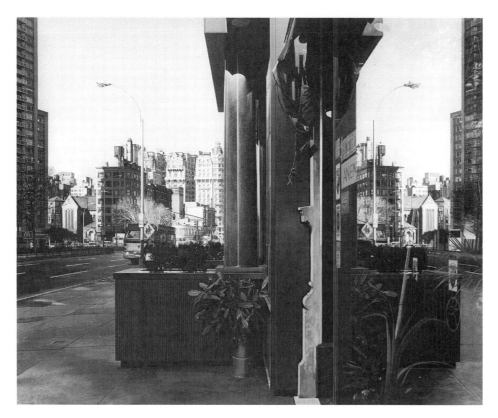

Figure 5.2
RICHARD ESTES (1936–)
Ansonia (1977)
Oil on canvas. 48 × 60 in.
Collection of Whitney Museum of American Art, New York.
Purchase, with funds from Frances and Sydney Lewis

Figure 5.3
JAN VERMEER DE DELFT (1632–1675)
View of Town with Tower and Windmill
Pen, ink, and washes of tone. 16 × 20 in.
Albertina Museum, Vienna

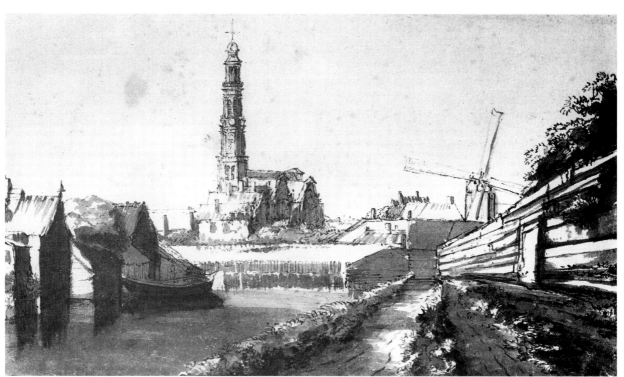

tive should refer to the bibliography. Here we will concentrate on the basic principles, to establish their function as general aids to perception and to show how they assist foreshortening in particular. To paraphrase Eugéne Delacroix's observation on the study of anatomy, perspective should be learned—and forgotten. The residue—a sensitivity to perspective—helps perception, varying with each individual and determined by his or her responsive needs.

THE PRINCIPLES OF LINEAR AND AERIAL PERSPECTIVE

Linear perspective is based on six principles. Each of these provides space- and volume-revealing clues, some of which have already been touched on in earlier chapters.

1. Relative scale. When forms known to be the same or a similar size differ in their scale, they indicate differences in their position in a spatial field. Thus, the decreasing scale of houses, trees, or fence posts suggests near and far forms in space.

2. Overlapping or blocking. When a form's position interrupts the contours of one or more other forms, partly hiding them, we perceive the overlapping form to be nearer than the overlapped one. Thus, seeing less than the entire form of an object suggests that its position is farther back in the spatial field.

3. Relative distance and position. When forms that are not overlapping and are known to be the same or a similar distance apart show a decreasing distance between them, we perceive them to be receding in space. Thus, the decreasing distance between fence posts or railroad ties suggests forms in space. Except when such forms are seen high above our eye level, the higher a form is in our field of vision, the farther back in space it appears.

4. Convergence. Perspective's main principle holds that when lines (or edges) known to be parallel appear to converge, they give the impression of going back in space. Thus corridors, houses, railroad tracks, or anything possessing parallel boundaries in any direction appear to recede in space if these boundaries are seen as inclined toward each other.

5. Cross-section or cage lines. When forms naturally possess or are, in a drawing, given a linear-textured surface, as in the use of structural hatchings, the relative distance and changes of direction between such lines suggest volume in space. Thus, objects as different as seashells, driftwood, cornfields, or barber poles, by their textured surface-state, suggest forms in space.

6. Light and shade. When one form casts a shadow on another, the shadow's length, location, shape, and especially its scale and value suggest the distance separating the two forms, the shape of the form casting the shadow, and the planar surface-state of the form in the area receiving the shadow.

The common denominator in these six principles is the diminution of scale. If all or most of these principles are invoked, forms—when uninterrupted by other forms—will appear to diminish in scale and finally disappear.

Aerial perspective is based on three principles. These apply mainly to forms in deeper space, such as distant houses and hills, but are sometimes employed in drawings of forms in shallow space.

1. Clarity. When forms appear less distinct in edge, detail, and general focus, we assume they are farther away than more incisively focused forms. Thus, a mountain seen at a distance appears vague and formless when compared with a nearby boulder.

2. Value range. When the value contrasts between forms diminish, often becoming lighter, but always more closely related, we assume these forms to be deeper in space than forms showing a wider range of values.

3. Relative texture. When forms diminish in textural clarity relative to other forms known to be the same or similar in physical characteristics, we perceive the less texturally active ones to be farther away. Thus, nearby grassy areas are seen as texturally active, those in the distance, far less so.

The common denominator in these three principles is that as distance increases, definition (clarity of focus, value contrasts, textural differences) decreases. Used together with linear perspective, aerial perspective will cause forms to seem more convincingly located in a spatial field.

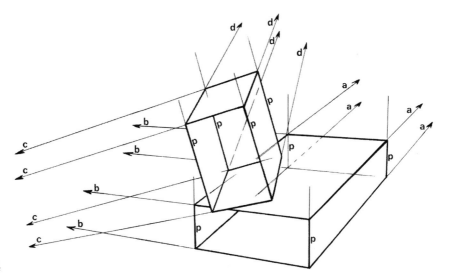

Figure 5.14

draw those you do not actually see very lightly, allowing some of these lines to disappear here and there along their paths.

In Figure 5.14 the two forms each show three groups of lines. Those marked *p* are parallel to the observer, despite the tilt to the left of those in the upper block. Lines *a* and *b* of the lower block and lines *c* and *d* of the upper one are not parallel to the observer and are therefore drawn in two-point perspective. There is no time limit for the various drawings on this page. When you have filled the entire page, go over each sketch to see if any of the forms seem distorted because the inclination of the lines is too extreme, or because they have gone awry. Look at these drawings again in a few days to see if you can locate the observer's position for each sketch and if they "feel right."

drawing 2 This drawing is to be completely imaginative. Again, draw in pencil on a sheet of 18 × 24-inch paper. Turning the sheet vertically, divide it into three even sections. Starting with the topmost section, draw a horizontal line 4 inches from its base, dividing it in half. In the second section, draw a similar line 2 inches from its top. In the third section, draw a horizontal line 2 inches from its base. These three lines will represent, in each drawing, the horizon-eye-level line.

Starting with the *middle* section, draw three block-like forms that appear to "sit" on the ground-plane. Each should be drawn in two-point perspective at an angle differing from the other two. This will result in six different vanishing points. We saw in Figure 5.10 that forms parallel to the ground-plane but not to each other have their own vanishing points on the horizon line.

Again, assume the forms are semi-transparent and let the converging lines extend beyond the

forms, this time all the way to their various vanishing points. You may find that a block's placement results in one or both of its vanishing points being located beyond the limits of the page. When this is the case, temporarily place a sheet of paper alongside your drawing, extend the horizon line, and, using a ruler, draw the converging lines onto this sheet of paper to their vanishing points.

There is a second way by which you can establish the three blocks. Instead of drawing the forms and adjusting their lines until they meet at their appropriate points on the horizon, you can begin by selecting a block's two vanishing points and drawing two *diverging* lines from each in the general direction of your desired location for the block. The shape resulting from the intersecting of the four lines establishes the block's bottom plane. Elevating a vertical line at each point of intersection raises the four sides of the block. To locate the top plane of the block, again draw diverging lines from both vanishing points until they intersect the four verticals at the desired height.

Whichever way you draw the three blocks, place them well away from the horizon line. They may, however, vary in their nearness to the viewer. These blocks, when completed, will be your "models" for the two remaining sections.

Using a ruler held vertically, locate the six vanishing points on the horizon lines of the first and third sections. In both sections, draw the three forms in the same relationship to the ground-plane (and to each other) as established in the middle section.

The differences in the location of the horizon line will make the blocks appear farther below the observer's position in the first section than in the third section. Depending on their height and position on the ground-plane, the upper portions of the

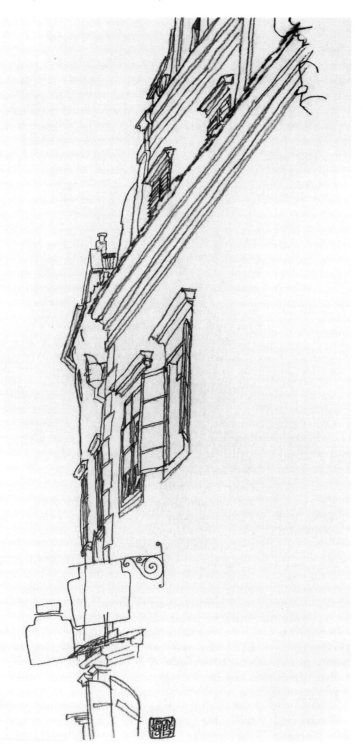

Figure 5.15
EGON SCHIELE (1890–1918)
Old Gabled Houses in Krumau (1917)
Black crayon, 45.8 × 28.8cm
Albertina Museum, Vienna

manikin-like, or, in the case of the still life, machine-tooled. But it should clearly show forms turned at various angles in space. As in Cambiaso's drawing, use some tones to help create more solid forms and clearly established spatial cavities. Where possible, indicate the stool or other support, and perhaps some corner of the room.

drawing 4 With your subject in the same position, you are to work this time seated, in a chair, on a low stool, or even on the floor. Begin as you did the previous drawing, by noting the horizon-eye-level line. Though the pose has not changed, your lowered position will have altered all the relationships between the subject's parts. Noting these differences, again draw each form as reduced to a simple geometric state, but this time do so lightly, using as few lines as possible. Once you have established the direction, scale, and overlapping of these forms (which are best thought of now as transparent), continue by drawing upon them what you *do* see of the subject's surface actualities. That is, using the geometric forms as "armatures" that show each part's essential mass and direction, go on to develop the surface forms of your subject. Normally, it is not necessary to use such severely summarized masses as a basis for drawings in which structural solids are to be stressed (we examine that in Chapter 6), but here it helps to control more easily the subject's perspective condition.

As you develop the simplified forms, do not bury them under small details, but keep a strong undercurrent of the geometric "parent" evident in all the final forms, as in Figures 5.27 and 5.34. The rule here can be: "When in doubt, leave it out."

Your goal here is to produce a drawing modeled mainly by structural lines that show convincing volumes in various positions in space as you saw them from your fixed position.

drawing 5 Rearrange the model or still life to create a strong foreshortening among many of the forms, as in Goodman's *Eileen on Beach Chair* (Figure 5.34). Locate yourself so that the subject is just a little below your eye level in order to increase the telescoping of forms. Proceed to develop the forms as in the previous drawing, but here, as in Goodman's drawing, emphasize the shape-state of the parts. This last drawing can be regarded as a kind of summary of the topics covered in the previous chapters, as well as in this chapter. This being the case, consider gesture, shape, line, and value to be as important as perspective. Here, then, perspective no longer dominates but takes its place as one more set of considerations in helping you to "essay" your subject's inherent and potential qualities.

Should you find that any of these exercises is beyond your present level of control, work out the subject's perspective state in a preparatory sketch, and, using it as a guide, begin your exercise on another sheet of paper. You will find the preparatory analysis helps you to place and construct the forms better.

drawing 6 Select a newspaper or magazine photograph of several forms (they may range from boxes to buildings) arranged at different angles on a flat plane. Overlay the photo with tracing paper and, using a ruler, establish the horizon line and the major lines running from the forms to the several vanishing points. When vanishing points lie beyond the boundaries of the photo, locate them by lines drawn onto sheets of paper affixed to either side of the photograph. Look for converging lines that lead to vanishing points above and below the horizon line, as in Figure 5.10.

PERSPECTIVE AS AN AGENT OF EXPRESSION

Perspective can contribute to expressive meanings by enabling the artist to draw a subject from the angle most evocative of its actions and character, and most compatible with the artist's feelings and intent. The view given in Sheeler's drawing (Figure 5.6) stimulates emotions about the scale and character of his subject. His use of three-point perspective helps us feel the building's towering elegance. Piranesi's turbulent drawing *Interior of a Prison* (Figure 5.35) shows a view that amplifies the artist's fascination and dread of his subject. Here, as in Figure 3.24, Piranesi proves that perspective can be a tool of exciting expressive possibilities. In a very different mood, Saenredam's drawing (Figure 5.7) shows a hushed and serene interior. Although both drawings owe much of their expressive force to their handling—Piranesi's furious attack contrasting sharply with Saenredam's delicacy—Saenredam's view is as necessary to his expressive theme as Piranesi's more oblique view is to his theme. Likewise, the expressive mood of Tintoretto's drawing (Figure 5.36) is due in part to the bold foreshortening of the forms of the head. Perspective, then, as these drawings demonstrate, need not be thought of as the dry logic of structure and space, but as a fertile source of graphic invention which may influence even abstract imagery, as in Figure 5.37.

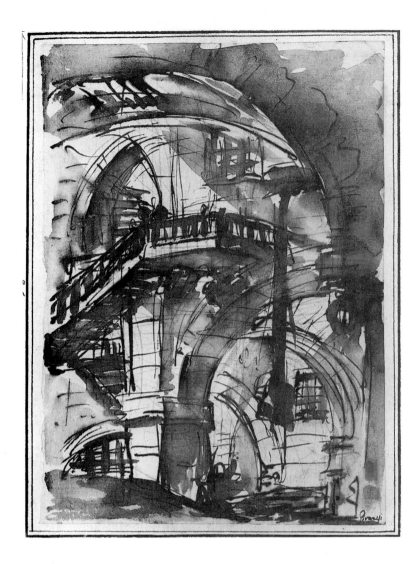

Figure 5.35
GIOVANNI BATTISTA PIRANESI
(1720–1778)
Interior of a Prison
Pen and wash over pencil.
25.6 × 18.9 cm.
Kunsthalle Hamburg

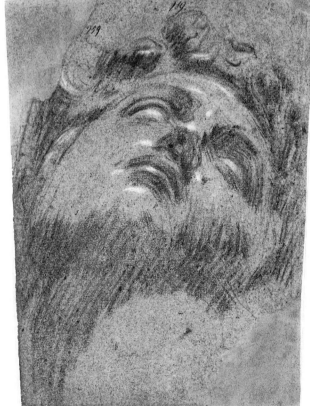

Figure 5.36
JACOPO TINTORETTO (1518–1594)
*Study of the Head from Michelangelo's
"Giuliano de Medici"*
Black and white chalk on toned
paper (detail)
Rijksrmuseum, Amsterdam

without volumetric clues. In Figure 6.18, Millet provides strong hints about the surface-state of the woman's arms, back, and skirt by the shapes of the planes and the nature of the contours surrounding these "empty" passages. In Delacroix's drawing (Figure 6.22), the differing directions between the figure's right thigh and hip are clear, though no line or tone marks the end of one part and the beginning of the other. Some of the appeal of these two drawings comes from our realization that so much is established by so little. Both are good examples of how much economy is possible in structural drawing. Note that, although both are pen-and-ink drawings, we can find, especially in the Millet, lighter, schematic lines along inner and outer contours and at junctions between planes—evidence of the preliminary framework.

But for the student the sculptural attitude toward forms should be tested through the experience of working from a subject's broader planes and masses to those smaller ones that clarify specific volume characteristics of its parts. In doing so, care must be taken to select only those small planar surface changes that are most informing of a part's smaller form-units. Just as in drawing major planes and masses, small ones are clarified by seeing *their* direction, shape, and location, summarizing *their* volumetric character, and explaining, by lines and tones, the way *they* join with other parts. The scale of a part or plane, then, should not affect the way it is perceived or developed. The planes of a pebble, blossom, or eyelid are as deserving of structural analysis as are those of a mountain, tree, or person.

It is helpful to think of every joining of planes or volumes, large or small, as interlocking, clasping, abutting, or fusing. The clarity and conviction with which such unions are drawn require more than sensitive perceptual skill. They demand *felt* responses to the ways they join. Although the drawings reproduced in this chapter are highly individual in temperament and intent, they all reveal the artist's feelings about the nature of the unions between planes and masses. Hence, seeing the relative scale, location, direction, and essential shape-state or mass of every plane or form is necessary to the clarity of their various joinings, but feeling the gentle or driving energy behind such joinings invests a drawing with the artist's expressive nature.

The gestural characteristics of such unions are limitless. They may suggest slow, subtle movements, as in the way the column of the young man's neck in da Empoli's drawing (Figure 6.2) seems to lift gracefully from deep between the shoulder masses that appear to part and allow its rise. Or they may seem fast and forceful, as in the interlaced race of folds around the young man's waist. They may be given to variously gradual fusions, as in Degas' figure drawing (Figure 6.12), or to sudden abutments of planes and wedge-like interlockings of form-units, as in Carpeaux's drawing (Figure 6.7) and Villon's etching (Figure 6.23). They may be frenzied couplings, as in Delacroix's drawing (Figure 6.8), or rhythmic, as in Leonardo da Vinci's (Figure 6.14). Often the nature of form-joinings eludes any verbal description.

Pearlstein, in his drawing of two nudes (Figure 6.26), emphasizes the boundaries and unions between form-units by dotted lines, solid lines, and washes of tone. Note the artist's sensitivity to shape actualities and to subtle joinings, such as occur in both torsos.

Another aspect of structure to be considered concerns inner or hidden supports. Some subjects such as human or other living forms, buildings, furniture, or even a log pile are constructed of parts which support and other parts which are supported. These form-arrangements create tensions and pressures between the parts of such subjects. Some of these forces are actual, some are implied. When a subject's forms are supported by, suspended from, or attached to an inner skeletal framework such as a human or other skeleton, or when naturally limp materials like cloth or leather are supported by solid masses beneath them, there are real tension and pressure between the visibly "held" and the inner "holder."

In such constructions, the supporting structure, whether skeletal or solid, is sometimes stable, as when a cube supports a cloth draped over it. Removing the cloth does not affect the cube's construction or behavior. Other constructions depend on mutual support among the parts. Two poles holding up a pup tent are themselves held in place by the balanced weight and tensions of its canvas cover, stretched taut when stakes are driven into the ground at each of its four corners. The human figure's construction is of the latter kind. Its inner supports and outer suspensions assist and restrain each other.

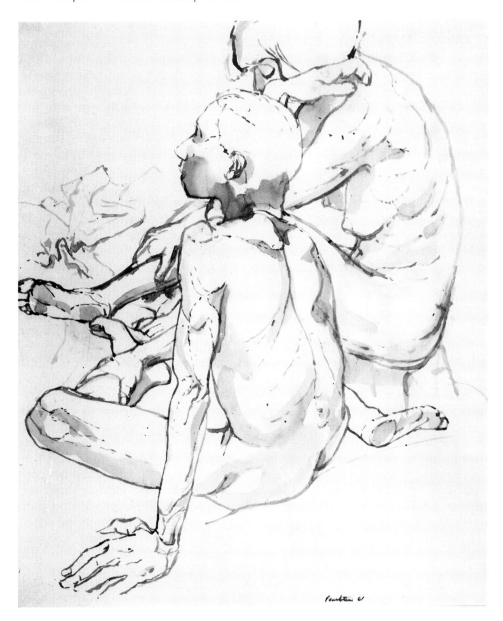

Figure 6.26
PHILIP PEARLSTEIN (1924–)
Two Seated Nudes
Wash drawing. 22 × 30 in.
Courtesy of the Frumkin/Adams Gallery

In such subjects the forces of weight and tension—the burdens of support and containment—create folds, bulges, and sags that disclose the strain, resistance, and pressure between the holder and the held. To infuse a drawing with the power to convey the *feel* as well as the *look* of such force and counterforce, the artist must empathize with the struggle between the inner and outer parts of the subject, must feel the weight and strivings of the parts. The force of gravity is an important participant in the struggle between the parts. Supporting frameworks, in addition to the tensions and pressures between themselves and the material they support, also resist the force of gravity upon themselves and the supported material.

The pressure upon the right shoulder of the figure in Michelangelo's drawing (Figure 6.11), the straining of the bones and muscles of the shoulder and the chest against the thin container of skin, the pressure of the heavy upper body upon the midsection—these are more than accurately noted observations. They are deeply felt responses to the actualities of the figure's structural character—intensified to express the artist's feelings about the drama of the powerful struggle of physical forces within and upon the figure. Likewise, in Delacroix's sketches from a Rubens painting (Figure 6.8), bone, muscle, and skin all strain, press, and resist each other to achieve a balance of forces. The knee bone of the figure's raised left leg, at the far left of the drawing, is barely constrained by the taut skin covering it. The lower leg drives up hard against the upper, which swells with bulging muscles that tell of the pressure upon them. At the drawing's far right, the bone at the elbow shows the strain of the arm's burden—of its being forced down while it strains to support its load. These actions

strike us as highly charged because Delacroix (and Rubens) felt their force, and intensified it.

Empathic responses to the ways in which planes and masses join, and to those generated by a subject's inner and outer structure and weight, help endow a drawing with a "life" that is the graphic equivalent to those qualities seen and felt in living subjects. But such responses are not restricted to organic forms only. All forms generate movement energies and tensions, and whether the energies are actual or inferred, the artist must feel the force of their structural activities as "meant" or necessary—as inevitable actions inherent in the subject's construction. To the extent that we can identify with these actions, our expressive involvement deepens, urging more incisive drawing solutions (Figure 6.27).

That such energies can come alive in inanimate objects can be seen in Goodman's *Wrapped Still Life* (Figure 6.28). The force with which the table's edges seem to push against the drape, and the drape's own harsh, planar facets, create

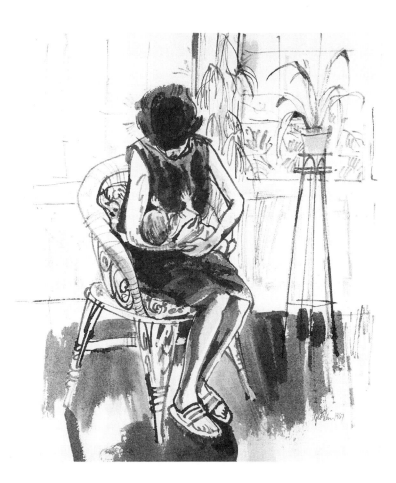

Figure 6.27
NATHAN GOLDSTEIN (1927–)
Mother and Child
Pen, brush and sepia ink. 15 × 16 in.
Collection of Drs. Arje and Elizabeth Latz,
Kiryat Ono, Israel

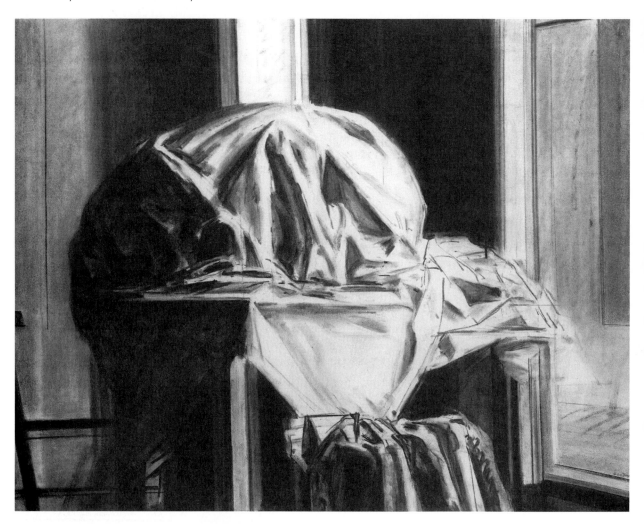

Figure 6.28
SIDNEY GOODMAN (1936–)
Wrapped Still Life (1970)
Charcoal. 29³/₄ × 36¹/₂ in.
Courtesy, Terry Dintenfass Gallery, New York

tensions and rhythms that activate what might otherwise be a dull subject. Indeed, the artist, in emphasizing the structure of the forms and the strong light falling upon them, creates a sense of expectancy and dread.

Pontormo's drawing *Striding Nude* (Figure 6.29) suggests the energies that drive planes and volumes into strong unions, and those issuing from pressures and stresses between inner and outer parts. Note how the volumes around the shoulders, knees, and ankles insert and clasp each other with hard intent. The planes abut with vigorous certainty, enacting the forceful energy of the interlockings among the form-units they produce. The skeletal framework emerges from deep within the figure to press against the containing surfaces at the ankles, knees, elbows, and at several places on the torso, creating firm anchors against which the muscles strain. The entire figure seems to vibrate with the activity of forms pressing, straining, and resisting.

Pontormo's interest in such energies is apparent in the way he suggests animated "ripples" of motion that course through the figure, and lesser ones that move between the parts. These actions are further strengthened by his showing some volumes as elongated—as if they were being stretched between fixed points. Such distortions serve to exaggerate the graceful flow of the forms. Just as Pontormo causes small

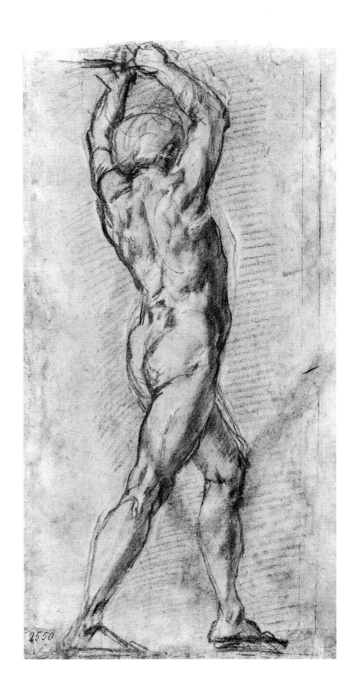

Figure 6.29
JACOPO DA PONTORMO (1494–1556)
Striding Nude
Red and black chalk, heightened with white chalk.
$16 \times 8^7/_{16}$ in.
The Pierpont Morgan Library, New York. 1954. 4 verso.

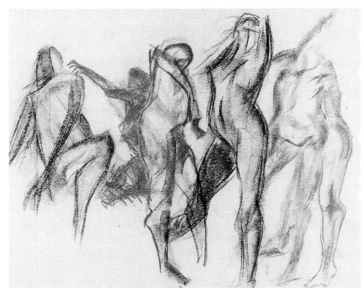

Figure 6.30 *(student drawing)*
KIRK ROSE
Conté crayon. 18×24 in.
Art Institute of Boston

form-units to rise from, swell, and subside into larger forms, so major volumes, like the torso, right arm, and right leg, suggest a pattern of moving, changing masses. In the right leg, for example, the volume begins at the ankle, swells at the calf and, beginning to subside, is overtaken by the clasping tendons of the upper leg. These, in turn, expand and merge to form one swelling, tubular mass which suddenly erupts into a still greater volume by the addition of the buttock, part of the pelvic area, and some muscles of the lower torso. We see the right leg and hip as *one* volume springing up from the ankle with some velocity, swelling, subsiding, and finally implanting itself deep within the torso. Its last identifiable ripples reach as far as the figure's rib cage. Evidence that such tensions and energies can enliven students' responses to their subjects is clearly seen in Figures 1.2, 2.19, 3.37, and 6.30.

THE DESIGN OF VOLUMES IN SPACE

Pontormo's interest in structural energy does more than make good use of a subject's clues for its gesturally expressive potentialities. By intensifying them, he clarifies another important category of response: the sense of volumes as related by a comprehensible order or plan—a system of abstract affinities. Chapter 9 will further explore the design of volumes, but here it is necessary to grasp something of the basic nature of ordered patterns among volumes, and of the necessity for such order in responsive drawing. There are a number of structural factors that can help extract this sense of order between volumes.

Similarities and contrasts of scale, direction, shape, value, texture, and manner of handling and of form joinings, as well as the distribution of parts within a spatial arena, all contribute to establishing a system of design among volumes. Especially does the distribution of masses, the various ways they overlap and interlock, provide a strong sense of order among volumes. Hence, when Pontormo stresses structural energies coursing through the figure, he also contributes to the sense of its abstract, dynamic actions and patterns.

This is so because sensitivity to a subject's structural condition is largely an awareness of relationships based on similarities and contrasts of scale, direction, location, and shape. The rhythms and affinities these relationships uncover help convey the subject's volume design. To the extent that artists wish to strengthen the sense of volumes as unified by an overall system of associations, *usually based on movement,* they will stress the visual bonds between the parts of their subject—the "alikeness" between unlike things—and their collective gestural behavior. For example, Pontormo's frequent use of straight lines to define passages of the contours causes these segments to "call" to each other, even when they are separated by great distances in the drawing, as are the straight lines that describe the spinal furrow and the feet. And such kinships reinforce movement energies.

Conversely, sensitivity to the rhythms and actions in a subject's forms helps discover structural facts, for, in responding to the "rush" and "resistance" of parts, our attention is drawn to the state of the planes and masses that produce such actions. Did Pontormo first see the dynamic or the structural aspects of the right leg—or both simultaneously? It is impossible to say. What is evident in his drawing, however, is his awareness that both of these qualities *are* the leg. Measurement alone can never make forms come alive, any more than empathy can. These two considerations, the mechanics and the dynamics of volumetric structure, are interlaced considerations.

Degas, in his drawing *After the Bath* (Figure 6.31), shows a strong interest in the design of volumes. Although the model's forms must have described something like the action of the drawing's forms, it is evident that Degas extracted and strengthened the continuity of their flow. They rise from the bottom of the page as three simple shapes that become three volumes as they move upward, united in a vigorous curving action continued and intensified by the forms of the upper body. The energy generated by the figure's forms sweeping to the right seems to have an "escape" in the hair that ripples down in a way that answers their rising thrust.

Degas' responses to his subject's volumes, united in a curving motion, is conveyed by virtually every available means. He accents the similarity between the shape and scale of the left leg and two parts of the nearby towel. Note that the lighter of the two shapes of the towel strongly resembles the left leg upside down,

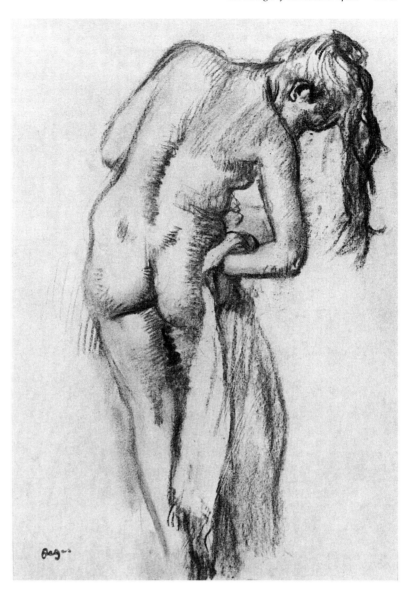

Figure 6.31
EDGAR DEGAS (1834–1917)
After the Bath
Charcoal. 13^7/8 × 10 in.
Sterling and Francine Clark Art Institute,
Williamstown, Mass.

while the other towel shape imitates the movement and direction of the leg and the contour of its right side. Degas' use of structural hatchings made of thick, bold charcoal strokes introduces a texture that further unites the volumes. He holds his darkest values in reserve while the curving action mounts, and commits them in the curve's "crescendo" in the head and hair—the two forms that, in descending, are in contrast with the rising of the others. Thus, values also help explain the moving pattern of the forms. Degas' stressing of the figure as comprised of twin halves and his treatment of the volumes as somewhat tubular give additional unity and force to the figure's forms. Note how emphati-

cally he overlaps the lower part of the head with the right shoulder, and how powerfully the right hand is forced into the towel.

That structural lines and volumetric clarity can participate in amplifying an expressive theme is demonstrated in Fishman's drawing, *Wounded Soldier* (Figure 6.32). The artist shows the soldier's greatcoat as weighty and animated, an enveloping presence that pulls downward in contrast to the soldier's subtle upward movement. Is this a contest between life and death ? Is the soldier only resting? The artist's intended ambiguity starts us wondering. The uniform, too, is purposely generalized; this is any wounded soldier in any war at any time. And

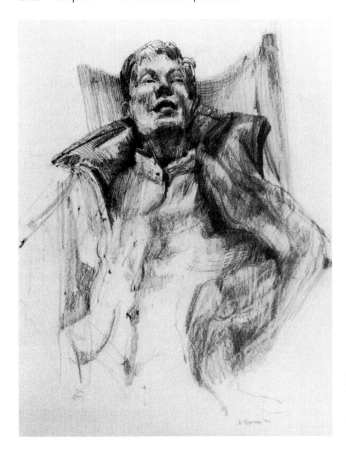

Figure 6.32
HARRIET FISHMAN
Wounded Soldier (1994)
Black chalk on gray paper. 21 × 14 ¹/₂ in.
Courtesy of the artist

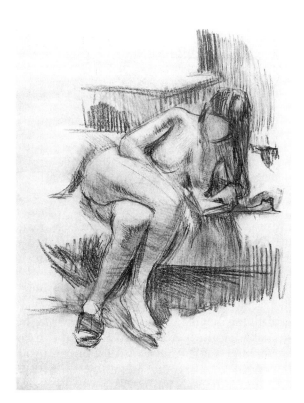

Figure 6.33
DOMENIC CRETARA (1946–)
Reclining Woman, Reading
Red chalk and oil wash. 14 × 17 in.
Courtesy of the artist

much of our response to this provocative image has to do with strong modelling based on a sensitive understanding of the subject's structural facts. Note, too, how Fishman arranges the forms to radiate from the soldier's body, creating some six or seven "spearheads." These add to the sense of some mysterious energy at work among the figure's forms.

Again, in Cretara's drawing *Reclining Woman, Reading* (Figure 6.33), a sound structural knowledge and a keen dynamic sensibility combine to create an image that is alive at both its representational and abstract levels. Here, too, as in Figure 6.34 (see also Figure 6.36), structural

insights uncover dynamic actions and vice versa.

In the following exercise, a series of drawings will stress the material discussed in this chapter. As you first look at your subject, most of its perspective, planes, system of support, the forces that drive them, and the subject's overall design potentialities may not be at all apparent. After all, you are looking for many things, and many of them are elusive and subtle. Their presence is better discovered by searching with an empathic as well as an analytical eye.

exercise 6a

MATERIALS: There are eight drawings in this exercise section. For the first six, use an easily erasable medium such as vine or compressed charcoal sticks or a 4B or 5B graphite pencil, on any suitable surface. For the seventh drawing, use only pen and ink. There are no restrictions on media for the last drawing.

SUBJECT: Still-life, figure, and envisioned subjects; discussed further in the context of each drawing exercise.

PROCEDURE: In the following drawings concentrate on the structural facts of your subject: on its measurements and relationships of length, scale, shape, direction, location, value, and edge, *and* on the rhythm and movements of its masses. In fact, your involvement in searching out these qualities should be so determined that the resulting drawings will be something of a surprising by-product of your experience in responding to the constructional, relational, and gestural aspects of your subject. The real value of these drawings is more in the quality of the realizations and insights they provide than in their successful accomplishment on the page. In responsive drawing, as in the development of any other ability, concept and experience precede successful usage. Here then, you must, strange as it may seem, concentrate on this new kind of searching rather than on results . . . on process rather than product.

drawing 1 Collect seven or eight small objects of a simple volumetric nature. Books, boxes, cups, bowls, or anything else that is basically box-like, cylindrical, or the like are usable, but the objects need not be severely geometrical in form. Fruits and vegetables, shoes, shells, even rocks will do. Cover some of these with a thin fabric such as cotton or jersey. Some of the objects may be par-

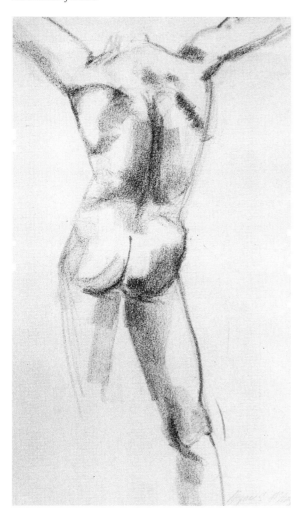

Figure 6.34 *(student drawing)*
MEGAN MCNAUGHT
Conté crayon. 18 × 24 in.
Art Institute of Boston

tially uncovered. Place the remaining objects upon the fabric, among the fully or partially hidden objects beneath it. Arrange all the objects in ways that reveal something of the forms of the hidden ones and that create strong protrusions, hollows, sagging and taut folds, and overlaps. The tensions and pressures produced will be roughly similar to those on the surfaces of subjects formed around skeletal frames. The overall arrangement should not be an extended, rambling one, but somewhat compacted, as in Figure 6.35.

This is a twenty-five-minute drawing. In the first five minutes draw in a schematic and investigatory way to establish a preliminary structural framework. That is, broaden your gestural approach to include a greater emphasis on establishing the subject's main directions, shapes, scale relationships, and volume summaries. To do this, you must disregard all surface effects of light and texture and all small details, *including minor planar conditions.* Avoid making this merely a contour drawing, but "get inside" a form's boundaries to define major planar joinings. Here you will draw edges in a simplified way, measuring the lengths between pronounced changes in direction, noting only prominent turnings and angles. This five-

minute phase has the general character and goal of gesture drawing, but it attempts to measure, however broadly, the subject's major structural actualities. It is somewhat similar in concept to that of Exercise 5b in the previous chapter. There, the need to clarify and stress foreshortening, overlap, convergence, and so on led us to draw the simplest available geometric volume to which a part could be reduced without losing its basic volume character. Thus, a head became a block or cylinder, because a visual case exists for either as an acceptable geometric core form. Here, such extreme generality is not desirable. Although the clarity of the subject's foreshortenings, overlaps, and so forth is just as important in this drawing as in Exercise 5b, clarity now should not be gained at the expense of the general structural spirit, as well as character of the subject's parts. Grasping the essentials of the subject's action and structure in the first five minutes is important to the development of the volumes in the remaining twenty minutes.

Figure 6.36 suggests a degree of gestural and structural summary, and of a stress on directions that the arrangement in Figure 6.35 could be reduced to. Note the use of structural hatchings to suggest some major planes, and the diagrammatic

Figure 6.35

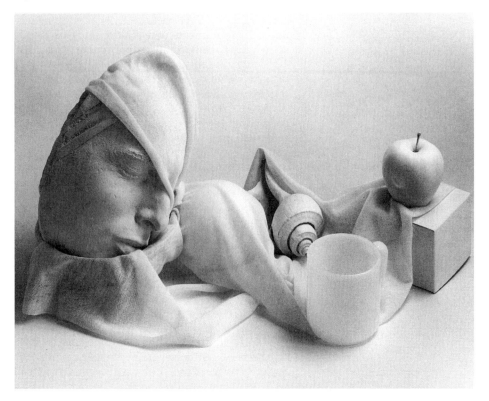

lines feeling out both solid mass and spatial areas. Note, too, the emphasis on pressures, tensions, and weight, and on the rhythms and movements between the parts.

This illustration should not influence you to emulate its particular characteristics—its handwriting. It is not intended in a how-to-do-it sense, but as an example of a serviceable degree of development of the subject's forms and forces in the five-minute phase. It is intended to suggest a degree of emphasis on direction, volume summary, and the energies of structural and moving forces, specific enough to establish important aspects of the subject's major masses, and general enough to be free of lesser and—for the moment—complicating ones. To summarize in a more sweeping way produces generalities too removed from measurable actualities and restricts reponses to the structural and dynamic energies. To draw the arrangement in a much less generalized way than that suggested in Figure 6.36 risks missing some basic observations having to do with direction and essential mass, as well as with relationships of scale and location, and the energies that flow between the parts.

In this five-minute phase, your goal is to extract from the arrangement the simplified nature of its various volumes and their relationship to each other, and to convey the dynamic forces that move among them. Look for independent parts that may share a common direction, scale, or value by comparing such angles, sizes, and tones with those of parts placed far from as well as near to each other. Stress the strongest pressures and tensions, and call forward the subject's overall design theme—the rhythmic order of its parts.

This phase of the drawing is limited to five minutes for the same reason that the gestural drawings in Chapter 1 were held to even briefer limits. It encourages a search for essentials before particulars.

In the second part of this drawing, the emphasis should shift to an analysis of the shape, scale, angle, and location of smaller planes—those that explain the various surface irregularities of the subject's components and any substantial volume variations formed by their unions. Even here, however, you should distinguish between those smaller, or *secondary planes* that advance your explanation of a part's structure, and those which, be-

Figure 6.36

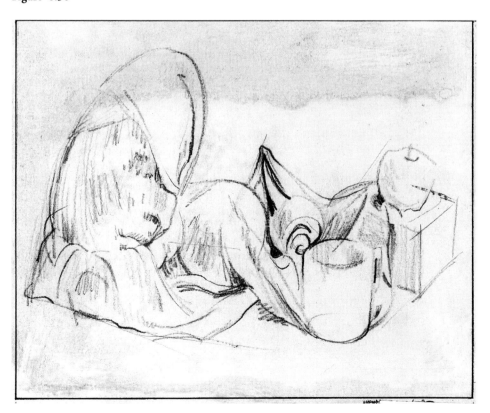

cause of their tiny scale—such as the hundreds of small planes in an extremely wrinkled cloth—merely crowd the drawing with unimportant, "busy" details. When a surface is comprised of such tiny planes, most artists draw only a few here and there to imply their presence throughout the object.

Beginning anywhere on the drawing, compare any generalized volume with its original in the arrangement. If the generalized volume represents a rather geometrically simple object such as a book or cup, you may find little to add to your first notations. Instead you may want to adjust its direction, perspective, scale, or contour. If it represents a complex and irregular object such as a pillow (Figure 6.37), it will require the addition of its secondary planes to convey its unique structural and expressive character (Figure 6.37B).

In the case of a volume formed around and

Figure 6.37

enclosing a space, as, for example, a cup, consider this enclosed space as a negative "volume." Instead of having it result from observations of the cup's solid parts, study the space as one more measurable component of the cup. Seen directly, its direction, scale, and shape requirements may warrant changes in your drawing of the cup's solid parts.

Now you are more precisely clarifying the subject's physical facts, moving energies, and overall rhythmic order. Try to keep a balanced attitude to all three considerations.

Here we should consider a common error in placement. Sometimes two adjacent objects are drawn so close that an overhead view would show them to be interpenetrated. Be sure that you allow enough room for the bodies of closely placed objects. Although your drawing of any volume stops at its contours, your ability to believe in the existence of its unseen back must be strong enough to prevent the invasion of one solid by another.

As you draw, try to feel the heaviness of the objects and the "determined" resistance of the fabric-supporting solids. Thinking of the fabric as sopping wet helps us to respond to its surrender to the pull of gravity. This also helps explain the form of the objects covered by the fabric.

As the drawing develops, refer to the principles of perspective to prove or help clarify any part of the drawing that seems troublesome. In fact, perspective considerations have been an influence throughout the drawing. Now a concentrated examination of relative distance, scale, and convergence, and any other perspective consideration dealt with in Chapter 5, can help you adjust some faulty or confusing passages.

drawing 2 You have thirty-five minutes for the second drawing. This time select three or four of the objects used in the first drawing and place them inside a cloth container, such as a laundry bag or pillowcase. Tie the container at the top with a rope long enough to tie onto some overhead support such as a rafter or pipe, enabling the container to hang free. As you draw, notice the folds caused by the weight of the container pulling against its restraining rope. At the top of the container they will be extremely pronounced. Lower down, the objects inside it will press against the fabric, revealing parts of their form. Try to show this struggle between the container and its restrainer, and between the container and the objects inside.

Again, begin the drawing with a five-minute analytical-gestural search for direction, location, shape, scale, and so on. Again, establish a preliminary armature based on the subject's essential structure and action.

In the remaining thirty minutes, spread your attention over the entire subject, advancing it together in the drawing. Here, be especially insistent on showing the pressures and tensions between the parts of the subject. Do not hesitate to make moderate adjustments to help intensify these forces—to exaggerate the weight of the objects and the pliancy of the container. Here, too, search for the abstract energies—the rhythms and movements—that the subject suggests.

drawing 3 Before turning to the more demanding subject of figure drawing, try a twenty-minute cross-contour study of several still-life objects, or of the figure itself, as in Figure 6.38. Begin by broadly roughing in the gesture with the side of your chalk and, as in our example, any segments of edge that will help clarify the general state of the masses. Next, using the point of your chalk, or a charcoal pencil, "feel" your way upon

Figure 6.38 *(student drawing)*
DENISE MOORE
Charcoal. 18 × 24 in.
University of Denver

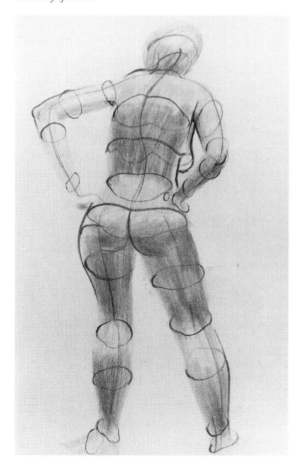

the subject's changing terrain by a slow, deliberate line that "rides" the hills and valleys as if a bug dipped in ink were leaving a trail as it moved along. Where possible, let the line move all around the forms, but try drawing some lines that run in the direction of a part's long axis, as in the line that traces the changing surface of the figure's back.

drawing 4 This is a thirty-five-minute drawing. Now, the human figure, preferably nude, should be used. If it is to be a draped figure, the attire should be simple and should not cause complex folds or billowing shapes. Again, begin with a five-minute analytical-gestural drawing. The forms should be simplified enough to help you establish the foreshortening of forms with some ease.

In the first drawing of this exercise, the independent nature of the objects helped you to understand their volume better. The objects were rather simple in their construction, and establishing their generalized volume-state was correspondingly simple. Now the subject is composed of complex organic forms, rooted in the central form of the torso—a single, extended system of inner-supported masses. Pose the model to avoid complicated overlappings of the limbs. A simple standing or seated pose is most suitable.

In such less compacted poses the forms are seen as flowing into one another. For example, there is no one place on a leg where we can see the ankle as ending and the lower leg beginning with sausage-link clarity. Instead, there is an interlaced, almost braided system of bone, tendon, and muscle, producing transitional planar passages. Sometimes these planes are subtle and fluid (Figure 6.12); sometimes they erupt from the surface forming clearly carved volume variations (Figure 6.11). Often, these transitional planar "avenues" can be traced for long distances above and below a joining of parts, adding to the flow of the forms. As your drawing continues beyond the five-minute phase, try to see the several planes, and the volumes they form, that explain these transitions. Their visibility is partly due to the pliant character of the skin, which, like the fabric, will collapse unless supported by a framework. As the inner systems of bone, tendon, muscle, and fatty tissue interact, their forms, pressed against the elastic skin, like the objects in the suspended container, reveal their support function and some of their volume by the amount of pressure they exert on the figure's surfaces.

In the remaining thirty minutes, try to see and feel the subject's structural behavior as having its origins deep inside, the result of forms and forces that press against the figure's interior walls. As before, first establish the secondary planes and then consider the smaller ones. Use only those

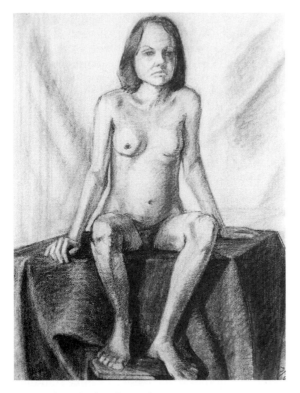

Figure 6.39 *(student drawing)*
Vine charcoal. 18 × 24 in.
Boston University

larger planes, and to avoid the enticements of little details as ends in themselves.

drawing 5 Allow one hour for this drawing. Use only a segment of the figure for your subject. It can be an arm, leg, torso, or head, from any challenging view of the form, as in Figure 6.40. Draw large—a little over actual size. Again, begin with an analytical-gestural search for the volume fundamentals described earlier. This time, however, take as much time as you need to establish these generalities. Now you have about twice as much time as you had for the previous drawing in which to draw considerably less of the figure. This will permit you to include many of the smaller planar changes that would ordinarily be omitted in drawings limited to less time, or to a smaller scale. In closing in on a part of the former whole, you will find that what are small planes in drawings of the segment as part of the entire figure are elevated here to the status of primary and secondary planes.

Figure 6.40 *(student drawing)*
TONY HURST
Black chalk, 18 × 24 in.
Art Institute of Boston

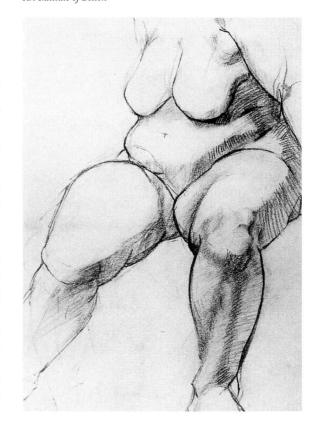

smaller planes necessary to explain the important structural characteristics of the figure's forms. Doing so will show you how much the impression of structured volume is carried by the primary and secondary planes, as in Figure 6.39. Often, only a few smaller planes are required, or, as in Delacroix's drawing *Nude Woman* (Figure 6.22), desired. Looking at this drawing we know that the artist has omitted many of the planes of the female figure, but nowhere are we left with blank flat areas. The figure's "topography" is readable everywhere. Here, the volumes owe much of their sculptural strength to Delacroix's emphasis upon those larger planes that denote important changes in the direction of a volume's surface. Such bold, selective carving of large forms by large planes itself gives volumes power and impact. It is impressive when so little can express so much. This is not to suggest that your drawing should stop at this degree of volume-revealing information. What is suggested by the example of Delacroix's drawing is the inadvisability of stopping short of this degree of volume building, to build such volumes by their

The longer drawing time allows you to make a more probing study of quite small structural details. As you begin to include these, be sure to keep them subordinate to the larger planes and masses. Here, as in the previous drawings, look for the pressures and tensions between the holder and the held, for the way in which parts join, and for the design of the segment—the continuity among its parts. Avoid involvements with illumination where it does not help explain volume, and use direction-informing hatchings to show the various tilts of the planes, as in Figure 6.38. Changing the direction of lines to correspond to the direction of the planes they describe is an important aid in explaining the subject's surface-state.

Your goal here is to develop a drawing so structurally clear and convincing that a sculptor could use it as a guide for a sculptural work and never be confused in understanding the subject's basic structure or the various planar changes on its surfaces.

drawing 6 This drawing is limited to fifteen minutes. Pose the model in some animated position. There is no time limit for establishing the broad volume generalities. You may, if you choose, attack directly, intending each mark as part of your final statement. In this case, begin in a gestural way, as described in Chapter 1. Whether or not you employ an underdrawing stage, continue to emphasize the major planes and masses first.

In the previous five drawings, establishing a preliminary structural and dynamic scaffold permitted you to develop your drawings in the knowledge that all early explorations were tentative—that they would largely be absorbed and altered by later drawing. Here, should you choose to work directly, every mark must respond to the subject with feeling and decisiveness. Instead of emphasizing analysis first and "conclusions" later, in direct drawing these considerations are parts of the same percept and the same action.

You may find that the reduced time demands a more energetic and broader approach to your subject. This can assist rather than restrict your grasp of the essentials. Figures 6.29, 6.30, and 6.31, show the kinds of energy and excitement such a spontaneous approach can reveal. This is knowledgeable simplicity, not empty flourish. Your drawing, too, should aim for volume in simple, sculptural terms. And it should convey the structural and dynamic energies that make it more than just bulk.

drawing 7 Using pen and ink (a ball-point pen will also work well here) and using Leonardo da Vinci's drawing (Figure 6.14) as a rough guide, make a drawing no smaller than 16 × 20 inches of some rock formations. Because pen and ink drawings take some time there is no time limit on this drawing. Your "models" can be any two or three interesting stones or pebbles. Arrange them in a good light and proceed to draw them large enough to fill the page. You might want to make your rock formation more permanent by gluing the stones to a rigid support. As in the previous drawing, preliminary underdrawing must be held to a minimum, for erasures are not possible. Your drawing is to carry the clarification of the rock's terrain even further than da Vinci does. His drawing is an investigatory probe; yours is to be an extended realization of the subject's forms, and of the *light* and *textures* upon it. The challenge here is not only to build solid volumes using a medium that restricts underdrawing and erasures, but to construct them well enough to show the surface effects of local tone, light, and texture without being buried or flattened under such surface detail. Keeping such surface changes from obscuring the forms will demand a strong grasp of each part's structure as well as the discipline to keep surface details from overruling basic structural facts.

drawing 8 This drawing allows you a great deal of free choice. *You* set the time limit, determine how much time, if any, to use for a preparatory stage, and select both the subject and the medium. Although the figure is an excellent choice for this largely self-directed drawing, you may want to apply the concepts and procedures you have been practicing in this section to a landscape, animal form, interior, or other subject.

You will even decide whether constructing volume is to be a dominant or supporting theme of this drawing. Your goal is to regard what you now know about volume-building more as a tool (albeit an important one) of responsive drawing, and to use it here as your interests require. Whether it will be central to your drawing's theme or subdued by other visual interests should now depend on your first, generalized responses to your subject—let the subject suggest the means and even the medium. But, however subordinated the role of volume may be in this exercise, and however subjectively you state the forms, none should be ambiguously drawn or discordant in the drawing.

Creating the impression of convincing structured volume is both a demanding perceptual challenge and an emotional experience. It calls for an understanding (and interworking) of

gesture, line, shape, value, perspective, and the ability to feel a subject's structural and dynamic energies, as well as to measure its actualities of scale, location, direction, and length. It is the quality of the negotiations among these considerations that determines the quality of the resulting volumes. By knowing what is involved in creating volumes, we also know what is involved in subduing them. In this way, we expand our control of the images we make.

so fully is because obviously *they* did—and it shows.

In Figure 7.20, color enhances the emotive force of an image that relies mainly on value for its expressive effect. But the drawing's somber tones are punctuated by muted, even scruffy applications of red, tan, and blue colors that, in straining but failing to break out of the drawing's brooding mood, only amplify it.

The expressive role of color in drawing need not be limited to strong emotion or dramatic events. Holbein's *Portrait of Anna Meyer* (Figure 7.21) is a gently crafted image in which the choice and use of color is in harmony with the sitter's introspective mood. These light-toned warm colors, only occasionally relieved by darker, richer hues, seem to suggest a warm and sunny environment; they hint at quietude and reflection. Holbein's choice of a reddish-brown for the belt is just the right note to serve as a link between the pink tones of the young woman's face and the several yellow and brown colors seen throughout the rest of the drawing. In value, too, it serves to bracket the area between it and the top of the head, to provide a much needed variation in color and value at that place in the drawing, and to "announce" the beginning of a series of encircling bands on the figure's forms that carry us up to the head, where the richer color of the cascading hair helps take our eye downward to start the cycle again.

To a considerable extent, the matter of color harmonics, referred to earlier in this chapter, is present in any work in which the colors integrate in their various functions. Nor does it require the use of many colors doing many things. Holbein's drawing is a good example of color's alluding to the condition of music. These color chords are like the strumming of a lute, whereas the chords in Figure 7.20 are of a harsher, louder kind.

Even some *monochromatic* drawings, that is, drawings made with black and white plus a single color, especially when made on a toned paper of a different color, show at least a rudimentary kind of color harmony that amplifies the drawing's impact, as Figure 7.22 demonstrates. In Watteau's drawing at least some of the dignity and introspection of the heads can be traced to the gentle warm tone of the page, from which the forms appear to rise and subside.

Redon's theme requires different colors, and his choice of charcoal on a paper toned a deep buff suits his purposes well (Figure 7.23). Note how the artist, by applying some tone to most of the page, makes the lower right

Figure 7.23
ODILON REDON (1840–1916)
The Grinning Spider
Charcoal on buff paper. 49.5 × 39 cm.
The Louvre Museum.

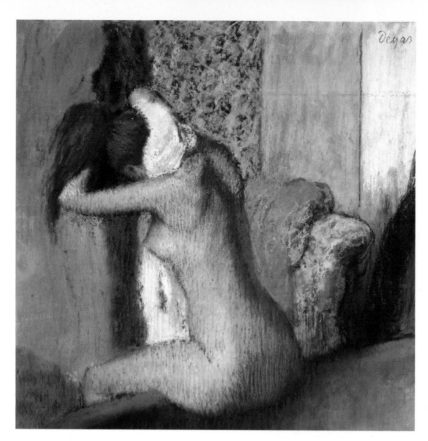

Figure 7.24
EDGAR DEGAS (1834–1917)
After the Bath (c. 1895)
Pastel. $27^5/_8 \times 27^5/_8$ in.
The Louvre Museum.

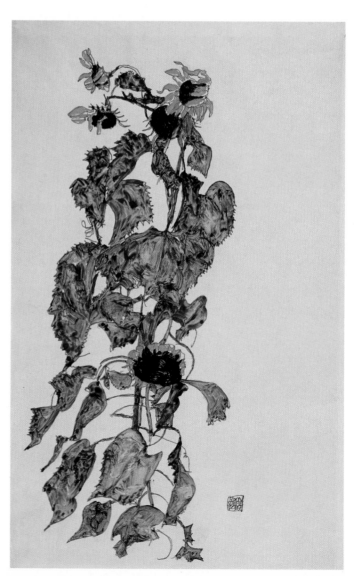

Figure 7.25
EGON SCHIELE (1890–1918)
Sunflowers (1917)
Gouache and watercolor. 46×29.8 cm
Albertina Museum, Vienna

side more intense and warmer in hue. This warmer tone increases the sense of color because where the gray tones overlay the buff color a slightly greenish cast is imparted.

There is no clear boundary separating the realms of drawing and painting, and any attempt to establish one is sure to end in frustration. This is so because these two disciplines overlap. Thus we have paintings in black and white (Goya and Kline, for example) and drawings in color. There are small paintings on paper and large drawings on canvas, paintings in line and drawings in value, paintings in dry media and drawings in paint, and so on. Not surprisingly, then, there are a number of works that defy being securely placed in either catagory. Some artists often work in a manner that places their imagery somewhere between drawing and painting. Degas' *After the Bath* (Figure 7.24) is a good illustration of this kind of visualization. The extent and quality of the drawing in this work seem to tilt the scale in favor of its being regarded as a drawing in color. However, the extensive use of color for clarifying volume and space and for compositional and expressive purposes, indeed, the complex color relationships and harmonies of this pastel, all suggest many characteristics usually associated with painting.

Schiele's *Sunflowers* (Figure 7.25) is another example of a work that occupies a kind of halfway house between the realms of drawing and painting. In doing so it serves to further show how interlaced these two realms are. Notice the artist's emphasis on the negative shapes, and how well the blackish brown and greenish yellow ochre colors harmonize with the tan page.

Such works make it clear that we do not stop drawing when we begin to paint. Painting envelops drawing and cannot be regarded as a separate pursuit. Drawing is the fundamental forming skill and is therefore a given condition in the process of painting, as it is in sculpture, pottery, weaving, or any other category of the visual arts. Adding the element of color to drawing introduces new challenges as well as new options and should not be seen as making the act of drawing easier. When color is judged to be necessary to our expressive purposes, its inclusion makes for an even more fascinating challenge of our responsive skills.

> *Drawing is the fundamental forming skill and is therefore a given condition in the process of painting, as it is in sculpture, pottery, weaving, or any other category of the visual arts.*

exercise 7a

MATERIALS: Unless otherwise noted, these drawings may be made with the medium (or mixed media) of your choice.

SUBJECT: Unless otherwise noted, these drawings may be of any subject matter you choose.

PROCEDURE: The exploration of color phenomena requires patient study and consequently no time limits are suggested for these drawings. Where no size limits are given, you may work as large or as small as you wish. Unless otherwise noted, do not make a drawing in line, to be colored in later. Such a coloring book procedure usually leads to tight and lifeless results. A better approach when drawing with color is to use it from the start—to think in terms of color at the outset. However, some of the following exercises do require that you add color to a completed line drawing.

Do not hesitate to make changes in your color choices as you proceed. In fact, it is usually not until *all* the colors in a work are in place that you can decide which colors need to be changed.

drawing 1 Personal color chart. Few students realize that they tend to favor a particular range and type of color. The chart you will make here is designed to help you explore your present color preferences and sense of color harmony. On any suitable support, rule a horizontal rectangle 1 inch high by 12 inches long and divide it into twelve 1-inch squares. The result should resemble a ruler. In the square on the far left, paint any color you *like,* using either gouache or watercolor paints. This may be a favorite color or one that happens to suit your mood at the time. In the square next to it, paint in a color that you feel is an especially harmonious partner for the first one. You are trying to produce what you will regard as the most satisfying chord of two-color "notes" you can conceive of. Continue to add colors to each square on the basis of its attractiveness and congeniality with the colors already on the chart. The only criterion here is your judgment, not the goal of making a balanced

or unified row of colors. You may choose tints, shades, or mixtures of any combination of colors, as well as colors as they come from the tube. Some colors may even appear more than once. When you have filled in the entire row, continue to make any changes you feel would satisfy your color sensibility even more. You can adjust colors to be richer or duller, lighter or darker, or replace some altogether.

If you redo this exercise in a few weeks—or even in a few days or hours—you may find that your mood dictates different choices and results in a different chart. However, if you collect seven or eight of these charts painted over a period of a few months, they will usually show a basic similarity. Some students will tend to produce charts of a muted and dark kind, others will favor lighter values of perhaps warmer hues, still others will tend toward intense hues offset by a few dark colors, and so on. Each of us has some particular color preferences, and knowing what these are can have important expressive significance. They are our particular means of communicating through color because they are *our* color "alphabet." We choose them because they reveal best how we feel about the things we draw or paint and they will therefore be used in a more or less consistent way. It is this consistency that makes it possible for the sensitive viewer to decode their meanings.

drawing 2A Warm and cool color. Working from any observed subject, use the following chalks, crayons, or colored pencils to model volume and space through the use of warmer and cooler tones as well as lighter and darker ones.

1. Black
2. Warm gray
3. Cool gray
4. Earth red

The exact hue and value of the above colors are not critical. The gray colors may be of a light or dark value, the earth red may range from burnt sienna to venetian red.

Begin by drawing lightly in a schematic manner with either of the gray colors to establish the subject's basic "armature," that is, its gestural aspects and some indications of the shapes of its parts. Continue to develop forms and space by relying mainly on warm–cool contrasts. Use cool tones to push back into space planes, parts, and whole areas; use warm tones to bring planes, parts, and whole areas forward. Black should be used sparingly and later in the drawing's development in order more emphatically to establish deep recesses, accents, and some color nuances.

drawing 2B Color on toned paper. Working from any observed subject and drawing on either a warm or cool-toned paper such as a buff or blue-gray pastel, use the following chalks, crayons, or colored pencils to model volume and space as described in drawing 2A.

1. White
2. Black
3. Earth red
4. Color of your choice

In this drawing do not begin with white. Instead use it later in the drawing's development to adjust values, establish highlights and accents, and lighten the tone of the page where desired. In using white to establish highlights, do so sparingly; less rather than more should be the rule (see Figure 7.22).

drawing 3A Color and composition. Make four identical copies of a simple nonobjective arrangement of about fifteen shapes within a 4 × 5 inch rectangle, similar to the example in Figure 7.26. These shapes should demonstrate a balanced arrangement in the format. Note that the shapes in Figure 7.26 are drawn in a way that suggest no background but rather a harmonious pattern of shapes on the picture-plane. Copies of your original drawing may be made on a photo copier.

Using any medium and, applying each color in a flat manner, make the following four drawings:

1. Select any hue on the color wheel and, using only black and white for color and value mixtures, compose a balanced and unified arrangement of monochromatic tones. Sensitive adjustments and placement of the various mixtures can suggest that more colors were used than is the case, and you should try for this effect.

2. Select any two of the three primary hues and, using only black and white for color and value mixtures, compose a balanced and unified arrangement of intense and muted colors. Again, try to suggest through various mixtures that more colors were used than was the case.

3. Using all three secondary hues on the color wheel plus black and white, compose a balanced and unified arrangement of colored shapes, each of which is the result of some kind of mixture among two or more colors, so that none of the secondaries (nor black and white) appears in a pure (unmixed) state. Here the purpose is to create an image of subtly muted colors that cannot easily be traced to their origins, that is, as having been produced by the secondaries and black and white. Therefore, the more mysterious and illusive the resulting grayed tones, the better.

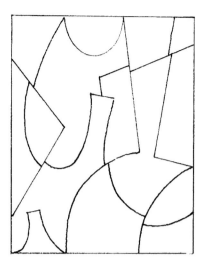

Figure 7.26

4. Use full color to produce a balanced and unified arrangement in which a strong area of visual attention is achieved by building up from muted tones to an intense area of color. However, the freedom to use any colors you wish should not necessarily lead you to use many colors.

drawing 3B Color and composition. Using any medium and any choice of subject for four drawings of any size, develop each one by using only the colors described in each of the four sections of the previous exercise (drawing 3A). Thus, your first drawing here will use only the single hue plus black and white, as described for the first drawing of the previous project. Your second drawing will use only two of the three primaries plus black and white, as described in the second drawing above, and so on.

You may elect to draw four different views or aspects of a single subject, or may vary the choice of subject with each drawing. For example, you may wish to do a self-portrait for the first drawing, an abstract interpretation of a still life for the second one, and so on.

Now that you are modeling form and creating space, you will need to consider more fully the distribution of values as well as colors to establish balance and unity in these works.

drawing 4 Ambiguous space. Make an abstract drawing of something observed that uses color to help create purposely ambiguous spatial and volume effects. Refer to Figures 7.11 and 7.12 as rough guides only in regard to their use of color in this way. There are no restrictions on size, medium, or kinds of colors used.

drawing 5 Complementary colors. On a sheet of warm- or cool-toned paper, make a portrait drawing using five or six colored pencils that are more or less complementary with the color of the paper. For example, if you select a blue-gray sheet, use pencils in the warm family ranging from a cream-colored one to a brown-orange one. If you select a tan or pink sheet, the pencils should be chosen from among the cooler colors. Be sure to have a range of values from light to dark among your pencils, but do not use either white or black. Use the value of the paper wherever it strikes the right value note in your drawing, as in Figure 7.22, where each head shows some of the tone of the paper.

drawing 6 Intense and grayed color. Using any medium, select any subject and make a drawing of an objective kind, in largely muted colors, in which the composition's main emphasis is dependent mainly on color intensity. This emphasis can be further strengthened by having some of the surrounding colors more or less complementary to the area of intense color. Unlike the fourth exercise in drawing 3A, which concerned an intense "eruption" among two-dimensional configurations, the requirements of tonal modeling here will necessitate your taking into account the light source when arranging your subject.

drawing 7 Quantity of color. Make two identical copies of a simple nonobjective arrangement of about fifteen shapes within a 4 × 5-inch rectangle, similar to the example in Figure 7.26 (and as more fully discussed in drawing 3A).

Using any medium and applying each color in a flat manner, make the following two drawings:

1. Select any primary color and, along with modest variations of it, apply it to most of the shapes in your design. Next, select any other contrasting colors, either pure or muted ones, and arrange them in such a way as to achieve a harmonious balance of these contrasting colors in the work. For example, if you select red as the primary, apply it to some shapes and, mixing it with orange, yellow, or a cooler red, apply these various mixtures to other shapes, giving the effect of several kinds of red occupying most of the design. Contrasting colors could then be of a cooler kind and of various shades and tints.

2. Select any muted warm or cool color and, along with modest variations of it, apply it to most of the shapes in your design. Next, select any other contrasting colors, either pure or muted ones, and arrange them in such a way as to achieve a harmonious balance of these contrasting colors in the work. The dominant, muted color can be extremely grayed and dark, or moderately intense and light.

drawing 8A *Expressive color.* Referring to Figure 7.21 as a rough guide with regard to mood, make an observed drawing of a seated or reclining figure, in any medium, showing the predominant use of one color (and some subtle variations of it). Try for a feeling of introspection and serenity.

drawing 8B *Expressive color.* Referring to Figure 7.20 as a rough guide with regard to mood, make any kind of drawing that enables you to show color and value being used to heighten a dramatic scene.

drawing 8C *Expressive color.* Using a toned sheet of any color and referring to Figure 7.22 or 7.23 as a rough guide in regard to mood, make a drawing using only one color (which may include the choice of black) to convey either a mood of tranquility, as in the Watteau, or a mood of unease or repulsion, as in the Redon.

drawing 9 *Toward painting.* Using Figures 7.24 and 7.25 as rough guides in regard to their approach toward painting, make a work of any kind, in any medium, that seems to occupy a place somewhere between drawing and painting.

Although color is only an occasional participant in drawing, when it is successfully joined to line and value it can have profound effects. For responsive artists, color provides one more important means of understanding their subjects and sharing these encounters with others.

8

media and materials
the tools of drawing

A DEFINITION

The substances that produce the lines and tones of drawing—the *media*—and the papers and boards that receive them—the *surfaces* or *supports*—simultaneously carry and influence an artist's responses and thus are important considerations in the forming of his or her works.

Some order can be made of the many varieties of media if one recognizes that they are all either *abrasive media,* applied by rubbing off particles onto the *grain,* or *tooth,* of the surface; or *fluid media,* applied by a brush or pen holding pigment suspended in some liquid agent. This agent is usually water plus some kind of *binder,* a material designed to hold the pigment to the surface. When applied, the pigment, binder, and water are absorbed into the surface. The water evaporates, but the binder dries among the fibers of the support, holding the pigment in place.

Although every medium is distinct in its character and range of usage, the graphic possibilities of each can never be fully exhausted.

There can be as many original uses of a medium as there are inventive artists for whom its nature is congenial and stimulating. Although the technical limits of a medium are fixed, the scope of its behavior within these limits is bounded only by the artist's sensitivity to the medium and by his or her creative wit.

A medium's limits and nature can influence the artist's tactics. We are not likely to draw a cloud formation with pen and ink in the same way we would draw it using charcoal. Thus, the medium will influence how we see our subject and how we choose to draw it.

It is not uncommon for many beginners to prefer "neat" media such as the harder degrees of graphite or charcoal pencils, but you should not reject an unfamiliar medium because of its bold or permanent nature. It can help lead you away from minor niceties toward major essentials. We should realize that too often the medium has been blamed for shortcomings of perception and conception. A compatible medium will stimulate invention and enhance expression but cannot itself improve perceptual skill or directly contribute concepts. The

medium is an integral part of the graphic message, but it is not the message itself.

Beginning with the cave artists, who discovered painting and drawing possibilities in natural chalks and clay, artists have always shown ingenuity in adapting any material that suggested potential as a medium or tool. The need to create certain textural, tonal, or color effects, or to improvise when art supplies were unavailable, has stimulated the invention of many tools and materials in use today. The first painting knife may well have been an artist's palette scraper. For years, soft bread was used as a charcoal eraser. Crumpled paper dabbed with ink, watercolor, or opaque paint was found to produce interesting results, and is now a common practice. Fingers were probably man's first "brushes," and there are few artists who do not add or adjust a tone or line in this way.

In the absence of a pen or brush, artists may apply ink or paint with a twig, a cotton swab, sponge, matchstick, or any one of a score of adaptable applicators. When the medium itself was unavailable, coffee or tea have been used, as have food coloring, iodine, and similar staining liquids. Almost any substance that can make a mark and any surface that can receive it may serve as drawing materials. Sometimes tools and media discovered in an emergency situation, or in a free experiment, have become favored media for some artists. One contemporary watercolorist of note for years regularly used Mercurochrome to produce golden reds and

executed his works on common shelf paper. Too often, however, as in this case, such innovations lack permanence or adequate control.

The abrasive media in common usage can be grouped into four general divisions: the several kinds of charcoal-based media; the several kinds of chalks; the fatty-based crayons; and graphite, with clay or carbon mixtures. The fluid media include waterproof and washable inks, transparent watercolors, and the several more or less opaque water-based paints. Sometimes

Figure 8.1
HONORÉ DAUMIER (1808–1879)
Connoisseurs
Watercolor, charcoal and pencil. $10^{1}/_{4} \times 7^{5}/_{8}$ in.
The Cleveland Museum of Art © 1997. Purchase, Dudley P. Allen Fund

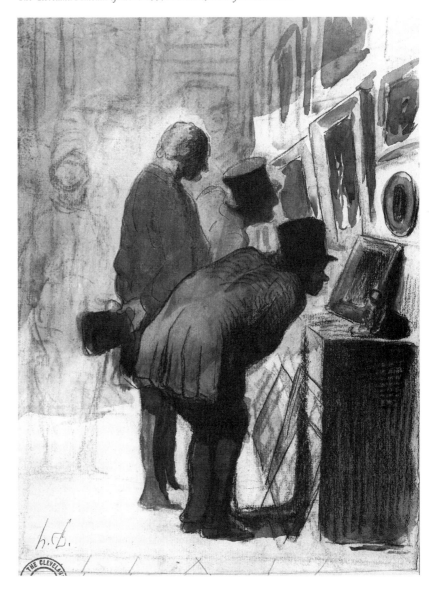

thinned oil paint is also used as a drawing medium—a practice of long standing.

Often dry and wet media are intermixed. In Daumier's *Connoisseurs* (Figure 8.1), graphite pencil, charcoal, and watercolor washes are used. Mixed-media drawings often result from the structural and expressive needs of the moment.

Sometimes an artist's strategy necessarily includes several media. Daumier's drawing seems to be one of these. Here, the soft, vague charcoal lines appear as a first, gestural under-drawing, as can be seen by the preliminary indications of a figure on the far left. Graphite lines delineate the forms more specifically, and watercolor washes convey the local tones and the broad modeling of the forms. Note the integration of the media; the drawing has no sizable segment expressed by only one medium. Each is active everywhere.

Unless media and materials are technically or chemically incompatible, they can be combined in any way that offers a solution to our desired goals. "Rules" for using the various media have often presented unnecessary barriers to creative expression. Many of these prescriptions for usage grew up around those procedures that direct the user toward a medium's most natural characteristics, or that have proven successful in the past. But the justification for the use of any medium or combination of media can be found only in the artistic worth of the work in question.

Because successful drawings always disclose a happy union of their meaning and the means used, every successful drawing is a virtuoso performance of the medium used. But placing the emphasis on a display of technical facility shifts the emphasis in drawing from analysis and expression to deliberate performance. Drawings then become not the result of an artist's interpretation of nature, but a show of skill in ma-

nipulating tools. When such clever usage becomes the primary objective, then a drawing's real subject has become the exhibit of an artist's facility with materials—a dubious goal.

THE ABRASIVE MEDIA

The common *stick,* or *vine charcoal* (Figure 8.2), probably used in prehistoric times, continues to be a popular medium. Stick charcoal is simply carbonized wood, usually willow, beech, or vine branches. The longer they are allowed to carbonize, the softer the charcoal sticks become, producing darker lines and tones. Because charcoal has no holding or adhesive agent—no binder—it is an especially friable material; that is, it can be very easily crushed into a powder. It depends, as do most abrasive media, on a surface that has at least a moderate tooth. When charcoal (or any abrasive medium) is rubbed across such a roughened surface, minute

> *successful drawings always disclose a happy union of their meaning and the means used*

Figure 8.2

Charcoal and chalk media. From left to right: compressed charcoal stick, soft chalk, conté crayon, hard chalk, sanguine red conté crayon, soft charcoal block, and white conté crayon. At bottom, stick charcoal.

particles are filed away and lodge among the hills and valleys of the paper's surface (Figure 8.3). Being extremely *friable*, stick charcoal needs only light pressure to mark a surface. Its particles are not usually embedded deeply into a paper's grain, and they erase or dust off easily.

Charcoal can be repeatedly erased and reworked. It can, when sharpened on a sandpaper block, produce quite delicate lines. When used on its side, stick charcoal makes bold, broad tones. Because of its easy application and removal, and its wide range of effects, it has been used for centuries to make the preparatory drawings that underlie many oil paintings. Such drawings, when they are developed to the desired degree, can easily be isolated by spraying with a weak solution of shellac or lacquer, called *workable fixative.*[1] For all these reasons, too, around the beginning of the nineteenth century charcoal became the standard drawing medium in the European art academies. Its easy handling made it an especially popular medium for making sustained, closely observed drawings, a practice that continues to this day (see Figure 2.6).

Although charcoal is often used for final drawings, its fragile hold on the paper, until fixed, makes it difficult to retain dark tones upon the page or to avoid smearing. Unwary students who sneeze toward a drawing heavily laden with charcoal may find their drawing suddenly faded, the particles "exploded" on the page. Fixing the drawing prevents this, but then erasure becomes almost impossible. One solution to the problem is to use fixative as the drawing progresses, at stages when there are not likely to be any substantial changes of major tones or lines. Workable fixative does not prevent additional drawing over fixed areas. In fact, it helps produce darker tones because the earlier charcoal layers, now encased in the fixing material, form a new, firm tooth and can hold new charcoal particles better.

Figure 8.3
Bold, heavy strokes drive charcoal stick particles into the "valleys" of a paper's surface texture. Light strokes deposit the particles only on the "hilltops."

Although stick charcoal's tonal range does not extend as far as the rich black possible with chalks and crayons, it permits a wide enough range for most drawing purposes and styles. It can be used for subtle line drawing, as in Figure 8.4, or for bold, tonal ones, such as Figure 8.5. Unlike most of the other abrasive media, which can hold on surfaces with a very fine tooth, stick charcoal's weak holding power will fail on such smooth surfaces. Even some of the smoother types of newsprint do not take charcoal well.

Compressed charcoal, made by pulverizing charcoal, adding a binding agent, and compressing it into small cylinders or square-sided sticks, produces richer dark tones, has good holding power, and is less easily erased than stick charcoal. Charcoal in this form is sometimes regarded as black chalk. It is manufactured in varying degrees of softness, and its character is controlled by the amount of binder added. The hardest compressed charcoal sticks have some of the characteristics of the natural black chalks in use from the fifteenth to the nineteenth century, when good quality natural black chalks became less available. (See Holbein's *Portrait of Cécily Heron*, Figure 8.6, for an example of a work containing some natural black chalk.)

Compressed charcoal, available in various

[1] Spraying fixative or any other studio substance should be done in a well-ventilated room or even outdoors for reasons of health.

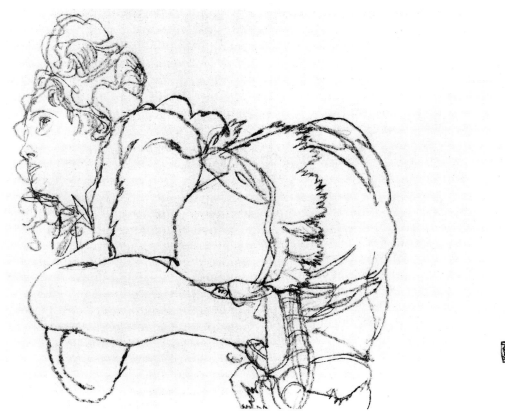

Figure 8.4
EGON SCHIELE (1890–1918)
Woman with Slipper (1917)
Charcoal. $18^{1}/_{8}$ x $11^{3}/_{4}$ in.
The Museum of Modern Art, New York
Gift of Dr. and Mrs. Otto Kallir
Photo © 1997 The Museum of Modern Art.

Figure 8.5
EDWARD HOPPER (1882–1967)
Sketch for "Manhattan Bridge Loop"
Charcoal. 6 ×11 in.
Gift of the artist. © Addison Gallery of American Art, Philips Academy, Andover, Mass. All rights reserved.

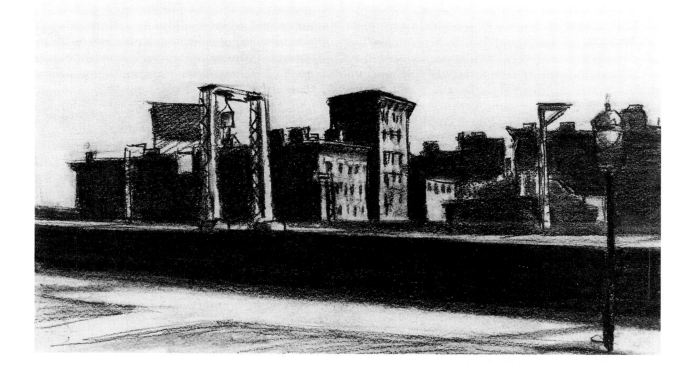

degrees of softness, is also manufactured in pencil form referred to as *charcoal* or *carbon pencils* (Figure 8.7). Fashioned into slender "leads," it is also sold in packets for use in holders.

The thin lines possible with a charcoal pencil allow for delicate line use (Figure 8.8). It is generally used for works of a small scale, or in conjunction with the broader charcoal media when linear or tonal statements of a more precise nature are required.

All members of the charcoal family are intermixable and frequently used together. Compressed charcoal is often used to deepen values and add accents to stick charcoal drawings. Charcoal media work well with water-based ones in mixed media combinations, as in Figure 8.1.

The term *chalk* has been freely applied to a wide variety of friable media, including those of a fatty-based composition. The term *pastel* has come to be associated with the great variety of colored chalks, but black pastel is generally made of ivory-black pigment (charred bone), gum arabic, and ball clay.

Harder to classify are those chalks that have a slightly waxy binder but are, in use, much closer to the more friable chalks than to crayons. All chalks can be erased to some degree, but those having a waxy base are far less erasable. The popular conté crayon is such a medium. Its slightly fatty, smooth flow (especially pronounced in the several earth red colors) still retains some of the look and feel of the more erasable, drier chalks. Conté crayon seems to bridge the division between chalks and the family of waxy-based media called *crayons* (see Figures 2.18, 4.28, and 4.43).

Today, an excellent choice of colored chalks is available. They range from the very soft and "painterly" ones to those of quite hard consistency that require some pressure to produce dark tones The rich texture of soft manufactured chalks is apparent in Degas' *Woman with a Towel* (Figure 8.9; see also Figure 7.24). Their rugged power lends itself well to such bold statements. Note that the artist achieves many subtle tonal harmonies by hatched lines, and that the smudg-

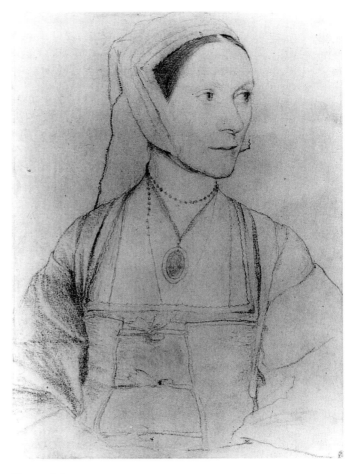

Figure 8.6

HANS HOLBEIN, THE YOUNGER (1497–1543)
Portrait of Cécily Heron
Natural black chalk. 15 × 11 ⅛ in.
Royal Collection, Windsor Castle

ing of chalk tones, so favored by the beginner, is seldom relied on in the chalk drawings of old or contemporary masters, although the fusing of tones can be an effective tactic, as Ipousteguy's drawing shows (see Figure 2.18).

Chalks are often used in combination with other media. Moore's drawing of miners (Figure 8.10) is a mixed-media work in black, brown, tan, yellow, and white chalks, pen and ink, gray washes of ink, and with some surface scratching to reveal lower layers of tone and color. Here the chalk's texture is revealed by the rough tooth of the paper, the repeated applications of chalk, the scratching through, and the use of washes which settle in the valleys of the surface, darkening them and leaving the chalk-covered hills lighter.

As in the case of chalks, there is a wide range of wax or other fatty-based crayons avail-

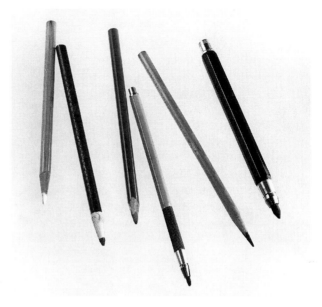

Figure 8.7

Figure 8.8
PABLO PICASSO (1881–1974)
The Donkey Driver
Carbon pencil. $10^5/16 \times 7^7/8$ in.
© 1997 The Cleveland Museum of Art,
Bequest of Leonard C. Hanna, Jr. Fund

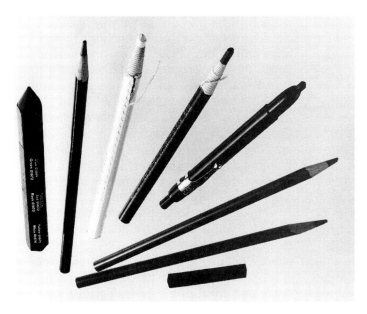

Figure 8.11

Crayon media. From left to right: carpenter's marking crayon, black crayon pencil, white crayon pencil with string for exposing additional crayon, black litho crayon pencil with string, mechanical holder with soft crayon "lead," sanguine red crayon pencil, sepia crayon pencil, and square stick of litho crayon.

able, from those of a rather dry, chalk-like nature to the somewhat greasy ones, not unlike children's crayons. Those that retain some chalk-like characteristics, such as conté crayon, usually contain soap, ball clay, and sometimes small amounts of beeswax. The greasiest ones contain high amounts of wax. Most crayon media are available in stick and pencil form (Figure 8.11) and are available in a wide assortment of colors. Some can be dissolved in water, others, in turpentine (making the latter compatible with oil paints). Such crayons will provide various painterly effects.

Toulouse-Lautrec's drawing (see Figure 1.11) illustrates the flowing, linear freedom possible with crayon. Picasso's *Head of a Young Man* (Figure 8.12) shows the rich blacks and the sharp focus of crayon lines. These tend to exceed even the strong darks and clarity of chalk lines. Because of the adhesive strength of the binder, crayon is almost impossible to remove from the page. For the same reason, the smudging of tones is not possible. Tones must be achieved by hatching, as in Figure 8.12. Many artists are attracted to crayon's sharp, rich lines and to the challenge of its permanence, which, like pen and ink, demands resolute decisions and handling.

One group of fatty-based materials was developed for use in the graphic process of lithography (Figure 2.23). Black lithography crayons and pencils (a waxy-based ink called *tusche* is also available) come in varying degrees of soft-

Figure 8.12
PABLO PICASSO (1881–1974)
Head of a Young Man (1923)
Grease crayon. 62.1 × 47.4 cm.
Courtesy of The Brooklyn Museum, Carll H. de Silver Fund

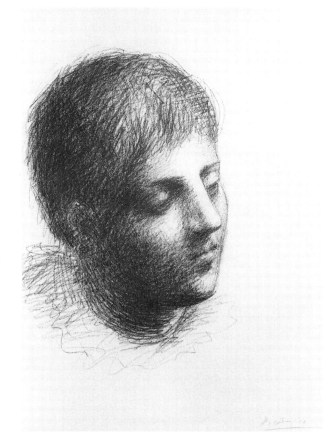

ness but are, as a group, fattier than most other crayons. They are a versatile and popular medium for both short and sustained drawings.

Because the fatty-based media do not require fixative and do not smear in the sketch-book, they are a useful medium for drawing out of doors. But their water-resisting binders make them less compatible in certain mixed-media combinations.

Perhaps the most familiar writing and drawing tool in use today is the *graphite pencil* (Figure 8.13), erroneously called a lead pencil. The confusion in terms probably resulted from the common, earlier use of the various metallic styluses, of which lead and lead alloy metals were the most popular. But many artists preferred the other metals, especially silver, because of the darker lines that resulted through oxidization (see Figure 8.14).

Although similar to graphite lines, metalpoint lines (usually silverpoint) are lighter, are not erasable, and cannot vary in width or value. While excellent for delicate drawings of a small scale that do not depend on such variations of line, metalpoint drawing has been largely superseded by the modern graphite pencil.

Graphite pencils are available in over twenty degrees of softness. The harder pencils usually carry an H designation, plus a number indicating the degree of hardness. The 1H pencil is the least hard of this group, the 9H the hardest. The softer pencils are marked B, and the higher the number the softer and darker the tones; these extend up to 8B. There are three pencil grades between two categories, usually marked (from softer to harder): F, HB, and H. All the hard pencils can produce lines similar to the fine lines of the metalpoint instruments. The various degrees are determined by the mixtures of graphite and clay. The more clay present in the mixture, the harder and lighter the line. The less clay present, the darker the line.

Like the slender compressed charcoal sticks, graphite "leads" are available for use in mechanical holders and in flat-sided sticks or blocks (Figure 8.13). The many degrees of graphite available provide a versatile range of linear and tonal possibilities. The beginner too often strains the range of a single pencil. It is, of course, unnecessary to have the entire range, but four or five degrees of softness are sometimes needed in extended tonal drawings (Figures 8.15 and 8.16). A good all-purpose selection might be 3H, HB, 2B, 5B, and 8B. Although the harder degrees are omitted here, some surfaces (and styles) may require their use. In general, though, their limited value range and hard, fine lines too often promote a tight, timid result. The softer pencils can still give great exactitude and more tonal range than the hard ones (Figure 8.17).

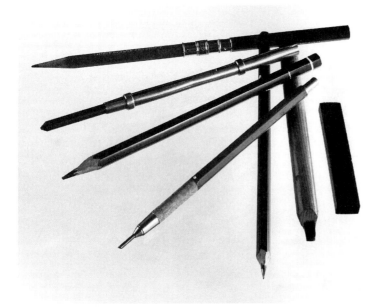

Figure 8.13

Graphite media. From top, counterclockwise: graphite pencil in pencil extender, thick graphite "lead" in double-ended extender made to hold any wide abrasive medium, an 8B graphite pencil, mechanical pencil holder for thin "leads," pencil made of graphite-carbon mixture (for very dense, black lines), flat graphite pencil, and broad, square-sided graphite block.

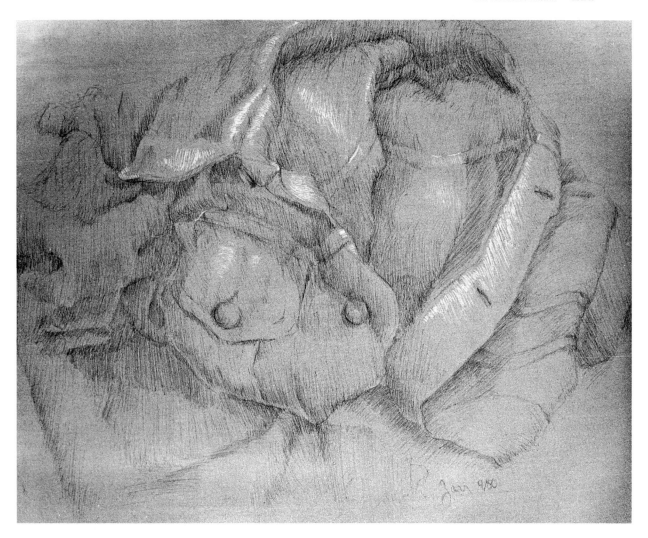

Figure 8.14 *(student drawing)*
CAROLYN ZARR
Silverpoint heightened with white on toned ground.
7½ × 9 in.
Arizona State University

If one's choice were limited to a single pencil, a 2B or 3B would serve most needs best, unless the drawing was to be large scale, in which case a 4B or 5B would be more useful.

Although graphite is easily blended, most artists prefer the texture and freshness of massed graphite lines (Figures 8.18 and 8.19). Graphite's easy erasability (less so in the very hardest and softest degrees) leads many students to overwork their drawings. Graphite's freshness is fragile and easily lost. Extensive erasure, blending, and reworking of tones and edges cause an unpleasant shiny and "tired" surface.

Graphite is a frequent participant in mixed-media works (Figure 8.1). Its ability to be used in faint wisps or powerful accents, its easy application over layers of almost any other medium, and its pleasing character as a dry "counterpoint" to wet media make it a versatile member of almost any combination of media. Graphite can even be made to function as a fluid medium by washing over layers of the material with turpentine or alcohol.

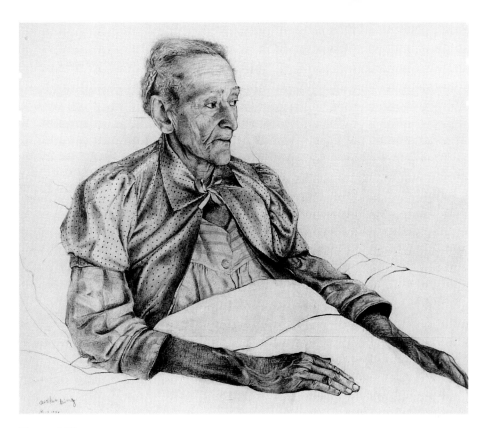

Figure 8.15
ANDREW WYETH (1917–)
Beckie King
Pencil. 28¹/₂ × 34 in.
Dallas Museum of Fine Arts, Gift of Everett L. DeGoyler

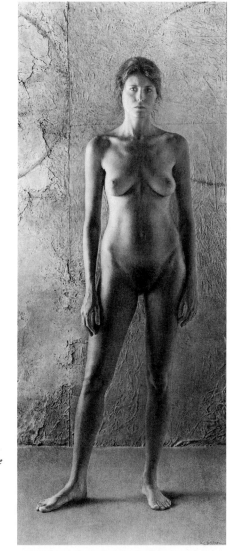

Figure 8.16
KENT BELLOWS (1949–)
Angela, Full Standing (1988)
Pencil on paper. 30 × 12 in.
*The Toledo Museum of Art; National Endowment for the Arts
Museum Purchase Plan Program and matching funds from the
Friends of Roger and Gayle Mandle, The Toledo Modern Art
Group, and Dorothy M. Price.*

toughest and most capable of accepting a wide range of media—are made of linen rag. They are also the most expensive, particularly the hand-made papers. The least permanent papers are made of wood pulp, untreated by any chemical preservatives.

Papers are classified according to weight and surface character. The figures designating a paper's weight refer to the weight of 500 sheets, called a *ream*. Thus, a 30-pound paper is one that weighs 30 pounds per ream. Newsprint, the paper used in the publication of newspapers, is a 30- to 35-pound paper. Some of the heavier papers, those used primarily for watercolor painting but also very well suited to drawing, weigh from 140 to 400 pounds a ream and are nearly as stiff as cardboard.

Rag papers are classified into three basic types:

1. Hotpressed. These are the smooth, and sometimes even glossy papers, best suited to pen-and-ink drawing of an exact or delicate kind and wash drawings that do not require repeated overpainting of tones. Hotpressed rag is the least absorbent of the three types.

2. Coldpressed. These papers have a moderate tooth and absorbency, accept all media well, and are the most frequently used. They vary somewhat according to the manufacturers' formula, but it is hard to find a coldpressed paper that is not an appealing surface for drawing.

3. Rough. The papers with the most pronounced tooth, these are least accommodating to fine or exact pen-and-ink drawing, although some artists enjoy working on such surfaces. They give ink and watercolor washes a brilliance and sparkle not possible with other surfaces.

Rag papers are sold in single sheets and blocks. The sheets in the blocks are attached on all four sides in order to flatten out any buckling that may occur when water-based media are used. Water by itself, or as part of ink or thinned paint, swells the fibers, causing ripples in the paper. Although the ripples are not generally noticeable in pen-and-ink drawings unless the lines are densely massed on a lightweight paper, not much water is necessary to cause them on most papers. The heavier the paper, the more water it can tolerate before buckling. Papers lighter than 140 pounds will buckle even with a quite restricted use of water. Papers of 200 pounds or more will not buckle no matter how wet.

To prevent buckling, the paper should be soaked for a few minutes and then secured to a stiff board such as particle board by taping it on all four sides with a gummed tape. If a second paper is similarly stretched on the back of the board, warping of the board is less likely, and a second sheet is ready for use.

For extensive use of opaque paints, only the heaviest papers or paperboards should be used. Unless, like illustration board, such supports are faced with drawing or watercolor paper, they may require priming to provide a more receptive tooth to hold the paint and to reduce absorbency. An acrylic *gesso,* or primer, designed as a base for paints, makes a good surface for both wet and dry media.

Illustration board is available in the three surface designations for rag papers. These boards are made of an inexpensive backing of pulpboard upon which is mounted a thin sheet of drawing or watercolor paper. Some are made with all-rag surfaces.

Oriental papers have a distinctive absorbent character. Often called rice paper, they are actually made from the inner bark fibers of a mulberry plant. Oriental papers contain none of the clay additives of many Western papers that reduce absorbency, and they are therefore far more absorbent and more prone to blotting. Often used in the graphic process of woodcut printing, such papers offer an unusual receptivity to sumi ink washes and brush drawing.

The term *bond* refers to a wide assortment of papers often used for writing and typing purposes. Bond papers vary in weight from 13 to 35 pounds, and in surface from the slick to the moderately grained. They may be made of either wood pulp or rag, or various mixtures of both. All are excellent for pen or pencil drawing, and those manufactured for general drawing purposes are receptive to most media. However, their light weight makes extensive use of water-based media impractical.

Many drawing pads and sketchboards do not identify the paper's ingredients. Advertised as "white drawing paper" or "all-purpose drawing paper," many are like bond papers in character. Most are heavier, weighing between 30 and 90 pounds or more. Their qualities vary according to their price. At their best, they are made of 100 percent rag materials.

A serviceable paper for practice drawings with dry media is newsprint, mentioned earlier. It is an impermanent paper of a warm, light gray tone and can be either smooth or moderately rough. The rough-toothed paper has a more interesting character and is generally heavier. It is especially receptive to conté crayon and compressed charcoal.

Bristol and *vellum* are heavyweight papers, often made of wood pulp but available in the all-rag state. Of postcard weight, they offer fine surfaces for pen and ink, brush and ink, and graphite. Often sold in pads of various sizes, they are a serviceable paper for almost any medium. These papers are usually treated with preservatives and chemically whitened. They are tough papers; all are long-lasting, and many are permanent. The Bristol paper has a hard, glossy surface and may take the softer abrasive media less well than vellum, which has a slight tooth.

Charcoal paper, usually between 60 and 70 pounds, is a fairly substantial paper, capable of the rough treatment that drawings in charcoal, chalks, and the other dry media often entail. Its rough tooth and tough "skin" take erasures well.

Figure 8.33
NATHAN GOLDSTEIN
Page of Sketches (1990)
Black chalk. 9 × 12 in.
Courtesy of the author

value and texture of the three dark areas, and note that each medium requires a decidedly different handling to produce the tonal change from dark to light.

In 1C, make a tonal drawing of any simple object, such as an apple, shoe, or mitten, using the 6B pencil. Draw the same object, from the same view, in 2C using charcoal, and again in 3C with crayon. Again, note the differences in handling required. Because the 6B pencil cannot produce darks as easily as the crayon can, more pressure is required. Because the crayon so easily produces strong darks, less pressure must be used for the lighter tones. Because stick charcoal is a soft tool that tends to make heavy lines, small details are not as easily drawn as with the other two media. Take advantage of what each medium offers. If crayon produces stronger darks, use them to show a more dramatic range of values. If charcoal can be manipulated on the page in ways that the other media cannot, do so to extract from the subject qualities that charcoal can state by these manipulations, including smudging and erasing. If graphite can state details with more precision, use this feature to explain smaller planes and tones. Let the limits and characteristics of the media guide your tactics.

Leave the bottom D row blank. You will complete these boxes after the next drawing.

drawing 2 Using the Bristol paper or its equivalent, again divide it as in Figure 8.40. In 1A, draw a gray tone of about 50 percent, using pen and ink. The lines can go in any direction or be cross-hatched. In 2A, draw the same value with the sable brush and ink diluted in water. Again, use hatched or cross-hatched lines only, but *fill only one half of box 2A*. In the other half, use the number 5 bristle brush and undiluted ink to match the value in 2A as follows: dip only the tip of the bristle brush in the ink and, with light back-and-forth brushing on a scrap of nonabsorbent paper, remove almost all the ink from the brush. When the brush is almost dry, it will produce a stroke of very fine, black lines that can be brushed into the other half of 2A, producing an optical gray. Naturally, this should be practiced first on a scrap of paper similar to Bristol. This process is called *dry-brush* and can be seen in the painting of the Flemish primitives as well as in many tonal brush drawings (Figure 4.21). The brush strokes of fine lines so produced look somewhat like chalk strokes. They permit a gradual building up of values (Figure 8.41). This can also be done with soft-hair brushes and ink, or thinly diluted paints, but acrylic is less adaptable to dry-brush handling than other paints. You may wish to use this manner of application later in this second drawing.

A **B**

Figure 8.41
Examples of drybrush. The strokes in A were made with a bristle brush; those in B, with an Oriental squirrel-hair brush.

In 3A, mix ink and Chinese white with enough water to allow for easy brushing, and apply the 50 percent gray tone by using any of the three brushes. This should be an opaque layer of paint, but a quite thin one. Now, as in drawing 1, rework these boxes in any way you wish, mixing media to produce volumes, textures, and tonalities.

In 1B, use pen and ink to make the same kind of tonal change as in drawing 1. Do the same with brush and ink in 2B, *after* you have moistened the box with clear water applied with a clean brush. This will make the ink spread. The more water, the more the ink will spread—and the harder it will be to control. Therefore, do not lay in any washes until the area is only faintly damp. If a segment becomes too dark, a clean soft-hair brush can pick up much of the tone while it is still wet. In 3B, draw the same kind of value transitions, using opaque mixtures of Chinese white and ink. This time use only sable brush, and draw fine lines with the thinnest opaque mixture. If the mixture is the correct consistency, the paint should easily glide upon the page with no sense of "drag." Dry-brush will work well here.

In 1C, using pen and ink any way you wish, make a tonal drawing of any simple object. Using brush and water, draw the same object in 2C. This can be done in the wet-in-wet manner used in 2B, or in any combination of wet and dry brush strokes. In 3C, the same subject should be drawn in any opaque manner with ink and Chinese white. The experience of the first two rows should help you decide how you wish to handle these three drawings in the C row. Again, leave the D row blank.

Now return to the D row of drawing 1. In 1D, using brush and ink and Chinese white, try to *imi-*

tate the drawing in 1C exactly. That is, your drawing in 1D should look as if it had been done with the 6B pencil. In 2D, use brush and ink (and water if needed) to reproduce the drawing in 2C exactly. Again, try to imitate the medium used in 2C. In 3D, use only pen and ink to reproduce the drawing in 3C. If you are working with other students, drawings can be exchanged at this point, so that you can try to reproduce someone else's C row of drawings.

When the D row of drawing 1 has been completed, return to the D row of drawing 2. Again, drawings can be exchanged. Now, use only the crayon to reproduce the drawing (and the medium) of 1C of drawing 2, using only the charcoal to do the same with the drawing in 2C, and the 6B pencil for the one in 3C.

In both sets of drawings in the D rows, you are straining the media by trying to get them to imitate each other. In most cases you can only get close to the original texture and character, but it may surprise you to see *how* close.

In drawings 1 and 2, you experimented with the various media and materials and tried to feel and see their character, strengths, and limits. You worked within those limits, taking advantage of their strengths, and finally worked against their limits, forcing them to "become" another medium. It is this full testing of a medium's range that provides us with the sense of its nature, its range, and its potentialities.

drawing 3 Turning the illustration board vertically, divide it into three horizontal sections of 10 inches each. Divide it vertically in half (Figure 8.42). Using black acrylic, the number 5 flat bristle brush, and water, make a gradual tonal change from black to white, allowing the white board to be visible on the far right side of 1A, as in the earlier tonal changes. Thus, as the tone lightens, you will use less paint and more water. In 2A, do the same, but use both black and white acrylics, keeping the paint film opaque. When completed, both should be smooth graduations of tone. This will be less easily accomplished in 1A. Once they have dried, dark areas cannot be removed. Therefore, adjustments in 1A must be made quickly. Here it is best to start with the lightest tones and work toward the darks on the left. If, after drying, 1A or 2A need further tonal adjusting, use both Chinese and acrylic white to touch up, and notice the better covering power when these paints are mixed. After completion, use these two boxes for further experiments with any of the other media.

Use 1B as an area in which to experiment on this new surface with all of the media you used in drawings 1 and 2. In 2B, wet the illustration board

Figure 8.42

lightly with clean water. When it is just slightly damp, lay in a thin, semi-opaque wash of 50 percent gray. When this has dried, use both of your bristle brushes in whatever way you wish to draw any simple object in black and white acrylic. In 1C, using black acrylic, any or all of your three brushes, and water, lay in the volume summary of another observed object. This should be done within five minutes. Continue to develop the drawing in any one of the abrasive media used earlier. In 2C, using any combination of these media, but omitting acrylics, and using any tools except brushes, try to duplicate the drawing in 2B exactly. In place of brushes, you can use your fingers, rolled-up paper, cotton swabs, sponges, or anything else. You may want to try duplicating 2B with abrasive media alone—perhaps using only charcoal.

In the preceding exercises you explored some materials by going with and against their character. This of course does not exhaust the possibilities. Acrylics can be used to imitate the various abrasive media; one combination of media can be made to imitate another; different surfaces would affect the behavior of both media and tools; different tools would affect the media, and so on. The possibilities are virtually endless.

At the beginning, it is better to probe a few media and materials and go deeper. Here, a suggested approach for the study of any medium, tool, or surface is offered to help you when you seek them out. Although all our materials continue to reveal their nature as we use them, the few hours spent in testing, forcing, probing—in discovering—can provide an understanding that may come only in bits and pieces over a long period of time. It may be years before we try some unusual combination of media in a drawing, only to find the combination works better than anything else we have tried for establishing the images we intend. But if, when first encounter-

ing these media, we take the time to experiment, we can learn this sooner.

The media and materials of drawing are the physical agents of our intentions. They do not themselves discover or invent, but they do influence results. To understand their important role in drawing, we have to learn to understand as well as enjoy our tools. One without the other does not yet produce control.

In the act of responsive drawing, our media and materials either help or hurt our interpretive efforts. They serve us well if we know them well—but they are never neutral.

9

visual issues
the forming of order

A DEFINITION

We have seen that in responsive drawing, *what* is drawn and *how* it is drawn are interrelated considerations. Each mark on the page does two things: it helps depict, or *define* a subject's structural and spatial characteristics, and, by its physical properties, it conveys a particular kind of dynamic meaning that suggests both energy and mood. In other words, each mark produces some kind of *expressive action*. Furthermore, by their interactions, that is, by the way a drawing's marks (its lines and tones) relate and affect each other, they create the visual forces that give a drawing its own pattern of abstract, order, as well as its expressive character. To expand an earlier observation about line, *all* the marks that constitute a drawing *define, act,* and *interact.* Each mark is a part of the drawing's *compositional and emotive* condition.

This chapter concentrates on those factors that influence a drawing's organizational aspects—its abstract (or formal) compositional order. Because each mark, of course, simultaneously affects a drawing's visual *and* expressive

meanings, to separate a drawing's organization from its expression risks distorting our understanding of both. Nevertheless we have separated these factors temporarily, focusing on the compositional ones in this chapter and on the expressive ones in the next, in order to help clarify our understanding of each and deepen our understanding of their interrelated nature.

Some cultures have always understood drawings as systems of *design*. The single Italian term *disegno* describes both drawing and design, as does the French *dessin*. In fact, it is impossible to regard any drawing as only descriptive, even when nothing more was intended. Seeing and sensing the visual relationships and forces generated by the lines and tones are unavoidable. Such dynamic behavior is always a part of any collection of marks and is thus a *given condition* of drawing.

In a good composition, the marks produce relationships, contrasts, and energies that convey a sense of *balance*—an equilibrium between its parts, and between them and the page. Additionally, all of the design's components—its lines, shapes, tones, colors, textures, and

masses—have strong interacting bonds of dependence and association that create an overall sense of oneness, or *unity*. But both of these conditions can exist in very dull drawings. A drawing of a brick wall or a Venetian blind, unless the overall sameness is relieved by some variety, *is* boring. A drawing's stability and unity must emerge from the stimulating action of contrasts, as well as the union of similarities. We need diversity as an antidote to monotony. General principles in art are best approached cautiously, but it seems safe to assume that whatever else art is or may be, it will not accept visual disorder or boredom as goals. In good drawings stability and unity are achieved by interesting contrasts, similarities, and energies. Moreover, we sense that their order is *necessary,* that *any* change will weaken their organizational resolution.

> *elements can show contrast on one level of relationship and similarity on another*

RELATIONSHIPS AND ENERGIES

The preceding chapters examined the *measurable relationships* of shape, placement, length, scale, direction, value, color, and mass, in order to learn how to see more objectively and to state volume and space more inventively. In doing so we touched briefly on design considerations concerning rhythm, movement, and continuity among a subject's parts. In this section we will expand our investigation of design to include other kinds of energies that emerge from these relationships, and to consider the balanced distribution of the subject's parts within the bounded limits of the page in ways that engage the entire page.

We have seen that all of a drawing's marks must be made of *line* or *value* and that these in turn create the several visual factors of *shape, color, volume and space,* and *texture.* All of the visual issues that concern a drawing's abstract, or *formal* design result from the behavior of these six basic factors. They are collectively called *the visual elements.* To discuss the relational possibilities that can occur in a drawing's composition, we will need to examine these elements further. As we do, remember that the term "element"

refers to anything from a line or tone or a chalk-mark's texture to the color or mass of a house. Remember too that, unlike the visual relationships between elements, the various abstract (and emotive) energies that these relationships generate are themselves invisible. We only sense or intuit them.

The possibilities for relationships based on similarity or contrast between the elements are limitless. In fact, in the best drawings the elements seem capable of endless interactions. Great drawings are never "used up." Relationships can be obvious or subtle. Each element in a drawing participates in at least a few, and sometimes many, different visual associations, producing different visual forces. These forces are as varied as the relationships that create them. Being so much a matter of sensed impressions, they elude verbal descriptions of more than their general kind of behavior.

Relationships are always based on connections of some kind, but they depend on contrasts to be effective. A shape may be large in relation to the page—its scale is *similar* to that of the page—but will appear even larger if it is seen in *contrast* to smaller shapes upon the page. Likewise, we do not usually regard a white sheet of paper as being bright, we regard it as blank. Not until dark tones appear on the page does its tone have any quality of light or any other visual meaning. Where everything is bright, nothing is.

A single vertical line drawn on a page creates a contrast with the "emptiness" of the page. The line is unlike any other part of the paper (though it is similar in direction to the vertical borders of the page). When a second line is drawn parallel to the first, obvious similarities of scale and direction exist between them. Two more lines, drawn at right angles to the first pair, are like them as lines but contrasting in their position. If the four lines form a square, they are related to the page *and* to each other by the shape they make. Thus, elements can show contrast on one level of relationship and similarity on another. When similarities overpower contrasts, the result is boredom. When contrasts overpower similarities, the result is chaos. A successful design must avoid both of these extremes. Its

contrasts may threaten but should never succeed in destroying balance and unity. The artist must organize contrasting elements into some greater system of formal order.

Although unlimited in their visual interactions, relationships among the elements can be roughly sorted into thirteen categories. These categories of relational activity and some of the energies they generate are as follows.

1. Line—the similarities and contrasts arising from their direction, length, weight and value, handling (or character), and their straight or curved nature, as in Figure 9.1. Note that some lines, despite their contrasting lengths, directions, thicknesses, and so on, relate by intersecting, location, or texture. Additionally, similar lines can contrast in their weight, color, direction, or handling.

2. Direction—the sense of movement or of striving for change, as when any like or unlike elements relate because of a continuity of their positions on the picture-plane or in the pictorial field. Direction is also sensed when similarities of length, shape, value, color, scale, or texture among various elements cause us to recognize common alignments among them. Such elements seem to move in various straight or curved paths, and even suggest their speed. Elements can "amble" along or can convey powerful velocity. The more unlike are the elements moving in a direction, the weaker and slower the sense of movement; the greater their similarities, the stronger their directional thrust. For example, note the strong fan-like energy of the

long lines in Figure 9.1, and the weaker (horizontal) directional energy that unites the shorter straight and curved lines at the bottom of the drawing.

All elements except shapes and masses whose boundaries are equidistant from their centers, such as squares and spheres, are *inherently directional;* they move in the direction of their straight or curved long axis. This being the case, directional cues, and the movement energies they generate, *always* pervade all other relationships. Thus, visual associations based on direction, and the sense of moving forces at work in a drawing (and in the observed or envisioned subject), are at the heart of any system of visual order. The importance in recognizing the dominance of directional relationships cannot be overstated. Just as directional forces activate the lines in Figure 9.1, so can we see them at work in the following illustrations of relationships among the elements, and in *all* drawings and paintings.

3. Scale—the similarities or contrasts of size between like or unlike elements. When other visual factors are alike or in balance, the larger of two elements will dominate the smaller one. For a strong sense of dominance to occur, the larger elements must relate clearly with those they dominate, as in Figure 9.2, where the scale differences between the houses, and between the trees, are more evident than the similarities of scale between the large house and tree, or the small house and tree. But note that, in sharing long, vertical axes and chevron-like endings at their tops, all four units relate by directional

Figure 9.1

Figure 9.2

cues (including the horizontal direction of their alignment).

4. Shape—the similarities or contrasts among shapes. In Figure 9.3, the shapes (including those affected by lines) form one set of relationships based on shape character, another based on scale, and still another based on moving energies. Because all values, planes, masses, and interspaces have shape, it is important to be aware of the shape groupings that the elements form in any drawing.

5. Value—the similarities or contrasts of value between elements. In Figure 9.4, the elements, in addition to relationships based on scale, shape, and direction, relate by similarities and contrasts of value. Note that in their doing so, new directional forces emerge, as in the "line" of light gray tones that runs obliquely along the lower portion of the illustration. Value is an important unifying factor. As a comparison between Figures 9.3 and 9.4 shows, value, when added to a line drawing, can affect visual groupings of elements on the picture-plane and in the spatial field of depth. Value, when used to show light striking forms, unites them by darkening the sides turned away from the light. Each form is affected by the light in the same way. Cast shadows also produce contrasts and bonds based on their dark tone. Both of these functions of value can be seen in Figure 9.5.

6. Color—the similarities or contrasts of color between elements. Color similarities make for strong visual relationships, creating bonds between highly unlike elements or parts. In Figure 7.5, apples and towel stripes connect through their common color. Conversely, the relationship between like elements or parts can be sharply reduced by contrasting their colors, as in Figure 7.14, where shapes are joined to others more by color than by their similar configurations.

Figure 9.3

Figure 9.4

Figure 9.5 *(student drawing)*
CAROLYN HONETSCHLAGER
Glasses (1980)
Ink and white on toned ground. 9 × 12 in.
Arizona State University

7. Rhythm—the sense of a regulated pattern of movement or visual occurrences between like or unlike elements. Rhythm can be thought of as a kind of visual meter, a system of moving or pulsating activities among the elements or among their properties of scale, location, or direction. And, like a musical meter, such relationships occur within some pattern of rigid or loose intervals, as in the "beat" of shapes and values in Figure 9.5. Like directional relationships, the presence of rhythmic ones can be sensed throughout the best drawings, where every line and tone, and every one of the forms, textures, or spaces they produce, is a member of one or more rhythmic systems. Often, rhythms are sensed most among elements repeating a similar movement or interval. The more often such activities are repeated, the stronger the sense of rhythm. Whether they are the "beat" rhythms of Figure 9.5 or the moving ones of Figure 9.6, the sense of rhythm is one of the stronger forces in unifying a drawing, weaving together many otherwise weakly related elements. When, as in Rembrandt's *Saskia Asleep in Bed* (Figure 9.6), strong rhythmic and directional forces are combined, intense movement energies course through a drawing, enveloping and uniting every part.

8. Texture—the similarities or contrasts of textures, whether of a tactile or media-induced nature, between like or unlike elements. In Figure 9.7, small circles unite flowers, grass, and field. Additionally, the artist intoduces a secondary theme of lines, mostly vertical, that likewise connect grass with buildings. Textures can create passages of surface activity that give other, more "restful" passages, greater meaning. Notice in this drawing how the dense concentrations of texture in and near the center give the more simply stated parts a greater feeling of light and tranquility.

9. Location and proximity—when like or unlike elements are seen as belonging together because they occupy positions equally near or far from the center of the page, or when unlike elements

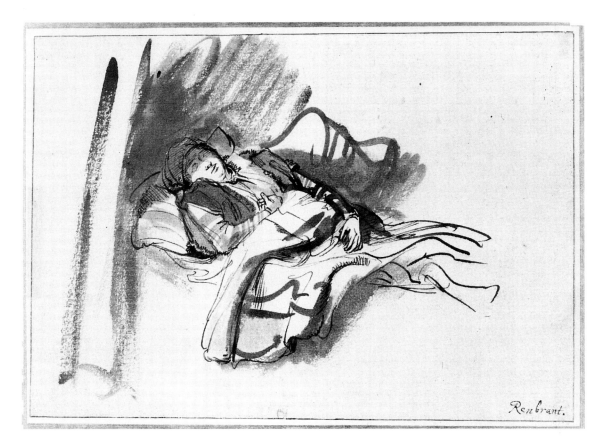

Figure 9.6
REMBRANDT VAN RIJN (1606–1669)
Saskia Asleep in Bed
Brush, pen, bistre ink. 13.7 × 20.3 cm.
Ashmolean Museum, Oxford

Figure 9.7
CARROLL CLOAR
Barn Sketch
Graphite and fiber-tipped pens on tracing paper.
23 × 24 in.
Arkansas State University Art Gallery, Jonesboro

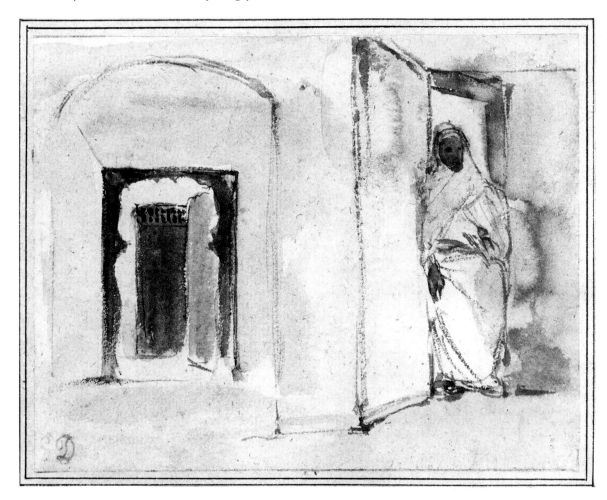

Figure 9.8
EUGENE DELACROIX (1798–1863)
Arab at the Door of His House
Watercolor. 10.8 × 14.5 cm.
Rijksmuseum, Amsterdam

are yet more alike than surrounding ones. Both of these conditions are seen in Figure 9.8. Delacroix relates the archway and the door beyond it to the large door and the figure on the right by centering each segment in its half of the page and by surrounding these concentrations of small shapes, values, and forms by large, light shapes, values, and forms. In a drawing of forms as unlike as leaves, locks, and cups, they will appear related if encompassed by forms, spaces, shapes, values, and colors unlike any in the cluster. It is difficult to overcome the unity of dense groupings. We cannot see an orange in a bowl of fruit as separate from the rest. However, through other relational forces, and by relating the orange with a symmetrically located form, color,

or tone, it can be made to join with elements far across the page. When elements are located very close to each other or to a border of the page, they produce a sense of striving toward contact, toward the completion of the suggested action. This is called closure, and it is a compelling force. It is impossible, for example, to disregard the circular "shape" a ring of dots suggests. Although no line delineates the circle, we sense its presence.

10. Handling, or character—the similarities and contrasts among elements because of the forceful, deliberate, or playful style of graphic expression. By changes in the handling, two otherwise similar lines, shapes, or tones can be made to

Figure 9.13

"work" with the drawing's design on the picture-plane but they conflict with three-dimensional meanings, and vice versa. For example, the eight shapes in Figure 9.14A relate in a balanced, unified way. There is a gradual progression in their scale; their several directions and abutments offer an interesting variety; and the design of the two "background" shapes embracing six smaller ones forms a discernible theme. But these shapes are less successful when regarded as blocks in space. The abutments between their planes and the borders of the spatial field, as well as the abutment between the blocks, weaken the impression of volumes in space. Such tangential connections make it difficult to know which of the blocks is ahead of the other or which is larger.

The six small shapes in Figure 9.14B are, from the standpoint of two-dimensional design, far too small to relate to the large shape of the picture-plane. Instead of the interaction between all the shapes, as in Figure 9.14A, here the little shapes form two isolated clusters, and the shape of the picture-plane remains passive. Additionally, the tension and direction between the two clusters of shapes create a diagonal "tug" that disturbs the vertical-horizontal orientation of the picture-plane. For, the first diagonal direction in a drawing, unlike vertical and horizontal directions, which always run parallel to two of the picture-plane's boundaries, is obviously "alone." Therefore, diagonals are usually counterbalanced by other diagonals, as in Figure 9.14A,

that almost touch, and in ambiguities between figure and ground shapes (Figure 9.13).

As these thirteen categories suggest, elements are always engaged in multiple relationships. For example, an association between two values will always include their *shape* relationship, and these shapes of tone have *location*, *scale*, *direction*, and *visual weight*, are *handled* in a certain way, and so on. A drawing's balance and unity depend on the artist's ability to *sense* and control these relational bonds. For, after the first few marks of a drawing, the relational possibilities, growing by geometric progression, are too many to be seen; they must be sensed. The artist is guided to equilibrium and unity by an overall sensitivity to a drawing's "rightness" of balance and cohesion—as much a matter of intuition as of intellect. Like all other aspects of responsive drawing, good compositional solutions are formed by facts *and* feelings.

THE CONFIGURATION AND THE PAGE

When the artist begins to draw, relational energies begin among the elements and between them and the page. These relationships exist as two- and three-dimensional events simultaneously. Sometimes two-dimensional relationships

Figure 9.14

where sets of oblique lines cancel each other's movements.

In Figure 9.14B, no good compositional end is served by the placement of such small forms in so large a field of space, but the blocks are clearly presented as volumes in space. Additionally, the sense of weight adds a second force. Acting somewhat as a counterforce, the pull of gravity starts a downward tug. This "promise" of a downward movement of the blocks, especially of the one on the right, seems to lessen the imbalance between the blocks and the page. If we turn this illustration on either of its sides, the sense of gravity, plus the forces of direction and tension, unite to create an even stronger diagonal pull. When it is seen right-side-up again, we sense the moderating effect of physical weight on the diagonal position of the blocks.

Although responsive drawings always convey some impression of the third dimension, they are formed by two-dimensional lines and tones upon a bounded, flat surface. Their design as two-dimensional *facts* must be compatible with their three-dimensional *impressions*. These facts and impressions must work with each other and with the shape of the page.

Many drawings are quick sketchbook notations or brief, preliminary investigations. Such spontaneous, on-the-spot efforts generally try to capture a subject's essential character and action, study some particular structural or textural aspects of its form, or serve as a preliminary design strategy for a work in another medium. We have seen examples in Figures 1.10, 2.34, 3.7, and 9.9. Often such sketches are not intended to be integrated with the page. Even here, though, an intuitive sense of balance between configuration and page, of the influence on the thing drawn by the shape of the surface, affects decisions about the placement of the configuration (or the several independent studies) on the page.

It is clear from Géricault's sketches of soldiers and horses (Figure 9.15) that the artist is absorbed in study and not (intentionally) with creating a balanced arrangement of forms on the page. Even so, it is difficult to imagine rearranging this group of studies into some better pattern.

However, other drawings, even when they do not fill the page, *do* intend a bond between the configuration and the page. Such drawings are conceived (or resolved) as arrangements of forms in spatial environments that depend on,

but do not touch, the limits of a page to make sense as a design.

In such drawings, visual issues actively involve the entire page. The outer zones of drawings that do not extend to the limits of the page may be empty of drawing marks but not of visual meaning. They always have shape, scale, and value, convey direction, and are similar to, or in contrast with, various parts of the configuration. They are always part of the drawing's design. These "empty" areas influence the configuration's *representational dynamics*, that is, what the things depicted do as actions (falling, running, bending, etc.), and what the *visual and expressive dynamics* do as actions. These figural, formal, and expressive states together are called a drawing's *content*.

Because so many responsive drawings are spontaneous, brief, and alive with energy, artists often use such a design strategy. It permits a strong concentration on the subject. Often the surrounding, empty area of the page acts as a "shock absorber" against which the drawing's forces are turned back upon themselves to start the cycle of moving actions over again. Then, too, this strategy allows a fuller concentration of responsive powers on the subject than when they are divided between it and the demands of a full-scale compositional scheme. This does not mean that such drawings are less united with the page than are those that fill it entirely. It means only that the encircling, undrawn area is assigned the less active, but no less important, role of containing and modifying the dynamics of the configuration.

In Rembrandt's *The Mummers* (Figure 9.16), the configuration is well within the limits of the page but strongly interrelated with its shape and scale. The drawing "opens up" in several places to admit the surrounding empty area of the page, physically fusing with it. The frequent reappearance of the white page within the drawn areas helps unite them. But the strongest bond between the configuration and the page exists in the organizational dependence they have for each other.

Near the drawing's exact center, the hand holding the reins marks the center of an expanding burst of lines, shapes, and tones of such power that we sense its radiating force in the hat, collar, elbow, leg, and reins of the figure on the left. This force is continued in the neck and chest of the horse, and in the lines near the man

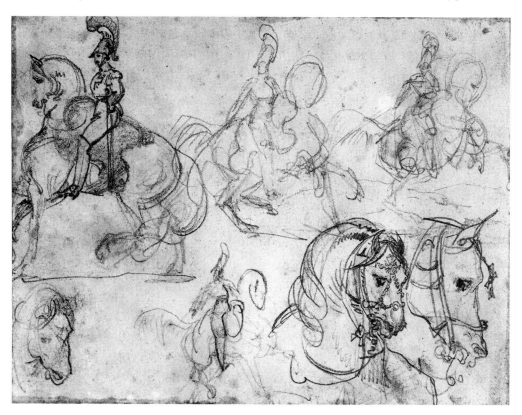

Figure 9.15
THEODORE GÉRICAULT (1791–1824)
Sketchbook: Sketches of Mounted Carabinieri, Heads of
Horses
Graphite. 17.4 × 23.2 cm.
Collection of The Art Institute of Chicago. Margaret Day Blake
Collection. Photograph © 1996, The Art Institute of Chicago.
All Rights Reserved. Gift of Tiffany and Margaret Blake

on the right. The release of such explosive energies warrants the thick, surrounding buffer of space (Figure 9.17A). We can sense an "implosion" too. The empty area absorbs the "shock waves" and sends them back again. These sensations keep alternating as we look at the page. Both the drawn and empty areas contribute to and share in these pulsations.

Had Rembrandt continued to draw the entire horse, the empty area would have been cut in two, destroying the surrounding buffer and weakening the radiating force as well. Had he made this drawing on a larger sheet of paper, the impact of the explosive pattern would have been greatly reduced and the subject overwhelmed by the scale of the empty area. No "echoes" would return from the limits of the page because they would be beyond the range of

the drawing's energies, and thus no visual interplay between the drawn and empty areas would exist. The configuration would be isolated in a sea of paper.

Every type of relational activity is present in this drawing. We see how powerfully line and direction are used, and how they pervade the entire composition. The rhythm of the many directional "spokes," radiating from the drawing's center owes much to line, and to those invisible "lines" of force that relationships of direction produce. An almost equally powerful visual theme that also moves through the drawing is generated by other directions, rhythms, and tensions (Figure 9.17B).

In Figure 9.16, beginning with the near man's lower leg, a vertical movement spreads left and right in a fan-like manner. The angle of

the near man's lower arm and the repeated lines of his waistcoat convey one half of the fan's spread; the other half is carried by the lines in the far man's coat, by the several brush strokes defining the horse's mane, and by the lines of the background near the man on the right. This fan-like action creates one tension between its two halves and another between it and the inverted V-shaped counterforce formed by the directions of the sword and the reins. The V shape is reinforced by some lines in the near man's saddle and by some of the lines between the leg and the reins. Tensions between the various lines and brush strokes of the horse make these marks seem to attract each other. These tensions, and the sense of closure between the marks, help us to "see" the largely nonexistent animal. The proximity of the two figures, and the dominant dark value between them, unite the men into one great diamond-like shape that is centrally balanced on the page in the same tenuous and provocative way as the diamond shape in Figure 9.10B. Visual and physical weight are also centrally balanced in this design. Note that Rembrandt reduces the physical weight of the horse's neck and head, lest the weight of so large a mass undo the drawing's equilibrium. Rembrandt's handwriting—its consistent, animated energy—further reinforces the power of the actions described above and helps to unite the drawing.

These are only *some* of the drawing's relational activities. There are many more. Indeed, each of the marks has some function that con-

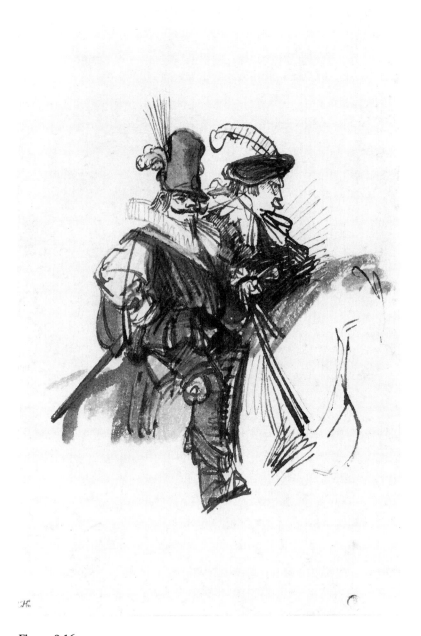

Figure 9.16
REMBRANDT VAN RIJN (1606–1669)
The Mummers
Pen and ink with wash. 21.2 × 15.3 cm.
The Pierpont Morgan Library, New York. I, 201.

tributes to the drawing's organization and unity. As we have stated, each defines, acts, and interacts.

Beginning students often question whether an artist consciously intends each of the force-producing relationships in a drawing. They doubt that the drawing's dynamics always

represent deliberate judgments, and they suspect that many of the relationships pointed out in a particular drawing never entered the artist's mind—and they are right! It was observed earlier that after a drawing is well under way, there are just too many bonds of association, too many abstract actions for the artist to see and consciously control, and the drawing's resolution depends on intuition as much as intellect.

This holds true for an examination of any particular drawing. As we study other drawing strategies in this chapter, we should remember that any analysis of a design reveals only some of its relational activities (probably those reflecting the analyst's own instincts about organization)—and that many of these may well reflect the artist's intuitive impulses *and subconscious interest*. For, the content of any drawing contains certain intangibles that express the artist's personality and philosophy that are not only subconscious, but resistant to any attempts by the artist to be free of them.

Also we must recognize that even if a drawing's relational life *could* be fully and objectively known, a key if impalpable ingredient would still be missing. This mysterious "something plus" certainly concerns a drawing's design and expression but is not limited to them. It is an elusive vital spirit that permeates the drawing, transforming the marks into active forces and meanings. If we regard responsive drawings as graphic equivalents of living organisms, then whatever gives the graphic organism "life" is as mysterious as those powers that animate and sustain living things in nature. Therefore, intellectual dissection can no more determine this "something plus" that separates art from competence than the character of a person can be learned by surgery.

What *can* be learned about the relational activities that form a drawing's design strategy makes analyzing drawings an important source of information and insight. Although the beginner rightly senses that drawing is not a wholly conscious activity, a more pertinent question would be: are these relationships really present? In the analysis of Figure 9.16, the several relationships and forces discussed occur too consistently, are too critically established, and are too self-evident to be mere chance or exaggerated claims on their effects. Moreover, the absence of visual discords and non sequiturs—of elements *not* engaged in the several actions discussed or not otherwise contributing to the drawing's order—is, again, beyond chance. Whatever an artist's personal "formula" between reason and instinct may be, the fact remains that in great drawings a great many questions and needs have been well answered.

> *Whatever an artist's personal "formula" between reason and instinct may be, the fact remains that in great drawings a great many questions and needs have been well answered.*

Although very different in style, mood, and subject, Diaz de La Peña's drawing *Landscape* (Figure 9.18) shows a use of the empty areas of the page similar to that in Rembrandt's drawing. Here, a "ground burst" of radiating directions spreads out on the horizontal plane of the field as well as on the picture-plane and almost fades away at the edges of the page, retaining the encircling, single shape of the rest of the page. Again, the plan is the use of the outer portions of the page as a force-absorbing belt of space. The trees, rising from the center of the burst, take on more contrasting force from it. But, unlike the vigorous energy in Rembrandt's drawing, the forces in Diaz de La Peña's are more muffled. The horizontally located configuration, the pronounced texture of the chalk medium, the restricted value-range, and the soft edges of the forms make this a quiet design, compatible with the subject's restful mood. The surrounding space, especially that above the

Figure 9.17

A **B**

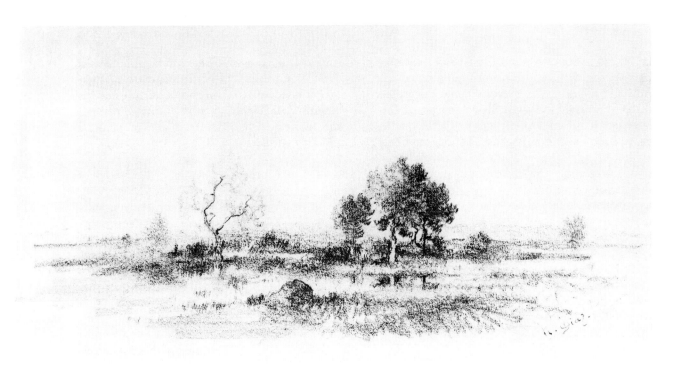

Figure 9.18
NARCISSE VIRGILE DIAZ DE LA PEŃA (1807–1876)
Landscape
Black chalk. 6 × 11 in.
Sterling and Francine Clark Art Institute, Williamstown, Mass.

Figure 9.19
KENNETH CALLAHAN (1906–)
Summer Bug
Sumi ink. 23$^1/_{16}$ × 35$^1/_4$ in.
Worcester Art Museum, Worcester, Mass.

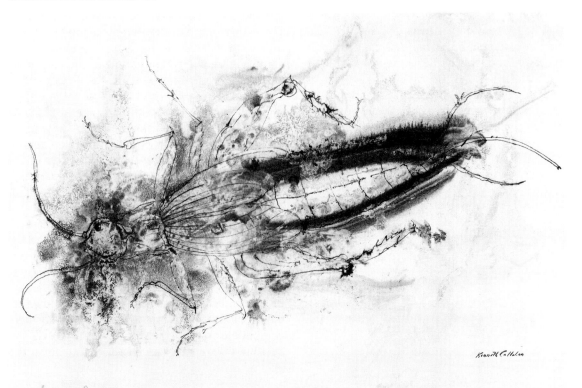

landscape, reducing and absorbing the configuration's energies, helps to suggest the drawing's pastoral nature.

The surrounding buffer in Callahan's drawing *Summer Bug* (Figure 9.19) does have some light washes of tone near the insect, but again, the space serves to contain and contrast with the actions generated by the configuration. A sense of the bug's slowly moving legs is conveyed by the rhythms between them. Callahan uses the visual weight and dominance of the dark tone on the last segment of the bug's body to counterbalance the physical weight and

downward tilt of the form and, by this single, strong contrast, to heighten the drawing's fragile delicacy.

While the Diaz and Callahan drawings are widely divergent in subject, time, and style, they share a similar organizational strategy. This encircling of a horizontal image by white space, an overall gentle handling, pronounced textures, and energies radiating from a central point in the image are tactics common to both works.

A somewhat similar abstract theme organizes still another kind of subject in Cretara's *Sleeping Woman* (Figure 9.20). Here again an en-

Figure 9.20
DOMENIC CRETARA (1946–)
Sleeping Woman
Red chalk. 14 × 18 in.
Courtesy of the artist

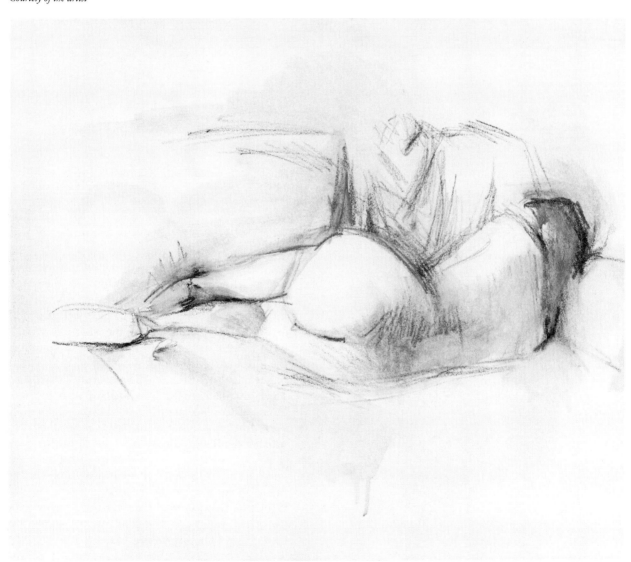

circling buffer of space "fits" the configuration's moving energies, emerging mainly from the center of the image. Again, shapes in the configuration open up to merge with the surrounding space.

As these examples show, drawings of differing subjects can utilize a common design plan which gives them a kind of family resemblance. Conversely, drawings of the same or similar subjects, even when a common set of abstract patterns is used, can also be markedly contrasting. This can be seen by comparing two drawings, by Hokusai and Rodin (Figures 9.21 and 9.22). Both use a broad "pedestal" of curvilinear lines, shapes, and volumes to support the animated behavior of their subject; both emphasize the rhythms of drapery and figure; and both shape the configuration into a rough C-shaped curve (reversed in Hokusai).

Hokusai places the figure to the right of the page while Rodin places it almost centrally. These differences in location are due mainly to

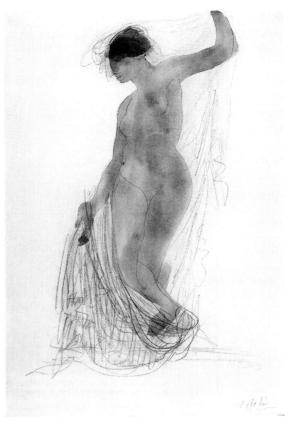

Figure 9.22
AUGUSTE RODIN (1840–1917)
Nude
Graphite with watercolor on cream wove paper.
$17^5/8 \times 12^1/2$ in.
Collection of The Art Institute of Chicago. Gift of Walter S. Brewster. Photograph © 1996, The Art Institute of Chicago. All Rights Reserved

Figure 9.21
KATSUSHIKA HOKUSAI (1760–1849)
A Maid Preparing to Dust
Brush and ink. $12^1/2 \times 9$ in.
Freer Gallery of Art, Smithsonian Institution, Washington, D.C.

the tilt and actions of the figures. In Hokusai's drawing, the extended material at the top and the swirling robe at the bottom of the page swerve abruptly from the figure's nearly vertical direction to move forcefully to the left. Had the artist placed the figure to the right, it would have left a very large pocket of empty space on the left, out of scale with the other shapes on the page and crowding the figure unnecessarily to the right. Her slight leftward tilt also permits Hokusai to place the figure near the right side. Were she exactly vertical, there would be too much weight and attention on the right.

In the Rodin, though there is not a single vertical line in the drawing, the design of the figure is vertical. Placing the image nearer to the right side would upset the drawing's balance on the page; moving it to the left would make the background shapes monotonously alike. Notice

that the background shapes echo the triangular shape of the woman's drape.

In addition to these nuances of differences in the same basic design themes, these two drawings differ in far more obvious ways, chief among them being a linear versus a tonal basis of expression. Although the drawings we have been examining do not fill the page, they *use* the page as an active part of the design and not merely as a blank area unrelated to the configuration.

Other themes require other solutions. Often, as in painting, artists draw to the borders of the page when the nature of their subject or of their design strategy for a particular work demands it. Although all responsive artists regard the subject and the organizational system it calls for as interdependent matters, artists vary widely as to which of these receives primary emphasis.

If we compare Figure 5.13 with Figure 3.3, we see that Campagnola's primary interest is in the subject, and Toulouse-Lautrec's is in the drawing's design. Although neither artist emphasizes one consideration to the neglect of the other, the differences in their responses to each is evident. For Campagnola the balance between directions, the contrasts and tensions between elements, and the rhythmic play between straight and curved edges are subdued. The forces are there; the drawing functions as a handsome system of order, but the design is below the surface—an intangible presence of pattern. In Lautrec's drawing the directions, contrasts, and rhythms are pronounced. As with all good compositions, neither drawing can be cropped or added to without destroying its balance and unity.

Hopper's drawing *Burlesque Theatre, Times Square* (Figure 9.23) conveys an even-handed

Figure 9.23
EDWARD HOPPER (1882–1967)
Burlesque Theatre, Times Square
Charcoal. 30.2 × 22.5 cm.
In the collection of The Corcoran Gallery of Art,
Washington, D.C. Museum Purchase, Membership Fund

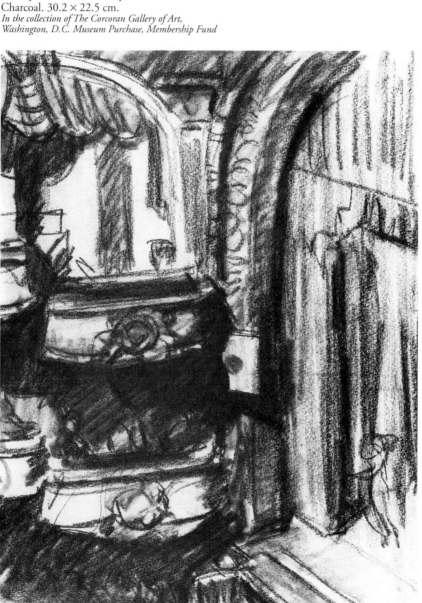

interest in both narrative and formal considerations. He captures the massive scale and baroque flavor of the theater—we sense its spacious interior and false grandeur. But Hopper is equally interested in the forces that convey these qualities as visual events in their own right.

Many of the drawing's parts are designed to suspend at oblique angles from the centrally located columns that curve to the left and right near the top of the page. To the columns' left, the theater boxes tilt down toward the left; to the columns' right, the curtains and stage tilt down toward the right. Together, these tilted forms—and the shapes, lines, and values that comprise them—act like chevron marks across the page. These oblique directions and the rising, double-arching vertical action that counters them comprise the drawing's basic design plan. The design works with the shape of the page and is as much a part of the drawing's content as the page is part of the design.

Hopper's use of bold contrasts of direction, value, and rhythms intensifies the tensions between the obliquely suspended forms. Note that Hopper increases the visual weight on the drawing's left to compensate for our tendency to sense things on the right as being heavier. Note, too, that some of the force of the various directional thrusts gains momentum from Hopper's

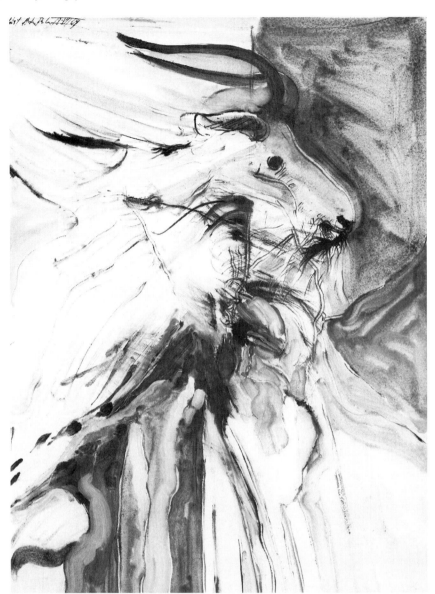

Figure 9.24
ROBERT ANDREW PARKER (1927–)
Ram (1969)
Watercolor on paper. $29^3/_4 \times 21^3/_4$ in.
The Arkansas Arts Center Foundation Collection:
Gift of the artist, 1969

consistently loose, energetic handling of the charcoal.

Although the style and handling in Parker's *Ram* (Figure 9.24) are not at all like Hopper's, both artists place moving energies high on their list of priorities. The elegant curvilinear action of the Hopper and the windswept patterns in the Parker show movement to be at

the heart of both works. One of the dependable common denominators of responsive drawing is the sense of moving energy—and consequently, of aliveness—at work in the image. Such drawings, no matter how different in style and purpose, indicate that directed actions and rhythmic play are forces that contribute greatly to both organization and expression. To more fully experience direction and rhythm at work within and among a drawing's parts, it will be helpful to analyze a few of the drawings in this book by making some drawings that extract these relationships.

exercise 9a

MATERIALS: Tracing paper, any soft graphite pencil, and any colored chalk or crayon pencil.

SUBJECT: Select any three of the drawings reproduced in this book that show strong directional and rhythmic actions.

PROCEDURE: In a three-phase progression, you will make three drawings that will extract the moving energies of the drawings you have selected. There is no time limit on these analyses, but you should try not to spend much more than fifteen minutes on each phase per drawing.

first phase Using the colored pencil, draw the directional activities first. This is done by placing a sheet of tracing paper over each drawing and selecting those straight, curved, or undulating directional actions that you regard to be the major ones—those having the most evident impact and energy. Begin by searching for those directed actions that unite parts of forms, unite interspaces and parts, and even the lines, shapes, and tones that form them. Depending on the drawings you have selected, these directed movements may correspond to the axes of forms, shapes, values, or textures. They may also be along the edges of any of these (but be careful not to turn your analysis into a contour drawing only), or they may be found in a "purer" state in various kinds of alignments. When several forms, shapes, interspaces, and so on appear to continue a direction, even though such like or unlike units may be separated in the drawing, your directional lines should continue from one to the other without stopping, as in Figure 9.25. In the drawings you are analyzing, such directional movement is felt as energy. You are making these energies visible. Therefore, try to feel the force of

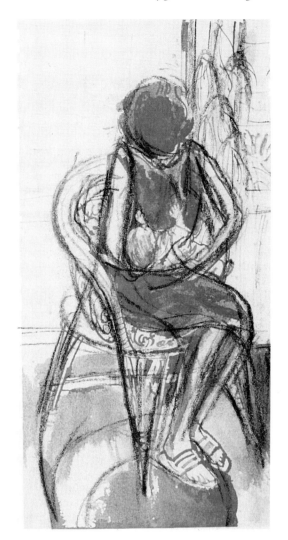

Figure 9.25

these moving energies. Although you are looking for directions that continue between larger units, you may find that directions first seen as independent ones join up with the flow of others. When a direction is conveyed by a form's edge, do not copy the contour, but draw its general character, its moving action. As in *gestural* drawing, seek out the drawing's main movements.

second phase When you feel you have established each drawing's major system of directional forces, begin to extract its rhythms, using a graphite pencil. As was mentioned earlier, the sense of rhythm occurs as repeated movements or "beats." Like all relationships, those based on rhythm can exist between any of the elements. Unlike the major directional forces that require strong

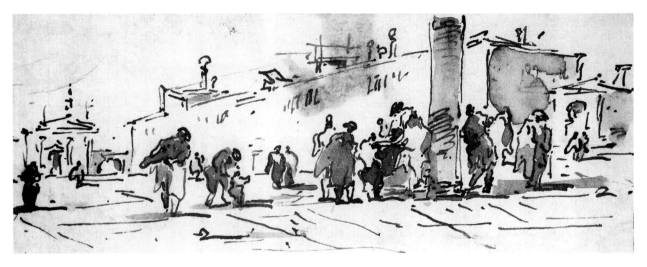

Figure 9.26
FRANCESCO GUARDI (1712–1793)
A Venetian Scene
Pen and brown ink, brown wash on cream paper.
$2^{15}/_{16} \times 7^{5}/_{8}$ in.
Courtesy of Fogg Art Museum, Harvard University Art Museums,
Cambridge, Mass. Bequest of Charles A. Loeser

or extended actions to have compositional significance, flowing rhythms are often built up by repetitions of smaller directions among the elements as well as among the major ones. "Beat" rhythms are generally seen in the spaced reappearance of any element. Sometimes both kinds of rhythm will be present in the same formations, as in Guardi's *A Venetian Scene* (Figure 9.26). Here, the figures offer a system of fence-like vertical directions that relate with other short vertical movements throughout the drawing to create a rhythm of up-and-down motions that animates the scene. Additionally, a "cadence" of small, dark and light value "beats" moves across the figures, as does a moving rhythm of wriggling lines. Notice that, collectively, the figures also form the strongest directional force in the drawing.

As you analyze each of the three drawings for rhythm, you can expect to be shunted onto a directional tract now and then. Flowing rhythms frequently merge with directional actions because both are concerned with movement, as can be seen in Figure 9.27, where rhythms and directions cannot easily be sorted out. But, because a drawing's pattern of directions is made up of major movement actions and its pattern of rhythms generally of lesser ones, we might regard the system of undulating edges of the forms in Figure 9.26 as rhythmic actions but regard the axes of the forms as directional ones. Keep the lines and tones representing rhythms general and simple, as in the

analysis (Figure 9.28B) of the rhythms of Pascin's drawing in Figure 9.28A.

Because you have been using two different sheets of paper, by placing this second analysis over the first it is easy to see which parts of the drawing emit both kinds of forces. There may be a few passages of a drawing that do not provide much of either force. Such segments may have other relational functions and will be relatively dormant as carriers of directional or rhythmic action.

third phase Now, with the reproduction nearby as your model, place a third sheet of tracing paper over the two analyses, enabling you to see them both, and, using a graphite pencil, begin to copy the reproduction. It will not matter that you may be using a medium different from that of the original. You need not go on to make an accurate copy of the drawing, but go just far enough to flesh out the forms around your extracts of the drawing's directional and rhythmic patterns. As you do, note the interrelated nature of the drawing's "what"—its figurative matter (arms, torsos, trees, drapes, etc.) with these two aspects of the drawing's "how"—its abstract design. In the best drawings, all of the elements that form the image form the design. No lines and tones are used *only* for depictive or dynamic purposes. Your goal in the third phase is to produce a version of the original that permits its directional and rhythmic qualities to be

Figure 9.33
YVONNE JACQUETTE
*Northwest View from the Empire
State Building* (1982)
Lithograph. 50³/₈ × 34³/₄ in.
Collection of Lois B. Torf

all, an area devoid of form. Only the coat hanger interrupts this enigmatic field, and, by its very ordinariness, seems to hover like a strange bird in strange foliage. Here, lines are busily engaged at both the depictive and dynamic levels in a way that calls equal attention to the subject and the life of the marks.

Picasso's *Three Female Nudes Dancing* (Figure 9.35) shows an interesting example of the "dual life" that the element of line is capable of. By drawing these figures in unconnected, rhythmic lines, Picasso calls our attention to an abstract harmony among the lines that is almost independent of their depictive relation. Despite being unconnected, the lines still suggest volume. But the shapes and planes that build these

volumes are hinted at rather than plainly declared, while the dynamic character of the lines is plainly declared instead of hinted at. This is not to suggest that these two conditions of the lines are weakly presented or confused, but rather that Picasso's plan requires such teasing suggestions and that, in fact, these two themes are engagingly interdependent. There is the *exact* degree of volume present to convey Picasso's linear motive: the simultaneous life of a line as an edge in space and as a line on paper. This idea is supported by the function of the paper's surface which, as in Sheeler's drawings, occupies several depth levels at the same time that it continues to exist as picture-plane. This dual impression of the second and third dimension (and

Figure 9.34
JASPER JOHNS (1930–)
Coat Hanger I (1960)
Lithograph. 25¼ × 21 in.
Collection of Lois B. Torf

of figural and abstract states of order) is further enhanced by the fact that there is not a single enclosed shape in the drawing. Just as we begin to sense several "shapes" forming masses, the openings between the lines remind us that we are looking at ink lines on a flat, bounded surface. But the moment we register *that* fact, the lines begin to make shapes, planes, and forms again. In this way Picasso creates a tensional life between the lines that merely descriptive lines cannot produce.

In the drawing by Wen Cheng-Ming, *Old Cypress and Rock* (Figure 9.36), we can read all the drawing's elements of line, shape, value, and texture as both flat occupants on the picture-plane *and* as forms in space. Here, there is no mark that fails to depict, act, and interact. The theme is an explosive eruption that spreads out from the center of the configuration's base. Note the clarity of the negative white shapes, and the strong rhythms activating every part of the drawing. The artist places the main thrust of

Figure 9.35
PABLO PICASSO (1881–1974)
Three Female Nudes Dancing
Pen and ink. $13^7/8 \times 10^3/8$ in.
Copyright SPADEM 1972 by French Reproduction Rights, Inc.

Figure 9.36
WEN CHENG-MING (1470–1559)
Old Cypress and Rock (Ku-pot'u) (1550)
Handscroll, ink on paper. $19^1/4 \times 10^1/4$ in.
Nelson-Atkins Museum of Art, Kansas City, Mo. (Nelson Fund)

the forms to the left of the page, countering the configuration's location on the right.

A similar strategy is used by Degas in his drawing *Three Dancers* (Figure 9.37). Located in the lower right, the figures are balanced on the page by their united, powerful thrust to the left. The visual and the physical weight of the dancer in the foreground, and the direction of the bench she is seated on, act as additional counterbalancing factors. Note that the other two dancers "run off" the page. This snapshot treatment has the effect of making us more aware of their shape-state (as well as the shapes of the several background areas) than we might otherwise be. And Degas uses shape to reinforce our sense of the second dimension. His emphasis on heavy contours intensifies their shape-state and the force of their leftward movement. This repeated use of heavy lines also serves as a unifying rhythm. Note how all the limbs stand out—a pattern of arcs moving to the left.

Schiele's *Portrait of Marie Schiele* (Figure 9.38) is a daring fusion of figural and abstract meanings. To call forward the harmonious play of the planes, patterns, and rhythms of the forms shown, the artist simply omits most of the torso. In doing so, he amplifies the abstract actions among the elements. And these shapes, lines, textures, and tones, in their animated and tactile properties and in their collective encircling action, reveal the artist's sympathetic feelings for the sitter, his mother. "Tender" and "tough" lines and tones become the graphic equivalents to the hard and soft surfaces in the subject, and serpentine lines suggest sensual undertones. Schiele, in finding engaging, graphic solutions to these form-revealing lines and tones, not only reinforces his representational message, but invents a fresh and provocative "treat" of visual themes and variations that has esthetic worth in its own right.

In Diebenkorn's drawing of a reclining figure (Figure 9.39) value shapes are the main elements in establishing the forms and the design. Again, we are made aware of the multiple activi-

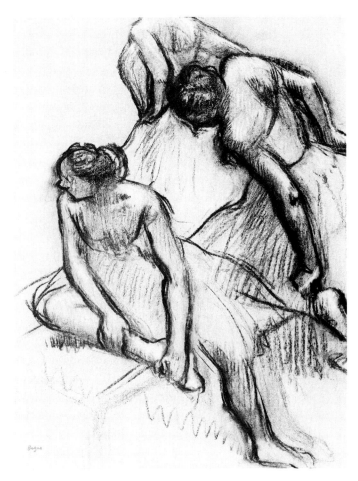

Figure 9.37
EDGAR DEGAS (1834–1917)
Three Dancers (c. 1889)
Charcoal and pastel. $23^{13}/_{16} \times 18^{1}/_{8}$ in.
Courtesy, Museum of Fine Arts, Boston
Bequest of John T. Spaulding

ties of the elements, and of their bold, two-dimensional life. The sense of volume is sometimes strikingly convincing, especially in the figure, by a great economy of means and without any lessening of vigorous dynamic actions among the elements. In the figure's upper body the lines, values, and shapes defining the forms of the head, shoulder, and breasts also enact a handsome abstract event that strongly supports figural meanings. The large white diamond shape of the light-toned portions of the figure, in contrasting with the large black rectangle in the upper right area of the drawing, poses a seemingly irreconcilable difference. But these contrasting shapes are related by their scale, their participation in directional forces forming a large X that extends from corner to corner on the

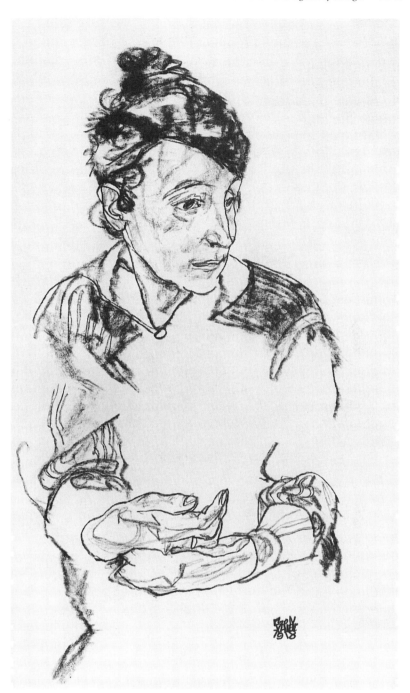

Figure 9.38
EGON SCHIELE (1890–1918)
Portrait of Marie Schiele
Black chalk.
Albertina Museum, Vienna

page, and even by their polarity in an otherwise textured and largely gray field of smaller shapes. Then, too, their differences are overcome by their respective visual weight function in the design. Neither is stabilized on the picture-plane without the other's counterbalancing action. They are also, and importantly, related in their representational function, each clarifying the other's position in the spatial field of the room. Finally, these two shapes relate by a sameness in their handling, and by black and white shape "envoys" that encircle each of these large segments. And, by appearing elsewhere in the design, these small tonal "shards" weave all the other elements together. Note, too, a secondary design theme that shows a radiating burst of di-

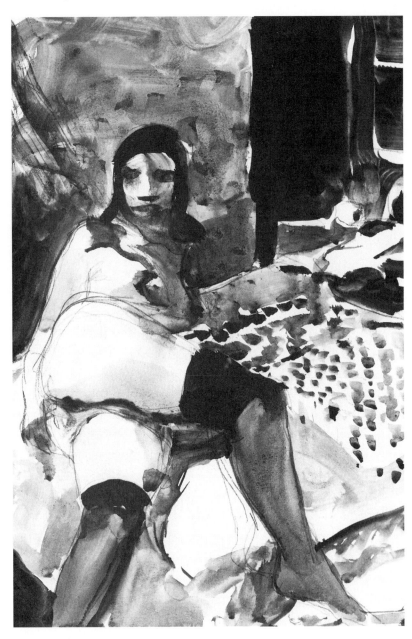

Figure 9.39
RICHARD DIEBENKORN
(1922–1993)
Untitled (1962[?])
Ink and wash on paper. 17× 12³/₈ in.
San Francisco Museum of Modern Art,
Purchased through anonymous funds and the
Albert M. Bender Bequest Fund

rections that erupt from the center of the figure's pose. As in all good designs, the arrangement of the elements here is *necessary,* not haphazard.

This necessary solution is evident again in Figure 9.40, where a balanced composition of value shapes is the primary design strategy. And, while Loring's realistic treatment of a seated figure (Figure 9.41) is in sharp contrast to Figures 9.39 and 9.40, here, too, equilibrium and unity emerge from the tonal order among the shapes. Notice, though, that Loring uses representational textures to vary *and* unify the design,

as when he echoes the stripes of the blouse and the tiny organic glyphs on the wall by similar textures in both maps on the wall.

A survey of the drawings in this book will show that the elements of every one exist on the several levels discussed. The two- and three-dimensional design of each is not the result of chance. Each tries to contain and resolve the energies within it, and in each, representational and dynamic meanings reveal an interworking accord that makes them come alive.

The following exercise consists of brief

Figure 9.40 *(student drawing)*
STEVE SASSER
Oil wash/pencil, 18 × 24 in.
Portland State University

suggestions for challenging your sense of balance and unity through the way you use the elements' ability to depict, act, and interact.

exercise 9b

MATERIALS: Graphite pencil, black chalk, brush and ink; bond, tracing, and watercolor papers.

SUBJECT: Described in exercises.

PROCEDURE:

drawing 1 Using any medium and paper, and selecting any subject, make a drawing that is contained well within the limits of the page, as in Figures 9.16 through 9.22. Begin by making a light gesture drawing that emphasizes the subject's main directional and rhythmic forces. Seeing these actions, decide on a design strategy that will utilize them. At least some of what you have extracted from the subject's actions and forms already represents a kind of subconscious design strategy. You have stressed certain relationships that other artists drawing the same view might not stress. They

might find other systems of directional and rhythmic associations that reflect *their* interpretation of the subject's arrangement. But seeing what energies have emerged from *your* responses to the subject, decide how they might best function as a major theme for your subsequent interpretation of the subject's forms and the drawing's balance and unity. As you draw, think about the role of the encircling space of the picture-plane. How far can the configuration spread on the page before its forces are too strong to be contained by the outer regions of the surface? Is there too much space? Does the image merely float on the page, leaving its empty areas unengaged? Are the shapes of the picture-plane actually part of your drawing's design? Does the image seem too heavy on one side, or seem to form a large, unanswered diagonal "supershape" on the page? In this drawing (and in those that follow) try to utilize the various kinds of relationships discussed earlier. It may be that a particular segment of your drawing requires a contrast (or sameness) of handling, scale, value, or visual weight to make it compatible with the rest of the design, or to have it strengthen or subdue another part of the design.

drawing 2 Select one of your directional analyses from Exercise 9a (or make another from one of the drawings in this book). Using the analysis as the basis for your design strategy, arrange a still life that reenacts the same general directional actions. For example, in Rembrandt's drawing (Figure 9.16) the explosive spread of its directed energies and its second directional theme discussed earlier should guide your placement of the components of the still life. Your completed drawing should suggest the same directional actions as those of the original drawing's design. Where possible, use the same medium, and even try to approach a similar handling of the materials.

drawing 3 Using tracing paper, carefully trace the major linear and tonal aspects of the Toulouse-Lautrec drawing *Equestrienne* (Figure 9.42). Turning your paper over, you will notice the reverse drawing is no longer balanced on the page. The drawing now seems to rush down toward the lower right corner. Taking any liberties you wish, make any necessary changes, additions, or deletions that you feel will balance the drawing and maintain its unity. If you wish, transfer the reversed view to a more durable paper before you begin to rework it.

drawing 4 Arrange any subject in a way that you feel suggests an interesting design plan for a *horizontal* format. The drawing should fill the page, as in Figures 5.15 and 9.32. Intentionally place a

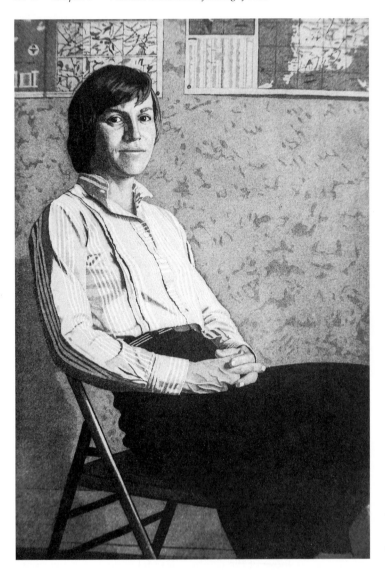

Figure 9.41
WILFRED LORING
Portrait of Pam T. (1980)
Aquatint. 24 × 16 in.
Courtesy of the artist

heavy object where it will appear in the drawing's lower right side, then counterbalance it by any combination of the basic types of relationships discussed earlier.

drawing 5 Without changing the subject or your view of the subject used in the previous drawing, draw it again to make an equally good design in a *vertical* format. Now you may need to increase or decrease the scale of the image on your page to help you develop a workable composition. Again, the physically heavy part should be located in the troublesome lower right.

drawing 6 Using line only, make a drawing that is just as active two-dimensionally as it is three-dimensionally, as in Figure 9.35.

drawing 7 Using black chalk, make a drawing in which line, tone, and texture are as active two-dimensionally as they are three-dimensionally, as in Figure 9.38.

drawing 8 Using only brush and ink (thinned with water as necessary), make a tonal drawing that is as active two-dimensionally as it is three-dimensionally, as in Figures 9.39 and 9.40.

drawing 9 Using Figure 9.29 as a rough guide, arrange a drape in any way that suggests an interesting play of directions, rhythms, shapes, and values. Working large (perhaps 24 x 30 inches or so), make a bold, twenty-minute drawing that stresses both the drape's structure and those dy-

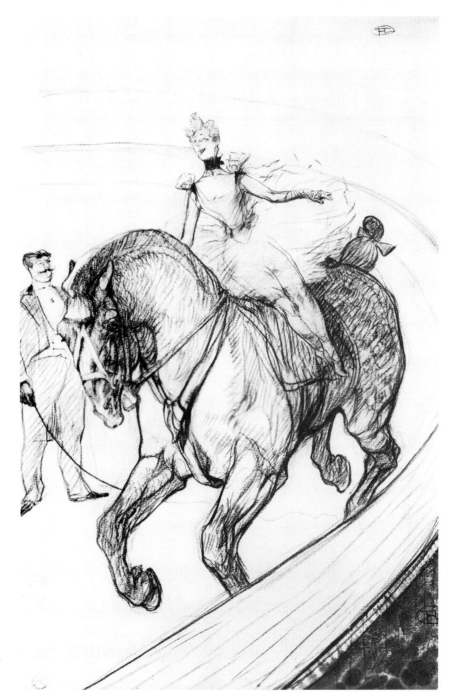

Figure 9.42
HENRI DE TOULOUSE-
LAUTREC (1864–1901)
Equestrienne (1899)
Crayon, wash. 19¼ × 12³/8 in.
*Museum of Art, Rhode Island School
of Design.
Gift of Mrs. Murray S. Danforth*

namic energies that suggest the drape's limp weight, as well as its resolution on the page.

 drawing 10 Select any drawing in this book that has a vertical format and, taking any liberties you wish with its forms, make a drawing that redesigns the image to work in a horizontal format.

You can, of course, redesign a horizontal drawing to work in a vertical format.

 In this examination of visual issues we saw that each mark adds a unit of energy to the drawing's depictive and dynamic meanings,

and that the drawing's design is dependent in part on the shape and dimensions of the page. To disregard these fundamental *given* conditions of drawing prevents our seeing the means by which an image's order and unity are achieved and its representational content is clarified and strengthened. But self-consciously planning the visual behavior of each mark is, as was noted earlier, impossible. Both judgments and feelings must negotiate the drawing's final form. The exploration of force-producing relationships can extend our responsive options in developing this final form. A drawing's visual resolution as a system of organized expression is as much the result of subconscious knowledge and need as of intentional strategy. A study of the visual means that can stimulate such knowledge, need, and strategy informs both our intellect and our intuition.

To broaden the options of both is essential, because our responses to the relational life of the elements on the page involve the same kind of comprehension that determines our responses to the subject. Increasing sensitivity to drawings as design systems adds to our perceptual skills and interests. It also adds to the expressive range of those intangibles of temperament and idiosyncrasy that meet the last requirement of a good drawing: the sense of a genuinely personal—and thus a genuinely original—view of what it is about a subject that makes us want to draw it.

10

expressive issues
the forming of meaning

A DEFINITION

A common thread through the previous chapters is the view that responsive drawings are formed as much by intuition and feeling as by intellectual motive and analysis. We *need* as much as *want* to draw in a certain way. And even our conscious intentions, our desire to make certain visual inquiries and order systems, are themselves shaped in no small part by intuitive knowing and subconscious need.

We might then further define responsive drawing as the *personal* ordering of perceptions. *What* and *how well* we draw are determined by the nature of our responses to both the visual and emotive conditions in the subject *and* in the emerging drawing, and by the character of our temperamental and creative attitudes and concepts. For some artists these concepts may be concerned mainly with visual considerations; for others, with expressive ones. But our *total* interest in a subject is always concerned, to some degree, with both. Some concepts affect the way we see the subject. Other concepts are influenced by the subject's effect on *them*. Still others affect,

and are in turn affected by, the changing states of the emerging drawing. Hence we bring certain perceptual and personal concepts to, and gain others from, each drawing. In responsive drawing, perception and conception are interdependent and mutually supporting considerations, and consequently so are the design and expressive aspects of the resulting works.

As was noted in Chapter 9, to separate the deeply interrelated issues of organization and expression risks the mistaken impression that they are independent, whereas in fact every mark added to a drawing adds to its expression as well as to its design. In the previous chapter our attention focused on the ways elements and relational energies shape and animate drawings. Here we will explore how elements and energies convey feelings and moods. But we should bear in mind that the same relational forces that express also organize.

Like the predominantly expressive lines examined in Chapter 3, *all* the elements can convey predominantly emotive themes—not only by what they depict, but through their inherent nature. That is, they can express at the depictive

and dynamic levels simultaneously. Expressively motivated lines, values, shapes, and other elements can be sensual, reserved, aggressive, sportive, and so on; they can create relationships with other

> *Genuine expressive meanings are not sought out at all, but come as a natural by-product of a genuine empathy with a subject's form and content.*

elements that stress such expressive qualities throughout the drawing. A drawing's expressive character, its emotive theme, like its design strategy, is produced through the relational behavior of the elements, beginning with the very first marks. Therefore, whether an artist tends toward themes that concern order or expression, neither theme can have universal meaning except in the presence of the other; these are fundamentally interworking concepts.

Expression, however, should not be understood as willful or arbitrary emotion. Genuine expressive meanings are not sought out at all, but come as a natural by-product of a genuine empathy with a subject's form and content. Nor must expression be understood only as passion. Expressive qualities can be contemplative, humorous, or serene.

Cézanne's sketch of two heads (Figure 10.1) is concerned primarily with the analysis and organization of volumes through a selective use of planes. Structural interests are dominant. But the search for and the satisfaction in the discovery of structural keys to an economical realization of the subject's volumes is a major source of Cézanne's excitation—and the lines express this. To be sure, the artist's study of his own features and those of his young son is influenced by his unflinching appraisal toward himself and by a more tender attitude toward his child, and the lines express this too. The authority and earnest nature of the lines reveal both the artist's depth of commitment to his visual inquiry *and* his feelings about it.

Guercino's *Head of a Man* (Figure 10.2) is not visually less active than Cézanne's drawing. Indeed, the drawing in the head has something of the same interest in planar construction, but it is more dramatically forceful. Here the lines and tones endow the man's character with some of their own energetic power. But Guercino's expressive interests are not limited to psychological or humanistic matters. He calls our attention

to the similarities of the curving movements of the collar and hair by a bold calligraphy that organizes as it expresses, and even continues such lines into the background. The cumulative energy of so many swirling lines cannot be read with the calm that is possible in viewing the Cézanne drawing. Guercino succeeds in conveying his felt impressions of the subject, but he is equally

Figure 10.1
PAUL CÉZANNE (1839–1906)
*Sketchbook: Self-Portrait and Portrait of the Artist's Son,
Chappuis 615* (1878–82)
Pencil, stains. 21.7 × 12.4 cm.
*Collection of the Art Institute of Chicago. Arthur Heun Fund.
Photograph © 1996, The Art Institute of Chicago. All Rights
Reserved.*

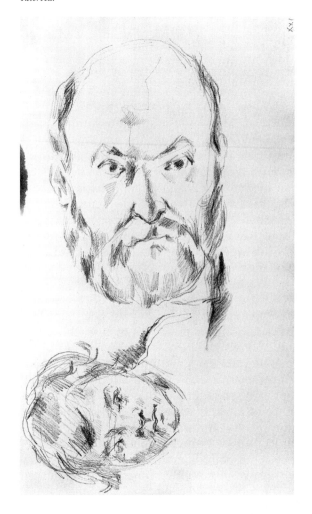

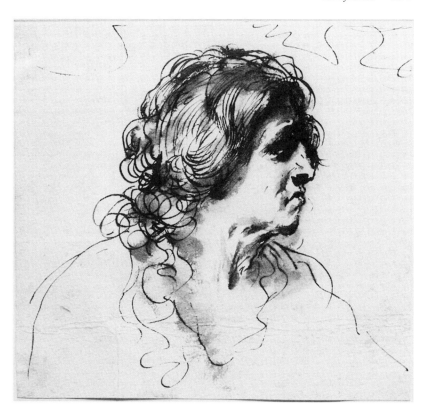

Figure 10.2
GUERCINO (1591–1666)
Head of a Man
Pen and brown ink, washed, on
paper. 13.7 × 15.2 cm.

successful in creating a field of strong visual and expressive energies. The man *and* the marks that depict him both express strength, authority, and intensity. The drawing's design supports its expressive theme.

Again, in Kollwitz's drawing (Figure 10.3), dynamic energies reinforce expressive (and organizational) matters. The artist's first drawing of the woman's head (upper left) is a more objective recording of what she saw. It may even be a more faithful likeness than the larger version, but it lacks the latter's assertive modeling and emotional impact. Perhaps Kollwitz also decided that the first drawing did not express her feelings fully, for the second one is a far more powerful evocation of a weighty head surrendered to exhaustion. The bolder value changes, the more ruggedly carved planes, and the sensitivity to gravitational pull all help to make it so. Organizationally, the diagonal alignment of the two heads, generating a pull toward the lower right corner of the page, is countered by our prior knowledge of which way these heavy forms would move if not supported by the unseen plane that supports them. Then, too, the higher a form is on the picture plane, the more visual weight it generates, and the smaller

head's higher location adds to its role in providing weight on the left side. This is a good example of visual weight and physical weight holding each other in check, as Figure 10.4 illustrates.

For Rembrandt, design and expression are not only inextricably fused considerations—they are almost always equally active properties of each form he draws. His drawing *Young Woman at Her Toilet* (Figure 10.5) strongly conveys his equal interest in order and empathy.

Visually, the alternating light and dark tones that splash across the page produce a bold design by their contrasts, movements, and tensions. The oblique direction of the two figures is countered by the direction of the two large dark masses of tone, subtly repeated in the seated woman's folded arms, in some of the folds in her skirt, and in the sloping shoulders of both figures. Radial energies beginning in the hand of the seated figure seem to give the flower-like shape of her configuration the power to "hold off" the enclosing dark tones. The similarity between the positions of the arms of both women, and the slashing, downward brush strokes at their waists, unify and animate the two figures while, in becoming lost among the dark tones on the right and in adding visual weight to the left

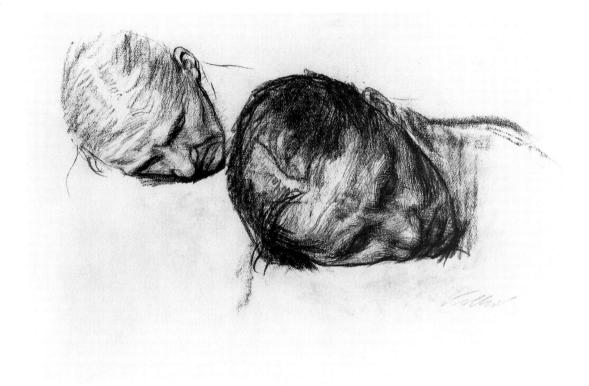

Figure 10.3
KÄTHE KOLLWITZ (1867–1945)
Two Studies of a Woman's Head (c. 1903)
Black chalk. 19 × 24³/₄ in.
The Minneapolis Institute of Arts. Gift of David M. Daniels, 1971

side, they unify and animate the drawing. Note how the light tones, flowing down through both figures toward the lower right corner, enter the foreground and sweep to the left, rising along the left side of the page to begin the cycle of ac-

tion again. This is not a placid design. Its overall stability is based on barely contained forces of considerable power.

Expressively, the design is no less powerful. The energies creating the visual activities

Figure 10.4

are, of course, themselves expressive forces. But there is another emotive quality that pervades this drawing. An ordinary domestic scene is here transformed by an atmosphere of expectancy. The light does not merely illuminate the women, it dignifies them, giving their forms and actions an indefinable grace and importance. This almost spiritual presence is created as much by the nature and behavior of the elements as by the depictive matter. The sudden shock of value contrasts, the bold sonority of the tonal shapes, the controlled turbulence of the lines, and the sweeping directions result from Rembrandt's intuition and empathy. A largely subconscious need and knowledge led him to believe that such harmonies and contrasts, at

Figure 10.5
REMBRANDT VAN RIJN (1606–1669)
Young Woman at Her Toilet
Pen, ink and wash. 23.8 × 18.4 cm.
Albertina Museum, Vienna

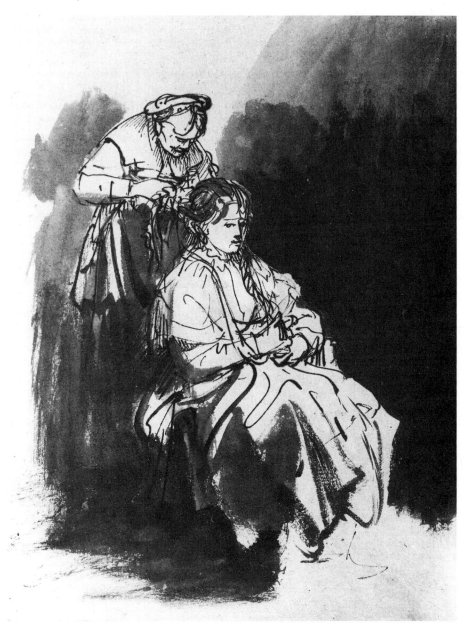

play among such forms, could generate just such a transcendental mood.

The interplay between the formal and expressive dynamics of drawing can be seen even in our reliance on expressive terms for describing visual issues (as in Chapter 9, and in our foregoing analyses of Figures 10.3 and 10.5), while expressive themes are conveyed by describing the visual behavior of the elements. To better understand the expressive nature of the elements, let us examine each of them in several moods.

THE ELEMENTS AS AGENTS OF EXPRESSION

Line. Although the expressive use of line has already been discussed, it will be helpful here to see some clearly different expressive states of this key element. In Figure 10.6 the five groups of lines shown, while not representative of its entire expressive range, do demonstrate some general types of expressive line. Group A are slow, earnest, and searching lines. As in Pascin's drawing (Figure 3.15), they are sensual and tactile. Group B are bold, energetic lines. Playful, sensual, or urgent, they are fast-moving, even frenzied, as in Van Gogh's drawing (Figure 3.34) or Guercino's (Figure 10.2). The harsh, slashing lines in Group C are aggressive, even explosive. Sometimes, as in Matisse's drawing (Figure 4.27), their thickness and the density of their clashing assaults on each other form tones. Group D are gentle, caressing lines. Not as slow and precise as Group A, or as animated as Group B, they move gracefully, as in Picasso's

drawing (Figure 3.18), or in the late Kamakura Period drawing (Figure 8.20). Group E are relatively mechanical and businesslike, but suggest certainty. They can be cold, as in Sheeler (Figure 9.30); delicate, as in Saenredam (Figure 5.7); or show a surprising energy and warmth, as in Papo and Goodman (Figures 3.8 and 3.29).

But few drawings are restricted to only one kind of expressing line. As was noted in Chapter 3, a line begun in one emotive mode can end in another. For example, note the differing kinds of line in Figure 10.5, and those that change character as they move. Of course, any kind of line can be used to enhance expressive meanings. Depending on the context in which a line occurs, even a short, straight line can evoke powerful expressive meaning. In another Kollwitz drawing *Woman Seated with Folded Hands* (Figure 10.7), the slight, short charcoal stroke depicting the woman's mouth more eloquently reveals the woman's purse-lipped, introspective mood than any extensive rendering of the lips could. The "knife-slit" nature of the line intensifies the artist's expressive intent. It not only depicts the gesture, it enacts it.

The Kollwitz drawing also conveys its mood through shapes and values that evoke feelings. The black cast shadow that "overshadows" the rest of the drawing is not large, dark, and unfocused by chance. Its dominance in the drawing is expressively necessary. Kollwitz seems to suggest it as a symbol of tragedy. Our universal apprehension of dark, unknown, ghost-like forms is awakened by the shadow. Kollwitz blurs its sharply defined and blackest segment with an outer dark tone, further suggesting an apparition-like presence in shadow.

Figure 10.6

A B C D E

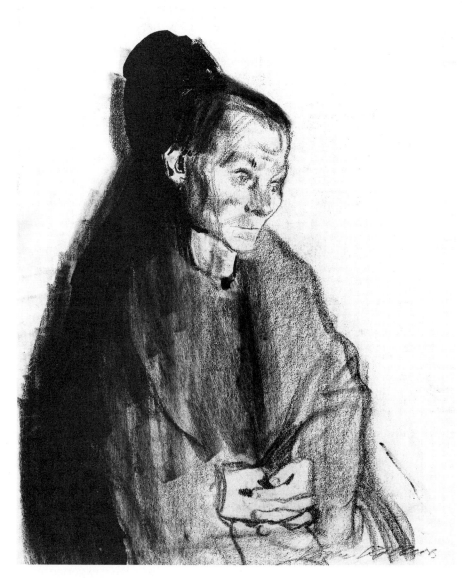

Figure 10.7
KÄTHE KOLLWITZ (1867–1945)
Woman Seated with Folded Hands
Charcoal touched with India ink. 24½ × 18¾ in.
Courtesy, Museum of Fine Arts, Boston. Helen and Alice
Colburn Fund

The woman's right shoulder, almost lost in shadow, seems to be caressed by the broad strokes of dark tones that fuse the woman to the cast shadow. All of the drawing's shapes, and the lines that define their edges, flow toward the shadow as if attracted to it by some force. Only the folded hands, their stark whiteness contrasting with the shadow, seem free of this attraction. This directed movement, whether supplied by

the artist's intellect or intuition, seems necessary to the drawing's expressive meaning. To adapt an old saying: "Expressive need (like love) finds a way."

In this drawing the relational energies of the elements, their differences of scale, weight, and location, and their various directional, rhythmic, and tensional forces are in strong alliance with the artist's expressive goal. Direc-

tions and moving rhythms leading from all parts of the figure to the cast shadow's "head" amplify the opposing direction of the woman's gaze—a countering action as necessary to the drawing's design as to its mood. The sense of the woman's fragility, relative to the ominous dark shadow, adds strength to the emotive force of both, while the ambiguity and tension in the fusing of their forms are equally necessary to the drawing's order and emotive tenor.

Shape. Like line, shapes conform to general types. In Chapter 2, we saw that all shapes can be finally grouped into two basic categories: geometric and organic. These categories are too general in discussing expressive uses, however. Figure 10.8 shows five groupings that typify some frequently used shapes. Those of Group A are stately; when oriented on vertical and horizontal axes they are stable shapes that suggest a dignified or calm air, as in Seurat's drawing (Figure 4.28). In Group B the shapes are active, agitated, and rather complex. Their action is strongly directional, but it is largely contained within the animated behavior of the shape itself. Rembrandt's and Guardi's drawings (Figures 4.15 and 9.26) show the intense activity of this type. The shapes of Group C are rhythmic and sensual in their movements. They may suggest fast motion, as in Renoir's drawing (Figure 2.31), or, when more convoluted, slow movement, as in Schiele's drawing (Figure 9.27). The angular, jagged shapes of Group D are active, even explosively so, as in another Schiele drawing (Figure 3.16), or Wen Cheng-Ming's drawing (Figure 9.36). Group E are relatively stable shapes and suggest slow or weak movement. They have a rather firm, dependable feel, as conveyed in

Holbein's and Picasso's drawings (Figures 8.6 and 8.12).

As in the case of line, all shapes are emotive, including those that combine different type characteristics. In Seligman's drawing *Caterpillar* (Figure 10.9), undulating and angular shapes struggle and resist each other but are united by the design's rhythmic strength. The absence of sudden or extreme value changes and the precise, restrained handling suggest a quiet contest rather than a dramatic struggle. As this example indicates, some of a drawing's expressive character is revealed by the nature of the shapes, and some by their collective behavior.

We should recognize that shapes, or any of the other elements, may clarify or conflict with a drawing's representational dynamics—the action and character of its identifiable forms. Where the things depicted are to be understood as stilled, as, for example, in a drawing of a sleeping figure, the presence of many shapes such as those in Groups B, C, or D of Figure 10.8 would work against the sense of stationary forms. Those in Groups A and E would tend to support such a stable and arrested state of motion.

The four arrangements in Figure 10.10 show a few of the limitless possibilities for shapes' expressive activity. Those in A move toward a common point in the design, as in the Kollwitz drawing (Figure 10.7). In B, the upper, active shape appears about to attack the placid one below, while the shapes in C seem to strain toward each other. Notice the sense of tension at the point of impending contact in these arrangements. In B and C there is also tension between the shapes themselves. We experience a back-and-forth recognition of each shape's situation. The shapes in D unite in a circular move-

Figure 10.8

A B C D E

Figure 10.9
KURT SELIGMAN (1900–1962)
Caterpillar
Varnish, black crayon and wash on white paper.
28 × 22 in.
Courtesy of Fogg Art Museum, Harvard University Art Museums,
Cambridge, Mass. Bequest of Meta and Paul J. Sachs

Figure 10.10 **A** **B** **C** **D**

ment around the page. Shapes engaged in such rotating actions can generate strong emotive energies, as in Ingres' drawing (Figure 9.29) or in Munch's lithograph (Figure 10.11).

Volume. The expressive nature of volumes is revealed by their weight and scale; by their physical characteristics, which, like those of line or shape, range from the passive and stilled to the aggressive and active; and by the nature of their interaction with other volumes. In Figure 10.12, the types of volumes in A (and the shapes of the planes that form them) combine in a balanced arrangement of great stability. In B the same volumes, rearranged, create tensions and instability. Volumes possessing complex contours, such as those in Leonardo da Vinci's drawing of heads (Figure 3.5), often take more time to understand than those with more simple contours. Although such complex drawings may convey strong expressive force, they may lack the immediate impact of drawings showing simpler contours such as those in Picasso (Figure 8.8), or Goya (Figure 10.13). Like the volumes in the Picasso, gently rounded forms, especially when they are simple and delicately modeled, can more directly express gentleness or quietude. When more angular in nature, and especially when harshly carved, they will suggest more aggressive states, as in the Goya.

The volumes in Lebrun's drawing *Kneeling and Standing Figures* (Figure 10.14) behave somewhat like those in Groups A and B of Figure 10.12. Compare the relative stability of the figure on the left with the tumbling forms of the figure on the right. In this provocative drawing, Lebrun uses sharp, slashing lines, brooding tones, slow-moving shapes, and ponderous volumes, each of which contributes to the drawing's haunting atmosphere of both coarse and spiri-

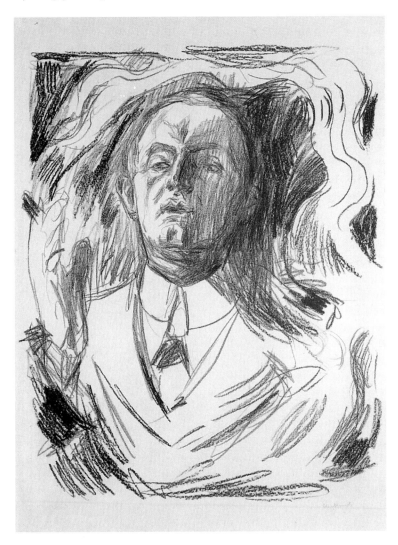

Figure 10.11
EDVARD MUNCH (1863–1944)
Self-Portrait with a Cigarette
Lithograph. 22$\frac{1}{8}$ × 18 in.
The Dial Collection

tual forces. But it is the strange floating quality of these heavy forms that is most provocative. This becomes evident if the drawing is turned upside-down. Now with the volumes less "readable," the drawing's overall mood is somewhat lessened.

Reducing the impression of physical weight and structure can itself be an expressively powerful tactic. In Mazur's drawing, *Study for "Closed Ward Number 12"* (Figure 10.15), the skeletal-like forms of the figure and the chair are sometimes left open to fuse with other parts of each other and the page, lessening

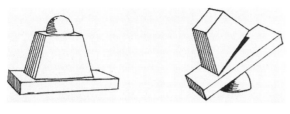

Figure 10.12

the impression of volume. The resulting angular "shards" of harsh and torn shapes, their clashing directions, and their overall pattern of angularity, as well as the intense light and shadow they produce, suggest at the abstract level the same desolate mood conveyed by the depictive content.

Again, in Polonsky's monoprint *Child with*

Figure 10.13
FRANCISCO DE GOYA (1746–1828)
Peasant Carrying Woman
Sepia wash. 20.5 × 14.3 cm.
Courtesy of The Hispanic Society of America, New York

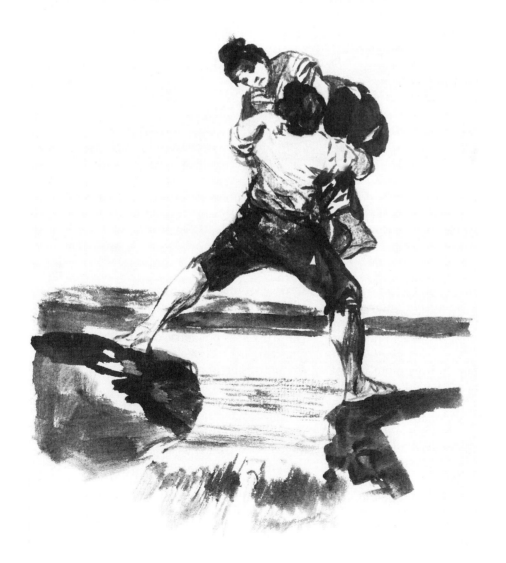

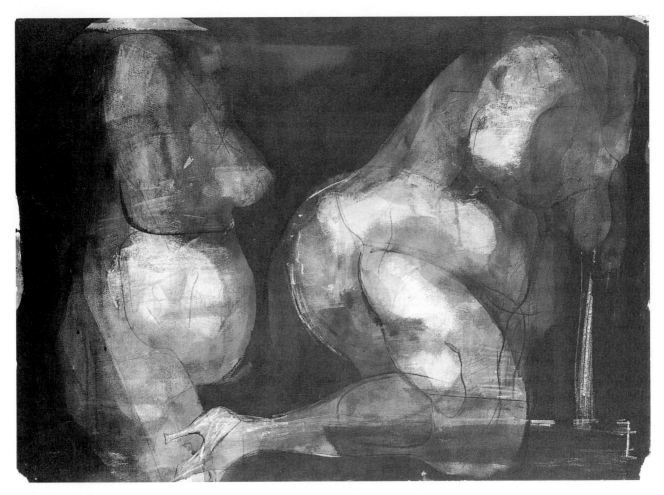

Figure 10.14
RICO LEBRUN (1900–1964)
Kneeling and Standing Figures
Brush and ink. 27⁹⁄₁₆ × 39¹⁄₂ in.
Philadelphia Museum of Art. Given by Dr. and Mrs. William Wolgin

Rat (Figure 10.16), dulling the subject's structural facts sharpens its expressive tenor. Here, the psychological contrast of a pensive boy nestling a giant and somewhat agitated rat in his arms is intensified by the artist's gentle treatment of the child's forms and his more urgent handling of the rat. The elements that form the boy all suggest stability and graceful rhythms. In the rat, the elements, especially texture, and the relational energies, especially those based on directions and physical and visual weights, suggest unrest.

But a volume's weight can be a powerful expressive force. We are not usually conscious of the force of gravitational pull unless we sense its absence, or unless it suggests danger. Vespignani relies on our appreciation of the meaning of its force in his drawing *Hanged Man* (Figure 10.17). The artist does not abuse our sensibilities by emphasizing the victim's agony, or by exaggerating the impression of heavy volume. Here, to our relief, volume is somewhat subdued. The implications of its weight are clear enough. Instead of a sensational description of one man's execution, Vespignani asks us to consider the indignity and tragedy of a person as a thing. Here, the expressive meaning points to humankind's universal inhumanity. The victim's isolated, labeled, and broken body is felt as an obscene act, a senseless loss rather than a repellent sight.

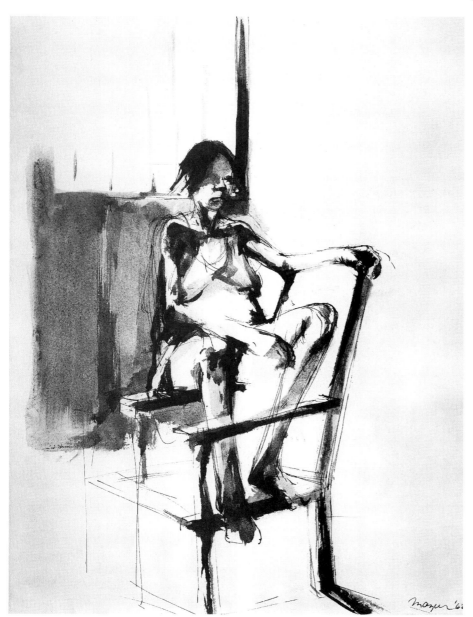

Figure 10.15
MICHAEL MAZUR (1935–)
Composition study for "Closed Ward Number 12" (1962)
Brown wash, brush, pen and ink. 15³/₄ × 19¹/₂ in.
Collection, The Museum of Modern Art, New York
Gift of Mrs. Bertram Smith. Photograph © 1997 The Museum of
Modern Art

Vespignani intentionally keeps the divisions of the page simple. There is even some ambiguity between the second- and third-dimensional state of the background. This has the effect of frustrating our wish to concentrate our attention elsewhere on the page; only the figure provides a visually logical and "comfortable" haven (and thus, an additional irony). The absence of a single white tone beyond the figure casts a gloomy pall over the entire scene, its stillness conveyed by the simple, block-like character of the design's large divisions. The

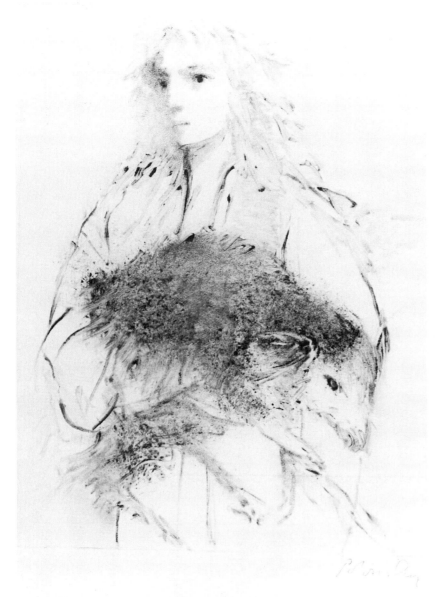

Figure 10.16
ARTHUR POLONSKY (1925–)
Child with Rat
Monotype. 9 × 12 in.
Courtesy of the artist

most active movement is in the oblique edge of the shadow, pulled away like a curtain. The figure's overall light tone, and the thin dark tones upon and around it, in being both lighter and darker than any other tone in the drawing, further isolate the figure and call our attention to it. Vespignani contrasts the simple purity of the man's forms with the clothing's tangled state and with the harsh, scarred and lettered poster. The awful stillness of the figure is intensified further by this contrasting activity of the lines, shapes, values, and textures upon it.

Texture. Textures, too, carry expressive meanings. The possible kinds of textural activity in drawing are unlimited, but all can be divided into two basic categories. There are the textures meant to represent the surfaces of forms or areas such as skin, grass, silk, or cement (Figure 9.41), and those resulting from the nature of a particular medium such as ink or charcoal (Figure 10.7). The former are illusions, the latter, facts. These two kinds of texture are not mutually exclusive, and many drawings show them allied in the pursuit of the artist's expressive purpose, as in Figures 10.2 and 10.16. Sometimes textures are

controlled and regularly patterned as in Figure 9.30, and sometimes they are very active and spontaneous, as in Figure 4.2.

The textural life of volumes can be highly expressive, as in Leonardo da Vinci's drawing of stratified rock (Figure 6.14). The expressive role of a medium's texture can be seen in another da Vinci drawing, *A Storm over a Mountain and a Valley* (Figure 10.18). Here the chalk's rough texture helps to suggest the charged atmosphere. The rugged grain of the chalk's particles envelops the components of this panoramic scene in tones that unify them and evoke the feel as well as the look of a rainstorm.

Leonardo utilizes the expressive power of textures throughout the drawing in creating its tumultuous mood. He divides the page into four horizontal bands of differing textures. First, the storm clouds' churning turbulence is in marked contrast to the straight lines of the rain that form the second band of texture. Below this, a generalized impression of the distant town is suggested by the short vertical and horizontal lines, by the trees, and by lines describing the letter C at various angles. Finally, the looser, complex texture formed by the circular lines, structural hatchings, long and rhythmic curved lines, and small, block-like forms conveys the impression of the rolling hills of the foreground. The drawing's turbulent mood is emphasized by the top and bottom bands of texture. Both suggest strong curvilinear movements that "bracket" the area of the storm, adding dynamic pressures to meteorological ones.

When a medium's texture is compatible with the textures it describes, emotive force is increased. In Bloom's drawing *Forest #1* (Figure 10.19), the naturally fine lines and small interspaces of dense pen-and-ink hatchings are in accord with the artist's emphasis on the texture of leaves, bark, and branches. The mysterious mood of the forest, enhanced by the stress on its wild, dense web of flora, is further amplified by the dense and vigorous web of the lines themselves. But note how well Bloom organizes this "disordered" scene. Subtle associations and patterns of large and small, light and dark, simple and complex, and straight and curved segments provide harmonies, contrasts, and movements that unify the image. And by subtle modifications of some textures, tones, and forms, the artist suggests some barely discernible hints of strange forms hidden among the shadows and

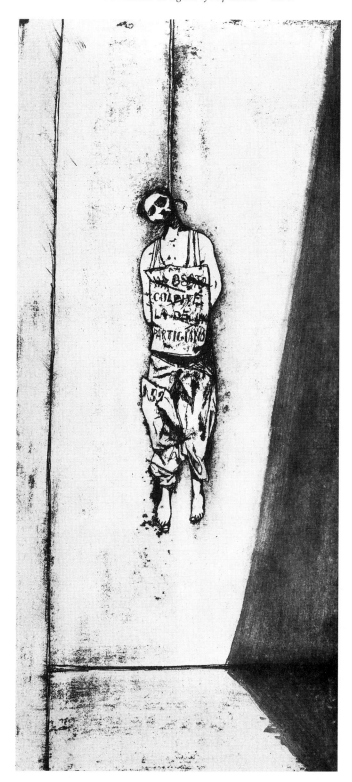

Figure 10.17
RENZO VESPIGNANI (1924–)
Hanged Man (1949)
Pen and ink, wash. 15⁷/₈ × 7¹/₄ in.
Collection, The Museum of Modern Art, New York. Purchase
Photograph © 1997 The Museum of Modern Art

Figure 10.18
LEONARDO DA VINCI (1452–1519)
A Storm over a Mountain and a Valley
Red chalk. 19.9 × 15 cm.
Royal Collection, Windsor Castle

branches. These passages add to the sense of the forest's forbidding but enchanting mood.

Value. We have seen value's power as an agent of expression in most of the drawings in this chapter. Values are bolder and more charged with energy when drawn with abrupt changes between them, as in Mazur's drawing (Figure 10.15). They evoke more dramatic or brooding moods when such changes involve large areas of dark tones, as in the Rembrandt and Bloom drawings (Figures 10.5 and 10.19), or when forms emerge from dark backgrounds, as in Figure 10.14.

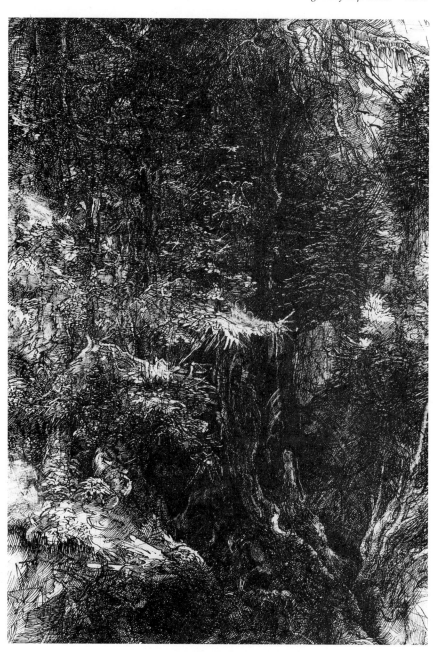

Figure 10.19
HYMAN BLOOM (1913–)
Forest #1 (1971)
Pen and ink. $23\frac{1}{2} \times 18\frac{1}{2}$ in.
Collection of Mrs. Sophie Goldberg
Courtesy of the artist

Again, in Courbet's *Landscape* (Figure 10.20), intensity of light has dramatic impact. The value variations are gradual, but the framing of a large square of light tones by the darker trees and their cast shadows makes the light on the trees and field within this frame radiate an intense glow.

Just the opposite tonal arrangement is used by Goya in *Al Mercado* (Figure 10.21), but the child's upturned face is made to radiate light by the surrounding dark tones. The virtual ab-sence of moderating gray tones gives this draw-ing an air of intensity and drama, which is heightened further by the harsh, dark cast shad-ows. Here the shapes match the values in bold-ness, adding to the drawing's sense of ex-pectancy.

The expressive force in the shock of strong value contrasts is seen in Raffael's *Eagle* (Figure 10.22), where the dark, hooked shape of the ea-gle's head and neck (echoed in the shape of the eagle's upper bill) suggests the animal's power

Figure 10.20
GUSTAVE COURBET (1819–1877)
Landscape
Black chalk. 19 × 30.5 cm.
Museum Boymans-van Beuningen, Rotterdam, the Netherlands

Figure 10.21
FRANCISCO DE GOYA (1746–1828)
Al Mercado
Brush and wash. 20 × 14 cm.
Prado Museum, Madrid

Figure 10.22
JOSEPH RAFFAEL (1933–)
Eagle (1972)
Watercolor over pencil, framed with pencil lines
on white coated poster board. 35.6 × 55.8 cm.
Private collection

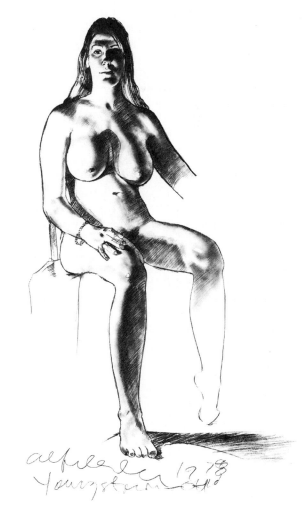

Figure 10.23
ALFRED LESLIE (1927–)
Untitled (1978)
Graphite on paper. 40 × 40 in.
The Arkansas Arts Center Foundation Collection: The
Barrett Hamilton Acquisition Fund, 1982

and grace and alludes to its unseen claws. Although the original work shows some washes of color, it is in the dramatic impact of the near-black and white contrast of tones that the drawing gains its main emotive strength. When such extreme value contrasts work to suggest the effects of a light source, then light itself becomes an agent of expression as in Figure 10.23. When the impression of illumination is conveyed by gradual tonal changes, such changes can not only suggest volume and space with great clarity, but suggest a mood of introspection and serenity, as in Murch's sensitive study (Figure 10.24). That value can transform a rather ordinary subject into an extraordinary expressive vehicle is seen in Bravo's *Package 1969* (Figure 10.25). The dark background, the brooding planes, and the flashes of light, against which the two stately white ropes ascend, set the stage for provocative metaphors.

Figure 10.24
WALTER MURCH
Study for "The Birthday" (1963)
Pencil, wash, and crayon on paper. 23 × 17½ in.
Collection of Whitney Museum of American Art, New York. Purchase, with funds from the Neysa McMein Purchase Award

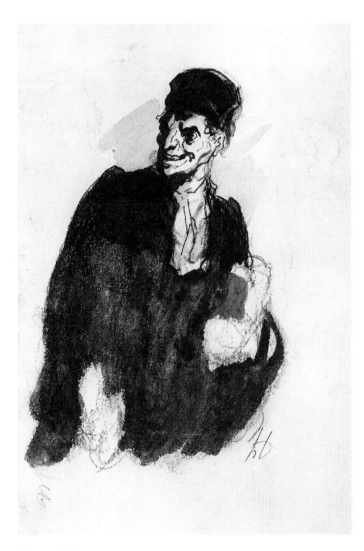

Figure 10.33
HONORÉ DAUMIER (1808–1879)
The Lawyer
Black chalk, pen and wash. 20.7 × 13.9 cm.
Museum Boymans-van Beuningen, Rotterdam, the Netherlands

ume develops until finally, in the head, structured volume is strongly conveyed.

By making the figure's shoulders and head the most convincingly three-dimensional of the forms, by placing the strongest value contrasts here, and by a provocative, somewhat caricatured expression of the face, as well as by the animated quality of the lines and tones that produce it, Daumier fixes our attention on this part of the drawing. The broader, lighter, and flatter character of the drawing's lower half contributes to the crescendo of attention upon the lawyer's malicious smile and the loose, energetic handling helps to convey the impression of his movement. Although we do not see his legs, the figure's overall tilt and the "windblown" nature of the shapes and tones suggest that he is walking quickly. Notice that the head, although its structure is more fully developed than that of any other part, is no less vigorously drawn.

As this drawing demonstrates, the commitment to a particular expressive attitude, partly reflected in a drawing's handling, is important. The best drawings always show such a consistent expressive strategy.

Another drawing by Daumier, *The Song* (Figure 10.34), shows a consistency of intent sustained throughout a more extensively developed work. As in the previous drawing, facial features (and the body of the centrally placed figure) are slightly caricatured.

subject in a manner not unlike Andrieu's treatment. Again, structural lines, block-like masses, and bold, tonal modeling help suggest the artist's emotive theme.

In Daumier's drawing *The Lawyer* (Figure 10.33), shapes and masses are simplified, but not to increase the sense of weighty mass. Here they cause a steady *lessening* of volume, as we read the drawing from top to bottom. In fact, covering the top half of the drawing shows the remainder quite without any suggestion of structured mass. Instead, the lower half of the image seems to suggest torn, ruffled value shapes. The further up we look, the more vol-

Here, contrasts of value are intensified, creating a strong light that plays across the group, boldly sculpting the forms as it gives them a sense of dramatic importance. Daumier deletes all extraneous detail. The clothing and hands of the figures are broadly stated. The background is simply a darkened spatial container for the group. The facial features are developed with a strong interest in the details of careworn folds and wrinkles. Daumier's sympathetic treatment of these weathered faces, temporarily enlivened by drink, suggests that the group's impromptu song is as sudden and as temporary as the intense light is to the darkened

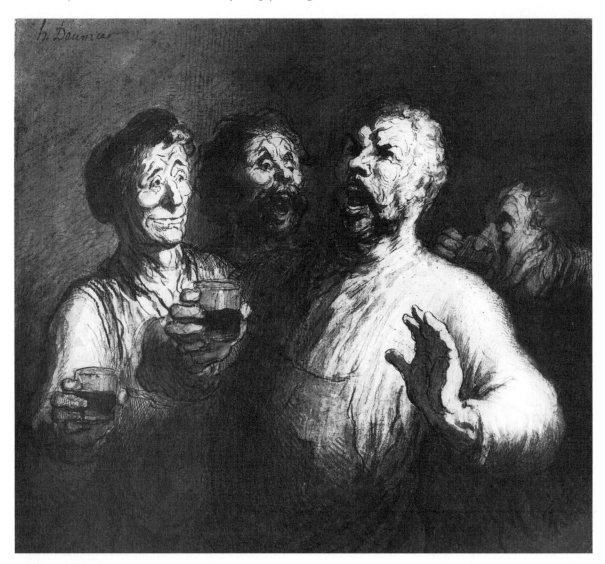

Figure 10.34
HONORÉ DAUMIER (1808–1879)
The Song
Black chalk, pen and black ink, gray wash, and
watercolor. $9^5/_{16} \times 10^7/_{16}$ in.
Sterling and Francine Clark Art Institute, Williamstown, Mass.

scene—that the usual state of both is more somber.

Note how the artist combines light and dark tones with clear and vague edges to help guide us to areas of emphasis. Notice also how the thick, rounded character of the forms, whether of a body or a finger, is everywhere the same. Even the volume-summary of the group itself forms a monumental, rounded half-sphere, its curved upper edge conveyed by the arc of the heads.

Daumier's mastery of facial expressions is evident in these four faces. The lines and tone of each not only model form, they also enact the gestures that animate these faces. Note especially the pulling action of the eyebrows and folds of the forehead of the man on the far right. There is not a line or tone that does not convey the drinking action. The shapes, forms, and directions of the head even suggest the movement of the head backwards. Such eloquently expressed human actions do not emerge merely

from patient scrutiny, but from perceptions and memory influenced by humanistic interests.

As Daumier's and Leslie's (Figure 10.23) drawings indicate, light can be a strong agent of expression. Rembrandt's mastery of light's emotive force is evident in his brush drawing *Girl Sleeping* (Figure 10.35). Despite the spontaneous and largely linear handling, Rembrandt's pro-

found grasp of structural essentials enables him to suggest planes turned toward and away from a strong light source, falling from the upper left side. The unusual intensity of this light, especially when seen against the retreating dark tone in the upper left corner, suggests a supernatural presence. The brush strokes appear to hover between a linear and tonal role, their spirited ab-

Figure 10.35
REMBRANDT VAN RIJN (1606–1669)
Girl Sleeping
Brush and wash. 24.5 × 20.3 cm.
Reproduced by courtesy of the Trustees of The British Museum,
London. Copyright British Museum

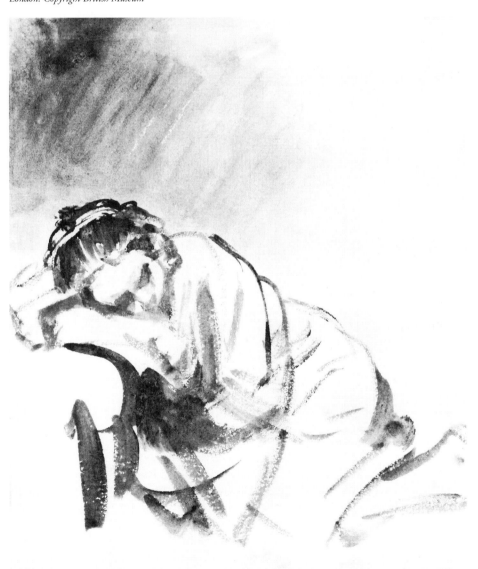

Figure 10.36
GEORGE GROSZ (1893–1959)
Trees, Wellfleet, Cape Cod
Charcoal, ink and watercolor. $19^5/8 \times 15^3/8$ in.
© *1997 The Cleveland Museum of Art. Purchase, John L. Severance Fund*

stract energies transforming the girl and her bed into swaying, restless lines and shapes that contradict her passive state. This contrast between her inaction and the driving energy of the elements also suggests that the forms are being acted on by some force.

The influence of felt responses on perception and strategy can be seen by comparing the different expressive moods of three drawings of trees. Figures 4.9, 4.10, and 4.11 show increased states of departure from studious objectivity toward more emotionally conceived images. Still another emotive theme emerges from Grosz's *Trees, Wellfleet, Cape Cod* (Figure 10.36). The rugged forms and tortuous movements of the trunks and branches; the occasional silhouettes,

shaded areas, and gray tones of the pine needles and grasses; even the misty tone of the page—all allude to a somber melancholy.

A more forceful handling of any approach to drawing intensifies its expressive force. The kinds of lines and tones in Grosz's drawing, and the drawing's somber state, when carried further can be powerful indeed, as Baskin's *Tormented Man* (Figure 10.37) indicates.

But recognizable subject matter is not necessary to strong emotive force. Kline's *Untitled* (Figure 10.38) and Lotz's *Illuminated Coils* (Figure 10.39) reveal how keenly these artists feel and reflect the forms and mood of their inner world.

Although in examining these drawings we have been concentrating on expressive factors, it must by now be evident that the artist's organizational and expressive interests are deeply interlaced matters, and that any drawing action generally involves both considerations. However, recognizing the differences between selections and changes based on formal visual issues and those that serve expression helps us to govern and integrate both kinds of response.

The drawing exercises that follow are intended to help you experience the role of the elements, of media, and of distortion in conveying expressive meanings.

Figure 10.37
LEONARD BASKIN (1922–)
Tormented Man (1956)
Ink. 39^1/$_2$ × 26^1/$_2$ in.
Collection of Whitney Museum of American Art, New York.
Purchase, with funds from the Living Arts Foundation Fund

Figure 10.38
FRANZ KLINE (1910–1962)
Untitled (1960)
Ink on paper. 8^1/$_2$ × 10^1/$_2$ in.
Collection of Whitney Museum of American Art, New York. Gift of Mr. and Mrs. Benjamin Weiss

Figure 10.39
STEVEN LOTZ
Illuminated Coils (1974)
White chalk on black paper. 24 × 34 in.
Collection of the author

exercise 10a

MATERIALS: For drawings 1 through 4: pen, ink, and chalk; no media restrictions on the remaining exercises.

SUBJECT: The human figure, landscape, still life, and imagined images.

PROCEDURE: Genuinely felt responses to a subject cannot usually be summoned on demand, and there is no really adequate substitute for such sincere reactions. The best way to utilize expressive strategies must, of course, occur before subjects that strongly engage your feelings. But, here, by aiming pairs of drawings toward clearly opposed expressive goals, you may, if you can enter into the spirit of these differing goals, invest them with some degree of meaning, and begin to experience new attitudes toward the uses of the elements, your media, and the devices of distortion or exaggeration.

There are no time limits on any of the following drawings. Except for the first four drawings, you can use any medium (or combination) you wish, on any suitable supports, of any desired size or shape. Because of a medium's influence on a drawing's emotive nature, it is advisable to vary these, but in each drawing the primary considera-

tion in selecting a medium should be its compatibility with your expressive goal.

drawings 1 and 2 Using a nude or simply clad model as your subject, make two drawings of the same pose, from the same position. In drawing 1, use pen and ink and any suitable paper 10 x 14 inches. Your expressive goal is to depict the model as passive, at rest. Try to convey a sense of tranquility and stillness. Here (and in *all* of the drawings in Exercise 10a), consider an overall design strategy (before you begin to draw) that you feel will emphasize your meaning. Because expression is conveyed by the elements as well as the character of the forms they produce, think about their use before getting started. A tentative, general plan should of course be based as much as possible on responses to the subject. In all of the drawings from the model, the subject should include at least some of his or her immediate environment. Once you begin, however, do not feel bound by any prior strategy but let any visual or expressive ideas or opportunities suggest a new plan for achieving your expressive goal.

In drawing 2, use black chalk, the softer the better, and any suitable paper, approximately 10 x 24 inches. Now your expressive goal is to depict the model as powerful, aggressive, and active.

Again, consider a general approach before you begin.

Having just selected very different qualities from the same view of the same pose, you will have to search for those actualities or potentialities in the pose that will serve this new goal. In this admittedly arbitrary search for clues to support expressive themes that the model may not easily suggest, you can more fully appreciate the many choices possible in the raw material. The more you study the forms and consider what choices and changes would help convey your expressive theme, the more they will appear. It is obviously helpful to pose the model in a way that will suggest some possibilities for either of these opposing goals.

Do not, in these first two drawings, rely on bold distortions. Indeed, try to avoid any but the most essential exaggerations, and keep these restricted to minor adjustments. As you begin to experience an expressive theme, subtle exaggerations will occur without your awareness. These unbidden changes are at this stage far preferable to any deliberate changes on your part. In general, drastic distortions make subsequent responses to a subject more difficult because the constant subject and the evolving drawing pull farther and farther apart.

drawings 3 and 4 Select a new pose that will again allow you to interpret it for the same two opposing expressive goals of drawings 1 and 2. This time, exchange media: using chalk, try to make drawing 3 convey gentle passivity; and using pen and ink, try to make drawing 4 convey aggressive power. With this exchange of media, new possibilities and restrictions occur, requiring new strategies and perceptions. Again, distortions should be few and minor.

drawings 5 and 6 Place the model in a new pose that offers some possibilities for depicting it as transfigured into a wraith, or cloud-like form in drawing 5, and into a machine-like form in drawing 6.

In drawing 5, show the model as being almost weightless. You may want to regard the forms as somewhat translucent and ethereal. Here you can either extend this mirage-like image to include the figure's environment, or use the substantiality of the surrounding forms as a contrast to those of the ghost-like figure. In drawing 6, using the same pose, try to regard the model as robot-like. You want to evince the sense of the figure's heavy weight and unyielding rigidity.

In this pair of drawings, distortions can become bolder but should be stimulated by the model's forms and grow from them as exaggerations of observed actualities, rather than being

tacked on arbitrarily to the image. For example, in suggesting the model as transformed into a machine, you may logically want to exaggerate the various interlocking unions of the forms (especially at the joints) to suggest machine-like fittings, or simplify forms into more severely "tooled" forms; deciding, however, to add gears and shafts here and there may be an arbitrary decision having little to do with the figure's forms and actions. But where such interpretations seem to be expressively necessary, use them.

drawings 7 and 8 Pose the model in a standing position that displays some rhythmic movements. In drawing 7, *subtly* suggest that the forms are made of some soft wax-like material that has just begun to melt. Here, distortions are built into the situation, but they should be employed with some finesse. Try to feel the pull of gravity straining the softening, projecting or supporting limbs, how they have begun to yield to their own weight, their form beginning to alter. *Make these masses structurally convincing.*

In drawing 8, use the same pose to subtly suggest the figure has begun to be transformed into a tree. Try to believe that this is actually happening, *must* happen; it will help you make inventive changes stimulated by the figures' folds, tendons, and muscles rather than by memory. Be sure that these changes occur gradually. Again, structural clarity, especially in the passages where "metamorphosis" is in progress, is important.

drawings 9 and 10 Make both drawings from the same view of the landscape. In drawing 9, convey the scene as forbidding, mysterious, or dangerous. In drawing 10, the same scene should suggest a peaceful, welcoming mood. This time, resist *any* tendencies toward obvious distortions of the proportions, perspective, or contours. That is, try to record the subject's physical forms with a reasonable degree of objectivity. Rely instead on your use of the elements, especially value, and your handling of the media to convey your intent. This will influence the physical state of the forms anyway, but here the selections and changes you make should result from use of line, value, texture, and the other elements to express your meaning, rather than from pronounced additions, deletions, or other drastic changes in the subject's actualities.

drawings 11 and 12 Make two drawings of the same view of a simple still-life arrangement. In drawing 11, suggest a serene and monumental air; in drawing 12, a feeling of turbulence and action. Here, emphasize two-dimensional activities as much as three-dimensional ones. Rely on shapes rather than on extensively modeled forms; and on

relational energies such as rhythmic, directional, and tensional ones, rather than on drastic distortions. However, do not hesitate to make whatever deletions, additions, and distortions you feel are necessary to amplify your expressive themes.

drawings 13 and 14 Make two drawings based on different kinds of imagined forms in space. Using Figures 10.38 and 10.39 as rough guides only, think of the title of the first of your drawings as *Great Structures in Vast Space,* and the second as *Movement and Light.*

In this chapter we have favored examples of strongly expressive works, in order to more easily identify the expressive factors at work. It is really impossible, however, to imagine a drawing without expressive meaning. Such meanings may be subconscious and unintentional in some; in others, expression may be held in check in order to unselectively duplicate a subject's surfaces. But this restriction is itself expressive of holding back intuitions and feelings that permit us to fully experience a subject's character and mood. Such drawings often reveal the artist's confusion between the acts of drawing and of superficial rendering. In still other drawings, expressive meanings, left unregarded, make their emotive themes confused and contradictory. They reveal an aimlessness of meaning, a wandering of purpose. There are drawings that are largely bravado—bold flourishes that convey little form or feeling—and drawings that are evasive, timid, or uncertain. All these characteristics are expressions of their authors.

All drawings reveal something of the artist as an individual: his or her greatness or smallness of character, wit, and resourcefulness, view of what is worthwhile, and philosophy of life. To disregard *the given condition* of expression as part of a drawing's content dissipates forces that could endow our drawings with greater meaning, impact, and life.

11

e n v i s i o n e d i m a g e s
i m p r o v i s a t i o n s o f f o r m a n d s p a c e

A DEFINITION

A sound knowledge of vocabulary is important to communication in any language, and the language of vision is no exception. For this reason the main theme of this book concerns the strengthening of our power to see and respond to the world around us by first learning about, and then organizing, the visual elements in ways that will better transmit our perceptions and feelings. Also, just as written communications can relate not only to things witnessed but also to things envisioned, so visual communications can tell of encounters with the people, landscapes, and specters of our imagination. But in choosing to turn inward for our subjects, we encounter even greater structural and dynamic challenges than when we draw in the presence of our subject.

Unlike the model, landscape, or still life before us—its masses rich in nature's inventive structural variants, bathed by form-revealing light, and yielding to unhurried inquiry—the forms of our imagination are vague and elusive. They shift and change even as we consider them. And because of the demands and opportunities in the emerging work, they continue to change while we draw them. All the more reason, then, to be able to keep up with their permutations, to be able to seize upon their essential structure and spirit from the shifting and shadowy stage of our imagination.

For beginners contending with the perceptual challenges of drawing the subjects placed before them, it would seem that the greater complexities involved in the realization of imagined or remembered forms are simply beyond their ability. And so they are, if their first attempts are figures, forests, or any other kind of complex form arrangements. Indeed, drawing such subjects from imagination is, for many mature artists, an extremely demanding challenge. But in drawing *simple* forms such as the block, the sphere, and the cone, we "prove" our ability to understand the structural nature of the masses that underlie *all* forms, and we are more likely to recognize their presence, in variously interjoined combinations, as the form-summaries of observed subjects. Once we *can* draw simple form concepts, it becomes readily possible to combine

311

them to produce more complex solids, as in Figure 11.1.

This ability is of the greatest importance for two reasons. First, because we cannot draw a form whose structure we do not understand, the more skill we develop in the invention of forms based on combinations of simple solids, the easier it becomes to decipher, clarify, and even alter the complex forms of our observed subjects. Second, without the structural understanding that comes from a wide variety of experiences with inventing structurally lucid forms, our ability to create envisioned images is severely restricted. After all, because the forms in our envisioned drawings are *ours*, are products of our past visual experiences, they are necessarily limited to the structural experiences we have had with the forms of our inner as well as outer world. Conceiving forms we have never encountered in our daily lives (at least not in the combinations we may desire) is the stuff that invented images are made of, but we cannot draw those we cannot visually *conceive*.

Nor is the problem in invented imagery one of structure only. For responsive artists it is equally important to "see" the gestural nature of their inner vision and to sense its dynamic conditions. Here again, the artist's stockpile of earlier visual and expressive experiences, gathered from nature's limit-

> *Conceiving forms we have never encountered in our daily lives is the stuff that invented images are made of, but we cannot draw those we cannot visually conceive.*

less supply, serves as the main resource of engaging dynamic inventions. Forces, like forms, must be experienced.

But to have such experiences in store requires more than functional seeing, more than seeing forms as obstacles to avoid as we move about in space. For example, we are all familiar with a variety of trees, but can we draw one, even one that conforms to no par-

Figure 11.1 *(student drawing)*
MARY-JO LANE
Masses in Space
Graphite. 14 × 17 in.
Art Institute of Boston

ticular species? To have known trees as tall, leafy masses, larger above than below, is clearly not enough information to go on. We may have planted them, decorated or climbed them as children; we may have been scraped, sheltered, or nourished by them. These experiences help us to *know* trees in ways important to our representations, but they do not help us to *draw* trees. However much we may admire their grand scale and color, their changing appearance through the seasons, and their general form characteristics, this is not yet enough information to serve our improvisations of these forms.

To draw a tree from our imagination, we must have analyzed the structural nature of many trees. We need to have explored and measured their masses, studied their surfaces and textures, and noted how their forms are arranged. But we also need to have experienced their dynamic and organic forces. Without deeply felt remembrances of their rhythmic energies, of the "calligraphy" of their branches, of the way they move in the wind, and of their roots clawing deep into the earth, we cannot call forward a convincing sense of "treeness." It is from the dedicated study of nature's forms *and* forces that the responsive artist's fund of structural and dynamic insights is nourished.

To appreciate how these insights can be developed and used, we will examine some invented images, favoring representational works because we can more readily see how forms familiar to us, but emerging from the imagination, can be processed into strongly expressive statements. In studying these drawings, notice that the artists consistently apply the same processes and disciplines as for drawings made from observed subjects.

APPLYING GESTURAL INSIGHTS

Many of the drawings of this chapter are preparatory sketches. Artists confronted with major undertakings in another medium have often approached their envisioned subject by making drawings that, in exploring the general state of the intended work's form and content, seize on certain large moving actions, structural traits, and relational patterns from the still indefinite image. A gestural "attack" is one of the most effective means of snaring these vague, visual no-

tions, and for much the same reasons as discussed in Chapter 1. Indeed, the more clouded the image on our "inner screen," the more necessary it is to get at its essence by the penetrating nature of a gestural approach.

Reni does this in his *Allegory of the Dawn, The Aurora* (Figure 11.2). The artist's initial efforts go toward laying hold of the image's overall gestural behavior: a stormy whorl of the many lines on the left forming a wedge and converging to a long, diagonal movement to the format's upper right corner. Reni's interest in the underlying actions of the intended work outstrip his concern for its masses. Yet the volume-informing contours, the curved hatchings that define the drapery, and the boldly simplified masses suggest his first decisions about the volumes of the intended work. Such a concentration on sheer energy makes it far less likely that the resulting image will bog down into a dull cataloging of isolated segments, for its directed actions and rhythms are an integral part of the initial compositional idea.

Guercino's gestural approach in his *Four Figures* (Figure 11.3) takes on the additional consideration of illumination. By doing so, he includes an important influence on the final work's dynamic character. Value, as we have seen, is a potent graphic force. As in Reni's drawing, the primary goal is the establishment of at least the principal characteristics of the actions of his subject and of the elements themselves. No doubt a painting based on such a broadly stated sketch would find the splashes of tone modified, the volumes more defined, and subtler relational activities developed. But its overall pattern of forms and forces, established at the outset, would, as in the previous example, strongly influence the results. What is of primary interest in both of these drawings is that the artists elect to approach their subject, not by a patient solving of each part's final form, but by a scanning of its principal moving energies.

Then, too, sometimes a drawing rich in gestural energies is necessary to the drawing's expressive theme. Such drawings are little more than the artist's gestural "strike" and can very effectively make a narrative point. For example, in Figure 11.4, the animated fervor of the speaker and the skeptical attitude of his listeners are eloquently conveyed in Gropper's fast sketch. But to effect this, he first had to strip his subject down to its essentials of form arrange-

Figure 11.2
GUIDO RENI (1575–1642)
Allegory of the Dawn, The Aurora
Pen, brush and ink over chalk drawing. 12.5 × 25.7 cm.
Albertina Museum, Vienna

Figure 11.3
GUERCINO (1591–1666)
Four Figures
Pen and brown ink and brown wash. 8 × 10³/₈ in.
*Cooper-Hewitt Museum of Design, Smithsonian Institution,
New York*

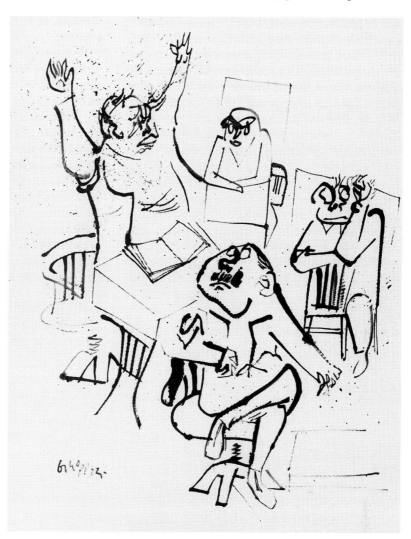

Figure 11.4
WILLIAM GROPPER (1897–1977)
Political Drawing (c. 1930s)
Pen, brush, ink. $22^1/_2 \times 17^1/_2$ in.
The Arkansas Arts Center Foundation
Collection, 1980

ment and form character. When Gropper's pen made its first saber-like thrusts, he knew he was after the spirit of a form—its essential structure and (exaggerated) form character.

Too often students drawing an imagined subject will revert to a tedious, piecemeal approach to their subject, "finishing" each segment before moving on to the next—and they may do so long after they would no longer consider drawing an observed subject in that way. This may occur for several reasons. First, there is the anxiety-producing fact of being responsible for the realization of forms they do not actually see. In the absence of real forms to draw, their attention is divided between first inventing and holding an image steady in the mind's eye, and then trying to react to its salient characteristics. Unable to hold on to the entire subject, they settle

for a conscientious description of parts. Unless they do have an adequate store of prior visual experiences with such parts, those they summon up are likely to offer meager graphic fare. Indeed, some of the most gifted artists on occasion show a slight lessening of inventive daring in their envisioned works in comparison to those made in the presence of their subject.

Second, without the forms before them, students fear that their imagined subjects will elude them and feel impelled to pin them down, piece by piece. But the results here are no more likely to succeed than when observed forms are described in sequence.

Third, the student's struggles with the difficulties of form realization make it all the harder to take on the search for unifying relationships and energies. But those given bonds

and forces in nature must, of course, be sensed in the subjects he or she invents.

In concentrating on gestural expression at the outset, Reni, Guercino, and Gropper "capture" their imagined image's overall behavior and mood. In this way, each establishes an expressive "seedbed" that keeps the envisioned image alive in the artist's mind and guides both the drawing's order and its emotive force.

APPLYING STRUCTURAL INSIGHTS

As we saw in Chapter 1, a gestural approach naturally leads to more specific structural and dynamic considerations. The artist's emphasis, in gradually shifting from a sensual-schematic exploration of what the forms are doing, to what they actually look like, also moves from an emphasis on the subject's arrangement and energies, to an emphasis on the planar nature of its surfaces. Most artists form their envisioned images in this general way.

In Poussin's *The Nurture of the Infant Jupiter* (Figure 11.5), the gestural drawing still dominates, but the artist has gone on to establish some general structural judgments and to enlarge upon the drawing's compositional order. In the drawing on and around the figures and the goat, Poussin begins to establish a few broad planes and shadows and to rework edges, giving substance to these forms and suggesting the space among them. Organizationally, a

Figure 11.5
NICOLAS POUSSIN (1594–1665)
The Nurture of the Infant Jupiter
Pen and brown ink. 17.4 × 24.1 cm.
Stockholm National Museum
(Statens Konstmuseem)

pattern of undulating rhythms, straight and curved forms, textured and "plain" passages, fast and slow directional movements, and a low, triangular grouping of the forms in the foreground flesh out the gestural skeleton.

> *Invented images rarely exist in the mind fully formed down to the last detail, waiting only to be transferred to the page.*

Poussin reminds us here that whether we are confronting observed or envisioned subjects, drawing involves both *discipline* and *release*. Discipline moderates the animated expression of the forms, especially of the branches and masses of leaves, insisting on structural essentials and a rhythmic rapport among them; release energizes the schematic lines that construct masses and establish tone, giving them the same sense of urgency as the more calligraphic lines.

Invented images rarely exist in the mind fully formed down to the last detail, waiting only to be transferred to the page. Typically, it is not until artists have loosely established the all-embracing but unspecified essentials on the page—generalities assembled from their total structural resources—that they begin to call on their knowledge of the specific forms of the intended image.

As we saw in Chapter 3, structure is a dominant consideration for some artists. It does not surprise us that the drawings of Michelangelo and Cézanne are formed, almost from the start, out of inquiries concerning length, plane, mass, location, and space, for structure plays an important role in their major efforts in other media. For them, gestural considerations accompany a search for their subject's fundamental structural and spatial conditions, rather than the other way around. But that such an approach is often utilized by artists whose works do not stress the constructional interjoining of every plane and form-unit may strike us as unexpected. However, recall that for the responsive artist, even when structural matters do not play a major role in a given work, a sound understanding of the subject's masses is essential to his or her interpretation of them, for whatever creative purpose, as Figures 8.37 and 9.24 indicate. It is at once apparent in these two drawings that, despite their invented and somewhat abstract nature, they show the structural sophisti-

cation of the artists. All the more reason, then, when artists invent, interpret, and integrate forms intended to be seen as volumes in space, to extract the envisioned subject's essential constructional features.

Raphael does this in his *Two Riders* (Figure 11.6), where gestural and structural interests harmoniously interwork to bring the artist's vision of monumental and fluent forms to the page. The massed lines that define broad, dark planes, and the volume-informing contours, are simultaneously engaged in establishing powerful masses and graceful movements that embody the graphic and temperamental gist of Raphael's invention and intent.

Again, in Figure 11.7, the initial, gestural lines are visible throughout the drawing, where they serve as a kind of scaffold upon which the artist builds the surface forms of an old woman. Although more than four hundred years separate the Raphael and Bloom drawings—not to mention very different styles and purposes—both artists envision form arrangements and rhythms first, then develop surface planes and contours. The beginner's tendency to start by establishing fixed contours, to be "filled in" later, is thus almost always reversed by master exponents of drawing, who know that contours are the inevitable results of *inner* masses and tensions, and wisely hold off the shaping of forms until they have understood their inner dynamics.

A similar *gesture-to-structure-to-contour* process guides Ricci's drawing *Achilles Gives Hector's Dead Body to Priam* (Figure 11.8). This is not to suggest that in certain passages the order may not be altered. But usually, artists hold off drawing final contours until they have a better sense of the subject's dynamic actions, structural essentials, and figurative conditions. We can, then, understand the process of many responsive artists as proceeding according to the following diagram:

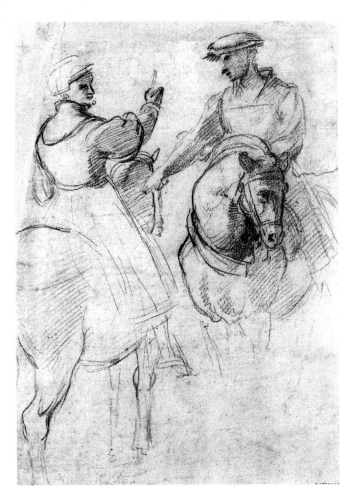

Figure 11.6
RAPHAEL (1483–1520)
Two Riders
Red chalk. 28.6 × 20.3 cm.
Albertina Museum, Vienna

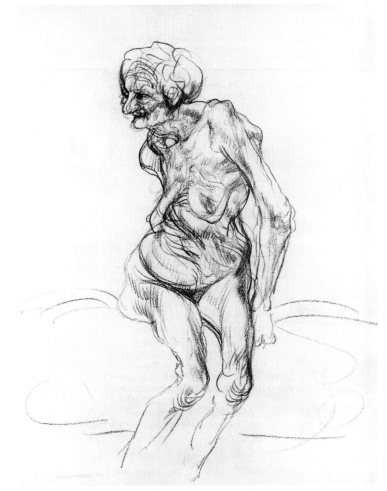

Figure 11.7
HYMAN BLOOM (1913–)
Nude Old Woman
Brown crayon. 9¹/₂ × 7⁷/₈ in.
Collection of the Grunwald Center for the Graphic Arts, UCLA, Gift of Mr. and Mrs. Robert Robles

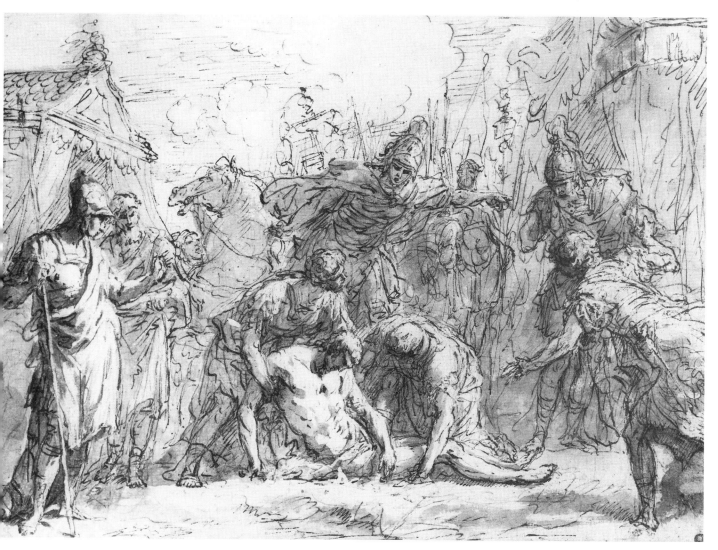

Figure 11.8
SEBASTIANO RICCI (1659–1734)
Achilles Gives Hector's Dead Body to Priam
Pen and bistre ink, heightened with white lead, on tan paper.
22.4 × 31.1 cm.
Albertina Museum, Vienna

And, as has been observed, when the subject is the indeterminate product of our imagination, such an approach, in fixing first on a vision's essential nature, is most suited to its veiled and elusive character.

A further observation on that point: even in contour drawings in which a single, deliberate, and continuous line conveys the image, a form of this process is at work. In such cases a kind of "mental gesture drawing" that goes on to take account of the subject's masses, and its abstract and figurative actions, precedes the drawing of the line. The line then records the results of this process, which has gone on in the mind's eye; the line "traces" the mind's contour judgments.

The expressive force of the dynamics that erupt from a fascination with structure is amplified when structural relationships exist between massive forms in a large spatial field. Piranesi, in

Figure 11.9
GIOVANNI BATTISTA PIRANESI (1720–1778)
Fantastic Interior
Pen and brown wash over chalk. $4^3/_4 \times 7$ in.
National Gallery of Canada, Ottawa

his *Fantastic Interior* (Figure 11.9), gives his imagination free play to build monumental masses that call to each other across vast spaces. And here, as in the previous examples, analysis and empathy combine to embrace the vision's essential nature, not its details.

That even beginning students, when shown the effects of overlapping, modeling, and illumination, can devise sophisticated imaginative works is seen in Figure 11.10. Here, a cubist-like abstraction based on the human figure owes much to an understanding of structural factors, developed in part by the study of simple form exercises (Figure 11.1). But Figure 11.10 also shows a sensitivity to the visual factors discussed in Chapter 9. If our envisioned images are to possess these relational, balancing, and unifying qualities, we need to consider such dynamic matters when we "draw" on our imagination.

APPLYING DYNAMIC INSIGHTS

As Annibale Carracci's page of sketches demonstrates (Figure 11.11), for many artists even the most preliminary exploration of an envisioned theme is conceived of as a system of expressive order. Each of these visual ideas is composed in its own format and considered for its balance and rhythms as well as for its masses and figurative theme. In some, even the basic value distribution is established, and all show the rudiments of relational activities to be developed. For example, in the large, central drawing, Carracci contrasts the shadowed figure in the foreground with the illuminated state of the mother and child, and he reinforces their importance by the radiating nature of the foliage behind them. And, in the group of three seated figures in the lower right, boldly curving, S-shaped move-

Figure 11.10 *(student drawing)*
Vine charcoal. 18 x 24 in.
Boston University

volvements with the forces that govern systems of organized expression. That the artist can call to mind the forms necessary to depict these figures is one thing; that he can compose them in a way that has compelling dynamic and humanistic meaning is another.

Rembrandt's envisioned images are among the most moving and original works in the history of drawing. Endowed with profound philosophical and creative insights, his drawings are at once moving human documents and astonishing graphic inventions. More than penetrating structural and organizational solutions are at work in his *The Holy Family in the Carpenter's Workshop* (Figure 11.12). Rembrandt also brings to this image his mastery of light, his ability to make value relationships evoke powerful abstract and psychological events, a skill developed from his many encounters with light's behavior in his portraits and landscapes. Again, we cannot envision what we have not experienced in our responsive involvements with nature.

Rembrandt's pictorial emphasis of Mary and the infant Jesus, unlike Carracci's solution of surrounding the figures with subtly radiating forms, is achieved by the almost blinding light that comes through the window directly above the figures. This light attains a supernatural brilliance, in part because of the room's sonorous shadows that seem strangely unaffected by it. The room's persistent dark tones are expressed by painterly washes of ink that are in accord with the lines' rugged vitality, and they activate areas that other artists might have stated as only dark. Note especially how important the two pulsating, dark tones on either side of the window are to both the design and expression, and how the bold and vibrant reed-pen lines hold up under the drawing's overall dark tones.

But some envisioned images, such as Bresdin's *The Crevasse* (Figure 11.13), are intended as final statements. When this is the case, the earlier gestural drawing, though it is often overlaid by subsequent drawing, is often, as here, visible in places. More important, however, is its influence on the subsequent drawing. Had Bresdin simply begun at one end of the blank page and drawn each part in turn, there would not be the complex relational play between shapes, rhythms, values, and textures, nor the majestic

ments animate and unite the group. Notice, in the several figures only just begun, how Carracci searches first for their gestural character and then turns to the construction of their masses.

Just as Carracci's ability to recall familiar forms and invent others is based on earlier analytical and responsive involvements with various forms, so is his repertoire of organizational and expressive tactics the harvest of earlier in-

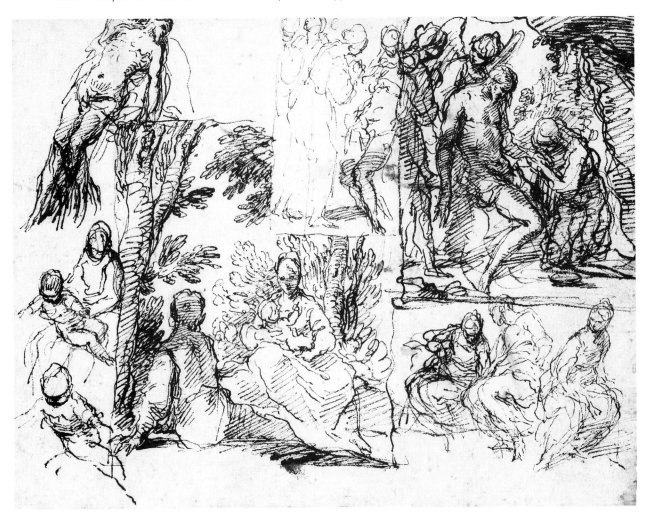

Figure 11.11
ANNIBALE CARRACCI (1560–1609)
Page of Studies
Pen and bistre ink. 20.5 × 27.2 cm.
Rijksmuseum, Amsterdam

eruptions of form they create. In imaginary images, where anything may appear, the temptation to create fantastic configurations sometimes leads the unwary into volume formations that are beyond their ability to explain. But intricate volumes in complex interjoinings with others, as occur in Bresdin's drawing, become more manageable when we remember that they are still only unusual juxtapositions of a handful of basic geometric masses.

Lest it appear that anyone drawing invented images is under an obligation to be especially explicit in explaining structure, it should be noted again that drawing is not sculpture and that the degree of volume-clarity in drawings made from either imagination or observation is determined by the artist. What is important in either case is the artist's *comprehension* of the forms he or she means to draw. Of course, some responsive drawings do contain passages in which volume and space impressions are subdued or intentionally ambiguous.

Indeed, the emotive force in another of Bloom's drawings, *On the Astral Plane: Beelzebub* (Figure 11.14), is intensified by the lessening of form clarity in the drawing's upper half. Rather than try to represent the indescribable evil of the devil-form, and in order more effectively to express its ghoulish activity, the artist holds back in the drawing's upper part, allowing our imagi-

Figure 11.12
REMBRANDT VAN RIJN (1609–1669)
The Holy Family in the Carpenter's Workshop
Pen and bistre ink. 18.4 × 24.6 cm.
Reproduced by courtesy of the Trustees of The British Museum, London. © Copyright British Museum

Figure 11.13
RODOLPHE BRESDIN (1822–1885)
The Crevasse (1860)
Pen and black ink. 21.2 × 15.8 cm.
Collection of The Art Institute of Chicago. Gift of the Print and Drawing Club. Photograph © 1990 The Art Institute of Chicago. All Rights Reserved

Figure 11.14
HYMAN BLOOM (1913–)
On the Astral Plane: Beelzebub
(1966)
Charcoal. 64 × 36 in.
Courtesy, Terry Dintenfass Gallery,
New York

Figure 11.15
ODILON REDON (1840–1916)
The Captive Pegasus (1889)
Lithograph. 13³/₈ × 11⁵/₈ in.
Collection, The Museum of Modern Art, New York
Lillie P. Bliss Collection. Photo © 1997 The
Museum of Modern Art

nations to participate. But, where Bloom intends for us to consider the symbolism of his imagery, convincingly structured forms emerge.

But the artist has planned far more than solid volumes in a well-established spatial field. He devises a somewhat symmetrical and even restful design, keeps its forms contained within the format, avoids harsh changes in value or bold directional forces, and envelops the configuration in dark and gently graduated values. In short, Bloom creates a stilled, brooding configuration, against which the strong diagonal thrusts and the sudden light intensity of the two clawing limbs have more expressive impact.

In addition to the intentional structural ambiguities noted earlier, the ones that result from such a dark and muffled configuration, there are other, psychological ones. The artist equivocates between the horrible and the beautiful. The light at the top may be a sunrise or an inferno; the insects crawling over the disembodied heads seem flower-like; and even the creature's limbs, drawn with sympathetic appreciation of their sinewy strength and their rugged

structure, seem to both attract and repel us. The more we examine this large, provocative work, the more we find the same profound interworking of structural and dynamic qualities to be seen in the artist's drawings from nature (Figure 10.19).

Again, in Redon's *The Captive Pegasus* (Figure 11.15), large segments of the drawing are not structurally explained. But, where masses come into the strangely selective light, their form shows the results of sound analytical understanding. And, as in the two previous examples, the selection and arrangement of unusual combinations of forms are made to seem more plausible by the artist's conviction in his vision, in its graphic and symbolic worth; and by the knowledgeable construction and ordering of forms provided by the artist's fund of perceptual insights.

The unity of this drawing is especially strong. The shapes, values, and volumes, the overall design scheme, and the emotive tone are all bold and direct. Elements associate and contrast emphatically, moving actions are powerful

Figure 11.16
RENÉ MAGRITTE (1898–1967)
The Thought Which Sees (1965)
Graphite. $15^3/_4 \times 11^3/_4$ in.
Collection, The Museum of Modern Art, New York
Gift of Mr. and Mrs. Charles B. Benenson. Photo © 1997 The Museum of Modern Art

and balanced, and the drawing's mood is sustained throughout by both the nature of the dynamic actions and the fervor of the artist's handling.

The subtle dynamic life in Magritte's *The Thought Which Sees* (Figure 11.16) shows an un-usual combination of forms and textures in a stilled design based on vertical and horizontal movements. In this way the artist implies a haunting surrealist mood. As this drawing demonstrates, a sound knowledge of what produces mass and space also serves us when we

Figure 11.17
RICHARD HENTZ
Symbol (1970)
Pencil. 22 × 30 in.
The Chrysler Museum of Art, Norfolk, Va.

wish to make these matters ambiguous. Like Magritte's drawing, Hentz's *Symbol* (Figure 11.17), a more active design scheme based on diagonal actions, does not show an underdrawing. But, as was noted earlier, even when this is the case, such works don't emerge fullblown. They are evolved by the artist (sometimes by separate preparatory sketches) through some degree of preliminary drawing, if only in the mind's eye. Even spontaneous nonobjective works like Kline's *Untitled* (Figure 10.38) are usually the result of numerous attempts to directly organize form and space, and they benefit from the patient study of the world around us.

This chapter does not attempt to be a survey of imaginative drawing. Rather, its purpose is to alert the reader to the need for the same high degree of analytical and empathic involvement that sound, responsive drawing of observed subjects demands. The following exercise

is designed to guide and test your ability to call on these structural and dynamic skills in drawing envisioned images.

exercise 11a

MATERIALS: No restrictions except where noted.

SUBJECT: Imaginary themes.

PROCEDURE:

drawing 1 Using Figures 11.1 and 11.18 only as rough guides, and using graphite pencils on a Bristol or vellum paper approximately 14 x 17 inches, draw several complex forms by interjoinings and fusions of simple geometric volumes. Although you will find it useful to select a light source for this tonal drawing, do not feel restricted to it when consistency would leave the structure of

certain parts poorly explained. Instead, adopt another light source for such passages. In general, your goal here should be form clarity. A sense of illumination is decidedly a secondary consideration in this drawing.

drawing 2 Using the same materials and attempting the same degree of form clarity, make an imaginary drawing of a number of everyday objects whose forms you are familiar with and can "see" in your mind's eye. For example, a spool of thread, a simple container or cup, a banana, a pencil, and a spoon would make a useful combination of form challenges. Assume these forms to be tumbling about in space. You may wish to draw some of these forms from several views, or overlap them, but do not allow them to run off the page. Because you are interested in a convincing impression of volumes in space, avoid an overconcern with textural effects or other minor surface detail. You may find it helpful to first establish an object's form by using an underlying pure form: for example, a lightly drawn cylinder may help you to draw the spool or the pencil.

drawing 3 Select any two objects that are different in form and function, and have one of them "metamorphose" into the other. For example, have a hand become a tree branch as it approaches the forearm. Or, turn a shoe into a hammer or a horn. The combinations are of course limitless, but again, avoid objects whose structure you are not certain of. In fact, you might very well make this drawing with the objects placed before you, because you will be inventing the transitional passage between the two forms. This area of change from one form into another should be *gradual,* as in Figure 11.19. Now you must decide what changes would occur as one form gradually adapts and gradually flows into the other. Your goal is to explain, through convincing structural changes, how one object altered its form to become the other.

drawing 4 Using Piranesi's drawing (Figure 11.9) as a rough guide, invent your own fantastic interior, but avoid overly complex or ornate forms.

Figure 11.18

drawing 5 Select any religious, mythological, or social theme and make three or four brief, preliminary sketches that explore different compositional and structural arrangements. Avoid complex scenes and unusual perspective views. One or two figures in some simple setting will be challenging enough. Draw at least one of these in a long, vertical format. Select the one you prefer and, after making further preparatory sketches, working from *observed* figures, draperies, landscapes, or other subjects as necessary, go on to make an extended drawing in which you may refer to all your preparatory sketches but to nothing else.

drawing 6 Using pen and ink on any suitable surface, and with Bresdin's drawing (Figure 11.13) as a rough guide, invent your own fantastic rocky landscape. Using graphite, you may wish to first rough in something of the scene's general

Figure 11.19

arrangement. Avoid using graphite for more than establishing the gestural nature of your imaginary scene and for noting a few general facts about the forms. Keep erasing your early graphite notations as the pen and ink drawing develops.

drawing 7 Using Magritte's drawing (Figure 11.16) as a rough guide, invent your own dream-like image in which odd juxtapositions of subjects, textures, and space predominate. You may use any medium or combination of media. And, as in drawing 5, you may make some preliminary studies of various locations and objects in front of you, and refer to these sketches as you make your imaginary drawing.

drawing 8 Select any reproduction in this book and draw your own version of the scene. Within moderate limits you may add or omit various forms. It is not necessary here to work in the manner of the artist whose drawing you are re-designing, nor is it necessary to make drastic changes from the original. Perhaps taking a slightly different view of the subject is all that you will need to provide you with a new set of relationships and forms. However, you should use similar drawing materials where it is possible to do so.

For some artists (and they include some of the greatest) the process of drawing can begin only with the stimulus provided by an observed subject. For them envisioned subjects hold little interest. Other artists (of equal stature) believe that we cannot draw anything really well until we can create good drawings of at least some of the things we envision. Whichever view we hold, it is clear that the *discipline* of inventing forms can only improve our responses to those we observe. For just as we learn about nature's rich, inventive store of structural and dynamic phenomena by a sensitive study of the world around us, so do we learn about ourselves, our creative strengths, susceptibilities, and needs, when we work from imagination. The best drawings, whether observed or envisioned, come from those artists who know nature and themselves best.

For those of us who find satisfaction and significance in the improvisation of forms and events, the need to understand how nature constructs the world around us is essential. Redon had this in mind when he observed, in a letter to a friend, "There is a kind of drawing which the imagination has liberated from any concern with the details of reality in order to allow it to serve freely for the representation of things conceived. . . . No one can deny me the merit of having given the illusion of life to my most unreal creations. My whole originality, therefore, consists in having made improbable beings live humanly according to the laws of the probable, by as far as possible putting the logic of the visible at the service of the invisible."[1]

[1] Quoted in *Artists on Art*, ed. Robert Goldwater and Marco Treves (New York: Pantheon Books, 1972), p. 361.

12

pathologies of drawing

some symptoms and defects

A DEFINITION

A good drawing not only succeeds in stating the artist's intentions, but does so in ways we regard as forthright, economical, organized, and compelling. When a drawing fails to meet one or more of these criteria, the fault is always in some kind of discontinuity of spirit, inquiry, composition, or commitment. A responsive drawing reflects the artist's perceptual, analytical, and organizational skills, and his or her dynamic sensibilities and expressive purposes. Together, these objective and subjective responses to the subject's "what" and "how" create the drawing. Such a drawing can be thought of as a graphic "organism," one whose structural and abstract conditions convey a sense of "life" within and among the marks. Like living organisms, graphic ones depend on an efficient, interrelated functioning of their parts for life. They can be organizationally and expressively "healthy," or can "suffer" various disorders that weaken and impede their effectiveness.

Regarding drawings as organisms that roughly parallel some of the qualities and frail-

ties of living organisms permits a useful analogy. It helps us understand how important the relational condition of all of a drawing's components is to its artistic well-being. It also helps us apply the same analytical honesty to our examination of the results that the act of drawing itself demands. We look to "diagnostic" objectivity when examining any organism's soundness. In fact, one of an art teacher's essential skills is just this ability to analyze a student's work objectively in order to suggest ways by which the student can better comprehend and show in the work what he or she regards to be important stimuli in the subject. Of course, total objectivity in evaluation is not possible, since evaluation necessarily involves the teacher's own esthetic persuasion and temperament. But the conscientious teacher whose purpose is enlightenment, not indoctrination, strives (like all good doctors and detectives) to be objective.

Instructors *do* encounter works that show an almost total innocence of the fundamentals of drawing. In such cases, the teacher *should* be less concerned with analyzing and correcting each symptom, or with salvaging the student's gen-

eral approach, however unique, and more with addressing the basic inability to respond visually. One does not help the visually illiterate by directing their interest toward a particular esthetic ideology. The teacher's task is to turn such students away from advanced concepts (that make perceptual, organizational, and expressive failure certain) and toward fundamental visual matters having to do with gesture, planar analysis, scale and value relationships, balance, and the like.

We are all limited by the quality of our perceptual comprehension, and by the kinds of responses they stimulate. The beginner's comprehension and range of response will expand greatly as his or her analytical and empathic understanding develop. If beginners develop their skills with little or no professional guidance (and some great artists such as Rembrandt, Cézanne, and Van Gogh had little formal training), the experiences and insights that expand ability must come through their own efforts to study drawings, to continuously make drawings, to learn about the materials and the history of drawing, and to sustain their commitment to drawing during those inevitable periods of little forward progress. If such students are in a program of art study, some, perhaps much, of their ability will reflect good instructional guidance. But, as with students working on their own, the responsibility for their artistic growth is, finally, their own. During the period of study and certainly afterwards, both the self-taught and those receiving formal instruction must continue to develop their own creative sensibilities and diagnostic skills.

In a formal art program students' creative goals are likely to be formed sooner, and the students have greater opportunities to develop the ability to analyze their work, to uncover and correct the factors that hinder them from achieving these goals. The exciting and even abrasive exchange of ideas both between art students and between them and the teacher, as well as the teacher's own excited involvement in art, help stimulate the formulation of good creative attitudes and challenges. Too often, the student working alone cannot discriminate between the

processes of drawing, which are universal, and the *techniques* of drawing, which are personal. Without the guidance of a knowledgeable teacher to help overcome fundamental perceptual and technical hurdles, the student may lose much valuable time developing superficial skills instead of responsive ones.

Both types of student can benefit from studying the drawings of every period and culture, with a view to grasping the universal principles of artists as far removed in time and culture as cave artists and contemporary ones.[1] All responsive drawings, whether of observed or envisioned subjects, show a sound grasp of structural and dynamic matters, an integration of expressive and organizational ones, and a compelling economy and authority. But these drawings should be studied primarily as declarations of various creative persuasions rather than as sources of skillful techniques to emulate.

> *An artist's personal "recipe" for drawing is not altogether freely chosen.*

An artist's personal "recipe" for drawing is not altogether freely chosen. Part of what motivates the way we draw is determined by our instinctive need to have certain undefinable qualities present in our drawing. Such intuitive and idiosyncratic needs are as insistent as they are intangible. Though we cannot point to the places in a drawing where they reveal themselves, we reject those of our drawings in which these qualities are absent. These unique and necessary conditions are rooted in our subconscious reason and need, and though they cannot be measured, analyzed, or altered, they permeate a drawing. Examples of great drawings demonstrate the artist's acceptance and utilization of these intuitive needs. In such drawings we sense that the artists have accepted themselves, have found the freedom and courage to be themselves—an act as necessary in art as in life.

But students or artists whose drawings are heavily influenced by other artists lose these qualities of self when they are "speaking" in another's "voice." If these intangibles that reveal an original presence are stifled, whatever else

[1] See Nathan Goldstein, *100 American and European Drawings: A Portfolio* (Englewood Cliffs, N.J.: Prentice-Hall, Inc., 1982).

the drawings may have gained through such influences and borrowings, they will lack a natural conviction, the feel of neccesity, and an infectious spirit. These intangibles cannot themselves make a drawing great, but their absence rules out greatness. The serious "malady" of followers, then, is twofold: in denying their *self*-participation they smother vital original meanings that might have brought their work to life; and, like all followers, they stay *behind* the admired artist in both concepts and inquiries, producing dull or forced variations of great themes. But more of this later.

Let us now examine some specific ailments of drawings. The more we learn about graphic defects—how systems of expressive order fail—the more we can do to avoid such pitfalls and to diagnose a problem when it is present.

There is a danger here, however. Absolute perfection is an impossible goal and we should not pursue it. It is wrong to assume that a drawing has failed because one part or one aspect of it is faulty. There is no individual without some blemish or flaw, nor is even the greatest drawing flawless. Many fine works show some minor waverings in organizational or expressive continuity, or some minor discrepancy in perception or handling. The wonder is not that a drawing can be great despite its imperfections, but that so much eloquence and strength is ever achieved with so few flaws. In fact, works of art are incredibly durable, even when quite pronounced problems exist.

As an example, in Millet's drawing *Shepherdess Knitting* (Figure 12.1) the position of the figure's right foot is difficult to understand. We are provided with no clues that explain how it came to be located on the figure's left side or why it is placed at so marked an angle. *In the context of the drawing's overall structural and spatial clarity*, this appears to be an inconsistency. Additionally, the dark shape at the figure's left shoulder, being somewhat independently stated, seems unaccountably heavy and isolated. In relation to the representational "pace" of the rest of the drawing, it seems to be only a weakly integrated member of the design. The several lines from the top of the page to the head seem to define a tree's edge, but their collective tone brings the lines forward where they can also be interpreted as descending into the figure's head. Despite these ambiguous passages, the drawing's gentle charm, and the seemingly effortless way

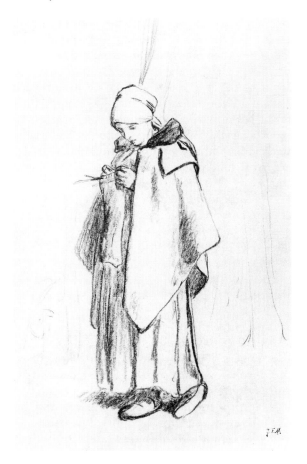

Figure 12.1
JEAN FRANCOIS MILLET (1814–1875)
Shepherdess Knitting
Black conté crayon on wove paper. $12^3/8 \times 9^1/2$ in.
Courtesy, Museum of Fine Arts, Boston
Gift of Mrs. J. Templeman Coolidge

in which Millet conveys the forms and character of the shepherdess, are impressive qualities.

The durability of a work of art can also be seen in the fragments of drawings, paintings, and sculptures from antiquity. The quality of choice and of means is so much a part of every segment that even surprisingly small fragments are able to overcome the absence of the rest of the work to convey esthetic meanings.

The following examination of common defects in responsive drawing is grouped into three categories: perceptual, organizational, and expressive. Throughout the discussion we should bear in mind that what may be a failing in the context of one drawing may be a vital function in another. More often than not, a response is right or wrong *in relation to the nature of the rest of the drawing* and not in relation to any

established conventions. What follows, then, is based not on any particular esthetic ideology, but rather on the universal visual principles of consistency, balance, and unity of a drawing's representational and dynamic conditions.

Hence, a truck too small for the road, a road too large for the house, and a house too far from the man entering it are errors in scale and placement only in a drawing where all other relationships of scale and location objectively reflect the various sizes and positions observed in such a scene. Conversely, in the context of drawings that intend *themes* of scale and placement distortions, large areas of objective denotation might appear in conflict with the rest of the drawing. Likewise, *random* structural ambiguities in the context of structural clarity, a solitary, "unanswered" diagonal thrust in a design based on vertical and horizontal axes, or *any other break in a drawing's type of design, expression, or handling* will have a weakening effect on the function of these factors and on the drawing's unity.

PERCEPTUAL DEFECTS

Learning to see a subject's measurable actualities, to analyze and relate its shapes, values, masses, and the like is, of course, a basic forming skill. Quite simply, we cannot draw the things we cannot understand. Sorting the gestural and structural essentials from the superficial niceties, being receptive to relational matters of every sort, and feeling the weight, strain, and energies among the parts (and among the marks that make them) are insights fundamental to any serious degree of growth as an artist. The following perceptual defects are among the most frequent and vexing:

1. Weakness in all measurable matters. A poor sense of scale relationships (proportion), placement, direction, or of shape actualities is generally the result of drawing what we know about our subject instead of what we actually see, or the result of a sequential assembly of parts. It also indicates a weak grasp of the need for relating activities in one part of a drawing to those in another, perhaps distant, part. Often, especially in figure drawings, the forms will steadily decrease in scale from the top toward the bottom of the subject, revealing no regard for relating the scale of parts, or for searching out

the subject's gestural character (Figure 12.2A). This problem is sometimes the result of the student standing or sitting too close to the drawing. Many such discrepancies can be more easily seen if a greater distance separates the hand and the eye. This "broad-spectrum" weakness signifies a basic visual illiteracy that requires the careful study of the issues dealt with in Chapters 1 through 6, with particular attention to matters of direction, scale, and shape.

2. Conflicting perspectives. A common result of sequential assembly, this defect is symptomatic of a disregard for relating the positions in space of all the drawing's forms, (Figure 12.2B) and for the need to perceive the angle of their long axes as well as their edges. When forms have been subjected to a probing search for their structural essentials, and when observations are "proved" by being tested against perspective principles, such defects are far more easily avoided. Failure to do so can result in any of the strange relationships shown in Sullivan's engraving *Satire on False Perspective* (Figure 12.3), the frontispiece to Kirby's book *Perspective*.

3. Overload of details. Again often a symptom of sequential assembly, this problem indicates an inability to analyze and extract the subject's essential directions, planes, and masses. Such an exclusive concentration upon surface effects generally smothers volumetric clues, thus destroying the very masses whose surfaces are so painstakingly examined. Usually, an

Figure 12.2

Figure 12.3
LUKE SULLIVAN (after design by William Hogarth)
Satire on False Perspective
Engraving. 14 × 18 in.
Courtesy, Museum of Fine Arts, Boston
Harvey D. Parker Collection

over-abundance of detail and a scarcity of convincingly structured volume go together, suggesting that scrutiny, not analysis, is at work. When good drawings do show exhaustive detail, as in Figure 5.38, form and space clarity are unaffected.

4. Parts isolated from the whole. This defect reveals a failure to consider the relative visual impact of form-units on the large mass of which they are parts. When small forms or parts receive more attention than the larger volume they constitute, such small segments conflict rather than accord with the large volume. The resulting isolation of such parts reveals an inability to establish a visual hierarchy among the drawing's major forms and those small forms and form-units of which they are comprised. In Figure 12.4, the eyes, nose, and mouth are more fully realized forms than the head as a whole.

its full effect is, by its very independence, isolated.

5. Unconvincing volumes. A weak sense of volume, when not due to an overemphasis on surface detail or a weak grasp of structural matters, is often the result of timid or confused modeling. A weak range of values, often only a few, small, light tones, sometimes diminishes the impression of volume, as occurs when a photograph is removed too early from the developing tray. Sometimes, having established the subject's structural essentials, the artist fails to maintain or develop them and turns instead to various effects of illumination or texture, giving rise to conflicting clues by hatchings or tones that run counter to a form's structure or that disregard it altogether. Volumes also suffer when pronounced, continuous contours, with their strong visual impact, overrule subtle inner modeling, converting forms back into shapes. Sometimes, too, volumes are drawn in positions that would have them occupy the same space (Figure 12.2B). That this can occur in the works of gifted artists is seen in Figure 12.5, where parts of the two cows at the far right seem to exist in the same space. Here, too, the placement of the cow at the top of the page makes it appear to be standing on the back of the large cow in the foreground.

6. Monotonous outlines. This weakness stems from the belief that only lines describing the boundaries of forms or parts can adequately convey a subject's volumetric character. The reluctance to leave the "safety" of the delineating edge to model the interior of a form makes some of these drawings look ghost-like. Usually, when interior modeling does occur, the use of single

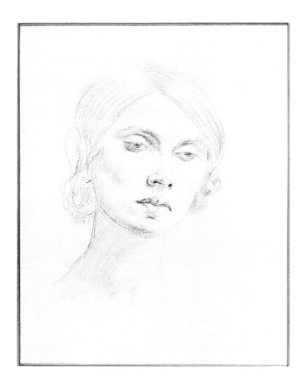

Figure 12.4
AUGUSTUS JOHN (1879–1961)
Head of a Young Woman
Pencil. $16 \times 12^{13}/_{16}$ in.
Courtesy, Museum of Fine Arts, Boston
Helen and Alice Colburn Fund

However, the strong rhythmic energy in every segment of the drawing helps somewhat to subdue the discrepancy between the strongly modeled features and the weakly stated head and neck. In the best drawings, all parts of the image fall short of completeness; they "need" each other to become completed. A part or form that doesn't need the rest of the drawing to have

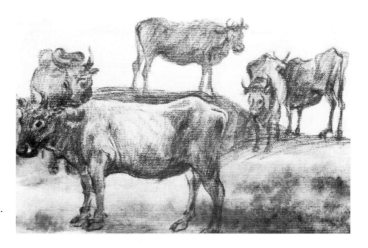

Figure 12.5
CLAUDE LORRAIN (1600–1682)
A Herd of Cattle
Pencil, sanguine, and wash. $4^3/_{16} \times 7$ in.
Courtesy, Museum of Fine Arts, Boston
William E. Nickerson Fund

lines to suggest subtle changes in terrain, as occurs in a figure, produces "scars" on the white shape of the interior rather than an impression of foreshortened planes and undulating surfaces. Another symptom of such drawings is the sameness of the width and character of the (usually) long and lifeless lines, resulting in forms that seem shaped out of wire coat-hangers. Such drawings reveal a fear or confusion about the use of tonalities to help establish edges and model form. But we should not confuse an inability to let go of line with the intentional use of it, as in Picasso's drawing of three dancing nudes (see Figure 9.35).

7. Stiff or wooden drawing. This suggests a fear of making errors and a disregard for gestural and rhythmic considerations. Ironically, the concern over making mistakes, the fear of "matching" energies in the subject by energies in the drawing, and the dread of making changes—of making a mess—have probably ruined more drawings than anything else. Fear is certain to result in drawings of a stilted and self-conscious kind. In responsive drawing there is safety only in sensitive perception, demanding analysis, and uninhibited response. Here, caution may be dangerous. When we don't enjoy the drawing process, we can be sure the viewer won't enjoy the results. Wooden drawing often results from an overconcern with surface detail at the expense of a subject's essential structure and spirit. Sometimes stiff form also occurs as a result of an overuse of straight lines and hard, right angles, often to the exclusion of all curved lines, as is seen in some mannered techniques.

8. Tonal "anemia." This defect occurs in tonal drawings when there is a fear of using dark tones, especially over large areas, even though a drawing's volumes, composition, or expression require them. Often the forms in such drawings are defined by outlines, making what little tone there is seem even less necessary. Beginning tonal drawings on a toned surface (either a tinted paper or one that is given a coating of

In responsive drawing there is safety only in sensitive perception, demanding analysis, and uninhibited response.

charcoal or graphite) is useful in overcoming a reluctance to use bold, dark, values.

9. Formula solutions. When remembered clichés replace responses to any of a subject's actualities, the results are trite or mannered. There is a failure to respond because of disinterest in various parts of the subject, an inability to visually comprehend them, or a preference for familiar solutions. Such drawings do not seem convincingly in touch with the subject. In part, they are not. When old answers displace analysis, formula displaces experience.

10. Breezy mannerisms. These are usually false flourishes that try to imitate the economical, authoritative, and variously engaged lines and tones of master artists. Drawings suffering from this defect usually convey little or nothing more about a subject than vague and poorly understood generalities. Often symptomatic of only a superficial grasp of perceptual skills, such drawings are often ambiguous about volume and space, design, and expression. They are merely flashy pretensions that allude to a fluent control the artist doesn't possess.

To discover perceptual defects in our drawings, we must be willing to go back and look for any measurable discrepancies in direction, scale, shape, value, and location that we did not recognize during the act of drawing. We must also come to understand that any faltering of concentration will hinder objective analysis.

In the excited involvement with the many interlaced factors of response to the subject and to the evolving drawing, one can easily overlook a scale relationship, misjudge an angle, or make some inadvertent inclusion or omission. Viewed later, unintentional exaggerations of scale, value, and the like, are often glaringly evident; but overworked, monotonous outlines, formula solutions, or an overload of details will remain as more pervasive defects unless they are examined critically. Such perceptual problems are certain to recur in subsequent drawings unless we objectively examine the concepts and procedures of our overall approach to drawing. The ability to analyze a subject's measurable actuali-

ties, and to recognize the symptoms that indicate faulty procedures and judgments, is necessary *for any kind of graphic goal.* How we perceive is not the same as what we do about our perceptions. In analyzing the perceptual defects of our drawings and working to overcome them, we also gain insights into our general approach that lead to artistic and even personal growth.

ORGANIZATIONAL DEFECTS

The way we organize our responses reveals our esthetic and temperamental interests. It reflects our understanding of the relational possibilities in the subject, and of the relational life of the marks that constitute our drawing. Sound perceptual skills require sound organizational sensitivity to have good creative and communicative worth. The following are some of the organizational defects most often encountered. Some are easy to spot, some are insidious and subtle, all diminish a drawing's formal order and, consequently, its dynamic meaning.

1. Labored drawings. Often these result from the fussy embellishment of parts with unnecessary details and "finish," isolating and reducing their relational activity. The problem is sometimes due to a poor choice of medium, where numerous attempts to force a medium to react to the artist's needs cause a general loss of spontaneity. Sometimes there is an almost obsessional concentration on some particular organizational or expressive theme so overbearing that the drawing's overall economy, spontaneity, and unity are weakened. Labored drawings often result from an overemphasis on representational considerations. Such drawings may reveal a high degree of accurate depiction but not a high degree of dynamic life. However, dull and overworked results will occur in drawings of any kind when the enlivening and unifying effect of abstract relational play is either absent or self-consciously overstated. Responsive drawings are complete when they cannot be made more visually and expressively exciting and succinct. "Finish," in the sense of photographic naturalism, is often the *finish* of a drawing's relational, abstract life. Accurate representation and inventive graphic design are *not* mutually exclusive, but the more thoroughly objective a drawing's imagery becomes, the greater the demands on our ability to organize the visual elements and energies that make such images.

2. Redundancy. The use of lines and tones for the same function in a single volume suggests a mistrust of values to convey the impression of volume without the aid of a final, encompassing line. This problem can be seen in Figure 12.6A. Although line and tone may work together in many ways, using both to say the same thing usually destroys a drawing's overall freshness, economy, *and* impression of volume. The duplicative behavior of line and tone is more confusing than clarifying, because the role of each is obscured by the presence of the other. Note that Figure 12.6B is more convincingly volumetric.

3. Random lines and tones. This problem usually occurs when there is no general strategy for the roles of line and tone in a drawing. In such drawings, some parts may be depicted by line only, other parts by tones, and still others by various combinations of line and tone. Although variations in their use are often desirable and necessary (see Rembrandt, Figure 6.4), extreme differences that lack any compelling visual or expressive purpose make it appear that two or more unrelated attitudes are at work in the same drawing (Figure 12.7). Such an erratic use of line and tone suggests a confusion or innocence about basic visual issues, goals, or both.

4. Ostentatious facility. When the dominant goals are cleverness in the use of media, or deft drawing devices, we face the problem of ostentatious facility. Although facility, that is, inventive and masterly control, is a desirable quality, drawings in which cleverness of execution is primary appear to be performances for approval rather than acts of graphic necessity. Such draw-

Figure 12.6

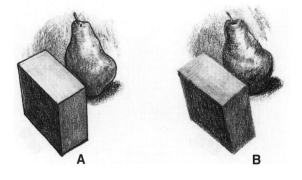

A　　　　　　　　　B

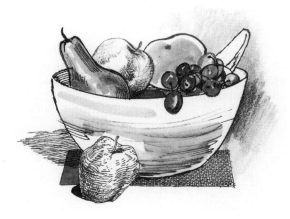

Figure 12.7

ings often disclose only a passing interest in dynamic considerations, and a fascination with deft solutions to figurative illusions or imaginative effects. When facility makes a drawing a system of clever representational or abstract mannerisms instead of an organized and penetrating interpretation of nature or imagination, the drawing becomes self-indulgent rather than pictorial, favoring exhibition rather than experience. Often, drawing mastery first shows itself in the artist's no longer choosing to please others.

5. Lack of unifying movements This suggests a sequential approach. Completing parts in a

piecemeal manner seldom permits their being woven together by directional and rhythmic forces that provide continuity between forms. The stilted results of a disregard for the moving energies that course through any group of forms may also stem from a concentration on the structural nature of small forms, to the exclusion of an awareness of their collective gestural, rhythmic character. Such drawings reveal an innocence of what is perhaps the most evidently present quality in the things we see.

6. Random shifts between the second and third dimension. Like any other inconsistency, such shifts indicate the absence of an overall dynamic theme—an uncertainty about the drawing's purpose or goal. Many drawings do show a shifting between two- and three-dimensional matters, as in Diebenkorn's drawing (Figure 9.39), where integrated changes in emphasis occur between events on the picture-plane and events among forms in space. But the random coming and going of volumetric and spatial clarity in a drawing indicates a disregard for the fundamental need to hold to one frame of reference—one "voice." When elements in one part of a drawing convey masses and space and those in another do not, there must be some comprehensive design strategy that embraces and unites these parts. Such a strategy is seen in Figures 12.8 and 12.9, where two- and three-

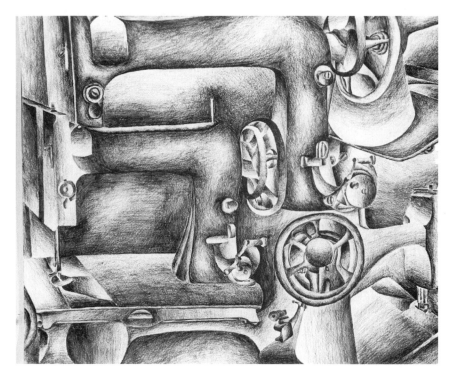

Figure 12.8 *(student drawing)*
Black conté crayon on paper.
18 × 24 in.
*University of Illinois at
Urbana-Champaign*

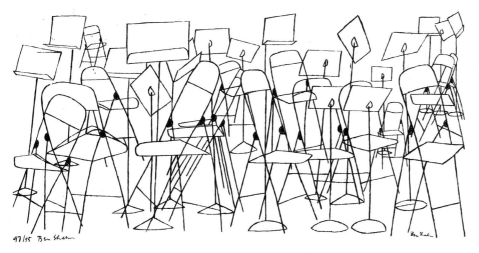

Figure 12.9
BEN SHAHN (1898–1969)
Silent Music (1955)
Screenprint. 17¼ × 35 in.
Philadelphia Museum of Art
Purchase, the Harrison Fund

dimensional phenomena are engagingly integrated.

7. Random placement of the configuration on the page. This defect suggests an indifference to the format's effect on the image. We have seen that a drawing's design consists of the configuration *and* the page. The impact on the viewer of a visually illogical placement of the configuration often overrides the drawing's intended impact. In Figure 12.10, the active dark shape in A overwhelms the several white shapes and seems crammed into the picture-plane, straining for release. The same shape in B appears less active and not at all crammed in. In fact, it appears somewhat isolated in so large a field of space. In C, it has been located in a position on the picture-plane that creates imbalance. Besides

destroying the equilibrium of the design of the page, such placement can sometimes weaken the overall nature of the configuration. An image that is itself stable, if placed badly on the page, becomes part of an unstable design. An incompatible relationship between the configuration and the page sometimes occurs in the work of capable artists. In Vigée-Lebrun's drawing *Study of a Woman* (Figure 12.11), the lack of "breathing space," around the figure, especially at the top, where the head touches the edge of the page, produces a slightly claustrophobic state in what is otherwise an excellent drawing (although the drawing may have been cropped by another hand at a later date).

8. The divided drawing. This results from strong divisions of the picture-plane by lines,

Figure 12.10

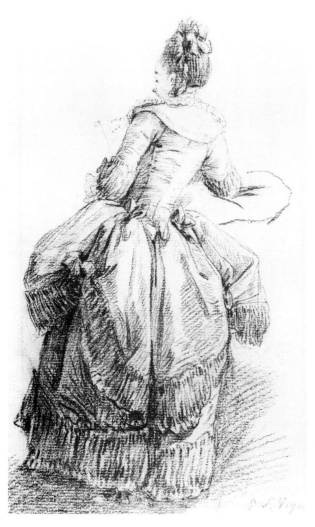

Figure 12.11
ÉLISABETH VIGÉE-LEBRUN (1755–1842)
Study of a Woman
Red chalk. 9½ × 5¹⁵/₁₆ in.
Courtesy Museum of Fine Arts, Boston
Gift of Nathan Appleton

their relationship to a third group on the left as well as to the smaller pillars and arches behind them, all form strong visual bonds of association. When a section is unintentionally severed from the rest of a drawing, the two parts can be strongly joined through direction, rhythm, value, and texture, as in Cheruy's drawing, or by placing one or more forms in a position that crosses the boundary to join the parts together.

9. Imbalance. This defect results from the visually unstable placement, direction, density, weight, scale, or value of the elements, and of the forms and spaces they create. It often results from such an exclusive concern with a drawing's representational aspects that the visual weight of its parts go unheeded. Balance is guided only partly by intuition and cannot be consciously ignored. The artist's design plan should include a tentative judgment about the scale and placement of the configuration on the page that will assist the drawing's balance.

To create a balanced drawing, the artist must cancel out visual forces that cause the design to appear to be falling or crowding to one side, that isolate segments, or that show any other unresolved instabilities among its parts. There are two basic ways of cancelling out forces. One is to answer a strong force on one side of the drawing with a similar force on the other side, as in Figure 12.13A. This more or less *symmetrical* solution, if too evenly established, can be rigidly formal and obvious, but when used subtly, it is a dependable way of producing equilibrium. In Rembrandt's *A Cottage among Trees* (Figure 12.14) and Villon's *Study for Farmyard, Cany-sur-Thérain* (Figure 12.15), balance is achieved through roughly symmetrical forms and forces. In both, a gentle curve, horizontally oriented and cresting near the drawing's center, describes the contour of the foreground's shape. In both, the curve's crest is the location of a strong mass that acts as a fulcrum for the rest of the drawing's masses, and in both, the masses flanking the central one bear a strong resemblance to it. Rembrandt continues the symmetrical system in the fences and in the horizon, making them quite similar to their counterparts across the page. Villon repeats the diagonal lines in the sky with the lines in the foreground.

A second way to cancel out strong visual forces is to answer them with different but equally strong forces, as in Figure 12.13B. This is

shapes, values, forms, or directional forces that isolate one part of a drawing from the rest, destroying the unity of the design. Such divisions, however, when they are offset by other forces in the design that weave them together, are a frequent device in drawing. In Cheruy's drawing of a church interior (Figure 12.12), the columns on the far right cut the drawing vertically, but they are joined to the rest of the drawing in several ways. One of the strongest connections is the unseen but clearly suggested arch spanning the interspace between them and the center group of pillars. The similarity of value and texture between the two massive pillar groups, and

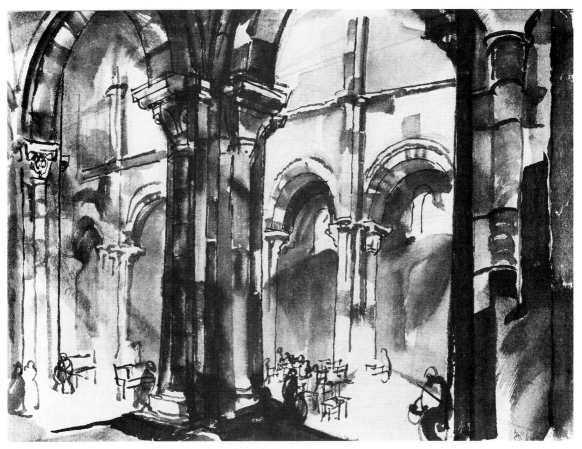

Figure 12.12
GERMAINE ROUGET CHERUY (1896–)
Vezelay, La Madeleine—The Nave (c. 1930)
Ink on Japanese paper. 12¼ × 17 in.
Courtesy of Fogg Art Museum, Harvard University Art Museums,
Cambridge, Mass. Gift of Edward Waldo Forbes

an *asymmetrical* solution. Asymmetry, being the more prevalent state in nature and offering unlimited design possibilities, more frequently occurs in responsive drawings, as a glance at the drawings in this book shows. In Ingres' *View of St. Peter's in Rome* (Figure 12.16), the placement of the cathedral to the left of center—its great facade and dome producing the strongest vertical movement in the drawing—is answered by the encircling sweep of the buildings, and by the pronounced curve of the roofed colonnade in the foreground. The single vertical direction of the obelisk on the right adds its energy to the drawing's balance and serves as a unifying echo of the vertical forces of the cathedral.

As we saw in Chapter 1, a gestural approach gives the artist an overview of the drawing's general compositional nature and needs. In drawings where imbalance occurs, the failure to establish the design's basic gestural premise at the start is often the cause.

Figure 12.13

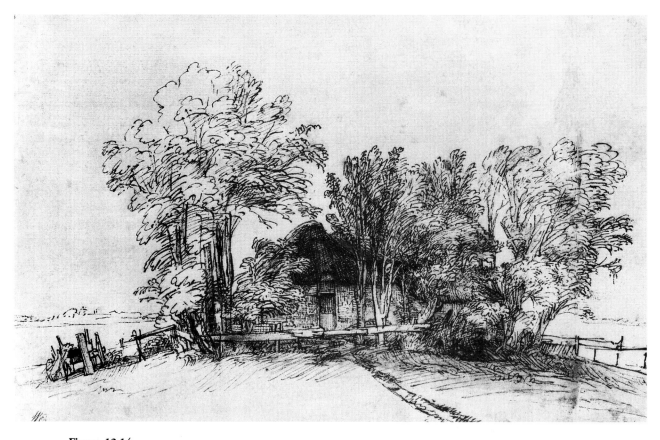

Figure 12.14
REMBRANDT VAN RIJN (1608–1669)
A Cottage among Trees
Pen and bistre. $6^3/4 \times 10^7/8$ in.
The Metropolitan Museum of Art. Bequest of Mrs. H. O. Havemeyer,
1929. H. O. Havemeyer Collection.

Figure 12.15
JACQUES VILLON (1875–1963)
Study for Farmyard, Cany-sur-Thérain
Pen and ink. $6^3/8 \times 9^3/4$ in.
By courtesy of the Boston Public Library, Print Department

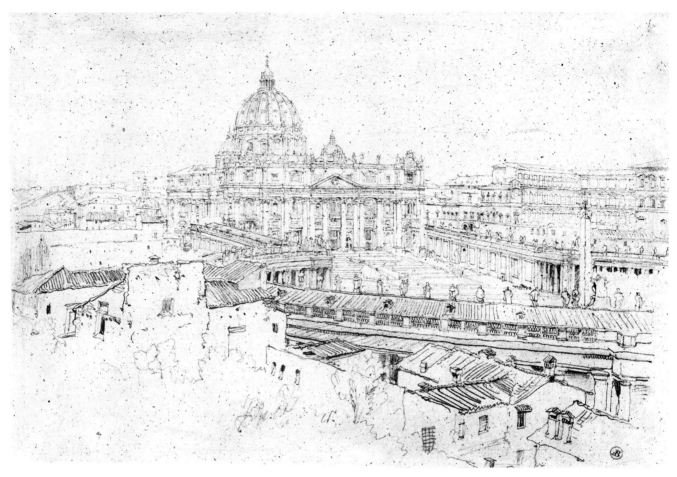

Figure 12.16
DOMINIQUE INGRES (1780–1867)
View of St. Peter's in Rome
Graphite pencil on ivory oatmeal paper.
33.6 × 49.8 cm.
Collection of The Art Institute of Chicago. The Joseph and Helen Regenstein Foundation. Photograph © 1996, The Art Institute of Chicago. All Rights Reserved

10. The generalized drawing. When the artist is in doubt about how to realize some of the smaller, more specific aspects of the subject and the design, the result may be a generalized drawing. Often students establish quite handsome drawings of the subject's generalities and a good, equally generalized design, but seem unable to apply or sustain the attitudes that brought these broad states about when developing the drawing's smaller structural and dynamic conditions. Of course, many artists intend a simply stated image, but all are *concise* rather than general. They may be simply stated, but they are rich in visual and expressive meaning.

By contrast, the generalized drawing only suggests possibilities and hints at conclusions. Its summaries are vague and seem more like uncertain assumptions than convincing assertions. Some students (and artists) make simple and general drawings in admiration of the economy of master drawings—and some of these do bear a superficial similarity to such drawings. But it is perceptual and organizational sensitivity and not simplicity for its own sake that leads to concise drawing. These sensitivities are expanded in drawings that probe and establish small forms and forces with the same sensitive commitment we invest in establishing the major ones, as in Figure 12.17.

Certainly, not all student drawings need to

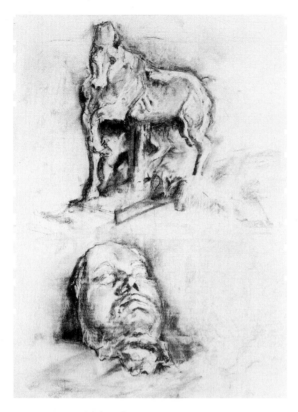

Figure 12.17 *(student drawing)*
CLAUDIA ROBERTS
Charcoal. 18 × 24 in.
Private Study, Newton, Mass.

be extensively carried to include a host of specific observations. But students need to develop the ability to state any highly specific detail or relationship to overcome *unselective* generality. They should, from time to time, reinforce the experience of applying the same degree of analysis and empathy to smaller matters that is given to major ones, as in Figure 12.18. This is important for another reason. Just as the search for the essential structure and spirit of a subject's differing parts helps us to see similarities between them, in drawing the smaller forms and actions, we come to see the subtle differences between similar parts and energies. For example, while it would, at the outset, be important to see the similarity of form and direction between, say, the twigs of a branch and the fingers of a hand holding it, it is also important, later in the drawing, to be able to show the differences between each twig and between each finger. Ironically, the insights that come from patiently establishing a subject's smaller forms and actions, and in-

tegrating them within its larger forms, is the fastest and surest way to eventual economy. This occurs because the more sensitive we become to subtle forms and movements the better we come to see how they may be more simply suggested by the larger ones.

EXPRESSIVE DEFECTS

Although perception and organization, are interdependent considerations, the expression of our genuinely personal responses to a subject's dynamic and representational meanings is the fundamental role of these considerations. Drawings in which our expressive responses are stifled or disregarded, or fail to touch on important facts and inferences about the subject, are either expressively evasive, confused, or derivative. The following expressive defects are some of the ways in which feelings fail to participate in the responsive process.

1. Expressive reticence or blandness. This weakness suggests an over-concern with depictive "correctness" or inhibitions toward the intuitive and emotive responses that influence perceptions. But, as was observed in Chapter 10, even this reticence is expressive. The beholder senses a restraining of impulses that both empathy and intuitive knowledge demand. If the artist does not risk commitment to his or her responses in a direct way, the drawing reveals the hesitancy and constraint.

All art teachers are familiar with the student who makes conscientious drawings that carefully avoid responses to the subject's dynamic potentialities. At one time most art academies insisted on just this kind of disciplined concentration on measurable matters. It constituted the main and sometimes only area of perceptual awareness. But such drawings often appear leaden, lifeless. Drawings that avoid the dynamic energies that create the graphic equivalent of life are lifeless.

Here it will be helpful to compare two highly representational drawings. They show the differences in attitude and result between an almost exclusively reportorial approach and one that utilizes expressive impulses. The anonymous Dutch or German School *Study of Ten Hands* (Figure 12.19) shows a great concentration on the observed state of the terrain in each part, with little concern for the gestural, rhythmic

Figure 12.18 *(student drawing)*
HILARY HEYMAN
Graphite on hot press paper. 22 × 30 in.
Arizona State University

flow within or between them. Each finger is drawn with hardly a clue to its participation with others in forming greater units of form—or as engaged in pointing, gripping, or supporting *actions*. In almost every instance, there is no convincing impression that the arms really continue inside the sleeves. For all the concentration on individual volumes, many volume relationships do not convince. For example, in the middle drawing on the far left the structural means by which the forearm interlocks with the hand is unclear. Although the surfaces of these hands are explicit, the general structure, weight, power, and expressive character of the hands are not. They "describe" various acts of exertion, but

they do not "enact" them. The artist is skillful. Many of the small folds and veins are deftly stated, and in some passages the drapery-like character of the skin, moving over bone, tendon, and muscle, is effective. Some hands, such as those of the bottom row (especially the one at the far left) do begin to "live." But the artist's basic theme is the scrutiny of small forms, too often at the expense of the large ones. A clue to the artist's thinking occurs in the beginning stage of the pointing hand in the upper right corner of the page. It is already a carefully delineated record of the outlines of the forms. Nowhere can we find a gestural or analytical line. Nowhere do lines express movement or energy.

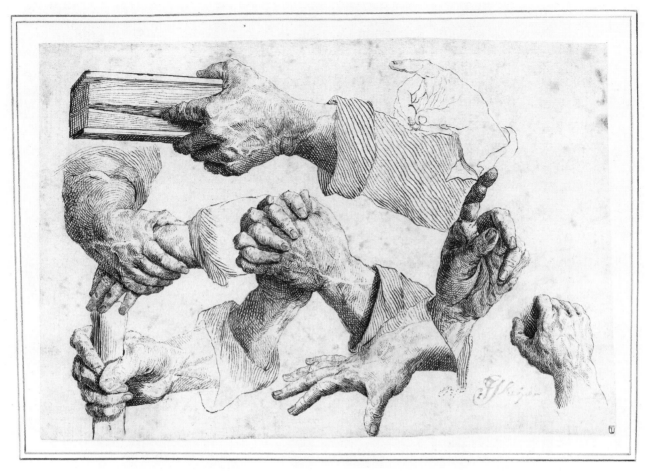

Figure 12.19
ANONYMOUS (Dutch or German School)
Study of Ten Hands
Pen and brown ink. 7⁷/₈ × 12¹/₈ in.
National Gallery of Canada, Ottawa

Compare this beginning state with the early stage portions in Rubens' drawing, *Study of Cows* (Figure 12.20). A different kind of sensibility is at work here. In the upper left and right corners of the page, and even in the more developed drawings in the lower right, lines search for the actions, tensions, and *masses* of the forms *at the outset*. In these beginning stages Rubens is concerned not with careful delineation (although he is plainly interested in understanding shape actualities), but with the *feel* of the forms' movements and with their essential constructional nature. The benefits to both the structural and expressive clarity of the forms are evident in the three larger drawings of the animals. The artist's response to their ponderous bulk and weight, to their slow movements, and to the powerful pressures and tensions created by the inner structural forms supporting and straining against the walls of the supported hide, creates convincing, living images of visual and expressive significance. All this is more than the result of scrutiny—it is the result of perceptions selected, altered, and ordered by feelings and intuitions as well as intellect.

It is feelings and intuitions, too, that cause Rubens to select (perhaps subconsciously) an overall design that fans out toward the beholder, with strong, curved movements sweeping to the left and right. Note the great clarity of the forms. Heavy, interlocking, but rhythmically related masses, and hatchings that move sensually upon the changing "topography" of the forms, convey Rubens' profound understanding of the masses.

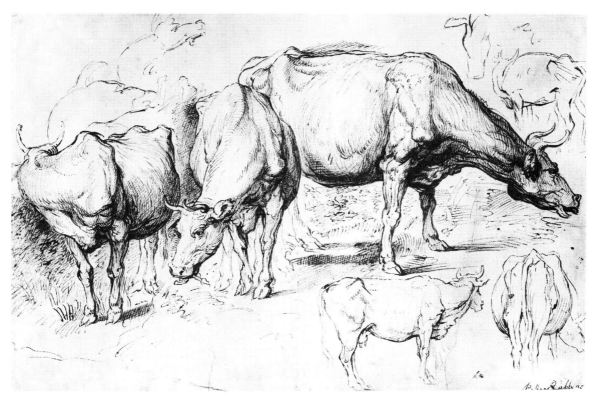

Figure 12.20
PETER PAUL RUBENS (1577–1640)
Study of Cows
Pen and ink. 34 × 52.2 cm.
*Reproduced by courtesy of the Trustees of The British Museum,
London. Copyright British Museum*

These qualities, like the design itself, are strong, deliberate, and graceful. Compare Rubens' design with that of Figure 12.19. Again, there is a kind of restrained quality to the arrangement of the arms and hands. They form an overall checkerboard pattern, somewhat mechanical and dull. Unlike the design of the Rubens drawing, which evokes something of the behavior and character of the animals, this design seems unrelated to the character of the subject.

In another comparison, this time with a sketch of two hands by Agostino Carracci (Figure 12.21), we find more spirit and force in this sketch than in the hands of Figure 12.19, despite their more thoroughly explored surfaces. While Figure 12.21 is only a rough exploration and Figure 12.19 is an extended study, the sketch is more responsive to structural matters than the study is to expressive ones.

In drawings that are expressively inhibited, more than the frank expression of felt responses is absent. The drawings appear diminished in the clarity and force of their representational meanings as well. With human forms especially, a failure to support representational actions and energies by abstract ones deadens the results.[2]

2. The literary or message drawing. When the artist is concerned more with storytelling, or with conveying a message (whether social, political, historical, or religious) through a drawing's figurative matter, rather than with creating a *visually* expressive work, the literary look occurs. Any storytelling message can be a valid property of any drawing (see Figures 3.14 and 10.17), but it should never replace the emotive force that the visual elements are capable of generating with an exclusive concern with "the way things look."

Whether or not it does so depends on the

[2] See Nathan Goldstein, *Figure Drawing: The Structure, Anatomy, and Expressive Design of Human Form,* 2nd ed. (Englewood Cliffs, N.J.: Prentice-Hall, Inc., 1981), chaps. 1, 5–7.

Figure 12.21
AGOSTINO CARRACCI (1557–1602)
Sheet of Studies
Pen and ink, some chalk. 20.5 × 27.2 cm.
Rijksmuseum, Amsterdam

artist's ability to govern two quite different kinds of expression. As we have seen, some artists actually need an essentially nonvisual theme. For them, conveying a social, spiritual, or other kind of message, far from competing with the demands of expressive order, stimulates it and is in turn enhanced by it. When there is such a reciprocal relationship between dynamic and narrative expressions, the results (as many of the drawings in Chapter 10 indicate) do not appear merely anecdotal. It is only when a narrative theme overpowers the artist and compromises his or her creative instincts, or when its demands are incompatible with them, that responses to both the subject and the drawing lead to the literary look.

To some extent, many of our responses to a subject's physical, dynamic, and psychological states are not directly visual issues. We cannot visually measure dignity, melancholy, or repose. But when such influences on perception expand to become a drawing's dominant goal by emphasizing representational issues at the expense of its abstract graphic life, the result is narration, not art. And though some artists are stimulated by nonvisual ideas and do their best work when spurred on by such themes, other artists, who may feel just as deeply about social, religious, or any other nonvisual interests, create works that do not address these matters through the narrative aspects of their drawings. If such "messages" appear, they are felt as intangible qualities of the drawing's content.

3. The picturesque air. This problem is often sensed in works that, like anecdotal ones, stress depiction at the cost of dynamic expression. It stems from a usually sentimental or romantic in-

terpretation of the quaint, the strange, and the spectacular. Often such subjects do not belong to the artist's past or present environment but are adopted because of their popularity, their exotic or unusual nature, or their literary appeal. Sometimes these subjects romanticize an earlier society. Although windmills and covered bridges still exist, it is difficult to see them objectively, because they are no longer connected to the lives most of us lead. Any observed or envisioned subject is always valid, but it is harder to respond to those we have no real familiarity with, or those that have become banal or sentimental because of overuse. The need for squeezing expression out of unusual situations or places subsides as we learn to evoke expressions out of the visual elements and the people, places, and things around us. It has been observed of Cézanne that "he made bowler hats out of mountains, and mountains out of bowler hats."

4. The influenced drawing. The problem here is that the influenced drawing usually lacks the conviction and daring present in the drawings it was influenced by. We are not referring to drawings that show a faint residual influence of a particular artist or style. An artist who by temperament and esthetic disposition finds that he or she shares a point of view with that of a colleague, master, or stylistic period is bound to reflect some superficial similarities. But even though such artists may show an influence in their work, it is essentially original work if it is not restricted by, or imitative of, the influencing works. It is hardly uncommon in the history of art for some artists, and among them some of the best, to expand upon or even to develop new concepts stimulated by the innovations and idiosyncrasies of others. After all, in being ourselves as artists, it is natural to search out "kindred visual spirits" among other artists, past and present, just as in our social lives we search out friends who strike us as good and wise. In both cases, influences occur. In both cases, our understanding, our abilities, and ultimately our freedom to be ourselves is *increased*.

But strong influences do not permit the expression of personal responses. An adopted manner is usually an imitation of a technique, rather than a concept; and whichever it is, its presence always prevents the development of one's own creative ability.

The heavily influenced drawing is often unselectively dependent on the techniques and idiosyncrasies of the admired artist. In his drawing *The Degradation of Haman before Ahasuerus and Esther* (Figure 12.22), de Gelder combines many of Rembrandt's drawing characteristics to summon up a Rembrandtesque image. But he succeeds only in imitating Rembrandt's personal graphic "handwriting." Interestingly, such traits are sometimes regarded by innovators as being of little importance to their purposes, or even detrimental. As the late American artist Philip Guston observed about his imitators, "They all seem bent on exaggerating just those things I'm trying to get rid of in my work."[3]

De Gelder's marks *are* strongly reminiscent of Rembrandt's handling, but they fail to convey Rembrandt's perceptual or dynamic understanding. In short, de Gelder's drawing does not convey a Rembrandt-like *content*. How could it? The lines and tones that are *necessities* for Rembrandt—the results of his negotiations between perception, feeling, and intent—all serve to amplify his unique and deeply felt responses. No one can summon up another's sensibility, and no sensibility can conceive and sustain the special demands of another.

De Gelder's understanding of volume and design does not support the kinds of daring that are natural and necessary for Rembrandt. Note the ambiguities in the forms of the figures. None of the heads or hands suggest the quality of structural analysis, the weighty mass, the design, or the expressive power of comparable forms in a Rembrandt drawing.

Compare the bold control of the heads and hands in Rembrandt's *Three Studies of a Child and One of an Old Woman* (Figure 12.23), with those in the de Gelder drawing. Note, too, that where Rembrandt creates transitions between broad and precise kinds of handling, de Gelder's changes in handling are abrupt inconsistencies that serve no visual or expressive purpose. Where Rembrandt's washes of tone convey light and volume with certainty, de Gelder's are uncertain—sometimes rather tightly encased by line, sometimes obscuring volume, and sometimes simply inconclusive and weak. They seem somewhat unrelated to the rest of the drawing. The evenly spaced diagonal lines that cross the center of the drawing, unlike the lines behind

[3] In a private conversation with the author.

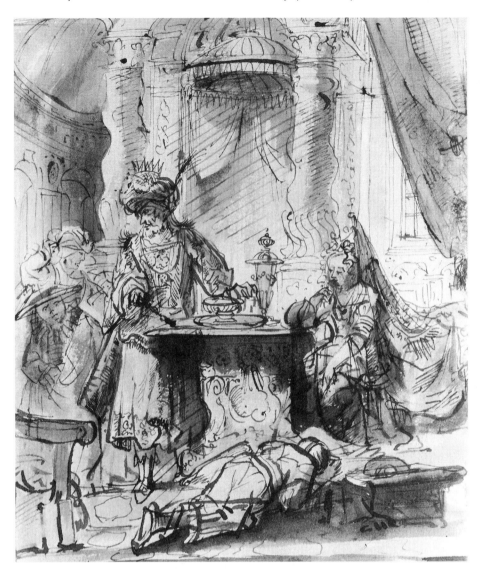

Figure 12.22
AERT DE GELDER (1645–1727)
The Degradation of Haman before Ahasuerus and Esther
Pen and ink and wash. 19 × 16.5 cm.
Collection of The Art Institute of Chicago. Charles Deering Collection.
Photograph © 1996, The Art Institute of Chicago. All Rights Reserved

the seated child in Rembrandt's drawing, do not stay well back but come forward and hover in space somewhere between the figure of Ahasuerus and the pillars in the background. De Gelder is uncertain about the perspective and the architectural forms on the far left, and some of those in the center background are left unclearly stated as volumes in space.

These defects suggest the limits of his perceptual, organizational, and empathic comprehension. *No technique or imitation of technical mas-* *tery can camouflage such limitations.* The attention and energy focused on imitating another's point of view obstruct those abilities the artist *does* have, and further weaken the results. But the heavily influenced student or artist who begins to search for (and respect) his or her own responses sooner or later finds a satisfying creative freedom (and result) that imitation will never provide. Along the way the artist discovers important truths about his or her *self*, making further original work more likely.

Figure 12.23
REMBRANDT VAN RIJN (1606–1669)
Three Studies of a Child and One of an Old Woman
Pen, brown ink, and brown wash with slight touches of discolored
white body color on white paper.
$8^3/8 \times 6^1/4$ in.
Courtesy of Fogg Art Museum, Harvard University Art Museums, Cambridge,
Mass. Gift of Meta and Paul J. Sachs

5. Conflicting meanings. We sense this defect when a drawing fails to convey a consistent visual attitude, mood, or handling. It is sometimes symptomatic of a disinterest or confusion concerning a subject's structural and dynamic properties. But changes in goals and handling, after a drawing has begun, too often produce conflicting results. Such drawings reveal a weak grasp of those factors that establish unity. The freedom of response to a subject and to its emerging

Figure 12.24
JOYCE TREIMAN (1922–)
Study for "Big Lautrec and Double Self Portrait" (1974–75)
Pencil. 20 × 20 in.
Collection of Jalane and Richard Davidson

equivalent state on the page does not extend to *arbitrary* changes in attitude toward the subject or to its manner of presentation within the same drawing. For example, in a landscape drawing that is primarily tonal and concerned with aerial perspective, a sudden switch to a linear, diagrammatic exploration of the structural aspects of a house in one corner of the drawing is a glaring inconsistency.

Such conflicting goals are not uncommon in student drawings. This problem often results from experiencing the many new ideas and challenges a good program of art study provides. But conflicting interests and goals violate one of the most fundamental requirements of any art form: the organizational and expressive need to sustain a single, overall purpose.

This is not to say that multiple meanings are impossible in drawing. In the example just mentioned, both tonal and diagrammatic ideas can be quite compatible if an interest in both is made an integral and reoccurring theme of the drawing's expressive order. In Treiman's *Study for "Big Lautrec and Double Self Portrait"* (Figure 12.24), the seeming "errors" in scale and perspective are integrated, intentional changes that enhance the enigmatic mood of this envisioned grouping.

Conflicting meanings may sometimes be noted when the figurative expression is at variance with the expressive nature of the handling and design. For example, in a drawing of a figure performing some dramatic action requiring strenuous physical exertion, a delicate, deliberate handling and a design that stresses horizontal and vertical directions or otherwise appears tranquil or stately would tend to weaken and contradict the figurative action.

Expression and order are the dimensions of an approach to drawing that will yield works that live. Beginners too often become preoccupied with the multiplicity of factors in drawing and disregard the general responsive direction of their work. That is, busy learning how to see, they lose sight of what it is they intend to convey. In time this seemingly unmanageable number of considerations begin to come together and work for the student almost automatically. Then it will be most important to recognize that perceptions and methodologies are servants that perform best when the best demands are made of them. And the demands of a sensitive analytical and empathic sensibility, perceiving and ordering in a personal way, create original style. Style, in fact, indicates the key to our priorities—it reveals both temperament and in-

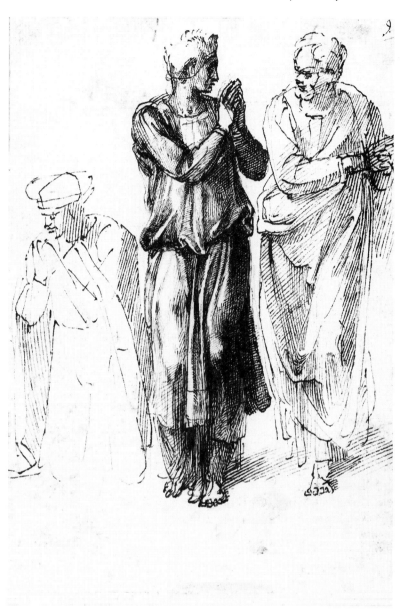

Figure 12.25
MICHELANGELO BUONARROTI
(1475–1564)
Studies of Figures
Pen and ink.
Teylers Museum, Haarlem, The Netherlands

tent. Therefore a search for style not only is futile, it is beginning at exactly the wrong end. Intent must precede a personal form for expressing itself, and it brings with it the conditions that shape style. Style, then, is nothing we choose: it is given, inherent in our nature and purpose. In the end, style is character.

The symptoms of basic weaknesses in responsive drawing examined here (and there are others) should provide a basis for the evaluation of our drawings that further experience will broaden. In responsive drawing the most pernicious underlying causes of so many defects are the faulty judgments that result from an exclusive concern with imitating instead of analyzing and interpreting nature, and with a sequential approach in pursuing that limiting goal. As Michelangelo's *Studies of Figures* (Figure 12.25) so well demonstrates, beginning with a search for a subject's structural and dynamic essentials provides the comprehension and control that lead to sound drawing.

What engages our participation—as well as our admiration—in a responsive drawing are the activities that suggest choices and energies contending with each other. Their resolution into a system of organized expression invites us into the drawing—not only to admire, but to participate in the negotiations that shaped them into this living system.

13

finding your way
options and attitudes

All of our creative activities occur in the context of what we know and what we want. Our personal experiences in living and in the realm of art shape our creative purposes. But because what we know is bound to influence at least some of what we want from our drawings, the responsive artist is always interested in new information and new experiences in and beyond the realm of art; he or she is always, in part, the responsive student.

The answer, then, when young artists wonder: "What should be my area of concentration and the nature of my artwork?" or, more simply, "What happens now?" is of course determined partly by the fields of visual communication that attract them and partly by what they must then do to develop their skills further. Those who wish to be illustrators or graphic designers will find their future drawing skills shaped largely by the special demands of clients, deadlines, budgets, and changing modes of commercial visualization. Even here, though, the individual stamp upon our work—our unique style of imagery—will play a leading role in determining how successful (and satisfied) we will be as

artists. This is even more the case for young artists who mean to make the fine arts their primary (or only) area of interest. But whatever our personal visual goals may be, the more penetrating our perceptual and conceptual inquiries, the more inventive and effective our drawings will be. As the poet e e cummings put it: "Always the beautiful answer who asks a more beautiful question."

And the "beautiful question," as we have seen, asks for more than superficial answers; it inquires about the essential nature of a subject's form and character, and even creates the possibilities for meanings that transcend the subject. The best drawings, of whatever culture or era, possess visual and philosophical connotations that go beyond depiction to become universal, timeless expressions. All good art is in the service of something greater than the artist's intentions.

It has been observed throughout this book that the content of a responsive drawing is the sum of its representational and abstract condition—the total impact of its depictive and dynamic meanings. A drawing's content may be

shallow, interesting, or profound, according to the quality of the artist's perceptual awareness and the quality of his or her conceptual, expressive, and intuitive responses. When such responses reach a critical intensity of synthesis and vitality, a drawing's content is experienced as a living force. But the basic skills that lead to drawings of such integrity and spirit are those of analysis and empathy; we cannot interpret what we do not comprehend. And the best route toward our area of visual interest—toward those matters that, in meaning most to us, will more likely mean more to others—is the one that best tests and trains us to see beyond the surface to the heart of the things we draw: the continuing exploration of visual phenomena as revealed in art and nature and, by these efforts, of yourself. We have, then, come full circle from the quote by the great French painter Delacroix at the beginning of this book: "O young artist, you search for a subject—everything is a subject. Your subject is yourself, your impressions, your emotions in the presence of nature."

In this chapter we will look at some ways of continuing art study that—although hardly ensuring high-quality creative results—may keep us from the quality we aspire to if left unregarded. While determining quality in drawing is bound to be a largely subjective judgment, certain criteria such as economy, authority, organizational and expressive clarity, and unity are sure to remain universally important in the evaluation of a drawing's quality, if only because our human sensibilities naturally look for balance and order, meaning and spirit.

There are, of course, levels of quality. Even when the factors of economy, authority, and so on are in ample evidence, we can still discern differing levels of involvement, of inquiry, and of the integration of means and meanings. Figures 13.1 and 13.2 are accomplished drawings, each by a much honored artist at the height of his creative powers. The subject matter is roughly similar, as is the level of realism. Each shows some admirable features not to be found in the other. Sloan's drawing is the more spontaneous; Sheeler's, the more precisely crafted.

> *All good art is in the service of something greater than the artist's intentions.*

Sloan explains the way planes abut and fuse; Sheeler's modeling is more the result of illumination. Their purposes and expressive moods are plainly different and equally valid.

Yet on balance Sheeler's drawing appears to be the more provocative and metaphoric work. There is an intensity of concentration on a few issues—the figure as "landscape," the striking two-dimensional pattern, an air of mystery, and a strong sensual undercurrent that rivets our attention. Sloan's drawing is an example of a somewhat familiar set of issues treated in a somewhat familiar way. It is a more casual denoting of something observed, stated in an assured manner. But if Sloan's drawing is an impressive performance, Sheeler's is an impressive invention. In the latter, each of the elements of line (as edge), value, shape, volume, and texture is asked to perform a more demanding role. This is not so because Sheeler's drawing is more fully developed than Sloan's, but rather an intensity of commitment to a particular set of engaging visual ideas has set off a more engaging set of dynamics, whereas Sloan's less probing inquiries provide less interesting answers.

In developing your way of drawing, it is important to aim for an intensity of commitment, to become so keenly engaged that the drawing's energies lead the way to images that come alive. Sheeler's commitment leads him to an interest in form realization which goes beyond the volumetric condition of the figure's masses. There is a poetic equivocation that plays with scale and identity. The drawing is a close-up of a figure, its ample forms implying the fruitful properties of ancient fertility figures; but it suggests a monumental and barren landscape. It is at once realistic and abstract, substantial and illusory. The forms express both strength and pliancy, are both inviting and indifferent. Such contrasting readings attract our interest and, by their universality, will always provoke attention.

Developing the perceptual sensitivity that uncovers lasting visual and expressive qualities requires a concentration on the three main concerns of this book: first, the study of drawing as inquiry into the structure and dynamics of form and space; second, the study of drawing's rela-

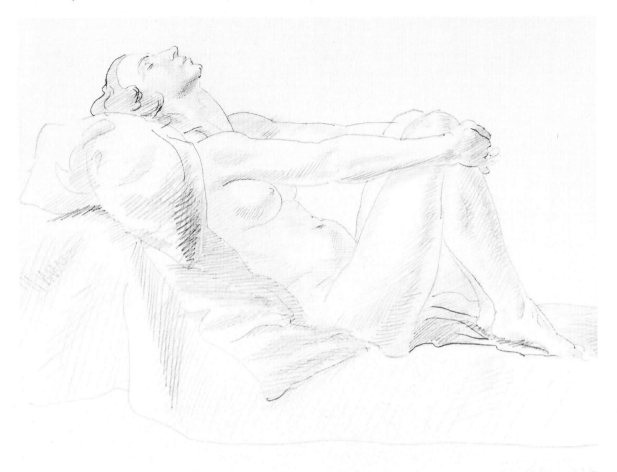

Figure 13.1
JOHN SLOAN (1871–1951)
Nude (1931)
Pencil on paper. 7³/₈ × 9¹/₈ in.
*Collection of Whitney Museum of American Art, New York. Gift of
Helen Farr Sloan.*

tional and expressive potentialities; and third, the study of outstanding works of art.

It is by these routes of study that we come closer to our particular way of showing others, through our works, what we find to be valuable in the things we choose to draw. And finding our own means of expression is necessary if we are to create images infused with those energies and inflections that only our unique sensibility can provide. The great American dancer Martha Graham put it this way: "There is a vitality, a life-force, an energy, a quickening which is translated through you into action, and because there is only one of you in all time, this expression is unique. And if you block it, it will never exist through any other medium and be lost. The world will not have it."[1] But to translate this force into the action of drawing requires an ongoing program of study—of inquiry, trial and error, risk-taking, and practice.

Hence the ongoing need for the artist—both student and professional—to draw continually, to examine the drawings of others, and to be always aware that the study of nature's limitless structural and dynamic patterns is fundamental to personal creative growth. And we must be engaged in all of these studies at the

[1] Harold Taylor, *Art and the Intellect*, published for the National Committee on Art Education by the Museum of Modern Art, New York. Distributed by Doubleday & Company, Inc., Garden City, N.Y., p. 22.

Figure 13.2
CHARLES SHEELER (1883–1965)
Nude (1920)
Charcoal.
Collection of Mrs. Earle Horter

same time. Prolific artists, unless they fertilize each drawing with new structural, relational, and expressive demands, may only produce variants of their present range of skills and insights. Investigative drawing sheds light on nature, nature teaches us important truths about drawing, and great works of art reveal insights on both drawing and nature—they tell on each other.

In making such inquiries of nature and art, each of us comes upon certain qualities and characteristics we find especially compelling, certain aspects of nature and art that satisfy us enormously and that we want to explore further. These discoveries are likely to be the first of those components that will form our own point of view, for those qualities in nature and art that attract us most are the same ones we mean to show in our drawings.

Responsive artists, then, are the ones who never tire of examining the practices and products of drawing, or the world around them

which serves as both teacher and subject. Ingres observed that when he found himself in circumstances where drawing was not possible, he would "draw with my eyes"; the aging and ill Matisse would spend many hours drawing wildflowers in his garden; Cézanne, when asked where he had studied art, replied, "In the Louvre." Such artists experience an ongoing fascination with the behavior and patterns of the people, places, and things around them, with the spectors of their imagination, and with the finest expressions of creative activity. Responsive artists are always inquisitive. Their perceptions—invariably both penetrating and innocent—search for new knowledge and new experiences. They have what has been called a "hungry eye." In part, the hunger they seek to satisfy is one of self-knowledge. They seem to know that their growth as individuals and as artists are aspects of the same process. The old adage, "You are what you eat" can be extended to the realm of art: *You are what you draw.* Your drawings reflect what fascinates you as an artist and as an individual. Responsive artists do not make drawings *of* their subjects, but *about* them. They don't draw as they think they should, but as they feel they must.

That is why responsive artists cannot predict where their work will carry them. Life and death have a way of intruding. Facing the brutality of the war raging around him, Goya evoked, in his drawings, the anguish he saw and experienced (Figures 3.14 and 9.12). Gropper's amused cynicism of legislators at work led him to make many satirical drawings of this subject (Figure 11.4). Mondrian, too, made numerous drawings that explored his fascination with the wonder of life in flower forms (Figure 13.3).

The visionary drawings and paintings of the artist Patricia McDowell underwent a powerfully expressive breakthrough after her diagnosis of cancer in 1987. Bravely facing her circumstances, she not only continued to be highly productive, but created works of extraordinary power and beauty (Figure 13.4). As the writer, Robert Simon (her husband) put it, "My wife's encounter with cancer unleashed a rush of creative energy. Her work became looser, more spontaneous and instinctive, yet at the same time formally richer and more complex. . . . Her soul was entering the numinous and she found a way of depicting what she saw."

In the practice of drawing it is necessary to

Figure 13. 3
PIET MONDRIAN (1872–1944)
Chrysanthemum (1908–9)
Black conté crayon with graphite, charcoal, and brown crayon.
$23^{3}/4 \times 15^{1}/8$ in.
Smith College Museum of Art,
Northampton, Mass.
Purchased 1963

make drawings of both long and short duration. Although the long drawing—the extended exploration of a subject's smaller forms and surface features—is a most informing kind of study, the developing artist must concentrate at least as much on those shorter drawings that test and expand his or her ability to see, select, summarize, and state important visual and expressive characteristics (Figure 13.5).

The brief drawing, whether its time limit is imposed by the instructor or by ourselves,

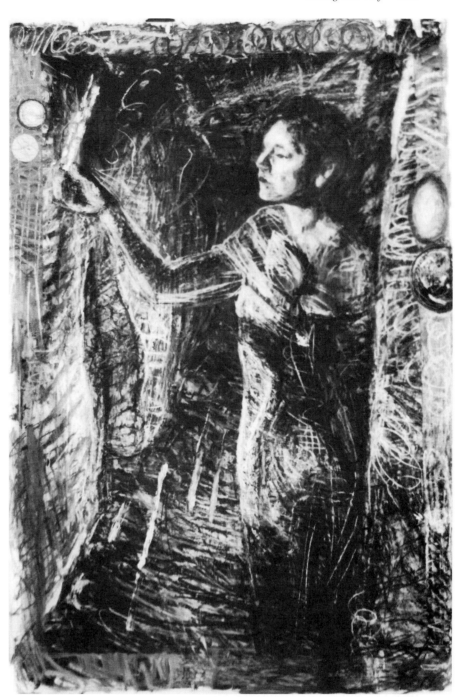

Figure 13.4
PATRICIA MCDOWELL
(1948–1993)
*Nola in the Vast Chamber of
Messages* (1990)
Oil paint, colored pencil, paint
stick, and charcoal, on mylar.
42 × 62 in.
Collection of Robert Simon

sharpens our ability to analyze and respond, thereby sharpening our perceptual sensitivity to the things around us. Thus the repeated practice in concentrating on structural and dynamic essentials constitutes an important part of our training in searching out other engaging subjects to draw. In this sense our perceptual sensitivity, working as a kind of visual detector, scans our environment or our imagination for a significant "contact." Our unique creative "receiver" seeks certain kinds of stimuli. Drawing a subject that does not attract usually produces weak results.

When a contact is made, a state of excitation occurs. The artist sees possibilities for cre-

Figure 13.5
HARRIET FISHMAN
Man on Crutches
Black chalk. 9 × 11 in.
Courtesy of the artist

ative expression in the subject's actualities and implications and is stimulated to draw. For some artists, almost any random collection of forms can trigger creative ideas. Others, although just as perceptually sensitive, are attracted by only a few subjects. Not surprisingly, as perceptual awareness develops, the range of subjects that attract students usually increases.

An artist's initial interests are stimulated because of a rough, general kind of perceptual analysis. Some general ideas and impulses have

formed in his or her mind about the creative potential in a particular subject. These perceptions include general information about the subject's gesture, structure, arrangement in space, and the relational and emotive character of its figurative and abstract states. They also include stimuli that tug at the artist's psychological sleeve. Subjects we strongly want to draw contain something in their arrangement or meaning that attract us, although we can seldom say why. Indeed, it is easier for us to explain why we

don't want to draw a particular subject (or in a particular style) than to say why we do.

These considerations and feelings do not occur in a sequential way when we examine a potential subject, but overlap and affect each other. For example, perceptions of a part's direction and shape are simultaneously perceptions of its representational, expressive, and abstract conditions, and which of these considerations receives emphasis depends as much on our psychogenesis—on the nature of our *self* as shaped by living—as on anything in the subject itself.

The order of priority of perceptual interests in the completed drawing—how much attention and development each of the above considerations gets—is then, as was noted in Chapter 11, a key to the artist's style. And style is not altogether a matter of choice, but of esthetic and temperamental necessity. One of the characteristics of great drawings is the artist's wholehearted acceptance of his or her own style and character. It is as if such drawings say for the artist, "Here I am."

Just as the brief but penetrating sketch is a useful exercise in expanding our overall perceptual understanding, so sometimes are the first, general perceptions themselves the main purpose of an artist's drawing. This is, of course, often the case in quick preparatory sketches where the artist concentrates on a subject's depictive and abstract essentials.

The initial perceptions that stimulated Baglione's quick sketch *Group of Four Figures* (Figure 13.6) appear to be the dynamic energies of massed forms that generate the moving action of the forms toward the right side of the page. This movement is further conveyed by the tight enclosure of the format. Its "squeezing" pressure on the forms suggests their being forced toward the only open area within its boundaries, that is, the space on the right. The sense of forms advancing or striving to do so is also conveyed by the positions and gestures of the four heads. Starting on the left, each seems more involved with movement. The increasing tilt of the figures and the directional thrust of the lines that comprise them further add to the sense of impending movement. Note that the figure nearest to the right side is "committed" to the directed action by being in an off-balanced position. This drawing is a clear example of the union of figurative and dynamic actions.

The sketchbook (see Chapter 8) is a useful

Figure 13.6
Attributed to BAGLIONE (C. 1573–1644)
Group of Four Figures (Study for a Presentation of the Virgin in the Temple)
Pen, brown ink and brown wash. $3^5/_{16} \times 3^5/_8$ in.
National Gallery of Canada, Ottawa

means for expanding our drawing opportunities when we are away from the studio or school, especially for quick notations (but also for drawings of longer duration). Among the many dividends of drawing anything, anywhere, and as often as possible, is the fund of experiences that accumulates. The motives that make us draw are themselves nourished by such experiences. Each time we draw we add to our unique creative purpose.

That students can be guided toward creating valuable personal statements in the spontaneous mode is demonstrated by a number of the student works reproduced in this book. Figure 13.7 is a good example of a brief sketch with a point of view. The power generated by the bold strokes and contrasts of value, the inner tensions among the thrusting lines and shapes, and the drawing's tenuous balance all attest to the young artist's assertive interpretation of her subject.

Figures 13.6 and 13.7 are alive with the visual and expressive considerations of the responsive process, but they show responses only to those visual cues necessary to establish the

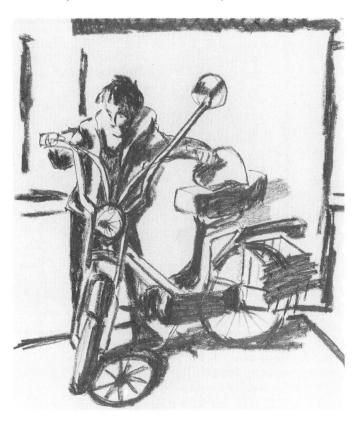

Figure 13.7 *(student drawing)*
KATHY SEVERIN
Charcoal.
University of Denver

Figure 13.8
FRANS SNYDERS (1579–1657)
Study of a Boar's Head
Pen, brown ink, and brown wash. 12.8 × 18.5 cm.
Reproduced by courtesy of the Trustees of The British Museum,
London. Copyright British Museum

broad essentials of an expressive design. Such energizing considerations must not be abandoned in drawings of longer duration.

Snyders, for example, in *Study of a Boar's Head* (Figure 13.8), probes his subject's forms and forces more deeply. Part of the almost symmetrical design's energy comes from the smaller forms. Snyders emphasizes the rhythmic movement of forms to the left and right of an invisible border which is the vertical midline of the boar's head. Tusks, ears, and bristles "rush" away from this unseen axis with a force that energizes the entire image. As in Figures 13.6 and 13.7, directed action is a strong dynamic theme, but here structural matters contribute to (and gain from) these forceful movements. Were the animal's head drawn on a horizontal axis, the sense of symmetry might appear obvious and dull. By tilting the head to the fight and counterbalancing it with dark tones on its left side, Snyders modifies the symmetry, cancels physical with visual weight, and establishes a more compelling compositional and expressive state.

The challenge for Snyders, in carrying the realization of the forms further than Baglione does, is to find organizational and emotive employment for the smaller forms, the textures, and the values. The more specific our drawings become, the greater the danger of a piecemeal attitude entering the work, of small parts and surface effects being "rendered" in an isolating and separate way rather than adding to the drawing's overall figurative and dynamic meanings.

But, advancing a drawing past the first, broad essentials *does* require some perceptions that are different from those used to establish the first general impressions. The initial responses depend on our ability to summarize. Developing a subject's smaller specifics requires an ability to see differences. Snyders is fairly specific in explaining the differences between shapes, forms, values, and textures; but the marks that explain these differences are all simultaneously engaged in various relational activities and in developing the drawing's overall expressive design. To perceive relationships between unlike forms and marks, and contrasts between like ones, requires an ability to differentiate between their measurable facts and their relational behavior. Obviously, sound perceptual understanding is sensitive to both of these considerations.

Good perception must also be sensitive to the needs of the emerging drawing. Chapters 9 and 10 pointed out that responses to the subject, once translated to the page, stimulate new responses—those that meet the depictive, organizational, and expressive needs of the image. Sometimes the initial stimulus comes not only from qualities perceived *within* the forms themselves, but from the artist's ideas about how these forms might be arranged on the page. Baglione's first impulse, as we have seen, is to establish a general system of visual and expressive conditions that takes into account the size and shape of the picture-plane. By contrast, Snyders, although he places the configuration sensitively in the format, emphasizes the relational aspects *within* the configuration. But, to differing degrees, both artists respond to both considerations. Additionally, each artist is aware that his intended emotive theme, if it is to have impact, must participate in matters of organization and handling. Because sensitive perceptual awareness includes empathic impressions, we can speak of the perception of expressive as well as visual conditions. As we have seen, relational activities are always both visual and expressive.

The easy stimulation of our creative instincts and the development of both our perceptual acuity and our personal response is best achieved by the practice of drawings that push the limits of our ability to see, relate, and react. The effort to increase our analytical and empathic understanding is a continuing necessity to the growing creative personality. The best artists have always been engrossed students all of their lives. Tiepolo's drawing *A Sheet of Sketches* (Figure 13.9) demonstrates something of the investigative studies that many mature artists continue to make. Here there is no attempt at picture-making—he has no "product" in mind. Rather, Tiepolo is after additional information and experience; he is sharpening his skills.

Such study does improve understanding and fluency. Note the similarity *and* differences between the two centrally placed heads looking to the right. The upper, more carefully developed of the two shows values used sparingly in the face. Here, lines carry the major responsibility for conveying volume. Below, the same forms are boldly brushed in by dark washes and there is almost no use of line. In these heads the artist

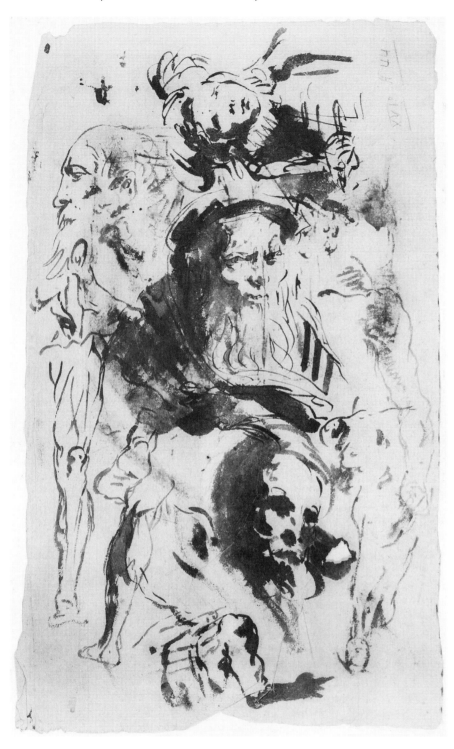

Figure 13.9
GIOVANNI DOMENICO
TIEPOLO (1727–1804)
A Sheet of Sketches
Brush and brown wash. 13³/₄ × 8⁵/₈ in.
Courtesy of Fogg Art Museum, Harvard
University Art Museums, Cambridge, Mass.
Gift of Dr. Denman W. Ross

seems to be testing different responsive solutions to the same forms.

Sketchbook studies such as Tiepolo's, in which no *conscious* compositional design is intended, or preparatory drawings, such as Matisse's *Seated Woman with Hat and Gown* (Figure 13.10), which *are* conceived compostionally, are, like all good drawings, attempts to improve perception and response. But, because these are both preliminary studies for other works, they show more clearly the searching, changing nature of drawings that are meant to deepen the

Figure 13.15
REMBRANDT VAN RIJN (1609–1669)
A Boy with a Wide-Brimmed Hat
Reed pen and ink. 8.5 × 9 cm.
Reproduced by courtesy of the Trustees of The British Museum,
London. Copyright British Museum

ure 9.35), to have employed more lines to sug-
gest *his* intent.

Yet in Aronson's *Rabbi* (Figure 13.18), the
sensitive exploration of volumes and the play of
light upon them, as well as the figure's mood of
inner strength and introspection, are established

with a remarkable directness and spontaneity.
Note especially the spare means used to convey
the structure of the head and hands.

As this drawing so well illustrates, the fac-
tor of economy is sometimes extended to in-
clude the simplicity of the design concept. The

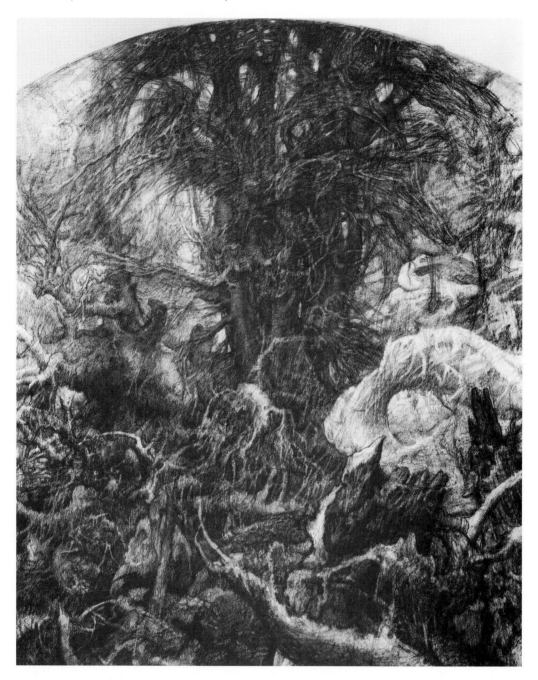

Figure 13.16
HYMAN BLOOM (1913–)
Landscape #14 (1963)
Charcoal.
Collection of Dr. and Mrs. A. Stone Freedberg, Boston

artist, in reducing this configuration to a straightforward system of simple shapes, values, and masses (even the more structurally developed forms suggest their geometric basis), heightens the drawing's expressive power. For,

as was noted earlier, an economy of means usually strengthens emotive force.

The bold simplicity of design in Wilson's *Dialogue* (Figure 13.19) adds an important dimension of expressive meaning to the represen-

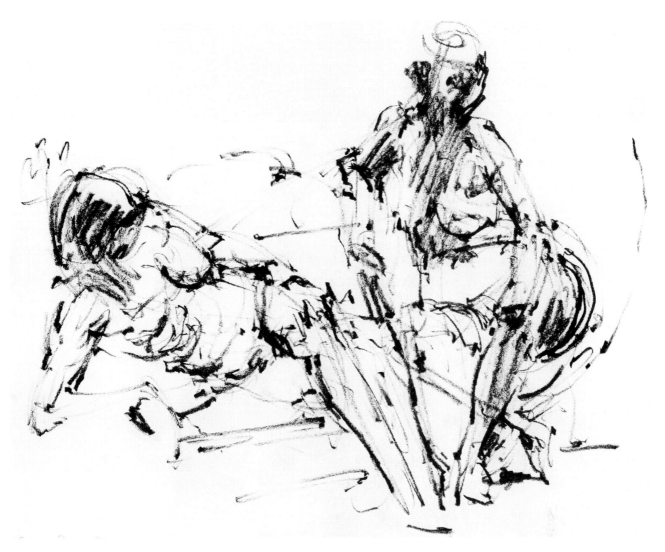

Figure 13.17
GEORGE ROSE (1936–)
Two Seated Figures (1973)
Black chalk. 20 × 28 in.
Courtesy of the artist

tation. The harsh confrontation of black and white values finds immediate symbolic equivalency. And in contrasting the gentle modeling of the child's head with the harsher handling of the skull, the artist takes his stand.

Abeles' lean and penetrating essay of a seated child (Figure 13.20) reveals the artist's sensitivity and wit both to his subject and to the means used in expressing it. There is a kind of visual pun in the undulating of both the chair and the child. The artist subtly emphasizes this rhythmic similarity by increasing the S-shaped curve of the child's left arm and by the wavelike ripples in her blouse and in the pillow that sup-

ports her legs. The effect of all these sly, roller coaster movements is a sense of animation that enlivens the image and underscores the relaxed child's limp weight. Note that while Abeles uses toned planes economically to establish the figure's forms, he doesn't hesitate to boldly tone large areas of the chair. In part, this tactic establishes the nature of the light source, but it also suggests the child's fragility and the chair's sturdiness. But the artist turns to just the opposite strategy when, in Figure 6.19, it is the heavy mass of the piano that must be reduced and the physical presence of the player, emphasized.

That an artist's expressive theme can dic-

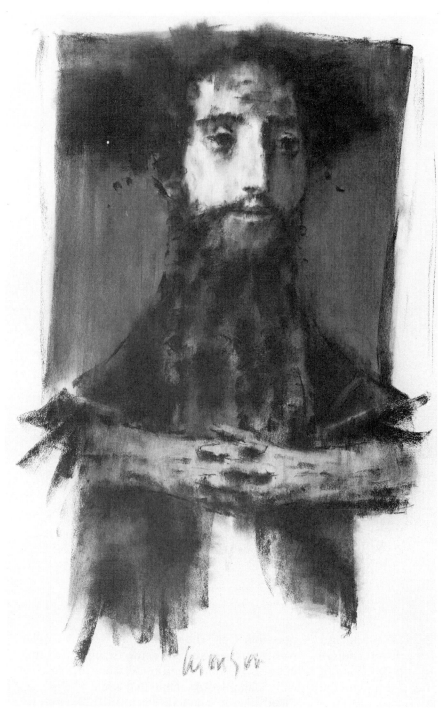

Figure 13.18
DAVID ARONSON (1923–)
Rabbi (1969)
Brown pastel. 40 × 26 in.
Courtesy of the artist

tate the visual tactics used and thereby increase the work's impact can be seen in another drawing by Abeles (Figure 13.21). This drawing of his prematurely born child tries to "lend support" in the infant's struggle to survive by giving him the strongest tones and forms, while reducing the life-sustaining apparatus to a pattern of ani- mated "thrusts" that are helpful but not as much as his son's fighting spirit.

Such selective judgments and the clarity of expression they lead to are best developed by being in touch with your feelings, with the way nature works, and with the fundamentals of an- alytical perception. In doing so, we aquire in-

Figure 13.19
JOHN WILSON (1922–)
Dialogue
Lithograph. 17½ × 13½ in.
Collection of the Museum of the
National Center of Afro-American
Artists

Figure 13.20
SIGMUND ABELES (1934–)
Child in a Wicker Chair (1971)
Charcoal pencil. 22 × 30 in.
Courtesy of the artist

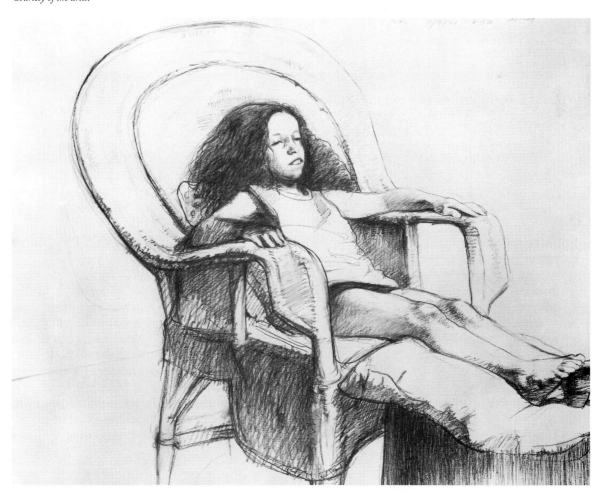

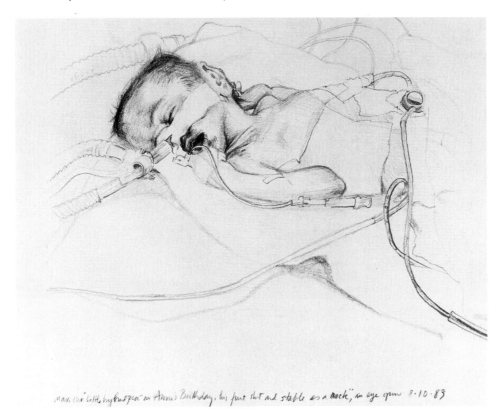

Max, our little "hybrid pea" on Annie's Birthday, his first shot and stable as a rock," in eye open 8·10·83

Figure 13.21
SIGMUND ABELES (1934–)
Max, Our Little "Hybrid Pea" (1983)
Charcoal pencil
Courtesy of the artist

sights and skills in the ways of form and space and in the ordering of our images that make our drawings more personal and inventive, whether that leads to some manner of realism (Figure 13.22) or abstraction (Figure 13.23).

A drawing's expressive purpose should determine how it is formed. But in whatever way our skills are directed, teaching ourselves to get at the heart of what is before us and to shape it in the simplest way that embodies our interests and intentions is the best way to get at our unique point of view.

In doing so, remember that it is harder to simplify than to imitate a subject, whether observed or imagined. Consider Tiepolo's *Houses and Campanile* (Figure 13.24), in which, in a spontaneous and certain manner, he reduces the scene before him, its structures, its spatial arrangement, its light, and even its temperature to a spare number of animated lines, shapes, and values.

Turner's drawing *Stonehenge at Daybreak*

(Figure 13.25) shows how much can be suggested with a few bold washes of tone. Here, delineating lines are absent altogether. Turner conveys the impression of a dawn landscape in a broad, painterly handling guided by powerful perceptual skill and a determined expressive objective. Note how clearly this "simple" handling depicts grazing sheep, coach and horses, and a sense of vast space.

Rembrandt's *A Winter Landscape* (Figure 13.26) is a masterpiece of economy. The drawing's design of fast and slow directional movements, enacting the same undulations as the snow-covered surfaces, is completely fused with the character of the representational matter. In a drawing of about a hundred lines and a few washes of tone, the artist creates snow-laden fields, shrubs, road, and rooftops. He even suggests the quality of the light and the feel of a silent, still winter day. Such limitations of means should be understood not as hurdles, but as necessary confines that intensify meanings. Goethe

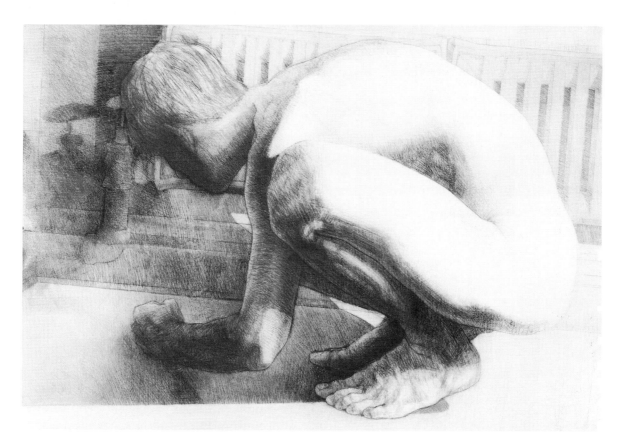

Figure 13.22 *(student drawing)*
STEPHAN WING
Figure/Interior (1982)
Compressed charcoal and wove printing. 44 × 30 in.
University of New Hampshire

Figure 13.23 *(student drawing)*
BARBARA ORLOWSKI
Ink-washed strips of paper. 18 × 24 in.
Michigan State University

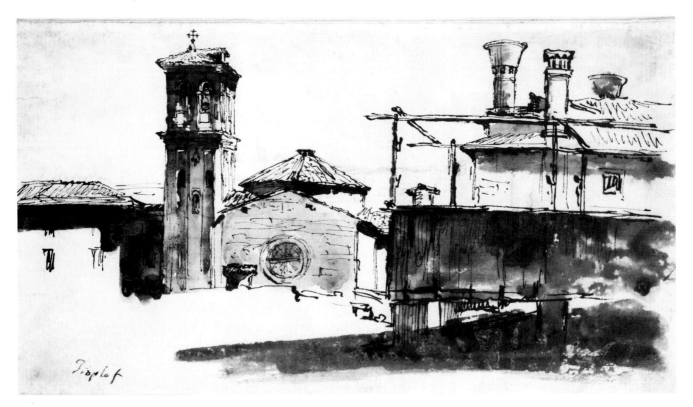

Figure 13.24
GIOVANNI BATTISTA TIEPOLO (1696–1770)
Houses and Campanile
Pen and brush in brown ink. 153 × 283 mm.
Museum Boymans-van Beuningen, Rotterdam, the Netherlands

may have had this in mind when he observed, "It is in self-limitation that the master first shows himself." Economy such as Tiepolo's, Turner's, or Rembrandt's demands exquisite perceptual and conceptual apprehension and responses shaped by a lifetime of contemplation and humility before nature, a fascination with the life of drawn marks, and an ongoing searching of self to uncover those genuinely personal questions, values, and needs that shape originality.

As was noted earlier, one of the best and fastest ways to heighten our perceptual and conceptual powers is, of course, to draw as much as possible. But our drawings must not repeat old inadequacies. If drawings are not formed by a demanding level of inquiry and response, if they do not reflect an engaging dynamic life, if they are not balanced and unified, or if they do not declare our own interests and judgments, they only strengthen the grip of old habits.

This book has been concerned largely with concepts that broaden the range of responsive options and thus with the breaking of older, restricting concepts. Some further suggestions to deepen our understanding of drawing, and consequently to move closer to our own necessary way of drawing, are appropriate here. Classes in sculpture, by enabling you to experience more directly the structural nature of forms in space, and classes in two- and three-dimensional design, by helping to explore more fully the dynamic life of the elements and the organizational possibilities they hold, would be most beneficial. These studies can provide information and insights concerning both structure and design too often overlooked in the study of drawing. And because our attitudes toward sculpture and design are less likely to be hemmed in by our early habits of procedure or prejudice, their study helps to hasten the breakup of old notions about drawing. Old habits are insistent. Beginning a

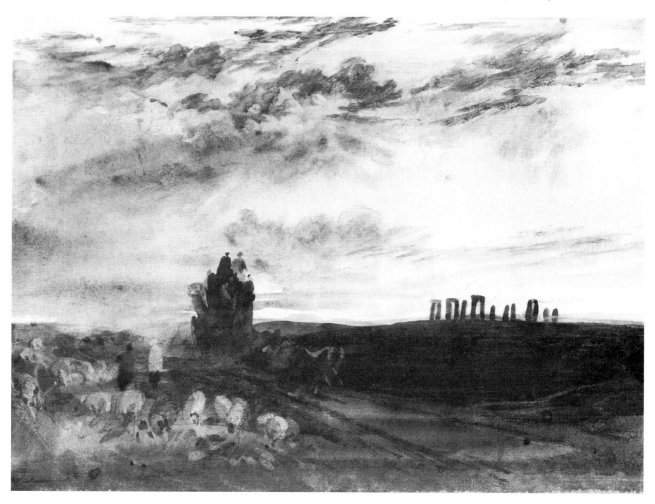

Figure 13.25
JOSEPH TURNER (1775–1851)
Stonehenge at Daybreak (c. 1816)
Graphite and brown wash. $7^5/8 \times 10^9/16$ in.
Courtesy, Museum of Fine Arts, Boston. Gift of the estate of Ellen T. Bullard

drawing by some manner of search for the subject's gestural character is for most students an uncomfortably daring step. Many hesitate and resist. Although they may accept the logic that a cautious collection of parts cannot succeed, the familiarity of this old habit seems preferable to the anticipated chaos of a more spirited, penetrating search for essentials. Sometimes the first few attempts at gestural drawing *are* chaotic. It is natural to falter in an unfamiliar process. Here, a trust in the basic principle that governs any building process—namely, the emergence of large essentials before small specifics—may help students over their first crucial barrier to responsive drawing. Once it is experienced, the many

dividends of the gestural approach make a retreat to a piecemeal assembly unlikely.

A useful and too often overlooked form of study is the faithful copying of old and contemporary master drawings. This practice was a major activity in the study of drawing for hundreds of years. Lest we put this study method aside as an antiquated one, let us recognize that almost all of the great masters made many such copies as students. Rubens, even as a mature and highly successful artist, continued to make copies of the paintings of the great Venetian artist Titian, just as Delacroix made copies of Rubens' works (Figure 6.8).

Every time a work is copied, a "residue" of

Figure 13.26
REMBRANDT VAN RIJN (1606–1669)
A Winter Landscape (c. 1648–52)
Reed pen, brush, and brown ink on cream paper. $2^5/8 \times 6^5/16$ in.
*Courtesy of Fogg Art Museum, Harvard University Art Museums, Cambridge,
Mass. Bequest of Charles A. Loeser*

information remains with us to broaden future responsive options. It seems reasonable to assume that the masters, as beneficiaries of this practice, passed it on to their students as a valuable aid to learning. The fear sometimes expressed, that copying masterworks will have the effect of influencing one's way of drawing, is unfounded. Our own creative needs soon reassert themselves but are then assisted by the expanded range of drawing tactics and insights gained from making copies. After all, when we carefully examine drawings we deeply admire, part of our study has to do with making "copies" with our eyes. That is, we experience, along with the artist, the drawing of a hand or a cloud, the gentle graduation of a value from dark to light, the refining of a form's edge, or the splash of an ink-loaded brush. Making copies only intensifies this experience.

It is further useful, after having made several copies of a particular artist's drawing, to make several drawings of your own in the general manner of that artist. Having to see your subject through the sensibilities of a Degas or a Diebenkorn can more fully involve you in rethinking certain of your drawing idiosyncrasies and habits, and in experiencing new drawing options. Then, too, copying masterworks makes it clearer to the student that for the best artists

the eye is an outpost of the heart as well as the brain.

But having mentioned the subject of influences, it should be noted that many young (and not so young) artists show in their work the influence of one or more favored artists. It is not an unusual occurrence and generally subsides or even disappears as the artist's own creative necessities begin to assert themselves. Such influences are usually helpful if seen as temporary crutches that enable one to enter areas of drawing where further, more personal growth can occur. The danger is in becoming dependent on this aid and avoiding a confrontation with self-expression.

Where possible, get to know other art students and artists. The exchange of ideas about any and all aspects of drawing is of course a very helpful means of gaining information, of testing your views and practices alongside those of others, and of sharing your enthusiasm and enjoying the support of kindred spirits.

In your study of the drawings of other artists, be sure to include an ongoing examination of works by contemporary artists. This study should be undertaken to discover, not novel styles of drawing, but new attitudes, concepts, and expressions in drawing that re-affirm and add to those lasting and universal qualities

of drawing that this book has tried to address. Avoid closing your mind to new and perhaps unsettling kinds of imagery. Instead, see if they acknowledge at least some of what you believe in, or are only expressions of an arbitrary and willful kind. The work of many of the best artists were at first seen as unsettling and even disruptive of popular values. But if unfamiliar styles and attitudes are made of "the real thing" they soon begin to reveal themselves to discerning viewers. After all, the deepest visual and expressive needs of humankind are universal and unchanging, are fixed, instinctual conditions woven into the fabric of human sensibility. The surface of art keeps changing, but not its core.

In Chapter 1 it was noted that drawing well is choosing, relating, and risking wisely, but first it is the willingness to experience with the heart as well as the eye. For, as Kenneth Clark has observed, "Facts become art through love, which unifies them and lifts them to a higher plane of reality."[2] We all have something to say. The problem is finding just what those things are which are dearest to our heart, and having the courage to state them fully. In doing so we only clarify what we are bound to say anyway, for, as Ralph Waldo Emerson put it, "As I am, so I see; use whatever language we will, we can never say anything but what we are."

For the responsive artist, art is a celebration of form. It is also, and importantly, a celebration of life. But these are shifty realities, and the artist's task is to hold on to as much of each as is possible. The American writer Willa Cather said it this way: "What was any art but a mould in which to imprison for a moment the shining, elusive element which is life itself—life hurrying past us and running away, too strong to stop, too sweet to lose."

[2] Kenneth Clark, *Landscape Into Art*, (New York: Harper & Row, 1976), p. 33.

bibliography

The books listed below are recommended for general reading, and for further information about perspective, media, and materials. The list does not include those books already mentioned in the footnotes.

GENERAL TEXTS

Anderson, Donald M., *Elements of Design.* New York: Holt, Rinehart and Winston, Inc., 1961.

Bertram, Anthony, *1000 Years of Drawing.* London: Studio Vista, Ltd., 1966.

Blake, Vernon, *The Art and Craft of Drawing.* London: Oxford University Press, Inc., 1927.

Chaet, Bernard, *The Art of Drawing.* New York: Holt, Rinehart and Winston, Inc., 1970.

Collier, Graham, *Form, Space and Vision* (3rd ed.). Englewood Cliffs, N.J.: Prentice-Hall, Inc., 1972.

De Tolnay, Charles, *History and Technique of Old Master Drawings.* New York: H. Bittner & Co., 1943.

Hayes, Colin, *Grammar of Drawing for Artists and Designers.* Studio Vista, London: Van Nostrand Reinhold Company, 1969.

Hill, Edward, *The Language of Drawing.* Englewood Cliffs, N.J.: Prentice-Hall, Inc., 1966.

Mendelowitz, Daniel M., *Drawing.* New York: Holt, Rinehart and Winston, Inc., 1967.

Moskowitz, Ira (ed.), *Great Drawings of All Time* (4 vols.). New York: Shorewood Publishers, Inc., 1962.

Rawson, Philip, *Drawing.* New York: Dover Publications, 1971.

Sachs, Paul J., *Modern Prints and Drawings.* New York: Alfred A. Knopf, Inc., 1954.

ON PERSPECTIVE

Ballinger, Louise, *Perspective, Space and Design.* New York: Van Nostrand Reinhold Company, 1969.

Burnett, Calvin, *Objective Drawing Techniques.* New York: Van Nostrand Reinhold Company, 1966.

Cole, Rex V., *Perspective: The Practice and Theory of Perspective as Applied to Pictures.* New York: Dover Publications, Inc., 1927.

James, Jane H., *Perspective Drawing: A Directed Study.* Englewood Cliffs, N.J.: Prentice-Hall, Inc., 1981.

Norling, Ernest R., *Perspective Made Easy.* New York: The Macmillan Company, 1939.

Watson, Ernest W., *How to Use Creative Perspective.* New York: Reinhold Publishing Co., 1960.

White, John, *The Birth and Rebirth of Pictorial Space.* London: Faber and Faber Ltd., 1957.

ON MEDIA AND MATERIALS

Chaet, Bernard, *An Artist's Notebook: Techniques and Materials.* New York: Holt, Rinehart and Winston, 1979.

Doerner, Max, *The Materials of the Artist and Their Use in Painting.* Eugen Neuhaus, trans. New York: Harcourt Brace Jovanovich, Inc., 1934.

Dolloff, Francis W. and Roy L. Perkinson, *How to Care for Works of Art on Paper.* Boston: Museum of Fine Arts, Boston, 1971.

Kay, Reed, *The Painter's Guide to Studio Methods and Materials.* Englewood Cliffs, N.J.: Prentice-Hall, Inc., 1983.

Mayer, Ralph W., *The Artist's Handbook of Materials and Techniques* (rev.). New York: The Viking Press, Inc., 1970.

Watrous, James, *The Craft of Old Master Drawings.* Madison, Wisc.: University of Wisconsin Press, 1957.

index